A SEPARATE PEOPLE

BRILL'S SERIES
IN JEWISH STUDIES

A SEPARATE PEOPLE

*Jewish Women in Palestine, Syria and
Egypt in the Sixteenth Century*

BY

RUTH LAMDAN

BRILL
LEIDEN · BOSTON · KÖLN
2000

This book is printed on acid-free paper.

Library of Congress Cataloging-in-Publication Data

Lamdan, Ruth.
 A separate people : Jewish women in Palestine, Syria, and Egypt in the
sixteenth century / by Ruth Lamdan.
 p. cm. — (Brill's series in Jewish studies ; vol. 26)
 Includes bibliographical references (p.) and index.
 ISBN 9004117474 (cloth : alk. paper)
 1. Women in Judaism. 2. Women—Legal status, laws, etc. (Jewish law)
3. Jewish women—Palestine—Social conditions—16th century. 4. Jewish
women—Syria—Social conditions—16th century. 5. Jewish women-
-Egypt—Social conditions—16th century. I. Title. II. Series.
BM729.W6 L36 2000
305.48'89240569—dc21

00–039776
CIP

Die Deutsche Bibliothek – CIP-Einheitsaufnahme

Lamdan, Ruth:
A separate people : Jewish women in Palestine, Syria and Egypt in
the sixteenth century / by Ruth Lamdan. – Leiden ; Boston ; Köln : Brill,
2000
 (Brill's series in Jewish studies ; Vol. 26)
 ISBN 90–04–11747–4

ISSN 0926-2261
ISBN 90 04 11747 4

PRINTED IN THE NETHERLANDS

"Women are a separate people"

(Babylonian Talmud, **Shabat**, 62a)

TABLE OF CONTENTS

INTRODUCTION

From the beginning of this century, especially since the 1950s, we have been deluged by articles and books on the status of women.[1] One of the reasons for this sudden surge of interest in the subject is the fact that women, despite comprising fully half the human race, have been underrepresented or misrepresented in historical or sociological works: Their feelings, responses and thoughts have simply been disregarded.

Inequality between the sexes has always existed. Women have not only been the objects of discrimination in most societies, they were also almost totally deprived of legal or other rights. Their inferiority and dependence on men was perpetuated from one generation to another, until it became a standard feature of the culture, education, and norms of society.

Until the 20th century, it was almost impossible for women to transcend the biological or gender-determined constraints in their lives. I say 'almost' advisedly, because there were a few outstandingly gifted or wealthy women. These, however, were the exception rather than the rule.

Although numerically speaking women were not a minority, in practice they had the status of a minority, even if they themselves were unaware of this.[2] They were discriminated against legally, socially, and economically. Their education, mode of dress, and freedom of movement were restricted. Even within the confines of the home and family, they had no control over their destiny. Social advancement through the acquisition of an education, capital, and a social or political network was barred.[3] From the moment they were

[1] There are hundreds such studies. Obviously, we cannot relate to them all in this context. Some are mentioned in the notes to articles cited below. For references to sources and articles dealing with the status of women in Western culture throughout the generations see: Osborne; Hufton; De Beauvoir; Shahar, *Fourth Estate*. Note that library books on 'Women' are usually relegated to the Anthropology or Sociology sections, the implication being that women are some strange breed or minority group. An example of this anthropological approach can be found in Rohrich and Hoffman.

[2] See H.M. Hacker.

[3] On the difference between a basic status and an acquired status, see Shapira and Ben-Eliezer, pp. 42-48. See also Biale, pp. 16-18.

born, a system of expectations and regulations governed their behavior at every stage of their lives. It was men who determined their fate. It was men who were the authors of most of the records, letters, documents and other historical sources available to us today. It was they who passed laws, and made decisions. Most artists, writers, or political leaders were men. It was men who expressed their opinion of women, not the other way round. There are virtually no sources on women by women. Consequently, any historical study on women is of necessity limited due to the absence of independent 'female' sources.

This fact must be borne in mind when reading works on the status of women in general, and of Jewish women in particular. So far, it has proved an insurmountable obstacle. In this study, for example, I have had to rely primarily on Jewish legal sources (*halakha*), which are the main available sources on the period and place of my research. These sources reflect the halakhic status of women and the way women were perceived by the rabbis and leaders of the community. They in no way reflect women's self perception.

In Judaism, as in Islam and Christianity, the intellectual inferiority of women is axiomatic.[4] In some respects, the Jewish sources relate to women in the same way as they relate to minors and slaves.[5] Naturally, there are also flattering pronouncements on women, on the lines of 'A Woman of Valor' in the Book of Proverbs (31:10-31), but these do not compensate for the legal discrimination against women. In actual fact, these positive pronouncements are simply descriptions of what is expected of a 'good' woman. Even Israel Abrahams, who brings numerous quotes from the Jewish sources glorifying women and their role in the home, was forced to admit that there is a discrepancy between these expressions of esteem, and the inferior status of women in practice in Jewish law.[6]

The Jewish sources stress a woman's role as wife, mother and housewife – roles which are presented as lofty ideals. Although it may

[4] See for example Shahar, *Fourth Estate*, pp. 12-13; Winter, *Society*, pp. 291-296; Stillman, "Attitudes," pp. 346, 350-351, and compare with statements from Jewish sources such as: 'Women are fickle' (*Kiddushin*, 80b, and parallel versions), 'Women are talkative' (*Berakhot*, 48b), 'Women are witches' (*Pesahim*, 110a), 'Women are incomplete' (*Sanhedrin*, 22b), 'A woman's place is in the home' (*Yoma*, 66b), and the like, and also statements in *Bereshit Rabbah*, Section 17, 6-7; Section 45, 5, *passim*.

[5] See for example: *Berakhot*, 20a; *Sotah*, 47a; *Bava Kama*, 87a, 114b; *Sanhedrin*, 105a.

[6] Abrahams, pp. 130-131, 170. See also Dinur, pp.15-18.

be argued that these ideals indicated concern for the stability and integrity of the Jewish family, and by inference, concern for the survival of the Jewish nation, in practice they helped perpetuate the inferior status of women. They helped foster a climate in which generations of women were brought up to consider their function as mothers and wives as their sole and inescapable destiny.

Women born into this normative system came to terms with it to a greater or lesser degree. This acceptance, interpreted by some as contentment, led researchers to paint an idyllic picture of life within the medieval Jewish family. Jacob Katz ascribes the low rate of divorce, at least in Askhenazi (Rhineland) society, to this attitude of acceptance.[7]

Most of the restrictions imposed on women by *halakha* were the result of the decisions, interpretations or constraints introduced by the early or later rabbinical authorities (*Rishonim* and *Aharonim* respectively). Halakhic consideration of women's rights usually stems from a paternalistic attitude of compassion toward the weak and oppressed per se. This paternalism frequently masked a wish to 'keep women in their place,' or served as a pretext for passing restrictive or discriminatory legislation. Such legislation, far from protecting women, as it claimed to do, was frequently used as a pretext for exploiting their weakness. Such weakness, however, where it existed, was the result, rather than the cause, of their oppression over the generations.[8] Women's exemption from certain halakhic obligations – such as positive commandments which are limited to specific times – may also have served as a pretext for discriminating against them and depriving them of their rights.[9]

Note that in contrast to some *halakhot* (Jewish laws) that seem to reflect women's inferiority to men (such as: laws of inheritance, legal

[7] Katz, *Tradition*, pp. 173-174; ibid, "Marriage," p. 43; Abrahams; Güdemann, pp. 79-82, 93. See also Yuval, pp. 177-178.

[8] Shahar, *Fourth Estate* (esp. first and second chapters); De Beauvoir (esp. second chapter); Goitein, *Introduction*, pp. 125-126; Keddie and Beck (esp. Introduction); Dengler; Stillman, "Attitudes"; Winter, *Society*, pp. 291-296; H.M. Hacker; Lee Osborne.

[9] On positive commandments that are restricted to specific times, see entry: "Woman," Talmudic Encyclopedia, Vol. 2 (1976), pp. 242-250; see also: Goren; Fishman (esp. p. 208 ff, and note 46 there); Euerbach, pp. 21-42; Falk, "Status", 362-363; Guthold; Mescheloff (esp. chapter entitled 'The Woman's Task according to *Halakha* – Motherhood, Chastity, Submission,' pp. 278-284); Berman (esp. pp. 121-122); Buber Agassi; Radai, pp. 183-184.

autonomy, laws of impurity), in the biblical narrative itself women, far from being hidden away in the recesses of the home, play an independent and active role. They are frequently arbiters of their own fate, and are actively involved in social, legal, and public issues. In this context, it is worth citing the words of R. Joseph Alsayag:

> By saying that women die for transgressing three commandments [see *Shabbat*, 31b], our sages of blessed memory were not implying that women are absolved from observing [all] other commandments. The reason why these three commandments are singled out is because they are more important. However, women are also obliged to observe all positive and negative commandments [...] The exemption [from positive commandments that are restricted to specific times] is not a biblical, but rather a rabbinical enactment [...] prescribed by the sages to preserve marital harmony – so that men would not scold their wives, or, for reasons of modesty – to spare women the necessity of walking through the streets [...] For they [the sages] have the power to legislate regulations [...] But the truth of the matter is [...] that from a biblical point of view, these obligations exist.[10]

Over the generations, the situation changed for the worse. Local conventions and regulations (*takkanot*) placed further restrictions on women's educational or professional advancement, and forbade them from appearing in public or participating in decision-making processes, even in the home. As a rule, one could say that *halakha*, as defined and applied by the rabbinical authorities, both incorporated and endorsed existing social norms, thus providing a pretext for the exploitation of women.[11]

Discrimination against women is most apparent in matrimonial law, inheritance law, and other laws touching on their personal status and their ownership of money or property. In these areas, *halakha* perpetuated women's dependence on the male members of the family, and made it easier for violent or mercenary husbands to exploit them. While the decisors found ingenious halakhic solutions for commercial and economic predicaments, they adhered to the often abstruse letter of the law in all matters pertaining to female autonomy. Even when justified by specific circumstances, no rabbi was willing to

[10] MS Amsterdam, Rosenthaliana, p. 361a.

[11] This conclusion concerning the consonance between *halakha* and reality ties in with Shulamit Shahar's conclusion concerning European women in the Middle Ages: 'The reality of women's life generally approximated their legal position' (Shahar, *Fourth Estate*, p. 19).

stretch out his neck by offering a more flexible interpretation of the law. This rigidity was particularly evident from the late Gaonic period on, when a trend toward local legislation applying to a specific locality or congregation, rather than to the community as a whole – emerged. Increasingly the sages argued that the legislative competence of the rabbis after the redaction of the Talmud was confined to financial matters only, and not to matrimonial law. This led to a retrenchment in halakhic exegesis, and to a further curtailment of women's rights.[12]

This book concentrates on the status of Jewish women in the 16th century Levant, and before going further it is important to place the research into its proper geohistorical context, bearing in mind the momentous changes that were taking place there throughout the century.

In late 1516-early 1517, Syria, Palestine and Egypt were conquered by the Ottoman sultan Selim I (1512-1520). Palestine became part of the province (*eyalet*) of Damascus, and its western part was divided into four districts (*sancak*): Safed, Jerusalem, Nablus, and Gaza (later, the district of Meggido/Lajjun was added), which were subject to the suzerainty of the governor (*Beylerbey*) of Damascus.

At first, the new sultan brought with him law and order and opened up economic opportunities which in turn triggered demographic changes which lasted almost until the end of the century. Sea and overland transport were improved and made safer, and were routinely used by merchants and pilgrims.

Contemporary Jews saw the Ottoman conquest of Palestine as yet another stage in the 'pre-Messianic tribulations' that heralded the redemption, beginning with the capture of Constantinople and the collapse of the Byzantine Empire in 1453, and continuing with the Expulsion from Spain in 1492 and the forced conversion of Portuguese Jews in 1497. The messianic hopes surrounding the conquest of Palestine together with auspicious political conditions, encouraged many Iberian and other refugees to make their way to Palestine. Some never made it as far as Palestine, but settled in various cities

[12] For a detailed description of the sources of legal authority and legislative enactments of the sages through the generations, the distinction between civil and ritual law, and the range of interpretative options available to the decisors, see Elon, *Jewish Law*, especially the section dealing with the sources of Jewish law, but also elsewhere. See particularly pages 401, 548-556, 686-687.

along the way in the Balkans, Greece and Anatolia, which were already under Ottoman rule. Others reached the outskirts of Palestine, settling in the nearby towns of Damascus, Aleppo, Sidon and Tripoli in Syria, and Alexandria and Cairo in Egypt. The Jewish communities in these places grew and prospered in the course of the 16th century.[13]

Those who actually reached Palestine brought about a profound transformation to the demographic and structural composition of the Jewish community there. If in the early century, the Jews in Palestine barely numbered 2,000-2,500, by mid-century they numbered an estimated 10,000-12,000, that is, an increase of over 400%! It should not be forgotten, however, that the Jewish population still constituted only a small percentage of the general population of over 250,000. Most of the Jewish population of Palestine was concentrated in the towns of Jerusalem, Safed and Gaza. By the middle of the century, there were about 350 Jewish households in Jerusalem, about 750 in Safed, and about 120 in Gaza. There were also small communities in Hebron and Nablus, and in several villages in the Galilee.[14]

Unlike previous immigrants to Palestine, these 16th-century immigrants comprised not only elderly people who wished to spend their remaining years in the Holy Land, but also, and mainly, families and individuals who had come there to live and work, and raise their families. Alongside mystics, soothsayers and repentant *conversos*, was an industrious, down-to-earth population, preoccupied with day-to-day problems, and employed in a broad range of crafts and professions.

The Jews of Palestine were divided into congregations depending on their ethnic origins and affiliation. These congregations comprised: Musta'rab Jews (native Arab-speaking inhabitants of Palestine, who dressed like Arabs and adhered to many of their customs),

[13] On the Jewish communities of Egypt and Syria see: Ashtor, Vol. 2, p. 438 ff; David, "Settlements"; Winter, "Jews"; Shmuelevitz, pp. 11-14; E. Rivlin, "History"; Cohen-Tawil; Lewis, *Jews*, pp. 235-238; Rosanes, Vol. 2, p. 141 ff; Vol. 3, pp. 218-241.

[14] On the Jewish population of Palestine based on Ottoman archives, see Lewis' articles, collected and revised in an anthology entitled *On History*, pp. 56-128; See also, Heyd, *Ottoman Documents*; idem, "Safed"; idem, "Turkish Documents"; Cohen-Lewis; Cohen, "Changes"; idem, *Jerusalem*, pp. 19-42, 153 ff.; Schur, "Relationship." For general information: Ben Zvi, *Eretz Israel*; Cohen, *History*, pp. 201-217, 247-248, *passim*; N.A. Stillman, pp. 87-91.

Sefardi Jews, Ashkenazi Jews, Maghrebi (North African) Jews, Italian Jews, and others. Safed, in particular, was noted for its profusion of congregations during its 'golden age.' However, the economic depression at the turn of the century led to the fusion or disappearance of many congregations, and to a decline in the Jewish population.[15]

This division into congregations was typical too of the Jewish communities of Syria and Egypt. There too, the traditions of the long-established local Musta'rab population came up against those of the Ashkenazi, Italian, Iberian and North African Jews. Each of these ethnic groups brought with it an assortment of traditions and customs from their country of origin. The differences between them were reflected not only in their way of life, but also in their halakhic decisions.[16]

After the Ottoman conquest, the leaders of the Musta'rab community, who had headed the Jewish community for generations, began to be supplanted by the Iberian Jews. The obvious numerical and economic superiority of the latter meant that by the end of the century they had 'incorporated' nearly all the other congregations. It was they who represented the Jewish community before the Ottoman authorities. Even the Ashkenazi Jews, who continued throughout to maintain their own distinctive identity and customs, were forced to acknowledge the superiority of the Sefardi Jews, and rely on them for representation before the authorities. However, despite the unquestioned cultural superiority of the Spanish Jews, for several decades the Musta'rabs fought hard to preserve their own customs.

This study is an attempt to examine the influence – if any – the encounter of the Iberian refugees with the traditions of the Rhineland, North Africa, Italy, and the Orient, had on the Jewish family and on woman's status in society. How was this meeting of different cultures reflected in the halakhic decisions that evolved in the refugee communities of the Levant during this period? Did it help mitigate the intractability of the sages, and if so, how was this expressed in practice? Finally, how far did the halakhic status of women correspond to their actual status, as reflected in society's attitude toward them in everyday life?

[15] Ben-Zvi, "Musta'rabs"; Rozen, "Musta'rabs"; David, "Ashkenazic Community," pp. 25-27; idem, "Safed"; Cohen-Lewis, pp. 155-161. By mid-century, Safed had more than fifteen congregations.

[16] Lewis, *Jews*, pp. 120-121, *passim*; Shmuelevitz, pp. 13-14, *passim*; Bornstein-Makovetzky, "Community"; Benayahu, "Sermons," p. 50, *passim*.

In speaking of the status of women there is always the danger of generalizing. Which women are we referring to? After all, women differ not only in character, but also in criteria such as family origin, economic status, ethnic affiliations, and place of residence. A woman of breeding, for example, is as different from a plebeian woman as an Ashkenazic woman is from a Sefardic or Musta'rab woman. Indeed, a comparative study of women is a fascinating topic in itself, and I have tried as far as possible to introduce a comparative dimension into this book. However, it is important to bear in mind that this study as a whole deals with 'ordinary' women, not exceptional ones. By 'ordinary' I mean the silent majority of women living in a specific Jewish society and accepting its normative way of life. This book examines the status of such women vis-à-vis that of men in the same society. To this end, we have had to generalize and refer to 'women' as a single category.

Since, as stated, most of the sources on women are by men, the resultant picture is not only incomplete, but frequently skewed. We have no way of knowing how women saw themselves, to what extent they considered themselves deprived or whether they wished to alter their situation. Virtually the only sphere where women could express themselves at all was within the framework of home and family. Indeed, the silent majority of women found fulfillment within this framework, where everyone knew her place and what was expected of her. Women's social inferiority was taken for granted, and their personal happiness and fulfillment were never considered. It is safe to assume that most women found happiness, or rather, contentment, in the company of a husband they grew to love and honor in the course of their marriage. No doubt, too, the management of household affairs gave them a certain sense of power which somewhat compensated for the discrimination they suffered in other spheres.

The above notwithstanding, the demands of *halakha* frequently locked horns with the demands of day-to-day reality.

Much of the information on which my research is based has been taken from the 16th- and early 17th-century Responsa literature. This literature, which constitutes a link in the generational chain of decisors and responders, is rich in historical and social material.[17] In the course of my research, I have reviewed thousands of Responsa by

[17] On the Responsa literature as a historical source on the Jews of the Ottoman Empire, see Shmuelevitz, pp. 1-9.

the rabbis of Syria, Palestine, and Egypt. I have attempted through-
out to ascertain the extent to which their decisions reflect a rigid,
literal interpretation of the law, or a more flexible, independent ap-
proach. As far as possible I have tried to clarify the factors that tip the
scales in favor of leniency, or in favor of rigidity.

Additional sources were: the homiletic literature of the times, with
its more mundane attitude towards women, and local regulations,
which reflect the attitude of the Jewish community and its leaders to
specific problems that arose. Travel chronicles and letters by travelers
to the Middle East provided material on the everyday life of Jewish
society as a whole, but little information on women as such. Original
contemporary manuscripts and documents – particularly from the
Shari'a court of Jerusalem and the Cairo Genizah – constitute a
fascinating, albeit limited, source on women.

Although my research focuses on the image and status of Jewish
women vis-à-vis that of Jewish men, there is no doubt that a com-
parative study of Jewish, Muslim and Christian women would be of
great interest. Although such a study is not within the scope of this
book, I have nevertheless made use of R.C. Jennings' research on
women in the Anatolian city of Kayseri (based on local Shari'a court
records),[18] to draw a comparison between Jewish and Muslim society,
where relevant. These records indicate that Muslim and Jewish law
are similar in their attitude toward women. Jennings' article is a
comprehensive study on the rights and status of the women of
Kayseri in the years 1600-1625, and their involvement in the local
economy and society. He found that seventy-three percent of women
who resorted to the Shari'a court in Kayseri during this period were
Muslims, and the remainder, members of the protected non-Muslim
minority groups (*dhimmis*). According to Jennings, the Shari'a court
records do not indicate any differences in the socioeconomic
behavior of Muslim and non-Muslim women.[19] Amnon Cohen, who
used Shari'a court records in his study on the Jews of Jerusalem
during the 16th-century, reached a similar conclusion: "The Jewish
women of Jerusalem, who lived far away from their Muslim counter-
parts in Kayseri, and in an earlier period, in practice enjoyed similar

[18] Jennings, "Kayseri".

[19] Ibid, p. 109. Most of the *dhimmis* in the area were affiliated with the Armenian
or Greek Orthodox churches. There is no reference to Jews living in Kayseri
(Jennings, "Zimmis," pp. 225-226).

rights to those of their Muslim sisters."[20] Dror Zeevi in his doctoral thesis, discusses the status of women in 17th-century Ottoman Jerusalem.[21] Where relevant, I shall be making references to these works.

In the course of my research, I frequently consulted Shulamit Shahar's works on women in Christian Europe in the late Middle Ages,[22] in order to compare the status and functions of Jewish and Christian women. To the best of my knowledge, no study had yet been undertaken of Christian women in Palestine during this period.

I would like to draw your attention to the following technical points:

a. As far as possible, I have tried to focus on the 16th-century Responsa literature and other 16th-century sources. From time to time I refer to earlier or later sources, but only when these are clearly relevant to our period also, or when information on a specific issue is particularly fragmentary.
b. The work includes many quotations from the Responsa literature and other halakhic sources. My omissions or additions are indicated by square brackets. All emphasis in the quotations is mine, unless otherwise stated.
c. All quotations from Talmudic sources are from the *Babylonian* Talmud, unless otherwise stated.
d. The appendix includes a short biography of the most frequently mentioned decisors, and standard acronyms of their names.
e. Since short titles were used in the footnotes, the bibliography, at the end of the book, is arranged accordingly. Hebrew titles were translated into English, except for titles of primary sources, where transliteration was provided.

Finally, I would like to thank my family who supported and encouraged me throughout this lengthy undertaking, and my mentor and friend, Professor Minna Rozen, who supervised my doctorate on which this book is based. I would also like to thank the staff of the Jewish Manuscripts Department and the Institute for the Reproduction of Hebrew Manuscripts at The National and University Library in Jerusalem.

[20] Cohen, *Jerusalem*, p. 149.
[21] Zeevi.
[22] Shahar, *Fourth Estate*; idem, *Childhood*.

My appreciation and thanks to Yaffa Murciano, who translated the book into English.

The translation was made possible by the help of grants from The Kaplan Chair in the History of Egypt and Israel, and the Chair for the History and Culture of the Jews of Salonica and Greece, Tel-Aviv University, and by the AMOS Presidential Fund.

WOMEN THROUGH THE EYES OF THE SAGES

The ideal woman as described in the Bible, in particular in the Book of Proverbs [31:10-31], is a devoted wife, a capable housewife, an excellent craftswoman, and a shrewd businesswoman, as well as being wise, generous and God-fearing. A woman who combines all these qualities is not only a source of pride to her husband, but has the additional value of enabling him to devote himself wholeheartedly to the study of Torah.

This paradigm of the ideal woman has not changed over the generations. On the contrary, the expectations it generates have been internalized by Jewish men over the centuries. Let us take, for example, an excerpt from a 16th-century manuscript entitled "A Marriage Prayer" – a supplication designed for young men desirous of finding a suitable match. The prayer reads: "Provide me with a wife and helpmeet as it says: 'I will make him a helpmeet for him" [Genesis 2:18] [...] And through her may I fulfill the verse: 'Whoso findeth a wife findeth a great good' [Proverbs 18:22] [...] And let her be a woman of valor [Proverbs 31:10], as it says 'a woman that feareth the Lord, she shall be praised' [Proverbs 31:30], and let her not be inclined to anger in any way."[1]

In the same vein, R. Joseph Alsayag, one of the sages of Safed, listed in a sermon he delivered at his mother's graveside, the four attributes befitting a woman:

First – She should be clever [...] *unlike most women who are foolish*
Second – She should be generous, *unlike most women who are mean* [...]
Third – She should be thrifty [...] *unlike most women who want their husbands to give endlessly* [cf. Proverbs 30:15], *without a thought for the consequences* [...]
Fourth – She should be of a gentle disposition, *unlike most women who are argumentative and quarrelsome* [...]

[1] MS London, BM, Or. 10112, p. 17.

These four attributes, R. Joseph Alsayag went on to say, corresponded to four traits that became a virtuous woman: modesty, generosity, business acumen, and efficiency in the home "where she should serve her husband faithfully, without duplicity."[2] These attributes obviously applied to his own mother, if not to 'most women.'

The ideal woman was preferably not too beautiful, since "Grace is deceitful, and beauty is vain" [Proverbs 31:30]. R. Samuel Ibn Sid of Damascus drew a distinction between rich and beautiful women, who were demanding by nature, and modest, unassuming women, whose sole raison-d'être was to look after their husbands:

> When it comes to choosing a wife, he who takes a rich and beautiful wife will come to regret it [...] For she will insist that he [...] take on any job, even one that is unfamiliar to him, in order to keep her in style, without concern for his Torah study. She will become a millstone round his neck [...] On the other hand, he who marries a modest, God-fearing woman, will benefit thereby [...] for his wife will provide for all his needs.[3]

Domineering women were considered a scourge. Dominance in a woman was thoroughly condemned, often serving as a theme for satirical doggerel:

> Three are the things that make me mad
> And four are the things that make me sad
> A scoundrel with an undistinguished father
> Who lays claim to fame and grandeur
> A poor man who suddenly turns rich
> And considers himself a philanthropist
> A fool who dares challenge a sage
> And roars like a lion in a rage
> But a woman who is controlling
> Fills me with loathing.[4]

These and similar passages are representative of the prevailing attitude toward women by the 16th-century sages and the community at large. Since most women did not qualify as women of valor, they were perceived in a negative light. Only those who humbly and faithfully served their husbands were considered worthy of respect. A

[2] MS Amsterdam, Rosenthaliana, pp. 361b-362a. These words are attributed to R. Samuel Saba, R. Joseph Caro's brother-in-law.

[3] MS Jerusalem, Samuel Ibn Sid, p. 46a.

[4] MS Jerusalem, *Iggerot Shadarim*, p. 173. On R. Hayyim Vital's contentious wife, see Vital, *Sefer ha-Hezyonot*, pp. 17-18; See also Laniado, pp. 58b-59a; Maharitatz, 231.

man could divorce his wife, or take a second wife, if his first wife failed to do her duty by him. This is illustrated in the following passage by the Mabit (R. Moses Trani) of Safed, about a woman who became blind:

> Since her blindness prevents her fulfilling some of her duties towards him [her husband], such as her handiwork, and since she is unable to do what she was formerly capable of doing [...] he also has the right to detract from some of his duties towards her. For not only has she ceased being an asset, she has actually become a liability. She is unable to perform the tasks that most women do for their husbands, such as cooking and baking. Nor can she properly perform those tasks that all women – even those with handmaids – perform for their husbands, such as serving him with food and drink [...] Since she is unable to perform these duties, he too is exempt from some of his marriage vows [...] and a permit may be granted him [to marry a second wife] without his wife's consent.[5]

In the same vein, the Radbaz (R. David Ibn Zimra) ruled that marriage was permissible even during the Counting of the Omer (a period of semi-mourning) in cases "where there were sound reasons for so doing [...] for example: if someone had not yet fulfilled the commandment of procreation, or had no-one to minister unto his needs, and the like."[6]

According to this view, a woman's primary role is that of a supplier of services. But that is not her only function. Women are also necessary in order to satisfy men's sexual needs, so that their minds are free for the pursuit of Torah.

The view of marriage as a means of avoiding sexual temptation was no doubt one of the reasons for the prevalence of early marriages, as advocated by the Safed kabbalist, R. Elijah De Vidas: "In

[5] Mabit, III, 51. The permit was granted by R. Elisha Gallico of Safed. R. Moses Alshekh, on the other hand, ruled that no permit was needed in the first place (Alshekh, 86). On the duties a woman was expected to discharge for her husband, see: *Ketubot*, 59b; Rambam, *Marital Laws*, XXI. And the Rambam's statement in *Marital Laws*, XV, 20: "Women are commanded to honor their husbands [...] and treat them like princes or kings."

[6] Radbaz, II, 687. Compare to the image of a wife as a servant or maid in the writings of R. Yom Tov Zahalon of Safed (Maharitatz, 40, 231). See similar statements in MS London, BM Or. 10118, p. 10; Toledano, p. 57. According to Ashtor (II, pp. 341-342) "Jewish women were not subservient in the way Muslim women were, but were respected and enjoyed many rights and privileges. Men viewed women in a positive light." And yet, despite his attempts to rationalize the male-female relationship within the Jewish family, he too concluded that: "men saw women primarily as housewives."

this generation men must protect their sons from sinful thoughts before they marry."[7] This theme recurs in songs, wedding sermons, and local *takkanot* (Rabbinical regulations).[8]

A man who had regular sexual relations with an accommodating wife who met all his expectations was able to devote himself whole-heartedly to Torah study, which was his sole purpose in life. As R. Samuel Ibn Sid pointed out in a wedding sermon: "A man without a woman is a man without Torah; a man only truly acquires Torah when he marries [...] since Torah is the be all and end all of matrimony."[9] In the same sermon, he explained the alphabetical arrangement of the verses of 'A Woman of Valor' as signifying that women enabled men to observe the entire Torah, from A to Z (*Aleph* to *Tav*).

The task of encouraging her husband to study Torah was presented not only as a duty, but also as a privilege, a kind of 'compensation' offered women for *their* lack of education. Since women, the reasoning went, were absolved from observing some of the commandments, including Torah study, they had no part in the privileges and rewards awaiting the righteous in the next world. But by enabling their husbands to study and by bringing up their children in the ways of the Torah, they too had a share in the world to come. This idea is expounded by R. Elisha Gallico of Safed, in his exegesis on the Book of Ruth:

> Because they further Torah study, by encouraging their sons and husbands to learn, they too have a share in this learning. The credit goes to them for allowing their husbands to devote themselves to Torah study, despite the sacrifice involved in putting their own needs aside, and patiently waiting for their husbands. It follows that the *tikkun* (spiritual redemption) of the men really belongs to the women.[10]

[7] De Vidas, *Reshit Hokhma, Sha'ar Hakedusha*, 17 (Amsterdam edition, p. 248a).

[8] See for example, the sermons of R. Joseph Garçon, MS London, Garçon, p. 33b; 37a; 212a; Toledano, regulation 7, p. 50; Berukhim Abraham, no. 12, p. 298; Hallamish, "Text", no. 31, p. 92.

[9] MS Jerusalem, Samuel Ibn Sid, p. 38a. Ibid, pp. 46-47, *passim*.

[10] Regev, p. 125. This was quoted, with slight variations, by R. Samuel de Uceda, Gallico's disciple, in *Iggeret Shemuel*, his commentary on the Book of Ruth (*Iggeret Shemuel*, 21, a:b). (See Benayahu, "Reasoning," p. 86. See also Gallico's commentary on *The Song of Songs*, ibid. pp. 84-85). Apparently, R. Samuel Uceda was not entirely happy with his Rabbi's interpretation. On this theme, see also: *Berakhot*, 17a; *Shemot Rabbah, Jethro*, 28b; Jellinek, Vol. 3, *Seder Gan Eden* 2, p. 136; Vol. 6, *Seder Gan Eden* (Addendum), pp. 151-152; Vital, *Sefer ha-Hezyonot*, Vol. 3, 8 (pp. 87-88); Mescheloff, p. 287.

Marriage, therefore, was perceived by the Sages, and therefore also by the community, as a means of fulfilling the commandment of procreation and of facilitating life for men. Women were expected to serve their husbands, satisfy their physical needs and give them the freedom to exercise their professions. Of course, the height of perfection was a man whose wife catered to all his needs so that he could devote himself wholeheartedly to Torah study. The sages emphasized that woman was by nature subservient to man, as the Cairo sage, R. Hayyim Hevraya said: "A true woman is subservient to her husband, and worth less than him, since from man was she taken."[11] Woman is thus perceived as an adjunct – not as an autonomous being – which can be discarded when it has outlived its usefulness.

The Sages' rather uncomplimentary view of women was compounded by their disparaging attitude toward their intellectual ability and moral integrity: "Once a woman has tasted immorality – she will soon sink into promiscuity."[12] Women cannot be trusted in financial matters, not only because they are capricious, but also because they cannot be relied upon to take care of their orphans' property, in the way men do; and if their husbands are still alive, any money they own automatically belongs to their husbands.[13] From a Jewish legal standpoint, "a woman can only acquire together with her husband."[14] Indeed, the 16th-century *posekim* (rabbinical decisors) even invalidated transactions made by women on their own property.[15] They believed that women were easily 'won over' and that it was possible, and even desirable, to pacify them with jewelry and promises they did not always keep.[16] Sages whose ruling were refuted by their opponents, were often taunted for acting like women.[17] Wom-

[11] MS Oxford, Hayyim Hevraya, his interpretation of the verse: "This is now bone of my bone" (Genesis 2:23), p. 48b.

[12] Lieria, Responsa, 17. See also: Gavizon, I, 1, 18; Caro, Responsa *Beit Yosef*, 88 (p. 137).

[13] Arha, 35 (p. 167); Mabit, I, 339; Radbaz, III, 891. See also: *Shabbat*, 33b; *Kiddushin*, 80b.

[14] *Kiddushin*, 23b; *Bava Kamma*, 87a, 88b-89a.

[15] Maharitatz, New Responsa, I, 21; Maharitatz, 1, 54; Radbaz, II, 501; IV, 1297; VI, 2187; Mabit, I, 190; II, 32, 148; Pinto, *Hoshen Mishpat*, 104; Caro, Responsa *Avkat Rokhel*, 160; Caro, Responsa *Beit Yosef*, 2.

[16] Radbaz, I, 68, 327, 349, 458, 509, *passim*; VI, 2255; see also R. Joseph Caro's advice to a son who wanted his father to divorce his wife (*Avkat Rokhel*, 184) and R. Moses Trani's statement 'that most women are compliant by nature' (Mabit, III, 131).

[17] Littman, "Capusi," p. 57. See also Alashqar, 114: 'You have made a mistake that not even women or minors would have made!' (p. 54a).

en's wishes were discounted, and they were considered unreliable witnesses. When R. Joseph Caro based a ruling on a woman's statement, his colleague's shocked response was: "With all due respect, *I never imagined you would base your decision on the statement of a woman!*"[18]

References to women as frivolous, untrustworthy beings were rife in the community, as the following verse, penned by a Jerusalem scribe, testify:

> If you see a woman awash with tears
> For the loss of husband and dearest
> Don't waste your pity,
> For in a jiffy
> She'll turn against those who are nearest.[19]

Since women were frivolous, the reasoning went on, they had to be kept in line. A woman who claimed ownership of property was not to be believed, since otherwise "*every woman* could steal from her husband, claiming a legacy or gift, effectively excluding her husband from any say in the matter."[20] Similarly, a woman who claimed she was raped was not to be believed, since otherwise "*every woman* who committed adultery [...] and was heavy with child could claim that she was raped at home, and was therefore permitted to her husband."[21] The motives of a woman who refused to follow her husband abroad were suspect, and she was punished by the loss of her *ketubah* (marriage contract) – lest she open the way to depravity: "Whenever she feels like it, she'll accompany him, and whenever she doesn't, she won't [...] *There's no end to it!*"[22] Similarly, a woman who asked for a divorce, even on legitimate grounds, was suspect, since "when the word gets around that *all women* can force their husbands' hands through similar arguments – they will learn to lie and wriggle out of their marital commitments."[23]

In other words, all women were considered guilty until proved innocent. If only given half a chance, they would immediately try to wangle money out of their husbands or trick them into divorce. By nature, they were untrustworthy beings.

[18] Caro, *Avkat Rokhel*, 85-89 (p. 84a). See also his Responsa *Beit Yosef*, 2; Galante, Responsa, 55.

[19] MS Jerusalem, *Iggerot Shadarim*, p. 173.

[20] Radbaz, IV, 1297.

[21] Alashqar, 77. See also ibid: 84, 94.

[22] Radbaz, I, 435.

[23] Radbaz, IV, 188; See also ibid, IV, 1331; Pinto, 45; Mahritatz, 193.

By far the most dangerous aspect of women in the eyes of the sages was that of temptress. Women were seen as the main obstacle to the attainment of moral perfection. They distracted men from the important things in life and caused them to waste time on trivial matters. All their talents were used for the purposes of seduction, and therefore they invited calamity and disaster. "They entice man and seduce him," as the Spanish expositor, R. Joseph Garçon, put it "For, just as a man cannot be enveloped by flames and emerge unscathed, so man cannot think of woman and not sin."[24]

This idea of woman as a siren, who could not be thought of, looked at, or approached without arousing lust, is not exclusive to Judaism, but is found in other religions and cultures too. Medieval Christians, for example, claimed that women were sorceresses, and Islamic and Near Eastern cultures portray women as witches and demons (Lilith). Evil was an integral part of women, granting them supernatural powers. Therefore they had to be fought and subdued.[25] Original sin held women in its stranglehold: "Witchcraft is prevalent among women since the snake implanted its poison in Eve."[26]

A woman who is widowed several times is considered 'a killer wife,'[27] but there is no parallel mention of a 'killer husband.' The sages were frequently consulted by widows seeking to remarry for a third or fourth time. A responsum by the Radbaz mirrors the ambivalence that surrounded this issue. His responsum, while based on realism and common sense, also reflects his belief in the demonic powers of women. It centers around the issue of whether a woman

[24] MS London, Garçon, *Sermon for the Sabbath of the Intermediate Days of Passover and for Circumcision*, pp. 80b-83b; ibid, *Sermon for Parshat Emor*, Damascus, 1513/4, p. 120b; *Sermon for a Plague, Parshat Terumah*, 1514, pp. 139b-140b.

[25] 'Most women are involved in witchcraft,' *Sanhedrin*, 67a; *Berakhot*, 53a. See also Schwarzbaum; Shahar, *Fourth Estate*, pp. 29, 194, 242-247; De Beauvoir, pp. 199-201; Y. Stillman, "Attitudes," pp. 345-346, 352; Trachtenberg, pp. 36-37; Abrabanel, pp. 23-40; Briffault, II, p. 555 ff.; "Sammael," The Hebrew Encyclopedia, Vol. 26 (1975), pp. 106-107.

[26] *Shivhei ha-Ari*, note 35 to letter 3, p. 44a. The exact text, as it appears in *'Emeq ha-Melekh'*, by Naphtali Bacharach of Frankfurt is: "It is the opinion of most that witchcraft among women originated from Eve's defilement by the serpent, which was the beginning of her undoing, rendering her unfit to fulfill commandments like a man. It is for this reason that the spirit of impurity cleaves unto them" (Bacharach, Sha'ar Tikkunei ha-Teshuva, Chapter 3, p. 17a). See also Benayahu, *Ari*, p. 60. On woman and original sin in the Bible and in *Bereshit Rabbah*, see: Dinur, pp. 21-28.

[27] See *Yevamot*, 64b; *Niddah*, 64a. On superstitions relating to 'the killer wife,' see Friedman, "Tamar."

whose first two husbands died of plague could be considered 'a killer wife.' The Radbaz draws a distinction between death caused by ordinary disease, and death caused by plague, although on the face of it, there seems to be little difference between the two:

> Leniency is recommended [i.e., the woman is not considered 'a killer wife'] if the death was caused by plague [...] Anyone who lives in a place overrun by plague is courting danger, *and his death is not caused by his wife* [...] For we see with our own eyes how single men are succumbing to the plague even more than married ones. And just as the single men's deaths are not caused by women, so the married men's deaths are not caused by their wives [...] However, [for this ruling to be true] the plague must be lethal, killing most of the city's inhabitants [...] Therefore, in my opinion, if both husbands died in the plague – she can [marry a third time]. A fortiori, if only one of her husbands died in the plague – she is not considered 'a killer wife' and may marry a third time. However, a situation in which three husbands died of plague already creates a strong precedent, and she should not marry a fourth time [...] I once met a woman in Jerusalem whose three husbands died of disease, and she was about to marry a fourth time. I warned him at the time that he should begin preparing his shroud, and sure enough, two months later, he died [...] One final proviso: the above ruling is applicable only if it is clear beyond doubt that the husband died of plague [...] If there is any doubt at all, we must be stringent [i.e., the woman is considered 'a killer wife' and is not allowed to remarry].[28]

This perception of woman as a dangerous Lilith found its most extreme form in the writings of the Kabbalists, particularly the pietist-Kabbalist sects of 16th-century Safed. In their desire to attain religious and moral perfection and complete *devekut* (devotion) to the Holy-One-Blessed-be-He, they strongly emphasized the subjugation of physical desire and purification rituals, shunning anything that might distract them from their Torah study and holy way of life.[29]

In their writings, women are portrayed as the main obstacles to a pure life. Since, they claimed, all women are by nature destructive and dangerous, it is better to avoid them as far as possible. Conver-

[28] Radbaz, II, 682.

[29] Pachter, *Literature*. Pachter's work deals with various aspects of homiletic and ethical literature of the Safed sages in the 16th century. Inter alia, Pachter refers in various places to the kabbalists' attitudes to women, and to sexual urges (see for example, pp. 352, 360-361, 448, 460). Gershom Scholem defines Kabbalah as 'a masculine doctrine, made for men and by men' (Scholem, *Trends*, p. 37). See also Biale, pp. 150-155; Hallamish, "Literature", pp. 172-173; Zack, pp.175-177; Tishby, pp. 607-626. For a general overview of Safed and its sages in the 16th century, see Schechter, pp. 202-285.

sation with them should be reduced to a minimum.[30] Men are instructed not to think of women or look at them, even from afar, lest their lust is awakened. Indeed, one of the ancient *takkanot* of the Safed Kabbalists stated: "Avoid looking at women, even at their clothes, unless absolutely necessary!"[31] And R. Elijah de Vidas, the disciple of R. Moses Cordovero and of the Ari (R. Isaac Luria Ashkenazi), offered the following advice in his guide to proper conduct: "*Close your eyes* where possible, and refrain from looking at a married woman, virgin, or widow. For nothing is as effective against lust as shutting ones eyes. And by so doing, you will fulfill the verse: 'And shutteth his eyes from looking upon evil' [Isaiah 33:15]".[32]

Likewise, men should not look at women's clothing or speak to them at any length. A woman should only be spoken to when absolutely necessary. According to De Vidas, looking at a woman is akin to idol-worship: "One should not look at a woman's beauty by day, so as not to become defiled by night, as it says: 'Turn ye not unto the idols' [cf. Leviticus 19:4]. This [verse] refers to one who looks upon a woman's beauty." In the same vein, man is advised to engage in sexual congress with his wife only late at night, and in absolute darkness. He should try to derive no pleasure from this union, but rather act as if he were forced into it by a demon.[33]

This view of women as impure, demonic and seductive is taken further in the various editions of *Shivhei ha-Ari* and similar sources, with their descriptions of demons, and people who are 'possessed by the devil.' Man is warned that he must speak to his wife before engaging in sexual congress with her, to ascertain that she has not suddenly turned into a demon.[34]

[30] Pachter, *Safed*, p. 139; ibid, p. 167. On women's loquacity, see De Vidas, *Reshit Hokhmah, Sha'ar ha-Kedushah*, Chapter 10, pp. 137b-140a;

[31] Toledano, Regulation 18 (predating 1577), p. 49. Other versions can be found in: Hallamish, "Text", regulation 19, p. 92; regulation 24, p. 96; Caro, *Maggid Meisharim*, page 2b; ibid, *Parshat Vayeshev*, p. 13b; Radbaz, II, 770; V, 535; Benayahu, "Yonah", p. 19.

[32] De Vidas, *Totzeot Hayyim*, pp. 13b-16a. See also Cordovero, pp. 56-57, 66.

[33] De Vidas (note 32 above). For allusions to idolatry and other derogatory practices, see Maharitatz, 40. See also Moses Ibn Makhir, pp. 18a-19b; Vital, *Etz Hayyim*, Vital's introduction to *Sha'ar ha-Haqdamot*, p. 5b; idem, *Sefer ha-Hezyonot*, p. 139; Caro, *Maggid Meisharim*, 10-11, p. 2b; ibid, *Parshat Beshalah*, p. 19; MS Oxford, *Hayyim Hevraya*, p. 50b.

[34] This, in light of the contents of *Ra'aya Mheimana (Zohar), Parshat Ki-Tetzeh*, p. 276a. See De Vidas, *Totzeot Hayyim*, p. 16a; Radbaz, *Maggen David*, Letter *Quf*, p. 43b; Benayahu, *Ari*, pp. 184-187, 190-191, 232-238.

Given the Kabbalists' negative attitude toward women, it is not
surprising that reincarnation as a woman is considered by them a
most serious indictment: "*A man's reincarnation as a woman is construed as
a punishment*. For did the Rabbis not ordain the prayer: '[Blessed be
He] who has not made me a woman'[*Menahot*, 43(b)]. On the other
hand, *a woman's reincarnation as a man is construed as a reward*. For she
moves up the hierarchy of holiness [*Berakhot* 28(a)]."[35]

In conclusion, there is a dark and tainted side to every woman, and
whoever fears for his soul, should keep far from her and her wiles.

The Safed Kabbalists were not very successful in imposing their
abstemious way of life on the public at large, both within and outside
Palestine. Within a dynamic, burgeoning society, where incidents of
waywardness were not unknown, it was no easy matter to impose
such constraints. The idealistic doctrine of the Kabbalists clashed
with the exigencies of everyday life. Thus, their exhortation not to
succumb to the evil inclination, not to waste time, and to refrain from
indulging in sexual and other pleasures, remained, despite their ef-
forts, the legacy of a few select circles. Nevertheless, they would seem
to have succeeded in introducing an element of soul-searching
among some sections of the public.[36]

Despite the low esteem in which women were held by the 16th-
century sages, their incompetence and ignorance in everyday affairs
occasionally worked to their advantage. Sometimes the rabbinical
decisors would side with a woman out of compassion and solicitous-
ness toward her, just because "women are not conversant with the
law."[37] Moreover, the decisors stressed that a 'woman of valor' – one
who was endowed with all the womanly virtues, and who fulfilled her
duty toward home and family – was certainly deserving of respect

[35] Radbaz, *Metzudat David*, commandment 129, p. 28a. See also: ibid, p. 29a;
Caro, *Maggid Meisharim, Parshat Vayeshev*, p. 11b; Vital, *She'arim, Sha'ar ha-Gilgulim,
Haqdamah* 9, p. 33; *Haqdamah* 20, p. 53; idem, *Sefer ha-Hezyonot*, p. 169; Lieria Moses,
no. 8, p. 301.

[36] Pachter, *Literature*, pp. 409-416; idem, "Caro," pp. 62, 78-79, 83; Tamar; Idel,
pp. 122-123; Hallamish, "Text", pp. 90-91; C. Horowitz; The disparity between the
norm and reality is reflected in prosaic questions addressed to the decisors, and in
requests for popular remedies against the Evil Eye. See for example: Radbaz, I, 366;
II, 770; Mabit, I, 328; Regev, p. 117 (in commentary on the Book of Ruth 3:3); MS
London, *Shoshan Yesod ha-'Olam*, No. 385, pp. 163-164. (For more information about
this manuscript, see below, Chapter Four, "Married Life," note 4.)

[37] Radbaz, I, 53. See also, ibid, 398, 401; II, 599, 801, 837; III, 921; Radbaz,
New Responsa, 135; Mabit, II, 119; III, 68, 131; Caro, Responsa *Beit Yosef*, 84; Arha,
32; Caro, *Avkat Rokhel*, 184; Maharit, I, 66; Maharitatz, 177.

and affection from her husband and children. However, this attitude was predicated more on condescension and compassion, than on respect. The Mabit recommended: "A man should be careful to bring up his children in the right way [...] Even more important, he should be careful to cherish his wife, since she is *dependent* on him." Elsewhere, he gives the following advice to a husband who has fallen out with his wife: "He should behave toward her, both publicly and privately, with love and affection, friendship, and compassion."[38] The Ari's courtesy toward his wife, his readiness to 'honor and clothe her,' are frequently invoked as examples of his generosity and willingness to make concessions.[39] What the above indicates, however, is that concern for a wife's well-being was simply one facet of the patronizing condescension of the strong toward the weak.

Thus, paradoxically, woman was perceived as dangerous, seductive, and powerful, on the one hand, and as physically and mentally fragile, and in need of patronage and guidance, on the other. Fear, and perhaps even ignorance, of women, on the part of the 'stronger sex,' was translated into fear of mayhem, of the 'breakdown of boundaries.' Hence the portrayal of women as seductive, demonic beings, waiting to ensnare men in the net of their desires. The mythical power attributed to women had to be restrained. Moreover, safeguarding women's honor and modesty was actually a pretext for safeguarding men's interests – by reducing women's control over their lives and property. Thus, right from the start, women were not allowed to develop or progress at the same pace as men.

It is worth noting that the sages were no different from ordinary people in the way they related to privileged women, such as women of good breeding, daughters of the rich or of famous Torah scholars. These privileged women were given the utmost consideration, and enjoyed favorable treatment in law courts, to spare them embarrassment. They were destined for a life free of household chores and it was considered proper for them to bedeck themselves with jewelry, as befitted their honor and social standing.[40] The clear line drawn between these privileged women and 'ordinary' women shows that the social status of women had a profound impact on the sages and sometimes even on their decisions.

[38] Mabit, *Iggeret, ha-Sha'ar ha-Sheni*, Chapter 3; Mabit, II, 206.

[39] MS Amsterdam, Rosenthaliana, pp. 362-363; Benayahu, *Ari*, p. 317.

[40] Radbaz, I, 401. See also: ibid, 133, 281, 318, 331; III, 1044; IV, 1208; VI, 2059; Mabit, II, 119; Maharitatz, 177. On 'influential women' see Fishman, pp. 212-214.

FROM CHILDHOOD TO MARRIAGE –
"THE BURDEN OF A DAUGHTER"

Given the disparaging and condescending attitude towards women in most societies, it is not surprising that in 16th-century Ottoman Jewish society too, the birth of a daughter was not considered a cause for celebration. In keeping with this attitude, all prayers, blessings and amulets for pregnant women referred exclusively to male progeny – 'since women rejoice in sons.'[1] While the birth of a son was accompanied by great rejoicing – a festive meal with speeches and prayers of thanksgiving – the birth of a girl not only was not celebrated, but was frequently considered a misfortune, so much so that the hapless father was even to be pitied. When Isaac, for example, who already had several daughters, announced the birth of yet another, his friends taunted him with remarks such as: 'And who's the *mohel* [circumciser] of your daughter?"[2] Similarly, when the community leaders tried to persuade a man from Jerusalem who had deserted his wife and baby daughter to return, they could find no more convincing argument than: "a first-born daughter is a portent for sons."[3]

The disappointment fathers experienced at the birth of a daughter

[1] Quotation taken from funeral oration by the Spanish expositor R. Joseph Garçon (MS London, Garçon, 'Funeral oration in memory of R. Joseph Saragossi who died in Safed in 1507', p. 67). See also, Mabit, I, 299; MS Jerusalem, Samuel Ibn Sid , pp. 65a, 116a; MS Oxford, Hayyim Hevraya , pp. 11b, 13b-14b, 21b, 41b, *passim*; MS Cambridge, Misc. 35.23; David, "Genizah," Document 4, p. 34; Document 6, p. 37; Turniansky, letter 4, p. 199; letter 5, p. 201; Benayahu, "Shoshan," 440 (pp. 186-187), 490 (p. 215), 1839 (p. 525); "Travels of R. Moses Porayit," in Yaari, *Travels*, p. 296-297; "Travels of Moses ben Elijah the Karaite," in Yaari, *Travels*, pp. 311, 322; Littman, "Family," p. 237.

Much documentary evidence from the 19th and early 20th centuries also indicates a preference for sons, as reflected in popular aphorisms of the times. See: Yohas, pp. 256-257, and note 16 there. Nevertheless, Judeo-Spanish communities in Turkey and the Balkans used to hold a special 'naming' ceremony for girls (ibid, p. 266). On Christian norms in this respect see: Shahar, *Childhood*, pp. 71-73; For additional sources, see: Stahl, *Family*, pp. 331 ff.

[2] Berab, 20.

[3] MS *Jerusalem, Iggerot Shadarim*, letter 151, p. 182 (obviously based on *Bava Batra*, 141a).

is reflected in the following poem recorded by the scribe of the Jerusalem community:

> The father of the girl is taunted and teased
> And if a man takes her, he'll be sorely displeased
> Better by far to dig her a grave
> And thereby his honor to save.[4]

This predilection for sons is an integral part of an ancient historical-cultural tradition that is disparaging to women. After all, what reason is there to rejoice in the birth of a physically, psychologically and intellectually inferior being – who not only begins life at a disadvantage, but will retain that disadvantage throughout her life? These negative stereotypes, which go back many generations, mirror the mentality of a society where gender was crucial in determining a person's fate. Men's belief that the birth of a daughter spelt 'trouble', was the result not only of indoctrination, but also reflected a social reality in which the status of women was far inferior to that of men.

The birth of a daughter was not a cause for celebration for the mother either, not only because she knew what life held in store for members of the 'second sex', but also because her own status within the family and society largely depended on her ability to bear sons. Moreover, sons were an asset to women in their old age, unlike daughters who were no longer free agents once they were married.

The father's prime concern was to marry off his daughter, and efforts to find a suitable match and prepare a dowry began while the daughter was still young. For poor parents, daughters were a financial liability. The mere thought of the difficulties they would face when it came to marrying off their daughters was enough to kill any joy they may have felt at their birth. Indeed, many of the fathers were forced to travel far and wide in order to raise money for their daughters' dowries, as described below.

Amongst a collection of letters from Jerusalem there is a group of "Letters of introduction for indigent fathers who suffer the 'burden of a daughter' ['*Tsarat ha-Bat*']." These letters of introduction, written by the leaders of the community for fathers of nubile daughters anxious to raise money for their daughters' dowries, describe their plight in the following terms:

[4] Ibid, p. 173.

> Behold the sorry state of a father, who has *the burden of marrying off* his daughter who is past marriageable age. For she is like a weight round his neck. His house is empty, and he cannot even provide her daily needs [...] Witness this sorry sight, the misfortune of *Ploni* [anonymous], whose father used to hold a high position [...] but who has fallen on bad times [...] *The burden of his daughter is crushing him.* For she has matured and is ready for marriage, and there is no food or clothing in the house [...] Help him before he melts away like wax before *the devouring flame of his daughter* [...]⁵

Men who had several daughters of marriageable age were even worse off:

> *Our heart bleeds for the three,* who are of marriageable age, but who have nothing to eat or wear. Their impoverished father is cast into despair on their behalf. He can neither provide for them, nor marry them off [...] *The burden of his daughters* weighs him down, draining his strength, and aging him prematurely [...] Please help him by directing him to the right addresses in the various towns and countries he will be visiting.⁶

From the above, it is clear that daughters represented a heavy financial burden for impoverished fathers and that the latter, anxious to rid themselves of this burden, spared no effort to raise the money required to marry them off.

Daughters were a financial liability not only for the indigent, but for middle- and upper-class parents too, although for different reasons. For them, the property and gifts given as a dowry were an expression of social status. And although the dowry was ostensibly in honor of the daughter, in practice it was a reflection of the father's status within the community. Affluent parents, therefore, faced a thorny dilemma: On the one hand they felt compelled by social pressure to publicly demonstrate their generosity and ability to provide. On the other hand, since the dowry might pass, through their daughter, to her husband, or even to his children by another woman, they felt as if they were virtually 'throwing away' their property. The marriage of a son, by contrast, was a 'safe' investment, one that brought with it both economic advantage and enhanced prestige.

⁵ Ibid, letter 52, p. 97; letter 79, p. 120. See also: ibid, letter 162, pp. 191-192; Gavizon, II, letter 15, p. 306.

⁶ Ibid, letter 84, pp. 123-124; letter 178, pp. 209-210; letter 149, pp. 178-180; letter 154, pp. 185-186; letter 196, pp. 231-232. The dots over the Hebrew word '*shalosh*' (three) in the original manuscript indicate a play on words. The allusion is to the verse from Proverbs 30:21, as well as to the fact that the bearer of the letter had three daughters.

The reasons for preferring sons to daughters were not purely financial. The Safed kabbalists and their disciples, for example, believed that those who had failed to beget sons would be denied entry into the next world.[7]

The yearning for sons was particularly strong among second and third generation Iberian refugees. After the terrible calamities they had suffered, the break-up of families and constant migrations, their overriding concern was for a stable family life and for male progeny to continue the family line.[8]

Although as a rule the birth of a daughter was considered a liability, there were many exceptions to the rule, and many fathers cared and provided for their daughters. Parents frequently insisted that their married daughters live nearby so that they could continue to support them.[9] Particularly moving is a collection of letters, in which R. Joseph Mataron, the disciple of R. Moses Alshekh and R. Hayyim Haver of Safed, pours out his grief at the premature death of his daughter Sarah:

> Woe unto me, my heart is torn asunder, my heart is shattered. The wilderness closes in around me, my tongue cleaves to my palate [...] The world has become desolate, torn asunder. In the depth of my sorrow, I cry out in anguish [*tsarah*]. Woe is me, alas and alack, for my shrine has been plundered, my sanctuary, my Sarah, princess among daughters [...] My heart is faint and fever courses through my veins [...] In bitterness I pour out my anguished heart [...] for the Lord has taken my Sarah from me, by a whirlwind [*se'arah*] into heaven[10] [...] *For she was my supreme delight, she was dearer to me than a son* [...] My eyes cry out in desolation, they weep ceaselessly for my Sarah who is no more [...][11]

This letter, in which the inconsolable father pours out his grief to his friends, points to a special, perhaps even exceptional, tie between father and daughter. However, the emphasis on the fact that Sarah

[7] Galante, *Kohelet*, pp. 95b-96a; Hacker, "Pride," pp. 581-582 and note 113 there.

[8] Hacker, "Spanish Jewry", pp. 62, 72 (note 15); idem, "Pride," pp. 556-561, et al.; Benayahu, "Sermons," pp. 48, 133.

[9] For example: Radbaz, I, 198; Galante, Responsa, 13; Maharit, II, *Hoshen Mishpat*, 21; Maharitatz, 176; Mabit, II, 20; Alshekh, 132; Pinto, 47; Galante, *Kohelet*, 71b; MS Jerusalem, *Iggerot Shadarim*, letter 180, p. 216.

[10] A play on words [*Sarah-Se'arah-Tsarah*], based on Genesis 21:1, Kings II, 2:1, 2:11.

[11] MS Jerusalem, *Iggerot Shadarim*, the Letters of R. Joseph Mataron, letter 75 pp. 367-369. See also ibid, letter 77, pp. 371-373; letter 42, p. 325; letter 76, pp. 369-371; letter 78, pp. 373-374; letter 86, pp. 384-385.

was dearer to her father than a son, only proves the rule: that boys were generally preferred to girls.

As well as the financial burden of marrying off a daughter, the father also had to take responsibility for protecting her virtue. Chastity and modesty were important – if not the most important – assets demanded of a girl. Girls from good families were educated from birth 'to be industrious and modest,'[12] as behooves a loyal and capable wife. A modest girl had greater chances of contracting a good match. Safeguarding a daughter's virtue was of paramount importance. If a daughter lost her virginity through misadventure, her parents would hasten to bring witnesses and obtain an affidavit from the court to that effect, so as not to jeopardize her chances of getting married in the future.[13]

A stringent moral code which opposed premarital sex and saw marriage as a means of preventing sin, was one of the reasons for early marriages in all strata of Jewish society. Early marriage was perceived as a solution for the temptations that lay in wait for adolescent boys, as well as a way of freeing parents from constant vigilance over their daughters' chastity. Furthermore, as stated, the sexual fulfillment provided by married life freed men's energies for Torah study. The regulations of the Safed kabbalists explicitly stated: "Some righteous and virtuous men marry off their sons at the age of 13 or 14 *so that they will not fall into sin or contemplation of sin*. This is the right thing to do."[14] Those who delayed marrying off their sons in the hope of finding a more financially advantageous match were labeled by the kabbalists 'blood-shedders.'

Early marriage was also dictated by socioeconomic considerations. In affluent and prestigious families, parents were eager to marry off

[12] Mabit, II, 62. For references to modesty in girls, see also: Radbaz, I, 360; Galante, Responsa, 72; Castro, *Ohalei Ya'aqov*, 92 (p. 145a); Ratzhabi, p. 271, lines 63-64.

[13] MS Jerusalem, *Sefer Tikkun Soferim*, 42, p. 55b. This collection brings four different versions in connection with 'a virgin who is accidentally deflowered' (see *Yevamot*, 59b-60b; *Ketubot*, 11b, 16a, et al), with descriptions of various ways in which girls could be accidentally deflowered (see ibid, 41-43, pp. 55a-56b).

[14] Toledano, regulation 8 (post-1577), p. 50. Other versions: 'While some fathers marry off their children around the age of 13 and 14, others wait until they are 25 years of age or more in the hope of contracting a more advantageous match. These end up *committing a number of transgressions which carry the death penalty*' (Berukhim Abraham, 12, p. 298; Hallamish, "Text", no. 31, p. 92). Cf.: Shahar, *Fourth Estate*, pp. 66-67, *passim*.

their children as soon as possible, while they themselves were in their physical and financial prime, and could choose a match that befitted their socioeconomic status. The parents tended to engage in complex financial negotiations in order to reach a settlement that was acceptable to both sides. The young couple had no say in the matter; on the contrary, the parents wished at all costs to forestall any intervention on their part that might thwart their plans. Child marriages were also favored by fathers who were itinerant merchants and who wished to see their children 'settled' and their future assured in case anything happened to them. Since the lower strata of society tend, as a rule, to try and emulate the 'upper crust,' child marriages may well have become entrenched in society as a whole. Of course, early marriage was in any case considered desirable by the poor, as a way of escaping the burden of supporting their daughters.[15]

An engagement contract [*shiddukhin*] was first and foremost an economic transaction, dictated by rational considerations. The guiding principle in all cases was the socioeconomic compatibility of the two families, rather than the emotional compatibility of the couple. The bride had no say in the matter "since it is not the way of women to chose a match, for reasons of modesty."[16] The negotiations were undertaken by the father, or in his absence, the mother, brothers or other relatives. A young groom was also represented by his father. The parents, sometimes through relatives or matchmakers,[17] tried to reach an honorable settlement that would ensure the young couple's future – and safeguard the family assets. Qualities expected of a woman were: wealth, lineage, modesty, submission, and industry. Qualities expected of a man were: outstanding scholarship, or lineage and wealth. These factors – not personal happiness – were considered the keys to a successful marriage.

[15] Grossman, "Child Marriage," pp. 117-118; Caro, Responsa *Beit Yosef*, 42 (=Laws of *Ketubot*, 12); Lamdan, "Child Marriage".

[16] Beer, 28.

[17] For examples of matches arranged by go-betweens and matchmakers, see: Maharit, I, 131; II, *Even ha-'Ezer*, 28; Alshekh, 13, 30; Radbaz, VI, 2338; Maharitatz, 147, 250; Galante, Responsa, 73; Mabit, I, 78, 127; Benayahu, *Ari*, p. 216. A rather nice Safed custom mentioned by R. Solomon Shlomel of Dreznitz was that "matchmakers charged no fee" (Assaf, "Letter," p. 125). It is not surprising that this custom was to his liking, since matchmaking among Ashkenazic Jews was basically a mercenary transaction. See: Stahl, "Love"; Katz, "Marriage"; Goodblatt, p. 94. For further references, see: Stahl, *Family*, pp. 55 ff.

The terms of the *shiddukhin* ('*tenaim*'), especially those discussing the economic commitments of both parties, were laid down in standard clauses, specifying the items and amounts to be transferred, the means of payment, and the period of time during which the parents were expected to support the young couple. When engagements were broken off, as sometimes happened, the parents made no secret of the fact that they had agreed to the match for financial reasons only: "Everything rests on pillars of gold."[18] Sometimes the payment terms were extremely complex, resembling economic transactions in all respects.

Below is an example of an engagement deed drawn up in 1628:

> With joy and gratitude we are pleased to announce the engagement between Levi son of Reuben [of Egypt] and the virgin daughter of Simeon [of Safed], who have stipulated between themselves as follows: That the said Simeon shall provide 600 *groshos* [silver coins], 400 of them to be delivered forthwith to Reuben who shall invest them as he sees fit, and give over the profit to the said Levi. The remaining 200 shall be delivered at the time of the marriage [...] The dowry, which shall match Simeon's status, shall be no less than 200 *mataqil* [golden weights]. Simeon also undertakes to support his son-in-law and daughter for two years [...] If, God forbid, there should be any obstacle to the wedding, then the profit accruing from the 400 *groshos* deposited with Reuben shall be divided equally between Reuben and Simeon. Reuben and Simeon hereby agree that the party violating the agreement shall pay an indemnity of 200 *groshos* to the injured party.[19]

Another engagement deed written in Istanbul was brought before R. Moses Galante of Safed. In the deed, the father of the bride promised a sum of "two hundred thousand *levanim* – ["white pieces"-small silver coins], 180 of which equal one *perah* [a florin]." The bride's parents deliberately specified the sum in *levanim* rather than *perahim* [florins] so as to impress people with their generosity. Galante, however, vehemently condemned this practice:

[18] Arha, 32, end of responsum. See also Rofeh, 18; MS Jerusalem, *Zera' Anashim*, p. 475a-b.

[19] Arha, 31. The responsum was delivered by R. Solomon Ashkenazi. Responsa 32-33 there deal with the same matter, and also Lieria, Responsa, 19, (from which it is clear that the match was arranged between a 16-year old boy and a 5-year old girl, who were to be married five years later, when she was ten). For further examples of financial settlements, see: Pinto, 35; Galante, Responsa, 39; Maharitatz, 10, 108, 125, 147; Mabit, I, 85, 223; III, 8, 216; Radbaz, I, 369; Maharit, II, *Even ha-'Ezer*, 27; Gavizon, II, 90.

What can he [the father] be thinking of, mentioning thousands upon thousands of *levanim* which are almost valueless! Let him specify the amount in *groshos* [European coins], or in gold coins whose value is fixed [...] For the practice here [in Safed] is to specify sums in the *ketubah* or in deeds in *groshos*, however few these may be, rather than in *qatash* [small silver coins], even though most people here are poor. Whatever is he thinking of, quoting these huge sums – 200,000 here, another 4,000 there? Not only is his behavior childish and arrogant, he may even, God forbid, be invoking the Evil Eye, by quoting such inflated figures![20]

Presumably, the financial settlements drawn up between the families of an engaged couple in Istanbul were dictated primarily by social pressure: An impressive dowry indicated wealth and status, in keeping with the norms of a materialistic and affluent mercantile society. In Palestine, where the way of life was more modest and the population less affluent – such behavior was considered ostentatious and vulgar.[21]

Another important factor besides affluence was the sociocultural background of the families: Marrying into a good family or marrying a Torah scholar with a brilliant future was the highest goal, one for which considerable financial flexibility was called for. In one case, for example, a mother was prepared to 'deny herself' and even renounce part of her *ketubah* in order to ensure her daughter's marriage to a man from a prestigious Egyptian family. In another case, a man from Jerusalem was prepared to bequeath his entire estate in Safed to his daughter, Leah, provided she married a bona fide Torah scholar. There are other cases of parents who were prepared to pay more for a prestigious match.[22]

Conversely, marriage to a wealthy girl was a way for impoverished Torah scholars to upgrade their socioeconomic status, since social differences in Jewish society were mainly determined by economic factors.[23] Just as wealthy parents were keen for their daughters to marry Torah scholars, so were the latter anxious to find wealthy

[20] Galante, Responsa, 82.

[21] In Palestine, it was customary to give far smaller sums. See for example: MS Jerusalem, *Iggerot Shadarim*, letters 191-192, pp. 225-226; Maharitatz, 173.

[22] Maharitatz, 151; Turniansky, letter 6, p. 205; letter 4, p. 197; Galante, Responsa, 13; Gavizon, II, 90; Mabit, II, 160; Bentov, p. 218; David, "Sholal Family," p. 401; for considerations of this kind in Ashkenazic society, see: Katz, "Marriage," p. 29; idem, *Tradition*, p. 69.

[23] Bornstein-Makovetzky, "Stratification," pp. 82-84.

brides. For example, there was a woman of Safed "whom a certain Torah scholar married, simply on the hearsay that she was very rich." And R. Isaac Fasi of Safed was said to have ignored the Ari's advice in choosing to marry a wealthy widow rather than an impoverished virgin.[24]

Economic considerations also governed the tendency to marry 'within the family.' Obviously, families had an interest in keeping property and money within the family circle. The daughter's wellbeing may also have been a consideration, since relatives were presumed to treat their wives better. In any case, such marriages, which were usually contracted among wealthy or landed families, were generally between nieces and uncles or between cousins.[25] A refusal by one of the parties to marry a relative frequently developed into a huge dispute.[26]

Most engagement deeds also specified the date and time of the wedding. The groom undertook to wed his wife at the specified time, while the bride's parents promised to escort her to the bridal canopy 'in a compliant frame of mind.'[27]

It was customary, already at the engagement stage, to stipulate various conditions to ensure the bride's personal wellbeing. In many places, a rider was added to the engagement deed forbidding the groom to take a second wife, and specifying the couple's abode, to make sure that the couple resided near the bride's family.[28] In more unusual cases, the groom undertook to look after his wife's relatives too, such as her mother, brothers, or children from a previous mar-

[24] Galante, Responsa, 97; Benayahu, *Ari*, pp. 216-217. See also Maharitatz, 40; Maharitatz, New Responsa, II, 240; Ashkenazi, 15.

[25] Caro, *Avkat Rokhel*, 85; Mabit, III, 54, 83; Alshekh, 48; Radbaz, I, 538; III, 981; Maharitatz, New Responsa, I, 4; Galante, Responsa, 86; Maharit, II, *Hoshen Mishpat*, 98; Castro, *Ohalei Ya'aqov*, 16; Cohen, *Jerusalem*, p. 143. See Cohen-Pikali (Document 387, pp. 347-348) for permission granted by the Hanafi qadi of Jerusalem to Joseph ben Sa'id al-Hami, to marry his niece, which was against Islamic law. For other references and sources, see: Dinur, pp. 119-120; Friedman, *Polygyny*, p. 20, note 61 and p. 164, note 37; Stahl, *Family*, p. 74 ff.

[26] Galante, Responsa, 56. Also, ibid, 23; Maharitatz, 151; Mabit, III, 54. See also David, "Sholal Family," no. 4, pp. 400-401.

[27] Maharit, II, *Hoshen Mishpat*, 100. Also: ibid, I, 131; Maharitatz, 108, 262; Castro, *Ohalei Ya'aqov*, 128; Ralbah, 134; Mabit, I, 78; III, 142; Alshekh, 30; Galante, Responsa, 39; Caro, *Avkat Rokhel*, 85; Gottheil & Worrell, XL (third document), pp. 184, 186, 188.

[28] Mabit, I, 240; II, 9, 24; III, 142; Maharit, I, 131.

riage, or agreed to a condition that he would not remarry his ex-wife.[29]

The engagement deed sometimes contained bizarre conditions. In one case, the groom specified that if a plague broke out, he would take his wife as far as possible from the scene of the plague, even to the border of Palestine, although the custom was to flee to nearby villages. When the groom tried to renege on his commitment, the father claimed "It was for this very reason that this condition was included, although most *ketubot* do not include such a condition. For although it is customary to flee during an epidemic, the condition here was that he take her from town to town, not from village to village as is the practice, the reason being that it is tiring and not seemly for a woman to move from village to village."[30] The remainder of the responsum gives us an idea of urban deployment in 16th-century Palestine: "For there are several towns between here [Safed] and Gaza [...] but there are no towns [with Jewish populations] between here and the eastern border or between here and the northern border of Palestine, except for Sidon [...] Therefore, I am of the opinion that the groom must flee with her first to Tiberias, or Jenin, and thence to Nablus if necessary, and thence to the frontier town of Gaza."

The interested parties accepted all the arrangements under solemn oath and through a formal acquisition ceremony (*kinyan*) and stipulated penalties in the case of breach of promise. The situation became more complex if, for some reason, the conditions and penalties were not specified, or if one of the parties broke off the engagement for reasons seemingly beyond his/her control. However, according to the Radbaz, broken engagements in Egypt were 'one in a thousand.'[31]

The son's or daughter's refusal to go through with the match was considered a factor 'beyond the parents control' (*force majeure*) and therefore as grounds for breaking off the engagement without paying restitution. Nevertheless, one of the Palestinian sages differentiated between refusal by a daughter and refusal by a son. Daughters, he

[29] Mabit, I, 1; II, 45; Maharitatz, 233; Radbaz, VI, 2083; Ralbah, 26-27.

[30] Mabit, III, 211.

[31] Radbaz, III, 972. See also: ibid, I, 463; VI, 2063, 2338; Mabit, I, 78, 85, 223; II, 24, 163; III, 113, 142; Maharit, II, *Hoshen Mishpat*, 98; Castro, *Ohalei Ya'aqov*, 128; Alshekh, 13, 30; Galante, Responsa, 39; Arha, 31; Caro, *Avkat Rokhel*, 85.

claimed, do not usually refuse a match arranged by their father "since the Torah gave the father the prerogative to marry her off, even to someone infested with sores." Therefore, a daughter's refusal was an exceptional occurrence, generally indicating such total revulsion to the match, that no amount of 'appeasement' or promises could weaken her resolve. It followed that a daughter's refusal could be considered as *force majeure*, and the father did not have to pay damages or abide by his financial commitments. Since, however, a son's consent was required for a match arranged by his father, the fact that he might withhold his consent was a possibility the father had to take into account. It followed that a son's refusal could not be invoked as a pretext for annulling an engagement with impunity.[32]

One may assume that children gave their consent to most matches arranged by their parents, for several reasons. First, the centrality of the commandment of honoring ones parents in Jewish society left no room for dissent. Second, the couple were economically dependent on their parents.[33] Third, opportunities for personal acquaintance between young people, especially if they came from prestigious families, were almost non-existent. Despite this, and despite the fact that dissent was rare, it would appear from the sources that on the rare occasions when a girl adamantly opposed a match, the match was revoked.[34]

After the negotiations were concluded and the conditions signed, the engagement ceremony proper took place. This usually consisted of a festive meal arranged by the bride's father, during which gifts were exchanged between the parties, and the bride was presented with an engagement ring. The bestowal of gifts by the groom on the bride was performed to dancing and a fanfare of drums. The communal nature of this ceremony was meant, inter alia, to serve as a public demonstration of the affluence and generosity of the grooms' family. The groom and his family then came to inspect the seated

[32] Arha, 31–33.

[33] In Jerusalem, a man forced his refractory son to appear before the qadi and agree to the match contracted by his father on his behalf, or else face penury. See Cohen-Pikali, document no. 403, p. 355. Document no. 407, p. 358, may possibly be referring to the same son, Jacob ben Joseph, who was ordered to leave home for disobeying his father, but there is a gap of six years between the two documents.

[34] Mabit, I, 85; Alshekh, 30; Radbaz, I, 463; VI, 2063; Maharit, I, 131; Gavizon, II, 90.

bride bedecked in her finery and jewelry. Sometimes speeches were delivered in honor of the occasion.[35]

Concern that bridal gifts may be construed as betrothal [*kiddushin*] through 'acquisition' [*kinyan*] led to the promulgation of special regulations in the communities. The Radbaz ruled that in Egypt and Palestine bridal gifts held no legal force, but were simply part of the engagement ritual.[36]

The bride's dowry had three main components: money, jewelry, and clothes and fabrics. Among the Musta'rabs, money was usually transferred to the father or mother of the bride to help pay for the wedding. The Sefardic custom was heap jewelry on the bride. Money, gifts, and dowry were all specified in the *ketubah*. The jewelry given the bride included: bracelets, nose-rings, necklaces, rings, and gold adornments (*joyas*). As stated, the dowry also included household goods, bedding, lingerie, and clothes. An engagement deed drawn up in Cairo in 1511 provided a detailed list of dowry items, including gold and silver decorative pins, robes and fabrics, colorful scarves, embroidery, shoes, and combs.[37]

As stated, the signing of the engagement deed was generally sealed by a gift from groom to bride – usually some item of jewelry. The gift the famous poet R. Solomon Ha-Levi Alqabetz sent his bride was, however, somewhat unusual: "At that time R. Solomon Alqabetz, the son of R. Moses Ha-Levi Alqabetz, a great kabbalist, was residing in Safed [...] In the year 5289 of the Creation [1529] he wrote a book called *Manot Ha-Levi* [The Portions of the Levite], an exegesis on the Book of Esther. This he sent to his father-in-law on Purim as an engagement gift, instead of the more usual gold and silver jewelry that men send their brides [...] This gift, however, was far more

[35] Radbaz, I, 329; III, 960, 972; IV, 1222, 1305; VII, 55; Maharitatz, 10, 262; Maharit, II, *Hoshen Mishpat*, 100; *Even ha-'Ezer*, 28; MS Jerusalem, Samuel Ibn Sid , p. 4a.

[36] On this subject see: Lamdan, *Status*, pp. 38-45.

[37] Gottheil-Worrell, XL (in first and third documents); Ashtor, III, pp. 109-112 (see ibid, pp. 119-120, engagement agreement between a fairly poor couple in 1492); Stillman, "Genizah". A bride's dowry was also specified in various versions of a popular song from Spain. The inclusion of handmaids in the dowry is an indication of the antiquity of the song (see: Maoz, pp. 157-159; Attias, *Romancero*, pp. 205-206). For other references to the composition of dowries, see: Galante, Responsa, 14, 39, 82; Maharit, II, *Even ha-'Ezer*, 28; Maharitatz, 108, 125, 173, 290; Maharitatz, New Responsa, I, 9; II, 172; Radbaz, I, 382; Castro, *Ohalei Ya'aqov*, 92 (p. 144b); Mabit, I, 266; II, 163, 209.

precious to his father-in-law and brother-in-law than jewelry, gold
and diamonds."[38] Clearly the groom had found the right way of
insinuating himself into the good graces of the bride's father and
brother.

Books, a valuable asset in those days, were sometimes included in
the bride's dowry, to the gratification of learned sons-in-law. For
example, in an engagement agreement contracted with a Torah
scholar, the bride's father undertook to make over to his son-in-law
Levi "books which I currently own [...] as well as other books [...] I
intend buying with God's help, for the purpose of Torah study."[39] R.
Solomon Shlomel of Dreznitz, after immigrating to Palestine,
boasted in a letter he sent to the Diaspora, that the dowry he received
from his wife, the daughter of R. Israel Saruq of Safed, included
books on the kabbalistic writings of the Ari, which she had inherited
from her father.[40]

This exchange of gifts was meant to "endear the couple to each
other", as R. Joseph Caro put it.[41] However, if an engagement was
annulled, this transfer of gifts could prove problematic. The Radbaz
ruled that in such cases there is no difference between an engage-
ment gift and a betrothal [kiddushin] gift. The rule is that the gifts are
returned to the groom after deduction of expenses disbursed by the
bride's father for the engagement party, except for items which
through reasonable usage have become lost or worn. If a minor
claims to have lost some of the goods and jewelry given to her as an
engagement present, the parents are not held responsible, since she
was given the gifts to use, and her parents cannot be expected to
supervise her twenty-four hours a day to ensure no damage is in-
curred.[42]

After the engagement ceremony, the bride stayed at home until
the wedding. According to R. Samuel De Medina, a 16th-century

[38] Conforte, p. 36a.
[39] Mabit, I, 212.
[40] "Letters of R. Solomon Meinstril," in Yaari, *Letters*, p. 202. See also R. David,
who was interested in marrying off his daughter to an Ashkenazi, and to this end was
prepared to give "his house, books, household utensils and beautiful clothes" as her
dowry (Turniansky, letter 6, p. 205).
[41] Caro, *Avkat Rokhel*, 85 (p. 79).
[42] Radbaz, I, 329, 579; IV, 1308; See also Maharitatz, 10, 262; Maharitatz, New
Responsa, II, 172; Maharit, II, *Hoshen Mishpat*, 100; Galante, Responsa, 14; Caro,
Avkat Rokhel, 85. Compare B. Rivlin, "Family", 90-92.

rabbi of Salonika, the norm among Ashkenazic Jews was that an engaged couple did not meet. An 18th-century source confirms that this was the case in Aleppo too: Engaged couples did not meet before the wedding "and this has been the custom for many generations since the days of the early sages, may they rest in peace."[43] In other places, and particularly among the Sefardic Jews and Musta'rabs, the groom used to visit the bride's house frequently, particularly on the Sabbath to join them for the Sabbath meal. This enabled them to get to know each other better.[44]

It was not unusual for engaged couple to display affection, even with their parents' knowledge: "When Reuben became engaged to Leah [...] he was a frequent visitor at his father-in-law's house, secluding himself with her to caress her and kiss her. However, he was careful to go no further [...] *For thus it is customary to do in order to endear themselves to each other.*"[45] In some cases, the couple did go further, as the following incident illustrates: "After Reuben became engaged to the daughter of Simeon, the engagement [*shiddukhin*] was drawn out for almost three years. The fiancé (*arus*) used to seclude himself with his fiancée (*arusah*) in his father-in-law's house night after night, until he became overfamiliar with her."[46]

In more extreme cases, the couple actually indulged in premarital sex. A song by Israel Najara mentions an unscrupulous man by the name of Meir who "deflowered his fiancée in his father-in-law's

[43] Rashdam, *Even ha-'Ezer*, 31; Katzin, p. 13b; According to Ashtor (II, p. 357, note 10), this was an ancient custom, borrowed from the Muslims.

[44] Castro, *Ohalei Ya'aqov*, 92; Maharitatz, 262; Maharit, II, *Even ha-'Ezer*, 39; Benayahu, *Ari*, p. 216.

[45] Radbaz, III, 960.

[46] Gavizon, II, 50(56). This responsum speaks of a match between a couple, Kalonymus ben Samuel Butaril and Hannah bat Abraham Raqat yadi'a Al-Shami, in Alexandria in 1601, whose case was discussed at length in Castro, *Ohalei Ya'aqov*, 92.

Note how the terms *shiddukhin-erusin* became synonymous: In the 16th century, the betrothal (*erusin* or *kiddushin*) and marriage ceremonies (*huppah*) were combined, and this was even given halakhic validity through communal regulations (see Chapter 15, "Regulations Concerning Women"). The betrothal (*erusin, kiddushin*) ceremony was henceforth superseded by the engagement (*shiddukhin*) ceremony, whose original purpose was to allow the representatives of both families to meet in order to draw up financial arrangements. The event became a festive occasion, in which all family members and relatives participated, as had formerly been the case in betrothal ceremonies (*erusin, kiddushin*). In sources from that period, the terms '*erusin*' and '*shiddukhin*' are sometimes used interchangeably, as is clear from this responsum. See also Encyclopedia Judaica, Vol.2 (1976), p.1035.

house" [47] In two known cases which reached the rabbinical courts, the women became pregnant while engaged. In one case – the groom denied responsibility, claiming the girl had become pregnant from someone else, and sought to annul the engagement.[48] In the other case, after first promising to marry his fiancée (thereby admitting his responsibility), the man later backtracked when he discovered a halakhic loophole, which he used not only to break off the engagement, but also to discredit the girl. He had reportedly claimed: "that she had fornicated with her uncle, her mother's brother, a 30-year old bachelor. He [the uncle] had taken a liking to her before Reuben came on the scene, but because he was poor, cruel and violent, he was considered an unsuitable match. He was constantly jealous of the uncle who lived in the same house. She also had many bad neighbors, and it is common knowledge that there is no guardian of immorality."[49] After some years, the Hida [R. Hayyim Joseph David Azulai] of Jerusalem, warned: "The Early Sages have already decried the bad habit that has spread in some towns, namely that an engaged couple meet frequently, sometimes for years before their wedding, to sport together and indulge in frivolous behavior, and to kiss [nasheq] both by day and by night!"[50]

This habit of frequent encounters – and its consequences – was not approved by the sages and communal leaders. Therefore a regulation (takkanah) was adopted in Jerusalem stating *"that the arus should not meet with the arusah until the wedding eve,"* and in Safed stating *"the arus should not enter the home of his arusah."* Evidently in both regulations the words arus and arusah refers to an engaged couple (meshuddakhin), not a betrothed one [mekudashin].[51]

[47] Najara, *Meimei Yisrael*, p. 155b.

[48] Maharitatz, New Responsa, I, 9.

[49] Maharitatz, 108. See also Maharitatz, New Responsa, I, 29, for the story of a girl who was raped and became pregnant before the engagement period had elapsed. The father forced the fiancé to marry her.

[50] Azulai, *Lev David*, 16. The dots over the word *nasheq* in the original, indicate a play on words on the verse in Job 39:21. See also Freimann, *Betrothal*, pp. 32-33, 60-61, 99, 218, 276, et al; Friedman, "Matchmaking," esp. pp. 157-159.

[51] Freimann, "Regulations," no. 10 (p. 209); Mabit, III, 77. The Mabit's responsum is in reply to a congregational dispute in Arta, Greece, where the regulation was adopted by the local congregation of Romaniots and the congregations of Calabria and Sicily, but was bitterly opposed by the congregation of Apulia (see: Bornstein-Makovetzky, "Arta," pp. 144-145; Benayahu, *Beauty*, pp. 36-52). The Mabit states that the regulation had been in existence in Safed for some years. According to Benayahu (ibid, p. 34, note 15), this responsum can be dated to 1575. As stated

As we have seen, the regulations were not always observed, and meetings between the couple took place both openly and in secret. In Safed, in particular, it was difficult to enforce the *takkanah* due to the influx of immigrants during the 16th century whose custom permitted engaged couples to meet, and who were unaware of the *takkanah*. It was for this reason that R. Moses Trani argued in favor of leniency in allowing the fiancé to enter the fiancée's house, as long as this was done with certain constraints:

> "[The groom may visit only] from Sabbath to Sabbath, in the company of his father or elder brother, just to pay his respects. But he should not eat there, unless there is a special reason to do so […] And if there is anything they have to discuss during the week – he should wait outside the house, until he receives an answer. As the wedding day approaches, he may enter her house daily to discuss wedding arrangements. Likewise, they [the sages] may introduce a *takkanah* that most of the community can abide by, in order to prevent a situation whereby a *takkanah* is violated.[52]

The Wedding

A girl's wedding day was the most important day in her life. On that day she became the center of attention, and was surrounded by friends and family from morning to night.[53] Relatives and friends came to prepare the bride for the wedding, to escort her to the *miqveh* and to clothe her in her wedding finery which had been especially sewn for the occasion. They adorned her with jewelry and escorted her to the groom's house, where she was seated under a canopy in her finery "visible to all, as they came to greet groom and bride."[54] The wedding feast was usually held in the bridegrooms' house or in

above (note 46), in the 16th century the term "*erusin*" (betrothal) was used interchangeably with "*shiddukhin*" (engagement). Usually, if the betrothal was legal and to the satisfaction of all parties concerned, and the bride had reached puberty, the betrothal (*erusin*) was performed immediately prior to the wedding ceremony proper (*huppah*). This effectively forestalled the need to prevent encounters between the betrothed couple. Compare also B. Rivlin, "Family", p. 92.

[52] Mabit, III, 77.

[53] Castro, *Ohalei Ya'aqov*, 71, 92 (p. 144b); Caro, Responsa *Beit Yosef*, 2; *Pinto*, 26; Ashkenazi, 5.

[54] Mabit, I, 241; Castro, *Ohalei Ya'aqov*, 60; Turniansky, letter 6, p. 203; Zeevi, p. 321. On Romaniot customs while escorting the bride to the *miqveh*, see: Benayahu, *Beauty*, pp. 36, 39.

his parents' house, and it was they who paid for it (the bride's father, on the other hand, usually paid for the engagement party). With the above in mind, we can now understand the full force of a bachelor's supplication that the Creator grant him "all he needs for the wedding, including jewelry for the bride, without great effort on his part."[55]

The *ketubah* was written by the scribe in his home prior to the wedding. The day before the wedding, the rabbinical emissaries brought it to the bride's home for signature. The signing ceremony was also carried out in public, with the bride attired in her new clothes and jewelry:[56]

> Since it was the custom in Egypt to read out the *ketubah* before the entire congregation, especially when a girl was getting married for the first time, all those present were witnesses to the transaction. For it is the custom for the rabbinical court emissary to bring the *ketubah* to the bride [...] and the scribes do not sign until it has been legally acquired from the groom [*kinyan*]. Immediately after the legal transfer, the rabbinical emissaries take back the *ketubah* and make sure it does not leave their hands [...] We have already warned the scribes several time that they should not relinquish the *ketubah* until it is signed.[57]

This extreme caution stemmed from the fear that mistakes might occur in the heat of the moment, amidst so much excitement and commotion. A mistake of this kind did in fact occur at the wedding of R. Jacob Berab's daughter, when it was unclear if the witnesses had properly witnessed the acquisition ceremony.[58]

In Egypt and in Palestine, the wedding ceremony took place by day, and in Jerusalem, early in the morning, after the morning service.[59] Occasionally, weddings were held on the Sabbath eve. However, this was risky, since the validity of the marriage was question-

[55] MS London, BM Or. 10112, p. 17; See also: Galante, Responsa, 9, 73; Ashkenazi, 16; Radbaz, III, 866; Pinto, 25; Maharitatz, I, 16; Mabit, I, 344.

[56] Two dresses were sewn for the bride Beyla of Jerusalem: one for the '*kinyan*' (acquisition), and the second for the wedding ceremony proper, despite her great poverty (Turniansky, letter 6, p. 203). On the remuneration of scribes in Egypt, see Radbaz, II, 622.

[57] Radbaz, IV, 1142. On the 'acquisition' [*kinyan*] ceremony see also ibid, II, 801; IV, 1245.

A question addressed to R. Joseph Ibn Tzayyah concerned the validity of a *ketubah* that had been written by day and signed by night immediately prior to the wedding and Seven Benedictions [*Sheva' Berakhot*] (MS Jerusalem, Tzayyah, 502, p. 233).

[58] Badhab, 98.

[59] "Travels of R. Moses Porayit" in Yaari, *Travels*, p. 297.

able if the ceremony was delayed until after daylight ('transfer of property' being prohibited on the Sabbath).[60]

In Safed, an interesting problem arose in connection with a widow's entitlement to the *ketubah* money after her husband, R. Joseph Ansikhon, fell ill and died immediately after the week of wedding celebrations ended. Although the wedding took place on a Friday, the bride's parents – R. Joseph Molkho and his wife – persuaded them not to consummate their marriage on Friday night, so as "not to change the custom, which is to consummate the marriage on Saturday night." However, when he came to claim his bride on Saturday night "according to local custom," it transpired that she had started menstruating prematurely, and was therefore forbidden him. A few days later the man died, without consummating the marriage. Was the bride entitled to claim the main *ketubah* and increment (additional amount over and above the basic minimum), without her marriage being consummated? In his response, R. Josiah Pinto stressed: "The acquisition (*kinyan*) was properly effected through a legally valid ceremony. She is therefore entitled to the main *ketubah* and the increment [...] For the acquisition is effected by the wedding ceremony itself, not by consummation of the marriage." The fact that the bride had been 'clean' (available for intercourse) on her wedding day, and that the groom had willingly agreed to defer consummation of the wedding until Saturday night, merely strengthened her case.[61]

The act of *kiddushin* (betrothal, or sacrament), which consisted of the groom placing a ring on the bride's finger,[62] was followed by the wedding benedictions and festive meal, inaugurating the festivities proper, which lasted for seven or eight days. If there were many guests, the festive meal was divided into two or three 'shifts.' Alternatively, a larger location was assigned for the meal. The bride, groom and relatives were so busy serving the guests, they did not always have time to sit down and eat with them; usually they ate later.[63] The

[60] Radbaz, I, 121; III, 866, 931; Pinto, 74; Ben Shimon, *Nahar*, 170a, 180a.

[61] Pinto, 74. See also Radbaz, I, 121, 164; VII, 62; Radbaz, New Responsa, 199.

[62] Ralbah, 134; Maharit, II, *Even ha-'Ezer*, 28.

[63] Radbaz, IV, 1320. Also: ibid, I, *Even ha-'Ezer*, 179; Mabit, I, 241; II, 97; Pinto, 74; Vital Samuel, 20 (according to this source, the celebrations last 'even up to thirty days after the wedding'); Maharitatz, 178. For wedding customs in Jerusalem in the 17th century, see: Rozen, *Community*, pp. 245-246. On the custom of 'dancing before the bride' (*Ketubot*, 16b-17a), see Weller, pp. 23-38.

references in the sources to inappropriate conduct bear witness to the 'revelry' that was part and parcel of the wedding celebration. In one instance, an argument between the rabbis of Egypt over the privilege of reciting the wedding grace after meals got so out of hand that the rabbis of Palestine were called upon to settle the dispute.[64]

Entertainment consisted of poems and ballads read out or sung before the guests. Speeches were delivered by rabbis and professional preachers both at the wedding itself and on the Sabbath after the wedding [*Shabbat hatan*]. In these speeches, the speakers usually extolled the virtues of both groom and bride and their respective families, praised the institution of marriage itself, and offered the groom 'good advice.' These panegyrics were interspersed with verses from the weekly Torah portion and other sources.

The speakers stressed the importance of the institution of marriage as a way of preventing sin by removing temptation from the path of married man. As the preacher R. Abraham Laniado said: "How important it is for a man to find a good woman [...] for woman saves him from sin."[65] This theme is taken up time and again by the kabbalists and preachers. Another advantage of marriage, in the sages' eyes, is that it allows man to devote himself entirely to Torah study without distraction: "For the woman allows her husband to study Torah, by acting as a wall [barrier] for lustful thoughts [...] Thus we see how much good comes to a man who strives to find a wife."[66]

The importance of compatibility between the couple is also stressed: "Like should marry like, otherwise strife will ensue [...] For the righteous and the wicked cannot abide each other even for a short while, let alone a lifetime."[67]

As stated, the groom and guests were kept entertained by songs and poems, many of which excelled in rhyming puns.[68] The Pietists

[64] Mabit, I, 293, 317; Radbaz, V, 2239; Scheiber-Benayahu. See also Mabit, I, 291; Maharitatz, New Responsa, II, 239.

[65] Laniado, p. 58b.

[66] See MS London, Garçon, p. 37a, for an explanation of the saying 'without Torah there is no wall' (*Yevamot*, 62b). For other examples, see above, Chapter 1, entitled 'Women through the Eyes of the Sages.'

[67] MS Amsterdam, Rosenthaliana, Sermon 141, top of the MS. See also ibid, p. 316a; MS London, Garçon, p. 217a; MS Oxford, Hayyim Hevraya, pp. 48b-50b; 82b, et al.

[68] For example, the collection "Songs, Hymns and Paeans," an anthology of some 295 sacred and lay songs by Jewish poets of the Middle Ages, contains dozens of

of Safed made a point of singing before the groom and bride every Saturday night.[69] The famous poet, R. Israel Najara, wrote many poems and songs for grooms.[70] Below is one of his poems, with the customary puns, written "For the Occasion of the Rejoicing of the Law and for a Wedding Day":

> Make sure to put aside some money [*kesef*], a dowry's worth at least
>
> Make sure to gaze at her with yearning [*kosef*][71] your eyes on her to feast
>
> Make sure you win her father's blessing, his anger [*ketzef*] for to stay
>
> He will reward you well, ne'er fear, in every single way[72]

A collection of letters from Jerusalem contains 'burlesque' verses written by the community's scribe, on the fickle nature of women, domineering wives, and the sorrow experienced by the daughter's father.[73] These were almost certainly read out during the wedding festivities, for the entertainment of the groom and his escorts.

A detailed description of a wedding ceremony in a town in Syria in the second half of the 16th century is brought by the poet and traveler R. Zechariah Al-Dahri:

> [...] We accompany the groom to a hall large and wide [...]
>
> Saying 'rejoice O groom in your beautiful bride'
>
> And there the bride sits on her ivory throne
>
> So fragile and still, so sad and alone
>
> And the groom to his bride by his escorts is led

wedding songs. Many of these songs were composed by Solomon ben Mazaltov, the editor of the book, which was published in Istanbul in 1545. For information on this rare work, and a list of authors and poems, see: Markon.

[69] Toledano, regulation 8 (post-1577), p. 50; Hallamish, "Text", Regulation no. 32, p.92.

[70] Najara, *Zemirot Yisrael*, p. 571. The physician R. Yehuda Apomado commissioned "wedding songs and quips" from Najara (Najara, *Meimei Yisrael*, p. 143b).

[71] The dots above the word *kosef* in the original indicate a play on words: *kesef* (money), *kosef* (yearning), and *ketzef* (anger).

[72] Printed in the appendix of the booklet '*Or Torah*' by R. Nathan Amram of Alexandria (1850); Najara also drew up a 'betrothal deed' and '*ketubah*' between the Jewish people and God. This text became extremely popular among the Jewish communities of the Diaspora and Palestine, and was copied and translated many times (Najara, *Zemirot Yisrael*, 301(22), pp. 464-469; see also: Yahalom, p. 124; Benayahu, "Najara", p. 223).

[73] MS Jerusalem, *Iggerot Shadarim*, pp. 172-173.

And pledges the words which to her do him wed

His money to her he vows to consign,

While the elders bear witness to this noble design [...]

The groom them leaves along with the bride.

To the wedding feast we repair side by side

Here we are seated among top-ranking guests [...]

And drink his best wine, at his own behest.

And the beloved enters the garden of delight

A place all his own, filled with pleasure and light[74]

While all round people ask: Where's Avner and his song?

Why today of all days is he taking so long?

This is the day ordained by the Lord

It's a day for rejoicing, a day to record [...]

The fruit of his song is so lush and delicious

How goodly each thing when the time is propitious [...]

[The poet reads his poem on the months of the year] [...]

When the groom and his attendants this poem hear

they are filled with delight, jubilation, good cheer [...]

For seven full days they are drunk with elation

With song, dance, and drums, and joyful celebration [...][75]

Although in theory men and women were segregated at weddings –
"during the *Sheva' Berakhot* the groom is in one place and the bride in
another, among the women"[76] – this segregation was not always
effective. In practice, a wedding celebration was an occasion for men
and women to get together – a phenomenon which met with the
disapproval of the local sages and communal leaders. In Egypt, for
example, the custom was "to dance and sing before the bride to the
rhythm of drums during the *jilwa*[77] in the presence of women [...] on

[74] Alluding to the consummation of the marriage.
[75] Al-Dahri, section 27, pp. 318-319, 325.
[76] Radbaz, I, 121.
[77] The ceremony in which the bride is escorted to the groom's house.

the night the bride is escorted to the groom's house." Among the throng, the musicians had no difficulty mixing with the female escorts. "These depraved, unscrupulous men had no qualms about feasting their eyes to their heart's content on the bride's female escorts."[78] Even worse was the Egyptian custom "of hiring gentile girls, dressed in embroidered silk, to dance and play music. The intoxicated guests would gaze at them brazenly, and end up committing a variety of transgressions, ranging from the mild to the serious!"[79]

The Responsa literature discusses the legitimacy of hiring gentile musicians to play at weddings on Friday nights "to entertain the couple and guests with drums, harp and cymbals." Some of the sages argued that since this was a *mitzvah*, it should be permitted, while others held that since playing an instrument on the Sabbath was forbidden for Jews, it was forbidden to ask gentiles to play on their behalf.[80]

Another custom is referred to in a question put to R. Josiah Pinto from Damascus: "Some men indulge in strange antics at weddings, dressing up in women's clothes for an hour or two, to entertain the groom and bride."[81] From the answer, it is clear that this behavior did not meet with Pinto's approval, "since the joy we are commanded to feel is not the frivolous joy of dissipation, but the pure joy resulting from the performance of a *mitzvah*." Nevertheless, aware of how difficult it would be to abolish such a widespread custom, he chose to leave it intact. For "if the *dayyan* of the times is aware of a breach, but realizes that the community will not heed the voice of its teachers and deliberately ignore their rebuke, it is better they should transgress unintentionally than intentionally [...] For if he see that they will not listen to him, why should he compound their sin, by turning them into deliberate sinners?[...] The above notwithstand-

[78] Castro, *Ohalei Ya'aqov*, 60 (see also Sambari, 218).

[79] Ibid. Still on this subject, see below Chapter 8, "Social Norms versus Reality." Compare wedding ceremonies in Greece (B. Rivlin, "family", 95).

[80] MS Jerusalem, Tzayyah, 425, p. 101a-b. On dancing customs in weddings see Friedhaber, "Dancing"; Friedhaber, "Customs".

[81] Pinto, *Yoreh De'ah*, 16. Cf. Aligieri, *Yoreh De'ah*, 6: "Men and women alike put on strange attire to add to the general merriment [...] Indeed, this custom is deeply entrenched in Venice, Italy and the Rhineland, and even in Istanbul, a town renowned for its sages and scholars, without the latter demurring." On mixed dancing at weddings see: Friedhaber, "Dancing", esp. pp. 350-353; idem, "Customs". Conversely, in Egypt men dressed in white at weddings, as on fast days, in deference to the verse (Psalms 2:11): "And rejoice with trembling" (Radbaz, II, 693).

ing, no God-fearing person should associate with these people at such times!"

Because of the joyous nature of the occasion, it was customary not to hold weddings during the mourning period of the counting of the Omer. Only under exceptional circumstances, such as acute sexual frustration, or if there was no-one to minister to the man's needs, did the Radbaz permit a marriage to take place during this period. Even then, care was taken to tone down the joyfulness of the occasion.[82]

The marriage ceremony was a good illustration of the ambivalence towards sexual mores that prevailed throughout all strata of Jewish society: On the one hand, it was a joyous, almost hedonistic occasion, with food, drink, dancing, and entertainment galore – an opportunity to discard inhibitions. On the other hand, the entire ceremony took place under the vigilant eye of the community leaders and sages, who tried to prevent excesses by keeping the sexes segregated as far as possible.

As stated, the entire ceremony revolved around the bride, who was pampered and indulged by her female escorts and relatives. These were also responsible for keeping her apart from the groom. The groom, for his part, was surrounded by close friends who prepared him for contact with his bride through pertinent hints and allusions. Unlike the speeches of the rabbis and preachers, which revolved around serious moral issues and stressed woman's function as the vehicle to man's ultimate perfection, the more popular entertainment mirrored the sexual tension that prevailed in society in general, and between the couple in particular.

Age of Marriage

The parents and relatives of children of marriageable age left no stone unturned when it came to financial arrangements, but were not as a rule overly concerned about their children's wishes or wellbeing. For them 'a good match' signified a financially-secure match. Once all the necessary financial arrangements were made, there was no

[82] Radbaz, II, 687. Italian sages, such as R. Samuel Portaleone and R. Israel Solomon Lingi, also advocated weddings throughout the counting of the Omer, so that a man can fulfill the commandment of procreation ('*Pru u-Rvu*') (Benayahu, "Views", pp. 175, 180, 242-244; Benayahu, "Portaleone", p. 134)

reason, they believed, for the marriage not to succeed. On the contrary, they felt that they had fulfilled their obligations to their daughters and families. The daughter's age was considered irrelevant. She was simply expected to adapt to her new lot as women had from time immemorial.

The numerous references to child marriage in the 16th-century Responsa literature and other sources, shows that child marriage was so common, it was virtually the norm.[83] In this context, it is important to remember that in *halakha*, the term 'minor' refers to a girl under twelve years and a day. A girl aged twelve and a half was already considered an adult in all respects.[84] Between these two ages a girl was considered a *na'arah*.

The *Shulhan Arukh* states: "Every man is commanded to marry at the age of eighteen, although it is preferable to marry at the age of thirteen. Marriage before thirteen, however, is not advisable." From the above, it is clear that a boy of thirteen was considered too young for marriage. Indeed, the betrothal [*kiddushin*] of a boy who had not yet reached the age of *barmitzva* was not valid.[85] Girls, on the other hand, could be betrothed by their fathers even before they have reached the age of maturity. Fathers could arrange betrothals [*kiddushin*] for their daughters without their consent as long as they were minors.[86] Officially, however, the Sages did not encourage this. The Rambam (Moses ben Mimon, Mimonides), for example, gave the following admonition: "Even though a father may betroth his daughter under the age of twelve-and-a-half to whomsoever he wishes – it is not advisable to do so. The sages recommend that a man should not marry off his daughter when she is a minor, but wait till she is old

[83] For example: Alshekh, 120; Ashkenazi, 18; Berab, 18, 44; Castro, *Ohalei Ya'aqov*, 62, 84; Caro, Responsa *Beit Yosef*, 7, 71; Galante, Responsa, 14, 23; Maharit, II, *Even ha-'Ezer*, 41; *Hoshen Mishpat*, 61; Mabit, I, 78, 127; II, 96; Radbaz, I, *Even ha-'Ezer*, 45; III, 1006; VI, 2293, 2338-2339 (still on the same subject: Mabit, I, 321). See also: Gottheil-Worrell, XL, third document; Cohen, *Jerusalem*, pp. 143-144; Lamdan, "Child Marriage".

[84] Rambam, *Marital Laws*, II, 2-3; Caro, *Shulhan 'Arukh, Even ha-'Ezer*, Laws of Refusal, 155, 12 ff. For other references, see: Schereschewsky, pp. 47-50.

[85] Rambam, *Marital Laws*, IV, 7; Caro, *Shulhan 'Arukh, Even ha-'Ezer*, Laws of Procreation, 1-3; Mabit, II, 97; On age of maturity, see Rambam, *Marital Laws*, II. In the 18th century, the Hida stated: "In these generations the sexual drive is weaker. There is no need, therefore, to marry as early as thirteen" (Azulai, *Birkei Yosef*, II, Even *ha-'Ezer*, 1, 7).

[86] *Ketubot*, 22a; *Kiddushin*, 64a; Rambam, *Marital Laws*, III, 11.

enough to express a choice." Rabbi Joseph Caro expresses a similar opinion in the *Shulhan Arukh*.[87] These recommendations, however, remained theoretical; they in no way reflected the daily reality of life in the 16th century, or in earlier centuries for that matter.[88]

In Jerusalem, child marriages continued at least until the early 18th century, when R. Solomon Abdallah and his rabbinical court proscribed the betrothal of minors, since this practice frequently had 'adverse consequences'.[89] Until then, however, child marriages were a common phenomenon. The records of customs and regulations of the Safed kabbalists in the 16th century indicate that they used to contract marriages on behalf of their sons when their sons were about thirteen. Presumably the brides were even younger.[90]

The authority to marry off a daughter while she was still a minor granted the father enormous power. He could determine her fate for better or worse while she was still an infant. Presumably, most fathers had their daughters' welfare at heart, and wished to provide them with a secure future. In a society where a girl's greatest aspiration was to be a wife and mother, the father obviously considered it his duty, not just his right, to marry off his daughter as soon as possible.

However, as stated, early marriages led to many problems, some so severe that they ended in litigation. In the first instance, the groom was not always prepared to wait patiently for his bride to grow up. Reuben, for example, who was betrothed to the daughter of Simeon, promised not to betroth another woman before wedding her. How-

[87] Rambam, *Marital Laws*, III, 11, 19; *Prohibition of Cohabitation*, 21, 25; Caro, *Shulhan 'Arukh, Even ha-'Ezer, Kiddushin*, 37, 8, and annotation there. See also: *Kiddushin*, 41a, and Rashi there.

[88] Grossman ("Child Marriage") showed, in contrast to Goitein (*Society*, III, pp. 76, 79), that from the 10th century, child marriage was not only routine in Jewish eastern-Mediterranean society, but that the phenomenon had even spread through Islamic and Christian countries. Grossman discussed this phenomenon among the Jews of Ashkenaz (Rhineland) separately (idem, *Sages*, pp. 406-407; idem, "Family," p. 18). See also: Goodblatt, p. 94; Gudemann, p. 93; Katz, "Marriage", pp. 22-24; idem, *Tradition*, pp. 166-167. For further references, see: Stahl, *Family*, p. 58 ff.

[89] Azulai, *Yoseph Ometz*, 100; A contemporary of R. Solomon Abdallah says that the Jerusalem regulation was introduced "for reasons known to them" (Mizrahi Moses, I, 38). The regulation is also mentioned in other sources. See also Gelis, *Customs*, p. 327. R. Raphael Aaron Ben Shimon, who also referred to the ancient regulation, added: "Even though we have not found this regulation mentioned in rabbinical works here in Egypt, it has been adopted in practice"(Ben Shimon, *Nahar*, 170a).

[90] Toledano, regulation 7 (post-1577), p. 50; Berukhim Abraham, no. 12, p. 298; Hallamish, "Text", regulation no. 31, p. 92.

ever, after a while he claimed he had come of age, being already eighteen, while his fiancée was still only eight years old. When he had sworn not to betroth another girl, he had believed himself capable of patiently biding his time until she matured, but he no longer felt capable of doing so. In another incident, a man of thirty (!), whose betrothed was a girl of five or six, became weary of waiting until she came of age and was capable of bearing children.[91]

Sometimes a groom was not willing to wait for his bride to come of age, due to his father-in-law's failure to live up to his financial commitments. In one case, a man arranged the engagement of his 16-year-old son to a five-year-old girl for financial gain. The bride's father agreed to give his in-law some money to be invested "until she [the bride] reached the marriageable age of ten [!]" The groom's father subsequently sought to break off the engagement when the girl's father failed to live up to his side of the agreement. He no longer had anything to gain by waiting for her to grow up.[92]

It was not unusual for early betrothals to be contracted under false pretenses.

> Reuben arranged for his only daughter, a gentle, refined girl aged twelve, to marry Enoch ben Yehuda, giving him a handsome dowry of 1000 *sultanis* [Ottoman gold coins]. The girl, who was used to having two maids at home, was exploited by her ill-tempered husband and mother-in-law, who not only refused to feed her properly, but made her do all the washing, laundry, and other housework. Finally, no longer able to bear their physical and emotional abuse, she returned to her father's home.[93]

R. Joseph Caro of Safed, ruling in the girl's favor, insisted that the husband and his family show respect toward the wife and hire a maid to do the housework, especially since she had given such a generous dowry. Note that in his decision, R. Caro completely disregarded the age factor.

Another case brought down in the Responsa literature is that of a girl aged ten years, seven months, who married the son of one of the biggest merchants in town. In this case, too, the marriage ended in disaster: After they were married a mere six or seven months, the boy

[91] Mabit, II, 97; III, 119 (on the same issue, see also Alshekh, 13). See also Maharit, II, *Yoreh De'ah*, 47.

[92] Lieria, Responsa, 19 (for details of the transaction, see note 19 above); on the same issue: Arha, 31-33; see also Mabit, I, 78.

[93] Caro, Responsa *Beit Yosef*, 49 (=Laws of *Ketubot*, 15).

apostatized and began squandering their money. It was even
rumored that he wished to join the Ottoman army and leave his wife
an *agunah*. He agreed to grant his wife a *get* only after he had suc-
ceeded in extorting large sums of money from his father-in-law.[94]

One of the more appalling consequences of child marriage is illus-
trated by the following case. In Damascus, a man of over twenty-
three married a "chaste, innocent, retiring, and virtuous" girl of
twelve. Unable to consummate his marriage with her, he resorted to
violence. The girl's parents took his side, accusing the girl of being a
moredet (a 'rebellious woman' – a woman who refused to have sexual
relations with her husband), and even beating her. After more than
six months of such torture, some compassionate women intervened.
They discovered that the husband was impotent and perverted, and
had taken out his feelings of inadequacy on his wife. The rabbinical
court of Damascus, however, was unsure as to whether to coerce the
husband into giving a *get*, since he had admitted to impotence on a
number of occasions, but had claimed that his wife was a '*moredet*' on
others. R. Moses Barur of Damascus consulted the Mabit of Safed,
who likewise found it hard to reach a decision. Like other *posekim*
[decisors] in similar cases, he related only to the economic implica-
tions of the case, completely omitting any reference to the man's
odious behavior described in detail by R. Barur, or the young age of
the bride.[95]

From this and similar cases, it appears that the main concern on
either side was not to suffer financial loss by the annulment of an
engagement or betrothal. References to child marriages in the
Responsa literature occur only when there was a need to decide on
the validity of a betrothal or in connection with the girls right to
refuse (*mi'un*). Nowhere are child marriages as such questioned.[96] No
doubt, the child marriages referred to in the Responsa literature were
merely the tip of the iceberg. Barring financial problems, such mar-
riages were considered perfectly acceptable.

The exploitation and abuse of young wives, as described above,
was not only a function of the husband's personality but also of the

[94] Castro, *Ohalei Ya'aqov*, 84.
[95] Mabit, I, 267.
[96] Mabit, III, 54; Galante, Responsa, 72; Alshekh, 8; Caro, *Avkat Rokhel*, 85; MS
Jerusalem, Tzayyah, 366, p. 40b; 494, p. 220b; 529, pp. 254a-258a. On divorce
ceremonies for minors according to the Mabit, see: MS Jerusalem, *Sefer Tikkun
Soferim*, p. 132.

wife's immaturity. Had she been more mature, self-confident and experienced, her husband and family would not have found it so easy to maltreat her.

In light of the above, it is not surprising that young girls often could not make the break from their families, despite agreements to the contrary. Barring an explicit agreement to remain in the woman's home town, a woman who refused to accompany her husband was considered a 'rebellious' woman, with all the economic and personal implications this entailed.

> A young man from Hamat [Homs in Syria] married a child bride whose parents lived in Hamat. When her husband subsequently decided to move to Tsobah [Aleppo] she protested [...] Whereupon the husband said that it was his prerogative to decide where they lived. She could either agree to accompany him, or stay with her parents until her hair turned gray, in which case he refused to pay her maintenance or clothing.[97]

In another case, a girl who married Reuben while he was still a boy, refused to live in her father-in-law's house in Tsobah, and returned to the parental home. When her husband wanted to move to Sinim (Tripoli) where he had found work, she refused to accompany him. The rabbi in his responsum, ruled that "the small degree of pleasure the woman derived from living with her family" was immaterial, and that she must follow her husband, or else forfeit the main *ketubah* and increment.[98] Note how in all the aforementioned cases, the deliberations revolved around economic issues, rather than the girl's wellbeing.

Child marriages were particularly common among orphans. The sages stipulated that a fatherless female minor could be married off by her brother or mother, for her own good, so that she would not be left destitute. Indeed, it was the norm to try and marry off orphan girls young, even among the Pietists of 16th-century Safed. However, unlike other girls who were betrothed by their fathers under the age of twelve, orphans had the prerogative of 'refusing' (*mi'un*), thereby retroactively annulling the marriage.[99] An orphan girl, however, who

[97] Berab, 18.

[98] Galante, Responsa, 55. R. Samuel Vital reached the same conclusion (Responsa *Be'er Mayim Hayyim*, 24).

[99] *Yevamot*, 89b; 107a-b; 112b; Rambam, *Divorce Laws*, XI, 1-11; Caro, *Shulhan 'Arukh, Even ha-'Ezer*, Laws of Refusal, 155, and annotation there. A minor who is no longer under her father's tutelage (such as a widow or divorcee who is still a minor)

married after reaching her majority and refused to live with her husband, was considered a 'rebellious' woman, and had to undergo a proper divorce and forfeit all financial rights. Therefore, in many halakhic deliberations, it was important to ascertain the exact age of the orphan at the time of betrothal. In the absence of official records, the courts frequently resorted to the testimonies of acquaintances and neighbors. However, since the latter relied on memory or on circumstantial evidence (such as "the girl was eight months old before the plague," or "she was born after the capture of Nicosia," or "she was born after they moved house"), it was necessary to find other ways of ascertaining the bride's age. To this end, 'reliable women' were asked to examine the bride for signs of puberty. According to the Radbaz: "In Egypt we tend to rely on women to check for signs of puberty in girls, and their evidence is accepted for better or worse."[100] If the girl showed no signs of puberty during the examination, she had obviously been a minor when she was married, and so the marriage could be annulled.

Despite the right to refuse (*mi'un*) and the legal implications resulting therefrom, the sages still advocated child marriage for female orphans. Nevertheless, each case was judged on its own merits, as illustrated by the following incident adjudicated by the Radbaz and the Mabit. The guardian of a twice-orphaned girl, who lived with her step-mother and step-sisters, sought to arrange an early marriage for her. The Radbaz related mainly to two factors: The fact that the match might not come off, since the man in question was not willing to wait until the orphan reached maturity; and to the fact that her father, when still alive, had intended to marry her off while still a minor. The Mabit, however, introduced a psychological note into the argument. Surely, he argued, it was better to marry off the girl than to leave her to the devices of her step-mother. Both instructed the Court to weigh up all aspects of the girl's wellbeing, and to base their

is entitled to refuse, and resembles an orphan in this respect (*Kiddushin*, 44b). R. Joseph Caro states: "Surely it is common knowledge that an orphan who is a minor may refuse!" (Responsa *Avkat Rokhel*, 85, p. 86a). In order to avoid annulments of betrothals, R. Moses Isserles in his annotations to the *Shulhan 'Arukh*, warned against undue haste: "As a rule, the courts should not sanction the marriage of an orphaned minor if they have reason to believe that she may later refuse" (Caro, *Shulhan 'Arukh, Even ha-'Ezer*, Laws of Refusal, 155).

[100] Radbaz, VI, 2182; Mabit, III, 54; Ashkenazi, 6,19; Maharit, I, 40-41, 51; Rofeh, 8; Castro, *Ohalei Ya'aqov*, 26-27.

decision, inter alia, on character assessments of the various people involved in the case.[101]

The expense of marrying off indigent orphans placed a heavy financial burden on the community. Since a dowry was an essential prerequisite of any marriage, the community had an interest in helping those who wished to provide a dowry for an orphaned girl. Thus, when the relatives of poor orphans (like the impoverished fathers mentioned above) undertook fund-raising expeditions on their behalf, the communal leaders unhesitatingly provided them with warm letters of recommendation, urging their fellow Jews to come to their aid. Obviously a successful expedition of this kind absolved them of the onus of taking care of the orphan themselves.

Below is an example of such a letter, pleading the cause of two orphaned sisters in Jerusalem:

> The bearer of this letter has taken upon himself to help two orphaned sisters living in his home. Both sisters have long since come of age. They sit around disconsolately, with no father to care for them. This brave man is touched by their plight, but does not have the means to marry them off and deliver them from their unwed status [...] For he too can barely make ends meet [...] The sisters have depleted his resources, sapped his strength [...] Thus, he has no choice but to go from town to town to collect money on their behalf [...] And so he knocks on the door of the benevolent [...] beseeching them to give him whatever they can to marry off his sisters before it is too late [...] And so [...] the purpose of this letter is to broadcast his plight, so that you may feel compassion for him and give generously to this good cause [...] May these words find favor in your eyes. May you open to him the portals of your heart.[102]

Another way of securing the future of young orphaned girls is alluded to in the following letter: "To his excellency, Matzliah of Fano [...] May I remind you of my request to find us a servant. If this should prove difficult, a young orphan girl would do admirably. Without father or mother, she will never return to her country of origin, and will quickly forget her father's house."[103] Thus, orphan girls were

[101] Radbaz, VI, 338-339; Mabit, I, 321. Cf. Radbaz, III, 1039.

[102] MS Jerusalem, *Iggerot Shadarim*, letter 167, pp. 197-198. See also: ibid, Nos. 191-192, p. 228, and in the section of Mataron's letters, letter 36, pp. 320-321.

[103] Ibid, letter 28, p. 312. On the Italian custom to employ orphans as maidservants see: E. Horowitz, p. 205. On the relations between masters and female slaves in Jewish society see: Lamdan, "Female Slaves".

'exported' as servants for the wealthy. Presumably, their masters contracted marriages for them when they reached their majority.

The father's prerogative to marry off a young daughter also lent itself to serious abuse, such as marriages that were contracted frivolously or in jest, under the influence of drink. Obviously, the standard settlements and conditions that were stipulated during the engagement ceremony were missing in such cases. Nor was the early marriage motivated in this case by concern for the girls' wellbeing. Usually, once the father had sobered down, he regretted his deed, but by then it was too late. Evidently such kinds of marriage became something of an 'epidemic.' Indeed, several such cases reached the courts, particularly when the validity of the marriage was questionable, for according to the stringent interpretation of the law, borderline marriages required a *get*. This situation is reflected in a hypothetical question that R. Joseph Ibn Tzayyah of Damascus addressed to R. Joseph Caro, and which was debated also in Hamat, Tokat and Aleppo:

> [...] regarding various incidents that took place in local taverns. For example, if a man betrothed his son to his friend's daughter who was still a minor, and the father sealed the transaction by the consumption of a glass of wine or the transfer of a gold ring. Now supposing the son, as an adult or upon reaching maturity, rejected the betrothal contracted on his behalf, would the betrothal still be considered valid?[104]

Another similar case, which was deliberated by a number of sages, took place in Damascus in 1617. During a party, when spirits were high, one Samuel Nehmad instructed his son to betroth Muença, his cousin, and to solemnize the occasion over a cup of wine [*kinyan*]. The father of the girl, Rashid, subsequently denied having accepted the cup of wine. From the way the story is narrated, it is obvious that such incidents were by no means rare.[105] In Jerusalem, for example, two men who were whiling away time in the market in bantering and jokes "betrothed their young children to each other in jest."[106] An even more notorious case was that of an inebriated father who betrothed his as yet unborn daughter at a party! Even in this preposterous case, the Sages disagreed: Some argued that after a daughter was

[104] Caro, Responsa *Beit Yosef*, 9 (=Laws of *Kiddushin*, 7).

[105] Pinto, 26, 27 (Maharitatz), 29 (R. Hiyya Rofeh), 30 (R. Suleiman Ibn Ohana). See also: Maharitatz, New Responsa, II, 205, 206; Pinto, 31-33.

[106] Ashkenazi, 18.

born, a *get* was necessary, while others argued that it was not.[107] The above are but a few of the many cases of betrothals made under the influence of drink, or in jest.[108] This phenomenon indicates a social climate in which a woman's fate could be trifled with, and where men could abuse their halakhic prerogative of marrying off their daughters, a prerogative granted them on the assumption that they would use it in their daughters' best interests.

Some researchers are of the opinion that 16th-century Ottoman Jewish society was influenced by the surrounding Muslim society, where child marriage was commonplace. However, Muslim law, formally at least, holds that marriage must be based on mutuality. Therefore, a girl who is married off while still a minor may, upon reaching maturity, request an annulment of her marriage.[109] In Jewish law, on the other hand, the husband's consent is essential in such cases. Therefore, even if the custom of child marriage among Jews were influenced by the Muslim custom, the implications for Jewish women were totally different. For whereas in Muslim society, the marriage bond was perceived as an economic or social tie that could be easily dissolved, in Jewish society, marriage was perceived as a sacrament that could be dissolved only after serious consideration. It was women however, who had to suffer the negative implications of this consecrated bond.

In contrast to a social climate that allowed irresponsible marriages of this kind, the rabbis did their utmost to find a solution in each case. This usually consisted of finding a technical loophole that per-

[107] Radbaz, I, 414.

[108] For example: Maharit, *Even ha-'Ezer*, 42 (which relates the story of a father who "under the influence of drink, accepted bridal gifts from a reckless scoundrel in exchange for a gold coin"); Berab, 20; Maharitatz, New Responsa, I, 52; Maharitatz, 91, 236.

[109] The prevailing view is that this right was exercised only infrequently due to social and family pressures, and because of differences between the various Muslim schools of thought. However, a study of the Jerusalem Shari'a court records shows that requests by young Muslim, and even Christian, women for the annulment of marriages contracted without their consent were fairly common, and were frequently granted by the qadi (Zeevi, pp. 230-232). Zeevi (ibid, pp. 339-340) concludes that it was only towards the 19th century that the status of Muslim women begin to decline, mainly due to European influences. Nevertheless, Zeevi also quotes Eugène Roger, a Franciscan friar residing in Palestine in the first half of the 17th century, who describes the prevalence of juvenile marriages. However, Jennings' study of Kayseri in Anatolia shows that women who sued for the annulment of marriages contracted when they were minors sometimes received a sympathetic hearing (Jennings, *Kayseri*, esp. pp. 76-80, and notes 25-26 there, including references).

mitted the marriage to be retroactively annulled. This was true not only of betrothals made in jest, but also in cases where a minor was betrothed without her father's knowledge or consent.[110] If, however, a technical loophole could not be found, the girl was considered to all intents and purposes married, and required a *get* if she wished to remarry. As stated, each request for a *get* was an opportunity for extortion by the groom, often entailing lengthy litigation.

In conclusion, child betrothals, particular of girls, was a routine phenomenon in 16th-century Ottoman Jewish society, and one that had significant negative implications: For many, it marked an abrupt end to childhood at puberty (girls around twelve, boys around thirteen or fourteen), or even earlier. There was no intermediate stage of adolescence, but rather a sharp transition from carefree childhood to responsible adulthood.[111] Although it was customary for the parents to support the young couple for a number of years, this did not alleviate the plight of the young wife who was suddenly cut off from her family of origin and had to adapt to enormous changes in her life. Since most young couples lived in the parental home, their relatives had a large say in their lives. Conflicts between daughters-in-law and mothers-in-law were common, with the husband usually siding with the mother.

Child marriages influenced the relationship between husband and wife for many years, and resulted in an increase in the phenomenon of wife-beating. The greater the age difference between husband and wife, the greater her vulnerability, since his age in itself lent him greater authority in her eyes. The husband, for his part, related to her paternalistically, even hitting her when she did not do his bidding. A girl who was brought up to be modest and compliant found it hard to cope with the demands of a domineering and sometimes even violent husband. Frequently the patterns of humiliation and violence, once set, continued well into the marriage.[112]

[110] Rambam, *Marital Laws*, III, 13; Castro, *Ohalei Ya'aqov*, 16, 62; Radbaz, IV, 1129; Alashqar, 14; Berab, 56-57; on the validity of marriages made under duress see: Shohetmann, "Marriage."

[111] Most Christian writers of the Middle Ages divided childhood into three stages: from infancy to age seven (*infantia*); from 7 to 12 (girls) or 7 to 14 (boys) (*pueritia*); from 12 (or 14) until full maturity – approximately in the mid-twenties (*adolescentia*). In their writings, the third stage is mentioned mainly with reference to boys, since in medieval Christian society too, girls married young, usually before completing this stage (Shahar, *Childhood*, pp. 42, 51, 362, *passim.*).

[112] See Grossman, "Child Marriage," pp. 123-124.

This, together with parental interference in the couple's life, did little to enhance the wife's independence or self-confidence. Only a few young wives, especially those with a supportive family, managed to transcend social and psychological taboos and demand a *get*. Others who were less fortunate, had to resign themselves to unhappy marriages. In most cases, some measure of independence and confidence was attained only after a women left the parental home, and became a housewife and mother in her own right; or when she re-married, this time with greater experience or hindsight, or even with some money or property to her name.

CHAPTER THREE

THE EXTENDED FAMILY

In-laws

It was customary for the newly-weds to move into the parents' home (usually the husband's parents) for a period of time stipulated in the prenuptial agreement. The bride, who was often not much more than a child, not only had to adapt to her new status and obligations as a married woman, but also had to find her place within a closed and rigidly structured family setup. Thus, women did not always become independent through marriage, but simply exchanged one restrictive environment for another, less welcoming, one. Coexistence was by no means easy, and demanded sacrifices of all concerned. Young brides were particularly vulnerable; the younger the bride, the easier it was for her in-laws to meddle into her affairs, exploit her, and influence her husband to do their bidding. Some cases of extreme abuse by in-laws even reached the rabbinical courts. Ability to cope with this new situation depended to a large extent on the bride's stamina, and her husband's character and age. The passage from girlhood to marriage did not necessarily enhance the girl's status within society and family, and the shared living arrangements served as a constant reminder of the couple's absolute dependence on their parents.[1] Things were not much better when the couple moved in with the wife's family. No wonder the *posekim* viewed these communal living arrangements as the main cause of marital disputes.[2]

[1] See: Maharitatz, 229; Caro, Responsa *Beit Yosef*, 49 (= Laws of *Ketubot*, 15); Castro, *Ohalei Ya'aqov*, 50 (=MS New York, Hayyim Capusi, 3; see ibid, also 4, pp. 7a-10a); Mabit, I, 267; Maharit, I, 113.

[2] Gavizon, II, 42(43), 90; Maharitatz, 40 (and on the same subject: Ashkenazi, 15); Maharitatz, New Responsa, I, 27; Mabit III, 54; Radbaz, III, 888; VI, 2255; Alshekh, 91; Berab, 22; Vital Samuel, 4 (Damascus, 1644); MS Jerusalem, *Iggerot Shadarim*, letter 184, p. 216. Sometimes, disputes over housing rights arose when the husband died, and the widow demanded her rights. From the reactions of mothers, it transpires that even before the death of the son, they were not overly fond of their daughters-in-law. See: Mabit, I, 184, 270; Alshekh, 14; Maharit, II, *Hoshen Mishpat*, 73; Radbaz, VI , 2183; Caro, *Avkat Rokhel*, 101.

The above notwithstanding, we should not lose sight of the fact that the halakhic and juridical literature on which this research is based deals, by its very nature, with the exception rather than the rule. Presumably, the vast majority of women were able, in time, to adjust to their new situation, until they themselves became mothers and left their in-laws' home (which for many was their first taste of independence.) Indeed, a spirit of compliance and even cooperation usually evolved over time, even when the couple continued living in the parents' home. In the course of time, when these women themselves became mothers-in-law, they acted toward their daughters-in-law in a similarly authoritarian manner, thus bequeathing the pattern from generation to generation.

Despite the tension caused by overcrowding and parental interference, a sense of solidarity also existed. Some husbands supported their mothers-in-law, or looked after their financial affairs. Some mothers bequeathed property to their sons-in-law or acted as their guarantors on the implicit understanding that they, in turn, would provide for their daughters.[3] In an anonymous 'maintenance settlement' from Jerusalem, a man undertook to support his mother-in-law for the rest of her life: "She shall live in his home, eat of his bread, and drink from his cup. He shall treat her like his mother, and keep her clothed and shod for the rest of her life, in the manner she is accustomed to and according to his means."[4] Other sources, too, indicate positive ties between the young couple and their in-laws.[5]

Ties with the family of origin

Married women, even those who lived far from home, maintained close ties with their family of origin. These ties proved useful in times of trouble. If a woman was deserted by her husband, for example, her parents, brothers, and uncles, would stand by her and protect her

[3] Mabit, I, 207,270, 329; II, 220; Alshekh, 87; MS New York, ENA 2747, p. 8 (a copy of the Genizah document was provided courtesy of Abraham David).

[4] MS Jerusalem, *Sefer Tikkun Soferim*, p. 104b. See also Mabit, I, 1, where the groom regretted his promise to maintain his mother-in-law and sister-in-law in perpetuity.

[5] Lieria, Responsa, 17; MS Cambridge, TS NS 32, p. 53a (a copy of the document was provided courtesy of Abraham David); David, "Genizah," Document 16, pp. 52-53 (see also Kraemer, "Spanish Ladies," p. 259). On business dealings between in-laws, see Maharitatz, New Responsa, I, 14.

rights.[6] Where relevant, they tried to effect a reconciliation between the couple, offer economic assistance, trace missing husbands, and generally be of use.[7]

A woman contemplating divorce was particularly in need of her family's psychological and economic support. Without such support, she had virtually no chances of obtaining a *get*. On many occasions, it was her family that urged her to leave her husband, for a variety of reasons. Indeed, most divorce proceedings referred to in the sources (other than those prompted by conflicting property claims), were initiated by the wife's family. Sometimes, the cause of conflict was a long-standing dispute that resurfaced after the marriage. In other cases, the cause of conflict was the husband's decision to move away, in contravention of the prenuptial agreement. In most cases, however, the real grounds for divorce, even if unspecified, were disillusionment with the husband. In all cases, the bride's parents not only stood by her, they even urged her 'to rebel' (refuse sexual relations) and defy her husband. In extreme cases, they even urged her to come home and sue for a divorce. The woman's role was, at least in theory, passive. It was her parents or brothers who spoke on her behalf, or instructed her what to say. Note how in all these cases, the families had the resources and connections which enabled them to defy social convention and pressurize the courts. In most of these cases, the groom was a would-be Torah scholar whom the parents-in-law had agreed to support. Their original joy at having a Torah scholar for a son-in-law soon turned to dismay when they saw his true colors. For them, a divorced daughter was preferable to a daughter married to a ne'er-do-well.[8]

Parental initiation of divorce proceedings was so prevalent, that in one case R. Isaac Don Don from Damascus actually took the parents

[6] Mabit, II, 20, 114; Alshekh, 132; Pinto, 47, 75; Caro, Responsa *Beit Yosef*, 32 (= Laws of *Ketubot*, 8).

[7] Mabit, II, 37, 184, 221; III, 14; Maharitatz, 50; Castro, *Ohalei Ya'aqov*, 122; Ralbah, 80-81; Gottheil-Worrell, document XLIX, pp. 242-244; MS Jerusalem, *Iggerot Shadarim*, letter 172, p. 202; letter 180, p. 211; Sambari, p. 100 (p. 196 in photocopied edition); Cohen, "Damascus," p. 98.

[8] Mabit, II, 61; III, 54; Maharitatz, 207, 220, 227, 242; Alashqar, 31; Caro, *Avkat Rokhel*, 85; Gavizon, II, 42(43), 90; Mahritatz, New Responsa, 172; Castro, *Ohalei Ya'aqov*, 84; Ashkenazi, 15 (See the question regarding the son of R. Samuel Jaffe Ashkenazi from Adrianople, which elicited a response from sages in Palestine and Egypt, and which caused quite a furor. On this subject see: Mahritatz, 40; Mahritatz, New Responsa, 240); Radbaz, III, 853; Galante, Responsa, 44; *Sefer Zera' Anashim*, 41.

to task for inciting their daughter to 'rebel' and demand a *get* and full *ketubah*. "It is common knowledge that her parents were the ones who pressed her [to ask for a divorce], since she is like putty in their hands!"[9] R. Yom Tov Zahalon condemned parental interference in this matter, and castigated parents who incited their daughters to 'rebel': "May the name and memory of those who stir up strife between husband and wife be obliterated."[10]

Brothers and Sisters

Even after their sisters got married, brothers continued to feel responsible for them, and act on their behalf where necessary.[11] Several letters from the Genizah indicate deep bonds of affection, mutual solicitude and concern between brothers and sisters. In one such letter, Abraham invites his sorely-missed sister to come and join him in Cairo (he also includes a long list of things he wants her to bring with, including money!). In another letter, Miriam tells her brother how much she missed him over *Pessah*, and offers him advice in connection with his son's marriage. In yet another letter, Doña Jamilah gives her son in Alexandria an account of her daughter's wedding in Safed, and adds: "And you do not even send me two lines [...] You could have done so, not for me, but for your sister who, saying 'Oh, to receive two lines from my brother!', is tearing out her heart and does nothing but cry from your lack of affection [...]"[12] In one letter, the sister of a Musta'rab man who had gone to Cairo leaving his wife behind in Jerusalem, sent him a report on his wife's behavior, offering him advice on how to save his property from his wife's clutches, before she discovered his intentions of taking a second

[9] MS Jerusalem, *Zera' Anashim*, pp. 194a-199a (The question is missing from the manuscript, consequently the reason for the woman's 'rebelliousness' is unclear).

[10] Mahritatz, 242.

[11] Berab, 19, 54; Caro, Responsa *Beit Yosef*, 90; Maharit, I, 40; Mahritatz, 50; Galante, Responsa, 73; Alshekh, 50; Mabit, II, 37; Radbaz, III, 853; Maharit, New Responsa, 8; Castro, *Ohalei Ya'aqov*, 50; MS Jerusalem, *Iggerot Shadarim*, letter 167, pp. 197-198; Ashtor, III, pp. 142-144 (letter from Damascus, in which the author seeks help for his sister, apparently resident in Jerusalem, whose property had been embezzled); In Safed, R. Isaac Fasi was attacked by his wife's brothers for being violent towards her (Benayahu *Ari*, p. 216). See also Kraemer, "Spanish Ladies", p. 246.

[12] Gutwirth, "Family," pp. 211-212. Idem, "Letter," (English translation by Gutwirth). On these letters, see also: Kraemer, "Spanish Ladies", pp. 251-252, 257-258.

wife in Egypt. Evidently, not much love was lost between these two
sisters-in-law.[13]

Just as brothers cared for their sisters, sisters also cared for their
brothers, and supported them in times of need. Sometimes, they
acted as brokers in their brothers' financial and commercial under-
takings.[14] Tension between brothers and sisters was very rare, and
almost always triggered by property and inheritance disputes.[15] Ten-
sion between sisters and brothers-in-law, on the other hand, were
almost always prompted by disputes in connection with levirate mar-
riages, or *halitzah*, where the issue was frequently a financial one. In
one rather bizarre case, a brother-in-law insisted on going through
with a levirate marriage, in order to 'punish' his sister-in-law. "Al-
ready in his brother's lifetime he used to pick arguments with her,
insult her, and call her all manner of names, saying: 'When that
whore comes to my house I shall wreak my revenge!' "[16] Naturally,
she refused him. Litigation between widows and brothers-in-law con-
cerning payment of the *ketubah*, or child custody, was not uncom-
mon.[17]

Mothers and sons

The relationship between mothers and sons was one of mutual love
and respect. The Ari, for one, was fabled for honoring his mother:

[13] MS Cambridge, TS Glass 16, p. 260 (copy of this letter provided courtesy of
Abraham David, who is soon to publish the letter). On the other hand, we hear of
friendly relations between two sisters-in-law, when the husband's sister invited his
wife to live with her 'as a sister' (Mabit, I, 129).

[14] MS Cambridge, TS Glass 16, p. 265 (see: Kraemer, "Spanish Ladies", pp. 255-
256); Benayahu, "Genizah," document 9, p. 247; document 10, p. 249; David,
"Genizah," 4-5, pp. 33-36; document 9, p. 40; idem, "Personalities," document 3, p.
248; Maharit, *Hoshen Mishpat*, 42; Mabit, II, 37; Pinto, 75, 120; Radbaz, I, 32. For
more information on the relationship between brothers and sisters, see Kraemer,
"Spanish Ladies", pp. 254-259. The economic activity of women in the 16th century
will be discussed in detail below.

[15] Maharit, II, *Hoshen Mishpat*, 65; Radbaz, IV, 1300; Mabit, II, 143, 188; III, 152;
Berab, 45. Only one serious argument between brother and sister is mentioned by
R. Yom Tov Zahalon. Although the background to the argument is not clear, the
mother faced a serious dilemma when her son forbade her to visit her daughter
(Mahritatz, New Responsa, II, 167).

[16] Mabit, II, 158. See also: Castro, *Ohalei Ya'aqov*, 21.

[17] Galante, Responsa, 9; Mahritatz, 206; Mahritatz, New Responsa, II, 232 (and
16 ibid); Radbaz, I, 360; David, "Molina."

He made a point of kissing his mother's hand on the Sabbath eve, and ordered his disciples to adopt this custom. When his mother forbade her ailing son to go to the *miqveh* in winter, he complied, despite the great importance he attached to this ritual.[18]

Married sons continued to care for their mother's economic and psychological wellbeing.[19] Conversely, mothers supported their sons, stood surety for them, or cooperated with them in business ventures.[20] The following letter addressed to an unspecified rabbi, describes the anguish of a mother in Jerusalem, trying to raise money to redeem her son from captivity:

> A certain old woman approached us, her face bathed in tears. Her anguish and longing to see her son were so strong that we too were unable to hold back our tears. She told us how her son had disappeared several years ago, without a trace. She knew not if he was dead [*met*] or alive [*hai*][21] [...] Recently, however, she had been informed that her son was being held by a Jewish man for money he owed. The son had agreed to work for him without payment until the debt was repaid. Therefore, [...] we urge you to stand by Moses,[22] and help redeem the boy. Rest not, until the boy is delivered from captivity [...] and his aged mother consoled. For her heart is heavy, she is distraught over the fate of her dearly-beloved son. We urge you to adopt this worthy cause, and revive the spirit of this woman of Jerusalem.[23]

Correspondence between mothers and sons who lived far from each other was common.[24] The letters are of highly personal and yet uni-

[18] Benayahu, *Ari*, pp. 311, 322, 329; Vital, *She'arim, Sha'ar ha-Kavanot*, p. 3a; idem, *Sefer ha-Hezyonot*, 17 (p. 153). In one of his visions, R. Hayyim Vital describes his mother as "an important person and as beautiful as the sun" (ibid, p. 44).

[19] Mabit, II, 72; Radbaz, I, 523; Pinto, 105; Maharit, II, *Hoshen Mishpat*, 96. On the dilemma of a son, who is uncertain whether to treat his step-mother respectfully against his mother's wishes, see: Garmizan, 83. According to R. Elijah Mizrahi, rabbi of Istanbul in the early 16th century, sons tend to tell their secrets to their mothers, not their fathers: "When they wish to send something secretly to their fiancées, they do so through their mothers" (Mizrahi Elijah, end of 19). On the fate of a son who was disrespectful towards his mother, see Sambari, 196 (p. 227 in photocopied edition).

[20] Pinto, 71, 104, 105; Maharit, II, *Hoshen Mishpat*, 35; Mabit, I, 142, 339; Lieria, Responsa, 4.

[21] In the original, dots appears over the words *met o hai* and may be an allusion to the dead and live son in Solomon's trial (I Kings 3: 16-28).

[22] Cf. Isaiah 63:12. The dots in the original evidently allude to the boy's name, Moses.

[23] MS Jerusalem, *Iggerot Shadarim*, letter 72, p. 114.

[24] See, for example: Pinto, 104; Mabit, I, 142; MS Cambridge, TS Glass 16, p. 265.

versal content. Particularly impressive is the correspondence between
Rachel, widow of R. Eliezer Zussman Tzarit, of Jerusalem (originally
from Prague), and her son Moses, who lived with his family in Cairo.
Rachel's letters, written in Yiddish in the mid-1560s, contain the
usual miscellany of questions, as well as advice on business matters,
education, morals, and other, more mundane matters. Despite her
geographical distance from her son, she was passionately involved in
his life, and never failed to provide him with a faithful report of what
was happening back home. All her letters, whether querulous or
sympathetic, reflect the deep bond between mother and son. In one
such letter, Rachel questions the truth of the saying 'out of sight, out
of mind' in relation to the way mothers feel about their sons: 'For
mothers never forget their children, they never forget the agony of
child-rearing!'"[25]

Unfortunately, only one letter from her son survives. The letter
contains answers to some of his mother's questions, reports on his
family, especially the grandchildren, and ends with the following
wishes: 'May the Lord keep you strong and healthy, thus prays and
wishes your son who thinks of you day and night, Moses.'"[26]

The Sefardi counterpart of Rachel was Doña Jamilah of Safed
who kept up a correspondence with her son in Alexandria. One of
her letters ends: "Now I pray to the Lord for your life and your
sister's and your wife's and I ask you, send me two lines, so that I
should know of you [...] Regards to your wife and kiss the children
from us [...] And do send word about the children's welfare, may
they live forever, Amen."[27] The son of the Musta'rab Zahrah Azwaig
was evidently also a poor letter-writer, for his mother had to beg him
to write back: "My dear son, for the sake of God, please write back,
if only a few lines. For when I see your handwriting I am filled with
joy, as if I were seeing you in person."[28] Her letter, a report on
various matters she handled on her son's behalf, ends with regards to

[25] Turniansky, letter 6, p. 205.

[26] Ibid, letter 3, p. 191 (and introduction, p. 150). The document by which Rachel
grants power of attorney to her son is brought by David in *Immigration*, p. 219.

[27] Gutwirth, "Letter." The sender is the widow of R. Yomtov Shalom, a contem-
porary and associate of R. Hiyya Rofeh of Safed, and both disciples of R. Joseph
Caro. The son, R. Abraham Shalom (junior) was married to R. Rofeh's daughter
(Gelis, *Encyclopedia*, I, p. 138; III, p. 195). See also Lamdan, *Status*, p. 307, note 2.
English translation by Gutwirth. See also Kraemer, "Spanish Ladies", p. 253.

[28] MS Cambridge, Misc. 35.23. Fragments of the document were published by
Scheiber, pp. 394-395, and by Kraemer, "Spanish Ladies", p. 253.

his family. In another letter, an anxious mother writes: "Please send me a line with a wayfarer. My son, I will not burden you with my true worries, in order to spare you chagrin. Yet a few lines from you assuring me that all is well and that you are in good health would set my mind at rest."[29]

These letters, which show women with their strengths and weaknesses form a clear contrast to the idealized stereotype of the 'woman of valor'. A typical example of the latter can be found in R. Joseph Alsayag's funeral oration at his mother's graveside:

> This modest woman of valor, this God-fearing woman, my revered mother, may her soul rest in eternal peace. The pain of separation is so savage, so raw. Happiness has fled our hearts, joy has turned into mourning [...] The anguish is so great my senses are numbed [...] Woe is me on this day of vengeance, woe to this day of chaos, woe to this day of affliction [...] Again and again I open a book with the intention of studying, but the agony of my loss does not allow me to concentrate [...] Woe is me, for my loss is so great. Please do not reproach me if I speak out of character, but put it down to my grief.

In the same speech, the son goes on to explain the verse: "Her children rise up and call her blessed; Her husband also, and he praiseth her" (Proverbs 31:28), and says: "A woman of valor [like his mother] will not suffer the fate of an unworthy woman, who is discredited by her own flesh and blood. On the contrary, the children of a woman of valor are a credit unto her [...] Since children are the flesh and blood of their parents, a good son is an indication that the mother has a good character, while a wicked son usually indicates that the mother has a bad character."[30]

R. Joseph Trani's son, too, in his funeral oration, listed his mother's supreme virtues as being a good housewife and a helpmeet to his father (by encouraging him to study Torah).[31]

Underlying the deep love that inspired these two funeral orations was the implicit understanding that a woman of valor was one who toiled and served her husband and children cheerfully and faithfully. Such a woman deserved to be praised and respected by her sons.

[29] MS Cambridge, TS NS 32, p. 53b (a copy of this passage was provided courtesy of Abraham David). See also Kraemer, "Spanish Ladies", p. 254.
[30] MS Amsterdam, Rosenthaliana, pp. 360a-364a.
[31] Toledano, p. 57.

Mothers and daughters

There is very little information in the Responsa literature on ties
between mothers and daughters. The few references there are deal
mainly with matters of inheritance and transfer of property. None of
the correspondence in the Genizah was between mothers and daugh-
ters. At the very most, a letter might contain regards from mother to
daughter or vice versa. Naturally, mothers loved their daughters as
much, if not more than their sons. The emotional ties between them
ran very deep, so much so that daughters were sometimes given
priority in bequests and gifts.[32] The fact that this relationship is not
referred to in the sources may therefore be purely random, or may be
due to the fact that litigation between mother and daughter was
extremely rare. Also, correspondence was unnecessary, since most
daughters married men from the locality and lived near their moth-
ers even after they married. When a merchant from Adrianople de-
manded that his newly-wed wife from Safed move with him to
Adrianople, she adamantly refused: "I will leave neither Safed nor
my mother who bore me." She stood her ground, resisting his pleas,
and stayed with her mother even after her husband left town.[33]

[32] Mahritatz, New Responsa, I, 94; II, 167; Mabit, II, 143; Radbaz, VI, 2255.
[33] Berab, 22.

MARRIED LIFE

Love

As stated above, economic interests were the main considerations in
matchmaking. Indeed, the more affluent and respectable a family,
the less say the children had in choosing a partner. The engagement
and marriage were arranged by the parents with hardly a passing
thought to the subjective feelings of the young couple. The concept of
'romantic love' prior to marriage was unknown. Although, after the
wedding, the husband is commanded to love his wife, the kind of love
referred to is the love that evolves in the course of married life, more
akin to mutual respect and consideration than romantic love.[1] Mar-
riage was strictly a business arrangement, conducted over the cou-
ple's head. In most cases the couple deferred to their parents' judg-
ment. Sexual or personal attraction evidently did not enter the
picture. And yet, folksongs and ballads (*romanceros*) extolling the vir-
tues of love flourished. However, these were mainly Spanish love
songs, brought over by the Spanish exiles, and cannot be considered
a typically Levantine genre.[2]

The love songs and poems of R. Israel Najara of Safed, on the
other hand, really do reflect the reality of Sefardic Jews in Syria and
Palestine. Najara's love songs, even those extolling the love between
God and his people, prove that the *ideal*, at least, of romantic love
existed. Although these songs – describing the tribulations of love,
yearning and erotic attraction – were undoubtedly frowned upon by
the Safed sages, they became popular with the public, for whom they

[1] For further references and sources see: Stahl, "Love;" Stahl, *Family*; Biale, esp.
pp. 88-91.

[2] See: Attias, *Romancero*, introduction; idem, *Canconero*, introduction. The *Canconero*
includes only four secular love songs (pp. 25-27), which according to the editor, date
back to the late 16th or 17th centuries: Song No. 6 is from Greece, and songs 8-9 are
part of an anthology of poems and songs compiled by the cantor of the Levantine
synagogue of Venice for his own use in the late 17th century.

expressed emotions and desires that frequently had to be suppressed.[3]

Another sign that romantic love flourished despite the restrictive norms of the times is the assortment of love charms and spells that existed. Below are a few examples from an anthology of applied *kabbalah*, composed and compiled apparently in the first quarter of the 16th century, and later copied and adapted in different versions. The author, Rabbi Joseph Tirshom, visited Egypt, Jerusalem and Safed, but hardly any biographical information is available about him or his origins[4]:

> "Copy the following two lines on to the egg of a black hen, and bury it in warm ashes. This will make her fall in love with you, and seek you out."

> "Write these names down on two cane leaves. Insert the leaves in the cane and hang it in the wind. As the cane swings with the wind, the woman will be consumed with passion for you."

> "Draw a picture on the wall of the woman you desire. Ask the silversmith to make you a nail from a metal alloy. Knock the nail into the middle of the face, with three hammer blows. With each blow recite the following incantation: [...] 'May I find favor in the eyes of so-and-so daughter of so-and-so, and may an internal fire consume her so that she is incapable of eating or drinking, until she seeks me out and fulfills my wishes and desires.'"

> "Take three quills and write the following inscription on deer parchment, using saffron and the blood of a white dove as ink. Wrap the parchment in a lead case, and wear it on your right arm. After two days, remove it from your arm and throw it into the woman's house [...] You should write the amulet on a Thursday in a state of purity

[3] On the poet and his hymns see: Yahalom; Benayahu, "Najara"; Note that many of Najara's hymns were written to the tunes of well-known Spanish and Turkish secular songs, which are specified at the beginning of each hymn. Najara also adapted the Hebrew texts to correspond phonetically with the text in the Spanish or Turkish vernacular. R. Menahem de Lonzano decried this plagiary. See Benayahu, "Najara," pp. 221-225. See also: Avenary; Attias, *Canconero*, pp. 6-9. On Najara's moral behavior, see Vital, *Sefer ha-Hezyonot*, I, p. 34.

[4] For a comprehensive review of the work, its sources and versions, see Benayahu, *Shoshan*. Benayahu published the index to the manuscript in the appendix to this article, (pp. 219-269). The complete manuscript totals over 600 pages. According to Benayahu, this is an original work, although similar anthologies existed (ibid, pp. 197, 188). Forty-three (almost 50%) of the 112 remedies relating to women – are love charms of different kinds (19 of which are merely referred to in the index, under the heading 'Love,' but do not appear in the complete manuscript).

[after immersion in the *miqveh*]. Observe that Thursday as a fast day. With God's help, you will succeed."[5]

Popular love songs and amulets are clear proof that love thrived in the 16th-century Jewish communities of the Levant. Indeed, the use of amulets was so prevalent that a special *takkanah* had to be introduced, stating: "*It is prohibited to practice witchcraft in any form, even through a gentile proxy, and even for the sake of love!*"[6]

Thus, despite the fact that matchmaking appeared to be a simple business transaction, we see that romantic love still existed in one form or another. Even if initially the couple barely knew one another, love and affection often evolved later on in life, retroactively justifying their families' considerations.

Although most of our information derives from the more extreme cases of marital dispute which reached the courts, there are also surprising insights in the Responsa literature into the happier aspects of married life where bonds of real love and respect existed. The cases quoted, however, are mostly in connection with inheritance claims.

On occasion, wives were appointed exclusive guardians of their husband's property and children. Reuben, for example, in his will, appointed his wife trustee of all his property: "She shall be entitled to dispose of it as she sees fit, over the head of her son Simeon!"[7] Some childless couples left property to each other, even if the local regulations stipulated otherwise. Leah, for example, bequeathed her entire *ketubah* and estate to her husband, in appreciation of the way he had treated her throughout their marriage, never reproaching her for her inability to conceive. Her husband likewise willed all his property to her "bestowing upon her the great honor of sharing it with his sons."[8]

[5] MS London, *Shoshan Yesod ha-'Olam*, No. 1801, p. 522; No. 2160, pp. 575-576; No. 1109, p. 427; No. 1826, p. 523. See also ibid, No. 829, p. 305; No. 1749, p. 505. The detailed text of an invocation whereby a woman of Egypt attempted to instill love in the heart of her beloved can be found in MS Cambridge, TS Or. 1080.15, p. 81. In this source, the names of the couple, apparently Musta'rabs, have been preserved. Nevertheless, it is hard to ascertain the exact date of the manuscript, since it contains a variety of texts, only some of which are from the 16th century.

[6] Freimann, "Regulations," No. 13, p. 209 (see ibid, his comments, p. 213). In Arab society, some believed that when a man fell in love, he was the victim of witchcraft (Briffault, p. 557).

[7] Maharit, New Responsa, 11. Also, ibid, 9; Caro, *Avkat Rokhel*, 74; Mahritatz, New Responsa, I, 69; *Pinto*, 67; Alshekh, 128; Gavizon, I, 6 (Rhodes).

[8] Maharit, II, *Hoshen Mishpat*, 56. See also, Mabit, II, 17; Radbaz, I, 67.

Heirs who saw fit to challenge such wills did not always receive
legal redress. In one case, for example, where heirs questioned a
widow's ability to manage the money left her by her late husband, to
be kept for her daughter's dowry, R. Moses Ha-Cohen ruled in favor
of the widow. Since the father had his daughter's welfare at heart, he
reasoned, he must have had good reason to entrust his money to his
wife.[9] In another claim, heirs attempted to interpret their father's will
in a way that would prejudice his second wife and her infant son.
R. Joseph Ibn Tzayyah, however, ruled against the petitioners on the
grounds that "the husband's generosity to his wife was an expression
of the fact that he loved and trusted her."[10]

In contrast to the mercenary husbands who attempted to extract
money from their wives through fraudulent means,[11] there were those
who loved and respected their wives, and expressed their love
through financial largesse. This largesse took the form of generous
ketubot, bequests, or financial support for a member of the wife's
family. When Reuben, for example, had to draw up a new *ketubah* for
his wife after some mice had devoured the first, he took into account
the fact that his business had since flourished and offered her more
favorable terms.[12] Another husband expressed his love to his wife by
increasing the sum of her *ketubah*, declaring that: "In the normal way
of things, he would not have offered her more than 150 *groshos*, but
out of love for her he awarded her the princely sum of 650 *groshos*."[13]

Naturally, the happier the marriage, the more willing the woman
to make concessions, such as moving to another town (even if the
prenuptial agreement stipulated otherwise), or standing surety for her
husband.[14] Couples who loved and trusted one another usually drew
up property settlements in their lifetime. Since under Jewish law a
woman is not entitled to inherit her husband's estate,[15] technical
loopholes had to be found for getting round the law. In such cases,
the husband's potential heirs often felt cheated of their 'dues'. In-
deed, most of the information available to us comes from Responsa

[9] MS Jerusalen, *Zera' Anashim*, p. 31a-b.
[10] MS Jerusalem, Tzayyah, 536, pp. 266b-267a.
[11] See below, Chapter 10, "Marital Disputes."
[12] Gavizon, II, Appendix 6, 101 (p. 337).
[13] Maharitatz, 173. For other examples, see Mabit, II, 220; III, 176; Maharitatz, 233; Benayahu, *Ari*, p. 317.
[14] Pinto, *Yoreh De'ah*, 22; Gavizon, II, 47(53); Castro, *Ohalei Ya'aqov*, 109; Cohen, *Jerusalem*, p. 148; Cohen-Pikali, document 444, p. 386.
[15] See below, Chapter 15, "Regulations Concerning Women."

discussing attempts by aggrieved heirs to divest their father's widow of her inheritance. The most common loopholes resorted to were:

One. *Wills and testaments*: In his will, a husband may instruct the transfer of his property or part thereof to his wife. In one case, a dying man "bequeathed his entire estate to his wife, to do with it as she saw fit, on condition she never remarried but remained loyal to him.[16] In the event that she remarried, she would be entitled only to her *ketubah* plus 50 *sultanis* [gold coins] [...] He further stipulated that provided she did not remarry, no-one could sue her or submit any claims to her property."[17]

Two. *Gifts*: Since in Jewish law a husband may grant a gift to his wife, money or property could be transferred to her in the form of a gift, formalized by a legal deed. For example, Reuben, after first setting aside a minimal allowance for his heirs so as to avoid any halakhic problems, made over all his remaining property to his wife "to live in or rent out as she saw fit, without any third party having the right to appeal." The widow later sold the property to Simeon. When after her demise, Reuben's heirs challenged the validity of the sale and consequently Simeon's right to the property, the rabbis ruled that the sale was valid.[18]

In another case, the heirs claimed that their father had been of unsound mind when he made over his houses to his wife as a gift, in addition to her *ketubah*. They claimed that in the course of his last illness "he had become deranged," and even brought along physicians to confirm their allegation. R. Samuel Halevi, however, dismissed their claim, on the grounds that "The laws of nature or medicine are not our guiding principles [...] The witnesses [...] testified that he was of sound mind [...] when he gave the gift [...] Therefore, the gift he made out to his wife is valid, and she shall collect her *ketubah* from his remaining assets."[19]

[16] A woman who chose to remain a widow was thereby honoring her husband's memory. See Rashi, *Gittin*, 35a; 'When she chooses to remain a widow out of respect for her late husband.'

[17] Caro, *Avkat Rokhel*, 74. Similarly: Mabit, II, 89, 91; Beer, 75; Radbaz, III, 896, 920, 935; MS Jerusalem, Tzayyah, 536, pp. 266b-267a; Maharit, New Responsa, 11 (evidently this incident took place in Istanbul).

[18] Galante, Responsa, 15. According to *halakha*, a gift granted by a husband to his wife after marriage is hers and hers alone, and her husband cannot benefit from its usufruct. See responsa Rosh, rule 39, 3. On the subject of a minimal allowance for the legal heirs, see: J. Rivlin, "Wills."

[19] MS Jerusalem, *Zera' Anashim*, pp. 68a-73a. For another responsum by R. Samuel Halevi on a similar matter in which he also ruled in the widow's favor, see

Despite the above, if any legal or technical problem was found in the deed or will, the wife lost the case, even if it was absolutely clear that she was meant to be the beneficiary.

Three. *The Ketubah clause*: A husband could include a condition in the *ketubah* deed bequeathing all or part of his estate to his wife, over and above her regular *ketubah*. For example: "When Reuben and Leah got married, Leah provided a dowry of 300 gold coins, to which Reuben added another 150 gold coins, as is the custom, making a total of 450 gold coins. Reuben included the following condition in the *ketubah*: If, God forbid, he predeceased his wife, and she would have by then live offspring, his assets would be divided equally between his wife and offspring [...] provided she did not remarry [...] In the event that she remarried, she could claim her *ketubah* only."[20]

Another source of information on marital life can be found in the Responsa dealing with *niddah* (times when cohabitation is prohibited), as we shall see below.

Cohabitation and ritual immersion

One of the most serious offenses in the Torah is cohabitation with a menstruant woman (*niddah*): "And thou shalt not approach unto a woman to uncover her nakedness, as long as she is impure by her uncleanness." (Leviticus 18:19). This prohibition was stringently interpreted by the Sages to imply that not only was intercourse forbidden at such a time, but also any physical contact. To this end, several 'precautionary measures' were introduced. For example, the services a woman normally provides her husband must be performed indirectly (in an 'altered manner') when she is menstruating. Women are expected to strictly observe all the laws relating to *niddah* and ritual

ibid, pp. 392a-395a (also pp. 487a-490b). For further examples, see: MS Jerusalem, Tzayyah, 492, p. 213b; Maharitatz, 277; Pinto, 67; Caro, *Avkat Rokhel*, 74; Alshekh, 99. See also Caro, *Shulhan 'Arukh, Even ha-'Ezer, Ketubot*, 96, 4.

[20] Mabit, III, 144. See also, Caro, *Avkat Rokhel*, 91; Ashkenazi, 10; Maharit, I, 39; MS Jerusalem, Tzayyah, 465, p. 132b. As far as conditions which contravene Torah rulings are concerned, the rule is: "Conditions stipulating monetary matters are binding, those stipulating non-monetary matters are not" (*Tosefta, Kiddushin*, 3, 7-9).

purification, so as not to lead their husbands astray, under pain of *karet* (premature death). A woman who cohabits with her husband while she is *niddah* is transgressing a Mosaic law. Her husband must divorce her and she loses her entitlement to her *ketubah*. If she does not immerse in time, her husband may not cohabit with her.[21]

Ritual immersion is part of the day-to-day life of Jewish women, with direct implications on conjugal life. Thus, the Responsa literature on *niddah* constitutes a valuable and even unique source of information on intimacy and love between husband and wife.

Let us consider, for example, the following case, in which a couple approached the Radbaz with a problem concerning *niddah*. The couple, according to the Radbaz, were so deeply in love that divorce was not even a consideration. "For if he divorced her and remarried, he would constantly be thinking of his first wife, and if she remarried she would constantly be thinking of her first husband." Their problem was that the woman bled during intercourse, and the husband feared she may be forbidden to him. In this instance, the Radbaz himself personally advised the woman what to do.[22]

Another question addressed to the Radbaz also concerned *niddah*: "Reuben and his wife were living in hiding and had no-one to care for them. His wife subsequently became ill and began menstruating while she was ill. [The question was:] Could he look after her, even if this involved physical contact? Could he prop her up, help her lie down, and do whatever was required? If he were a physician, could he take her pulse? And if he were a bloodletter, could he let her blood? And did it make a difference if the woman's life was in danger?" In this instance too, the Radbaz inclined toward leniency. He ruled that since the couple were isolated and there was no one to attend to the sick woman, the husband could look after her himself.

[21] On the laws of ritual immersion, menstrual impurity, and ritual baths, see *Ketubot*, 72a; Rambam, *Marital Laws*, XXIV, 11; Caro, *Shulhan 'Arukh*, *Yoreh De'ah*, 183-201; *Even ha-'Ezer*, 20; In brief, a menstruant woman has to wait until the flow of menstrual blood ceases (usually about five days), cleanse herself and examine herself before dusk to make sure there is no flow of blood (*hefseq taharah*), and then count a further seven 'clean' days. On the night of the seventh day, she immerses herself in the *miqveh* after which she is permitted to have sexual relations with her husband. However, in cases of duress, such as when a woman is afraid to go out alone at night or when it is extremely cold, she may immerse herself the following day. See also Dinary, "Impurity"; idem, "Profanation".

[22] Radbaz, I, 410.

As to the fact that she was menstruating, this was an attenuating factor, since he was less likely to desire her while she was *niddah*.[23]

A number of Responsa favored leniency when a healthy sexual life was at stake. For example, when the Radbaz was asked if a husband could embrace and kiss his wife shortly before menstruation, he remonstrated: "I see no reason to be more strict than the early Sages. Would that the existing laws were properly observed! Stringency here would be detrimental rather than beneficial."[24]

Likewise, the sages of Palestine and Egypt were extremely flexible concerning the obligation of ritual immersion, especially during winter. In Cairo, Jerusalem and Hebron, women were allowed to enter the *hamamah* (Turkish baths) immediately after their immersion. The sages also sanctioned various techniques for heating the *miqveh*.[25]

Even if not explicitly stated, one of the reasons for leniency was no doubt the fact that women frequently took the law into their own hands, refusing to go to the *miqveh* when it was cold. This was so widespread that "the *mitzvah* of immersion at the right time was falling into disuse."[26] It was therefore clearly in the men's best interests to ensure that the process of immersion was as comfortable as could be. Men may even have formed a pressure group to demand more

[23] Ibid, IV, 1076. The reason for their being in hiding is not specified.

[24] Ibid, I, 163. See also ibid, 149; Radbaz, New Responsa, 136, 138; Alashqar, 91.

[25] Radbaz, IV, 166; Garmizan, 66, 67 (on the ritual bath's location within the public bathhouse, see also Caro, *Avkat Rokhel*, 58-60); Arha, 18 (This responsum contains a detailed technical description of a special device for heating the ritual bath of Hebron. Pinto (*Yoreh De'ah*, 17), discusses the same invention. For a comparison of the texts and further details, see editor's notes to Arha, 18, in particular note 1. See also Benayahu, *Beauty*, pp. 31-32. Benayahu brings another responsum on the same subject, by R. Jacob Falcon of Safed). See also Maharitatz, New Responsa, I, 5; Pinto, 17. In Jerusalem, the case of a Karaite woman who was raped upon leaving the bathhouse was brought before the qadi (Cohen, *Jerusalem*, p. 141; Cohen-Pikali, document 179, p. 172).

[26] Arha, 18. The possibility was discussed of women becoming infertile through immersing in cold water. R. Samuel Garmizan wrote: "As heaven and earth are my witness, I swear that I have heard that many women ceased *bearing* children [*leiled*], after immersing in cold water" (Responsa Garmizan, 67). Perhaps he was alluding to the ruling of R. Benjamin ben Mattathias, who permitted the *miqveh* to be heated through the addition of hot water, citing among his reasons that "strictures of this kind prevented women from fulfilling the commandment of procreation" (*Binyamin Zeev*, 158). However, there may have been a printing error in the Hebrew text, in which case the above text would read: "I swear [...] that many women ceased *going* [*leilech*] [to the *miqveh*]." On R. Benjamin's ruling and its implications, see Benayahu, *Beauty*, pp. 26-30.

flexibility from the rabbis, so that their conjugal lives could continue uninterrupted.

Women laid down the law in other ways too. The women of Cairo for example, immersed themselves in al-Khalidj, Cairo's ancient canal that filled up only when the Nile overflowed, and was therefore halakhically unacceptable (a river has to flow all year round to qualify as a *miqveh*). A fierce polemic arose over this issue between the Radbaz, who denounced this practice, and the local rabbis who argued against abolishing a custom that had been observed in their town for so many generations.[27]

Below is yet another example of how women took the law into their own hands. In a certain town (probably Damascus), immersion was forbidden on the Sabbath and festivals, so that cohabitation had sometimes to be postponed for a day or two. Certain women refused to wait, but immersed themselves before nightfall on the preceding day. The local rabbis condemned this practice. "In their haste to find a remedy, they have transgressed." It transpired, however, that these women were familiar with immersion rituals in other towns: "They know of other places where women are permitted to immerse on the Sabbath and it is not considered a sin." Since they were not allowed to immerse on the Sabbath as they wished, they took the law into their own hands and immersed a day earlier.[28]

The women of Damascus were even more independent. They went to the *miqveh* (usually situated in bathhouses owned by gentiles) by day, as a matter of course. When R. Joseph Ibn Tzayyah and R. Moses Barukh realized what was going on, they had a lock installed on the *miqveh* door. The key was handed over for safekeeping to a few trustworthy women, who were responsible for ensuring no-one entered the *miqveh* before sundown. Undaunted, some women broke the lock to the door and continued immersing themselves by day.[29] This was a landmark case, an example of how a group of women united

[27] Radbaz, New Responsa, 139, 140, 141 (in which he specifies the immersion customs of women in different places in Egypt, such as Damietta, Rashid, and Bab al Bahr). The dispute was brought before the sages of Jerusalem too, and the manuscript of the Responsa of Ibn Tzayyah brings a responsum on this subject (no. 488, pp. 201b-206b; an excerpt of which is quoted by Assaf in "Manuscripts," p. 496, where the word '*khalidj*' mistakenly appears as '*balidj*'.)

[28] MS Jerusalem, Tzayyah, 484, p. 187a.

[29] Caro, *Avkat Rokhel*, 58 (question put by R. Joseph ibn Tzayyah); 59 (ruling of R. Moses Barukh); 60 (responsum of R. Joseph Caro, who sanctions the *miqveh*).

by a common cause formed into a 'pressure group' and even dared
defy the local rabbis.

At the other end of the scale were women who were scrupulous in
their observance of every single law relating to ritual immersion. In
Jerusalem, for example, a group of Ashkenazic women sparked off a
halakhic controversy in connection with the heating of the *miqveh*.[30]
And in Aleppo, some newly-arrived Spanish women questioned the
halakhic validity of the *miqveh*, much to the chagrin of the Musta'rab
community, which had always used that *miqveh* without any prob-
lem.[31] A similar dispute broke out in Hamat [Homs in Syria]. In this
case, R. Joseph Ibn Tzayyah sanctioned the local *miqveh*, while
R. Joseph Caro invalidated it.[32] Another debate concerned a woman
who washed her hair on the Sabbath eve but did not immerse herself
ritually, because she believed it was forbidden.[33]

As stated, not all women were scrupulous in their immersion prac-
tices, particularly in Egypt. So much so, that already in the time of
the Rambam a *takkanah* was introduced to the effect that no woman
would be paid her *ketubah* and increment until she had sworn that she
had performed the laws of ritual immersion in a halakhically accept-
able *miqveh*.[34] Later on, a condition was even introduced in the *ketubot*
of Egypt stating "that if she sees even a drop of menstrual flow as
small as a mustard seed, she must wait seven clear days and then
immerse herself, [...] failing which she shall forfeit her *ketubah*."[35]
This precautionary measure did not always work, and sometimes
husbands themselves turned a blind eye to their wife's peccadilloes,

[30] Garmizan, 66; see also Arha, 18, note 2, and also there, p. 87.

[31] Caro, *Avkat Rokhel*, 52-53.

[32] Ibid, 54-55. At the end of his responsum concerning the *miqveh* in Damascus
(ibid, 60), Caro also alludes to the difference of opinion between himself and R.
Joseph Ibn Tzayyah: "Would that the latter, who dispute [the validity of the Damas-
cus *miqveh*], dispute the validity of the Hamat *miqveh*."

[33] MS Jerusalem, Tzayyah, 549, pp. 276a-277a. R. Joseph Caro states: "If her
husband is in town, she must immerse on time, so as not to forego the command-
ment of procreation even for one night" (*Shulhan 'Arukh, Yoreh De'ah*, 197). R. Moses
Isserles (Rama), in his annotations, adds: "She may immerse on the night of the
Sabbath if she was unable to immerse before then, but only if her husband is in
town. Otherwise, it is forbidden."

[34] Rambam, Responsa, II, 242 (the regulation dates back to the year 1167). See
also ibid, 369-370. The women of Egypt tended to follow the custom of the Karaite
women who washed themselves in water only. See: "Letters of R. Obadiah
Bertinoro," in Yaari, *Letters*, p. 120; Friedman, *Polygyny*, pp. 41-42; Ashtor, II, p. 343.

[35] Assaf, "Contribution," p. 123; Ashtor, III, p. 34; Friedman, *Polygyny*, pp. 102-
103.

remembering the *takkanah* only when it was to their own advantage (for example, when they wished to divorce their wives without paying their *ketubah*).[36]

We see, therefore, how women showed an unusual degree of independent thought and initiative in matters relating to ritual immersion. They were their own 'supervisors' and frequently used their own discretion to tighten or relax the rules in this very private and intimate matter. We see how some decisors were remarkably understanding of the couple's needs, and were extremely lenient in matters of immersion, out of consideration for the woman. Presumably they were motivated also by consideration of the man, since any deferment or failure to immerse on the part of women precluded cohabitation. In practice, therefore, the rabbis' solicitude was aimed at men just as much as, if not more than, at women.

[36] Radbaz, I, 90 (=Rambam, Responsa, II, 368). On the husband's frivolous attitude, see also the end of the aforementioned *takkanah* by the Rambam.

MOTHERHOOD

Conception

The institution of marriage is an expression of the survival instinct – on both a micro and macro level. On the macro level, it expresses the wish for the continuity of the nation or indeed mankind as a whole. On the micro level, it is an expression of the wish to continue the family line, to keep property within the family, to be looked after in old age, and of course, the need to love and be loved.

Judaism has turned this natural, existential need into a religious precept: "Be fruitful, and multiply, and replenish the earth" (Genesis 1:28). Although the Torah commandment [*mitzva*] "Be fruitful and multiply" is in the plural form, the sages explain that it is binding on men only. Therefore, men are commanded to marry in order to be fruitful and multiply.[1] The marriage laws, as well as the laws of inheritance, are an indication of how much value Jewish society attaches to procreation. A husband is allowed to divorce a barren wife, or marry a second wife. If a woman dies childless, 'sanctions' are adopted against the husband, and he loses some of his inheritance rights. The quality and viability of the marriage bond, therefore, depended largely on the woman's fertility. Naturally, women were eager to prove themselves in this respect as soon as possible.

Almost until the end of the 19th century, childbirth was often dangerous and there was a high rate of infant and child mortality due to epidemics and poor living and sanitary conditions. Therefore, bless-

[1] Caro, *Shulhan Arukh, Even ha-'Ezer*, I, 1. On the national importance of begetting children in Jewish law during the biblical period, see Biale, pp. 22-24. According to the Hillel school, the commandment is fulfilled through the birth of a boy and a girl. According to the Shammai school, however, the commandment is fulfilled through the birth of two sons (Mishnah, *Yevamot* VI, 6). In *halakha*, the Hillel school prevailed. The Rambam ruled likewise in *Marital Laws*, XV, 4. The *posekim* disagreed on this issue (see Finkelstein, p. 94). On the importance of procreation in Christian and Islamic societies, see the many cross-references in Stahl, *Family*, p. 222, notes 3-4; p. 268, notes 4-6.

ings and special prayers for a safe pregnancy and delivery were an integral part of life.

During the 16th century, the yearning for progeny was particularly intense among the Iberian exiles. The personal and collective existential crises they had suffered both during the Inquisition and after the Expulsion – the loss of children and relatives, constant migrations and innumerable plagues – led the refugees to pin their hopes of regeneration and revitalization on their offspring.[2]

The desire for healthy sons in order to continue the family line is a constant leitmotif in the writings and sermons of the rabbis who lived through and after the Spanish Expulsion, especialy of those who have lost children.

The twin scourges of mortality and bereavement, an integral part of the sanitary conditions of the times, were perceived by the Iberian refugees as an extension of the terrible afflictions they had suffered so far, and as being directed specifically against them. Many remarried, or married for a third time, in a bid to set up a new family. Indeed, R. Moses Galante encouraged this trend, as witnessed by his explanation of the verse: "In the morning sow thy seed, And in the evening withhold not thy hand" (Ecclesiastes 11:6):

> Even if your sons die when you are young, do not say I shall refrain from having children lest they too die. Beware of procrastinating! With-

[2] Hacker, "Pride." Note that Hacker's article is one further refutation of the doctrine of P. Aries et al., who claimed, inter alia, that due to the high infant fatality and mortality rates in the early and late Middle Ages, parents did not establish close ties with their children until they were older. According to this theory, a psychological self-defense mechanism prevented them from 'loving' their children, thereby shielding the parents from the terrible pain of subsequent loss. Elisabeth Badinter reaches a different conclusion. She argues that "it was not because the children died like flies that their mothers showed no interest in them. On the contrary, it was because their mothers showed no interest in them that so many children died" (Badinter, pp. 59-60). The theories of Aries et al. have been refuted long since. Although this is not the place to go into the subject, it is worth emphasizing that the sources brought by Hacker, as well as other Jewish sources from the Responsa literature and from contemporaneous personal correspondence, further refute the claim that parental love is a recent 'development.' Parents in all strata of Jewish society showed a high degree of concern for their children's safety, education and future. Despite the high mortality rate, their grief at the passing of a child was manifest. The claim that they became dulled to grief is simply untenable. Basically, parental love for children is a universal and cross-cultural phenomenon. See Badinter, pp. 59-60; Aries, pp. 38-40; Stone, pp. 68-70, 105-107, 113-114, 116-117, *passim*; Pollock, pp. 28-29, 140-141, 204, 260-261, *passim*; Shahar, *Childhood*, pp. 164-170, 207-209, *passim*; Stahl, *Family*, p. 360 ff.

> hold not thy hand! Learn from Boaz. Of his thirty sons only one sur-
> vived. Yet it was he who built up the House of Israel in his old age.[3]

The knowledge that a childless marriage was incomplete no doubt
added to the tensions of early married life. Women who failed to
conceive consulted Jewish and gentile midwives for 'remedies.'[4] If
these 'remedies' did not work, they pinned their hopes on amulets,
spells, and charms. Visiting the tombs of saints was also a common
practice. Queen Esther's tomb near the Galilee village of Bar'am was
a particularly popular pilgrimage site for childless women, or preg-
nant women desirous of a safe and easy delivery.[5]

The book "*Refuah ve-Hayyim mi-Yerushalayim*" – a motley collection
of remedies, amulets, and charms, some of which date back to the
16th century – contains several 'prescriptions' for barren women:

> This tried and proven remedy has its roots in an ancient source, and
> even helps women who have been barren for many years: Grind to-
> gether an eighth of an ounce of pepper and an eighth of an ounce of
> elephant bone, an eighth of an ounce of bdellium, and an eighth of an
> ounce of honey. The woman should consume this mixture with one
> finger on the night of her immersion and shall not fail to conceive.

Or:

> This [remedy] was handed down by the Ari, may he rest in peace: After
> the husband has walked around the synagogue seven times on Hoshana
> Rabba holding five kosher willow branches, he should remove the
> leaves of the willow branches, using the bare twigs as spits to roast five
> pieces of meat. He shall consume two pieces, she another two, and both
> shall share the fifth piece. This will help the woman conceive.[6]

The Ari also recommends reciting Psalm 23 prior to cohabitation, as
an aid to conception.[7]

The manuscript "*Shoshan Yesod ha-'Olam*" contains a number of
remedies for barrenness, two of which are brought below:

[3] Galante, *Kohelet*, 97b (on Boaz and Ivtzan being the same person, see *Bava Batra*,
91a; Rashi on Judges 12, 8).

[4] Alashqar, 89; Radbaz, IV, 1188; Ashkenazi, 15.

[5] Bentov, p. 222. On visiting holy tombs as a means of becoming pregnant, or
bearing a male child, see Vilnay, *Holy Tombs*, p. 31. On Esther's tomb in Bar'am, see
ibid, pp. 436-438. On visiting the tomb of the prophet Samuel as a remedy for
infertility, see "Letters of R. Obadiah of Bertinoro," in Yaari, *Letters*, p. 139. Cf:
Stahl, *Family*, pp. 280-283.

[6] *Refuah ve-Hayyim*, pp. 22, 24. See also ibid, pp. 8, 14, and many more, apparently
later, remedies.

[7] Benayahu, "Yonah," p. 16.

These names and seals should be written down and placed round the neck of the woman. Although they are proven remedies, you can test them by hanging them round the neck of a hen who is not laying, and it will begin laying.

These names should be written down and placed round the woman's neck without the husband's knowledge [...] If it is ordained for her to have children, she will have a child before the year is up. To see if this remedy works, hang the names on a barren tree, and it will bear fruit within the year.[8]

According to the Medieval theory of humors, men were associated with heat, and women with cold.[9] This theory was also invoked to explain various gynecological phenomena, such as the gender of the fetus. Since women not only wished to become pregnant but were especially anxious to bear a son, the gender of the fetus was of particular importance, as the following passage by the preacher R. Samuel Ibn Sid testifies:

The woman's womb becomes moist from the menstrual blood three days before the beginning of menstruation, and becomes increasingly moist as menstruation approaches. The menstrual blood at the beginning of the cycle is not the same as the menstrual blood at the end of the cycle [...] Therefore, when the seed is male, that is, from a warmer source – the womb must be exceedingly moist, else the seed will burn up and be destroyed. If the womb is moist, the seed will take root, and bear fruit. However, if the seed is female, and therefore from a cooler source, it is sufficient if the womb is moist even for only one hour.[10]

Pregnancy

The 16th-century sources do not contain much information about pregnancy, or the attitude towards pregnant women. This may be because they did not consider pregnancy anything out of the ordinary. Rather they considered it a natural state, and women were expected to function normally despite it. Pregnancy was not consid-

[8] MS London, *Shoshan Yesod ha-'Olam*, 581, p. 263; ibid, 1841, p. 526. See also ibid, 311, p. 138; 490, p. 215; 548, p. 243; 750, p. 284; 1052, p. 400; 1555-1556 (which are listed in the index only and do not appear in the text); 2172, p. 580. Cf. MS London BM, Or. 10162, pp. 29-30. Cf. Stahl, *Family*, p. 282, note 12. On the manuscript *Shoshan Yesod ha-'Olam*, see above, Chapter 4 (Married Life), note 4.

[9] See Barkai, *Science*, pp. 37-55; ibid, "Traditions".

[10] MS Jerusalem, Samuel Ibn Sid, p. 119b. On the yearning for a son, see Stahl, *Family*, p. 331 ff.

ered a reason for interrupting normal conjugal life. The Ari, for example, advised R. Hayyim Vital to continue cohabiting with his wife both while she was pregnant and while she was nursing.[11] Nevertheless, the rabbis did recognize that pregnant women were prone to bleeding, that many pregnant women felt unwell during the first trimester, and that they had to be extra careful during this period not to miscarry.[12]

Popular medicine barely related to pregnancy per se. Spells and remedies, however, did exist for preventing miscarriages. Miscarriages, especially repeated miscarriages, were the pregnant woman's worst fear.

The manuscript *"Shoshan Yesod ha-'Olam"* lists a number of remedies to prevent miscarriages, including the following:

> If you want to prevent a miscarriage, draw a picture of the woman and inside that, draw the picture of a boy. Turn over the drawing and write down sacred names. Use virgin wax. Give it to the woman to wear. She should wear it with the names facing outwards, and take care not to erase the names. As long as she wears the amulet, she has nothing to fear.[13]

Even the Ari, who was opposed to the practice of *kabbalah,* had a special remedy against miscarriages, as R. Hayyim Vital describes:

> The following is a remedy given to me by my mentor [the Ari] to prevent miscarriage: Each night before the husband goes to sleep he should recite the whole of Psalm 20, "The Lord answer thee in the day of trouble," and then repeat the initial verse: "The Lord answer thee in the day of trouble" with the appropriate *kavvanot* [devotional practices] as described below. This will help, as I know from my own experience.[14]

[11] Benayahu, *Ari*, p. 190 (and variations on p. 311). Among the Muslims, on the other hand, a man was not allowed to touch a pregnant woman. This, according to Meshullam of Volterra, accounts for the prevalence of polygamy among Muslims ("Travels of Meshullam of Volterra," in Yaari, *Travels,* pp. 46, 76).

[12] Radbaz, New Responsa, 63; Radbaz, I, 321; III, 865; Mabit, I, 98; II, 166; MS London, Garçon, *Sermon for Parshat Emor,* Damascus (?) (1513), p. 122b. (Cf. *Sanhedrin,* 70b; *Niddah,* 31a, sexual intercourse is recommended in the last three months of pregnancy, "since it quickens and perfects the fetus"); Turniansky, letter 3, p. 189.

[13] MS London, *Shoshan Yesod ha-'Olam,* 707-708, continuation of Thirteenth Virtue, pp. 278-279. Ibid, 305 (p. 137), 599 (listed in the index according to MS Gaster 177, but missing from the text), 657, 664 (p. 268), 757 (p. 287), 911 (p. 339), 1218 (p. 465), 1554 (appears in the index but not in the text).

[14] Vital, *She'arim, Sha'ar Ruakh ha-Qodesh, yihud* 8 (p. 93); ibid, *tikkun* 3-4 (pp. 41-42); Benayahu, *Ari,* pp. 290-291.

The contemporary *posekim*, like the earlier ones, forbade abortion unless there was real danger to the mother's life. When the mother's life was in danger, her life took precedence over that of the fetus.[15] Aborting a fetus was not considered murder, but damage to the husband's property.[16]

Childbirth

The Bible explains the pain of childbirth as a collective punishment imposed on the daughters of Eve following Adam's sin. A 16th-century sermon on the weekly portion of Genesis explains:

> Before this curse, pregnancy and birth were easy and painless. But when Eve tried to rule her husband by persuading him to eat of the tree, she was cursed that he should rule over her, as it says: 'and thy desire shall be to thy husband' [Genesis 3:16]. She was also cursed that she would lose her physical strength, as it says: 'in pain thou shalt bring forth children,' which had not been the case hitherto.[17]

Since, in the 16th century, childbirth was still life-threatening, most pregnant women and their relatives became increasingly anxious as the date of delivery approached. Death in childbirth was not uncommon, and any woman about to give birth – whether Jew or gentile – knew that her life was in danger.[18] Primipara were particularly susceptible.[19]

On the high rate of mortality due to childbirth, the Radbaz states:

> In Egypt, every day a woman dies in childbirth, and the midwives have gotten into the habit of beating the woman's stomach with a platter in order to hasten the death of the fetus [...] We have repeatedly implored them [the midwives] to open up the wombs of the expiring mothers and

[15] Mishnah, *Ohalot*, VII, 6: "If a woman is having trouble giving birth, the fetus is cut up in her womb and removed limb by limb, since her life takes precedence. If, however, most of the fetus has emerged, it must not be harmed, since it is forbidden to kill one person to save another." See: Maharit, I, 99.

[16] This issue is discussed at length by Sinclair, who brings cross-references to *halakha*, *midrashim*, and early and later decisors. See Radbaz, New Responsa, 22.

[17] MS London, Garçon, *Sermon for Parshat Bereshit*, Damascus (1508), p. 60a.

[18] See Shahar, *Childhood*, esp. pp. 63-65. See also supplication for a pregnant woman, sent from Jerusalem to the Diaspora, Yaari, "Women," p. 152.

[19] Maharit, I, 98. MS Cambridge, TS Or. 1080.11, p. 22; MS Oxford, Hayyim Hevraya, p. 26 ff.

remove the fetus [...] We have even sent along rabbinical emissaries to try and halt this practice.[20]

The following extraordinary attempt to save the life of a woman in labor is attributed to the Holy Ari:

> There was once a woman who found it difficult to give birth and whose life was in danger. Her relatives came to the house of The Rabbi [the Ari], in the hope that he could produce a *tikkun* [remedy] and deliver her from this fate. The Rabbi answered: It is true that she is in danger, and she has two children in her womb. But there is a remedy, if it can be found. They said to him: O Master, apprise us. He said: The remedy is: If a man who has never wasted a drop of semen in his life comes forth and places his 'circumcised member' in her mouth, she shall give birth forthwith and her life shall be saved. They said to him: Who is this man and we shall seek him out. He said to them: I cannot name the man, for by so doing I would be disparaging others. However, you may do the following: Put up notices around the city requesting that he who has never wasted a drop of semen in his life come forth and save the life of three Jewish souls. This they did. And when the Gaon R. Moses Galante the elder heard, he immediately rose and went with them, and placed his 'circumcised member' in her mouth, and she gave birth forthwith.[21]

This case is extraordinary not only because of the unconventional method used, but also because the Ari usually opposed the use of amulets and spells to facilitate childbirth, on the grounds that such remedies usually led to premature births, which in turn led to "early death, or poverty."[22]

Despite the Ari's disapproval, childbirth was so fraught with anxiety, women could not have managed without remedies of this type. A traveler who visited Palestine at the end of the 14th century relates that women used to gather stones from Rachel's Tomb as a charm for an easy delivery.[23] The traveler Arnold von Harff, who lived in the Levant from 1496-1499, mentions a cave near Bethlehem where the virgin Mary had supposedly hidden Jesus when Herod ordered the execution of the innocent babes. Pregnant women desirous of a quick and easy birth, would gather a spoonful of sand from the floor of the cave, mix it with a little wine or water, and drink the mixture. According to von Harff, both Muslim and Jewish women believed implicitly in this

[20] Radbaz, II, 695.
[21] Benayahu, *Ari*, pp. 224-225.
[22] Vital, *She'arim, Sha'ar Ruakh ha-Qodesh, tikkun* 4 (p. 42).
[23] The traveler is Bernard von Breidenbach. See: Vilnay, *Ariel*, "Rachel's Tomb," p. 6450; idem, *Holy Tombs*, p. 153; Weiss, p. 14.

remedy.[24] This custom shows how Christian, Muslim, and Jewish traditions converged when their lives were in danger. The fear of childbirth was a fear shared by all women, irrespective of religion.

Another example of how shared womanhood transcended religious differences can be found in a question addressed to R. Joseph Ibn Tzayyah: Was it permissible for women to wear 'a girdle against the Evil Eye' on the Sabbath? The girdle referred to here was probably the 'birth girdle' – an ancient panacea for painless childbirth, used in Christian society since the Middle Ages, which may have been imported to the Middle East by women of European, particularly Spanish, extraction.[25]

Amulets, charms, the use of sacred names, and verses designed to ease the pain of childbirth are described in "*Shoshan Yesod ha-'Olam*." Below are two examples:

> Write down these sacred names, sew them on into a new piece of cloth, and tie the cloth round the woman's navel, and she will give birth forthwith. Be sure to remove the cloth immediately after delivery.

> Take a piece of *afikoman* [matzo eaten at the conclusion of the Passover meal], soak it in water and place in the woman's mouth, taking care that she does not swallow it, and she shall give birth immediately. And as she delivers, you shall remove the *afikoman* from her mouth, lest her insides spill out.[26]

Note that of 112 amulets for women described in this manuscript, 21 were for an easy delivery, 11 were to prevent miscarriages, and 11 were for the birth of a healthy child. That is to say, about 40% of all the amulets were linked to pregnancy and birth.

Female relatives were present at the delivery and together with the midwife did everything to ease the woman's condition, as we see from this rare description of a delivery included in a question addressed to R. Yom Tov Zahalon:

[24] Harff, p. 189. Cf: Stahl, *Family*, p. 321, note 6.

[25] MS Jerusalem, Tzayyah, 344, pp. 23b-24a; Shahar, *Childhood*, p. 64.

[26] MS London, *Shoshan Yesod ha-'Olam*, 268 (p. 126), 586 (p. 264). Ibid, 505 (p. 222), 651 (p. 267), 779 (p. 292), 1691 (p. 491), 1730 (p. 499); Nos. 318, 322, 879, 941, 1533, 1616 appear only in the index and not in the manuscript itself. Further examples can be found in the continuation of MS *Shoshan Yesod ha-'Olam*, in a separate anthology of remedies and charms from the early 17th century (see Benayahu, *Shoshan*, p. 194), 1, 2 (p. 613), 21 (p. 616), 100-101 (p. 625). Remedies of this kind can also be found in the book *Refuah ve-Hayyim mi-Yerushalayim*, some of which the author claims to have found in 'manuscript form.' These apparently are the oldest in the collection (see for example *Refuah ve-Hayyim*, pp. 11b-12a ff.).

> May our Rabbi teach us the law concerning those who take the name of God in vain [...] especially women sitting on the birthing stool[27] who frequently utter the name of God. Should one try and stop them? If you argue that the women are in extreme pain and are therefore not responsible for what they say, what about family and friends who are there to give her support? Who will grant them permission to take the name of God in vain? Especially the midwife whose hands are soaked in blood and who is impure, who exclaims before each contraction: Oh my God, my God.

R. Zahalon's responsum, a paradigm of empathy and concern, provides us with a graphic description of women in labor, surrounded by their relatives and friends:

> It is clear that there is no cause to stop the woman, or family and friends, for she is praying for herself, and calls on God with passion, and her passion inspires the other women to pray on her behalf [...] And their words and prayers in turn calm her [...] For the family and friends who stand at her right-hand give her courage. All the more so their prayer [...] This being so, how can we forbid them to call on God in this impassioned way? [...] Especially the midwife, who more than any other inspires trust and confidence by her mere presence.[28]

This description not only reflects women's apprehensions and fears, but also the strength and encouragement they were able to give one another.

After a normal delivery, everyone breathed a sigh of relief. The birth of a son was a cause for celebration. A festive meal was arranged, and the mother was showered with gifts. The circumcision ceremony included certain interesting customs, such as protecting the new-born child from demons. Families who had lost children in the past used various charms and amulets to avert the Evil Eye.[29]

Childbirth also improved a woman's status, inasmuch as it proved that she was able to fulfill her family's expectations. On the other

[27] A special stool on which the woman sits when giving birth. See: *Erekhin* 7a; *Shabbat*, 129a.

[28] Maharitatz, New Responsa, I, 92.

[29] Mabit, I, 299; Radbaz, III, 921; Vital, *Sefer ha-Hezyonot*, 6, p. 49; "Travels of R. Moses Porayit," in Yaari, *Travels*, pp. 296-297; Benayahu, "Letter," p. 237; Rozen, *Community*, pp. 244-245; Gelis, *Customs*, Laws of Circumcision, 7, p. 283 ff. A detailed description of the circumcision ceremony of the Ari himself can be found in Sambari, p. 100 (pp. 195-196 in photocopied edition). On the Sefardi custom of 'selling' children to ward off the evil eye, or of changing the child's name, see Maharitatz, New Responsa, I, 81; Grünwald, p. 226. For a remedy for a woman whose children have died, see MS London, *Shoshan Yesod ha-'Olam*, 429, p. 185. For comparison and further references, see Stahl, *Family*, p. 345.

hand, motherhood was not necessarily the passport to self-confidence or autonomy. On the contrary, when the young couple lived within the extended family, the mother-in-law often continued to be the dominant presence in the house. Sometimes it took years for the young wife to become a woman in her own right, with sufficient confidence to stand up to her husband and in-laws.

Most Jewish women nursed their children themselves. The same potion used by women to hasten and alleviate childbirth, as described by the traveler von Harff, was used by women who had difficulty nursing. If this failed, the neighbors would help out by nursing the baby in turns.[30] Rich people hired wet nurses, perhaps in imitation of European social norms.[31]

Women normally nursed their babies for two years. Out of concern for the child's wellbeing (lest the mother became pregnant and weaned the child prematurely thereby endangering its life), the sages allowed the use of contraceptives by women during this period (*coitus interruptus* was also sanctioned during this period). Once the child was born, its wellbeing took precedence over the mother's wishes or convenience. *Halakha* stipulated that a mother had to nurse her child, if the child refused to nurse from another woman, even if she was divorced, in which case the father had to pay her for nursing his son.[32] In a case brought before the Radbaz, Simhah, the divorced wife of Shalom Cohen of Gaza, agreed to continue nursing her son after being promised a weekly sum in addition to her maintenance, until he was weaned.[33] It was rare for a mother to refuse to nurse her children. In one such case a woman is described as a *'moredet'* whose husband refused to give her a *get*. She refused to nurse her son and abandoned him to the mercy of the community, much to the Radbaz's dismay: "This betokens an unbelievable degree of cruelty. Indeed, I wonder if she is not a *Gibeonite* [gentile], since the children of Abraham, Isaac and Jacob are exceedingly merciful."[34]

A nursing widow or divorcee could not remarry until at least 24

[30] The index to MS *Shoshan Yesod ha-'Olam* lists a remedy for a woman who has "no milk in her breasts," but the full version is missing in the manuscript itself (Benayahu, *Shoshan*, 887, p. 244); Mabit, II, 166; Maharit, I, 134.

[31] Radbaz, IV, 1103 (=1021), and ibid, 1157; Badinter, pp. 65-69, ff; Shahar, *Childhood*, pp. 95-119; Stone, pp. 106-107.

[32] *Yevamot*, 34b; 42b; *Ketubot*, 59b.

[33] Radbaz, I, 360; VII, 15; Castro, *Ohalei Ya'aqov*, 120.

[34] Radbaz, VII, 16.

months had elapsed from the onset of nursing.[35] This was certainly
not convenient for women, especially since it sometimes took longer
for a child to be weaned.[36] Widows or divorcees for whom a suitable
match had been proposed, sometimes tried to circumvent this law, as
the following story illustrates:

A woman gave birth four months after her husband's death. Dur-
ing delivery, her relatives made 'a sound like a brass fountain' to
drown out the sound of the baby's crying as it emerged, and thereby
prevent her from bonding emotionally with the child. They even
hastened to hire a wet-nurse, so that the woman would not have to
nurse him and would not be in the category of a 'nursing mother'
who had to wait two whole years.[37] Indeed, R. Meir Gavizon and
another, unspecified, rabbi found a way of permitting her to remarry
quickly. One wonders why there was a need for such haste. Was the
woman herself in a hurry to remarry, or was the family anxious for
her to remarry for economic reasons? Unfortunately, our source pro-
vides no answer to these questions. One can merely surmise, by
reading between the lines, that family considerations of this kind had
their part to play. In any case, it was very common for widows and
divorcees to marry for a second or even third time soon after they
were divorced or widowed.

Child-rearing

Despite the view that prior to the 17th century, childhood as we know
it, with a close parent-child relationship, did not exist,[38] Judaism saw
childhood as a distinct stage in human development. Children were
not perceived merely as 'little adults' but rather as distinct beings, to
be reared in accordance with their specific needs, characters and
abilities, in the spirit of the verse "Train up a child in the way he
should go" (Proverbs 22:6). Although early marriage in Jewish society
cut childhood short (at the onset of sexual maturity), at least for the

[35] Caro, *Shulhan Arukh, Even ha-'Ezer*, 13, 11.

[36] See for example: Radbaz, I, 349; Mabit, II, end of 209; Caro, Responsa *Beit
Yosef*, 19 (=Laws of *Ketubot*, continuation of 1).

[37] Gavizon, I, 33.

[38] Aries. For a survey of Aries, his precursors, and his followers, see: Pollock, esp.
pp. 1-32. See also note 2 above.

first few years children were the object of loving care and attention, and their special needs were taken into account.[39]

Rachel, the grandmother whom we mentioned above, showed a special understanding of the younger generation in the following advice she sent to her son: "You'll achieve more by using kind words than by being strict," and "If you're kind to Arele [the 'less successful' child] he'll respond. If you give him a present, you'll have won his affection."[40]

Until the age of six, both boys and girls were cared for mainly by the mother. At the age of six, the father became the dominant figure in the son's education, so as to prevent the son from being overexposed to female company. The *posekim* unanimously agreed that it was unhealthy for a boy to grow up in female company. When a Gaza resident vowed not to cohabit with his first wife, after taking a second wife in Cairo, the sages asked R. Jacob Castro to join them in annulling the vow, since the children of his first wife "might go astray without their father's supervision."[41]

The same approach is reflected in a sermon delivered by R. Joseph Garçon, probably in Damascus in 1513 or 1514, on the verse: "Hear, my son, the instruction of thy father, And forsake not the teaching of thy mother" (Proverbs 1:8):

> '*Hear* my son the chastisement of thy father' – for the father will always instruct his son in the right way even if he [the father] is the most wicked person in the world [...] 'And *forsake not* the counsel of thy mother' – this is formulated as a negative commandment, since a woman does not have the wisdom to chastise her son. But she may offer good counsel from time to time. When this happens, the son is commanded not to spurn his mother's good counsel.[42]

We see how women as a rule were considered incapable of providing a proper education for their sons, and that women who offered good

[39] See, for example, Radbaz, III, 851; VII, 15. Since my thesis is on women, not children, I cannot go into this subject. There are references in the sources to girls' games. See reference to a child-bride who lost her jewelry while playing (Galante, Responsa, 14); also references to girls who lost their virginity while jumping or climbing (MS Jerusalem, *Sefer Tikkun Soferim*, 42-43, pp. 55b-56b).

[40] Turniansky, letter 2, p. 187; letter 4, p. 197.

[41] Castro, *Ohalei Ya'aqov*, 106.

[42] MS London, Garçon, p. 119b. Amnon Cohen also reached the conclusion, based on documents from the Jerusalem Shari'a Court, that the child's education was entirely the father's prerogative (Cohen, *Jerusalem*, p. 147).

counsel were considered the exception rather than the rule. Their main contribution to their sons' education was to ensure they were not late for school or *bet hamidrash*.[43] Their main educational function was to serve as a role model for their daughters by instructing them in their "womanly tasks and in the art of modesty."[44]

There is very little information in the sources about the mother-child relationship. Most of our knowledge comes from cases revolving around the death of a parent, such as moribund women imploring relatives to take care of their children. Widows or divorcees who wished to remarry usually stipulated that their future husbands must provide for their children's basic needs, care for them in a manner 'befitting an infant' and marry them off when the time was ripe.[45] Many women put aside every spare penny in order to provide their children with a decent education or dowry. The sources also inform us of how mothers cared for their sick children, especially during plagues.[46]

Divorcees or widows usually wished to retain custody of their young children. This was not always so easy, however. Relatives frequently placed obstacles in their path, or sought pretexts to remove their children from their custody, as indicated by the rabbinical court records. Although many relatives may have been motivated by concern for the child's wellbeing, many were simply anxious to get rid of the mother, who, as a 'foreign implant' was no longer welcome.

According to *halakha*, the mother has automatic custody of boys until age six, and of girls irrespective of their age. In the case of a widow, the boy is not placed in the custody of potential heirs, out of concern for his safety.[47] In the case of a divorcee, "a boy is not

[43] See the sermon of R. Samuel Jaffe Ashkenazi, MS Amsterdam, Rosenthaliana, p. 338. See also Chapter 1, "Women through the Eyes of the Sages."

[44] Mabit, II, 62. There is a striking similarity to Christian society in Medieval Europe on this issue. See Shahar, *Childhood*, pp. 170, 274-275, 342-343.

[45] Mabit, II, 45; III, 1; Maharit, II, *Hoshen Mishpat*, 21; Ralbah, 133, p. 93b; Maharitatz, 54; Galante, Responsa, 104. I found only one case in which a woman, whose husband had agreed to support and marry off her daughter from a previous marriage, later changed her mind (the couple subsequently sought "an annulment of the condition). The rabbinical court emphasized that this was a rare occurrence: "It is rare for women to be so cruel as to revoke a daughter's prerogative!" (Radbaz, IV, 1325).

[46] Gavizon, II, Appendix 6, 101; Maharitatz, New Responsa, 3(b); Mabit, I, 182, 312; II, 34; Radbaz, I, 513; Caro, *Avkat Rokhel*, 160; Galante, Responsa, 121; MS Jerusalem, Tzayyah, 600, p. 341a-341b.

[47] *Ketubot*, 102b.

removed from his mother's care until he has reached the age of six. The father meanwhile is forced to pay maintenance for the child. Once he has turned six, the father may say: 'if he comes to live with me, I will support him, but if he stays with his mother, I will not support him.'"[48]

These rules were not often strictly adhered to. In three out of four divorce cases referred to in the sources, the father was awarded custody of the children, even in the case of infants and girls.

The Radbaz sees the mother as "a mere instrument,"[49] i.e., simply as a supplier of services. If the infant is too young to recognize her as a separate being, or if he has been weaned and is no longer dependent on her physically, he is better off with his father. Other possible arguments formulated by the Radbaz, are: "The father can say [to his divorcee]: I am worried about any possible risk to the child's safety. He can further say: If the child is ill, I can see to his needs as long as he is in the same city. I can also support him, if he is in the same city. Furthermore, I can take over custody of the child when he no longer needs his mother. But if the mother moves far away, who will fetch the child? I am under no obligation to go to the trouble of seeking out the child and fetching him back from some distant place!"[50]

The Mabit draws a distinction between boys and girls. Although in his opinion it is in the boy's best interests to live with the father, since fathers are more generous towards their children than mothers (!),[51] he admits the importance of the mother as a role model for her daughters. "The reason why the rabbis stipulated that a daughter stay with the mother is not because the mother loves the daughter any more than the father, but rather for the daughter's improvement, so that she will learn what is necessary from her mother [...] And it is common knowledge that daughters are better off with their mother

[48] *Ketubot*, 102b; Rambam, *Marital Laws*, XII, 14; Ibid, 21, 17 (the reason being that up till the age of six, the father is obliged to support his children; see *Ketubot*, 65b); Caro, *Shulhan 'Arukh, Even ha-'Ezer*, 2, 7; See entry "divorcee," Talmudic Encyclopedia, Vol. 6 (1965), pp. 330-331.

[49] Cf. *Sanhedrin*, 22b: "Woman is the raw material, and may only draw up a contract with he who has fashioned her into a vessel."

[50] Radbaz, III, 851.

[51] Mabit, I, 339. Inter alia, he contrasted the verse "As a father hath compassion upon his children" [Psalms 103:13] with: "The hands of women full of compassion have brewed their own children" [Lamentations 4:10].

than with their father, if their father has remarried, since this is the way to their improvement."[52]

Widows, unlike divorcees, were usually granted custody of their children. The sources refer to a widow who demanded an income from her husband's estate in order to raise her three little boys. The deceased's brothers, however, undertook to raise the orphans themselves, at their own expense. In this case, R. Yom Tov Zahalon, overriding the law that a son is not to be entrusted to the care of potential heirs, ruled that "of course if it is in the orphans' interests we shall remove them from their mother's care, and shall tell her: 'If you wish to provide for them from your *ketubah* and not from their property, they shall stay with you.' But if she wishes to use up their legacy, she has no leg to stand on. Besides, their uncles will educate them in the study of Torah, which she is not able to do."[53] For him, the children's economic wellbeing and Torah education, overrode their emotional needs.

The Radbaz pronounced in favor of a man who tried to prevent the wife of his deceased brother from taking her infant daughter to another city. "Even though the rule is that daughters stay with their mother forever, this is only so that the mother may serve as a role model, instructing her daughters in the art of modesty. If, however, the mother is immoral, or immoral people enter her house, the relatives have a right to remove the daughters from her care. And how will this come to their attention if she lives in another city?"[54] – The slightest doubt that a woman might go astray when far from the vigilant eye of her in-laws, was sufficient reason to prevent her from moving away.

When the doubt became certainty, a daughter could certainly be removed from her mother's custody. Thus, a father claimed custody of his daughter from his promiscuous ex-wife when the latter became pregnant, arguing that 'the daughter might be influenced by the mother, especially as she is already seven and has some degree of sexual awareness [...] It is a well-known fact that children copy their parents, and that daughters follow in their mother's footsteps." The father was granted custody of the daughter.[55].

[52] Mabit, II, 62.

[53] Maharitatz, New Responsa, II, 232 (also ibid, 16, on the same subject).

[54] Radbaz, I, 360 (the Radbaz points out the sages of Salonika were divided over this issue).

[55] Radbaz, I, 263

In the following moving case, some of the most frequently cited grounds for removing orphaned children from their mother's care are listed:

> Reuben died leaving behind two sons, one just under five and the other still an infant. His widow wished to move to another country with her sons. Reuben's father, however, tried to prevent her, claiming that the children were still young *and he feared lest, God forbid, a calamity befell them on the way.* He further argued that *sooner or later she would remarry, and the orphans would live in a foreign country, and he would not be able to offer them assistance.* He further argued that *he was obliged by the Torah to teach them reading the Torah etc.*, as it says: 'Make them known to thy children and to thy children's children' [Deuteronomy 4:9]. And one of the children was almost five – the age for studying the Torah – and already knew a little of the weekly portions. Who would educate him, who would teach him, if they were taken away? The *mitzva* [of educating the grandchild] was incumbent upon him. And when the other child was old enough to study Torah and *mitzvot*, who would teach him if not his grandfather?

The Mabit, in his answer, justifies leaving the boys in the custody of their grandfather:

> If the court considers it in the orphans' interests to stay with their grandfather, they may order the mother not to leave the city until the child is weaned. As far as the five-year old is concerned, it is clear that if she wishes to leave the city she cannot take him with her [...] *All the more so if she wishes to leave Eretz Israel and go abroad*, especially since children are more at risk than adults when traveling.

Only at the end of the responsum are we enlightened as to the identity of the actors in this tragedy:

> The Reuben referred to in the question is my son Nathan, may he rest in peace, and the two children are his children Moses and Barzilai, may their Rock and Redeemer protect them. The children are my children, and the pain is my pain. And I am obliged to look after them and raise them in Torah and *mitzvot*. And may God instill love and fear of Him in their hearts, and make their latter days better than their earlier ones.[56]

This unusually personal responsum is the result of a process of soul-searching on the part of the anguished Mabit. Although obviously very close to his grandchildren, he was aware of the difficulties of separating them from their mother. The 'formal' grounds he invokes do not conceal the true motive behind his ruling: his overwhelming love for his grandchildren.

[56] Mabit, I, 164.

The anthology '*Zera'Anashim*' contains a responsum that sheds light on the numerous considerations that were raised in any deliberation of this kind. The case involved a widow with two children, aged three and six. When the widow remarried, she wished to have custody of her children, so that her new husband could educate them. The children's uncle, however, claimed that it was in the children's best interests to stay with him, or with his mother, or even with their mother's father, who thus far had been responsible for their education. Obviously, the uncle was reluctant to leave the children with their mother. In this case, the *posek* [decisor] took into consideration not only the economic and educational aspects of the case, but also the mother's feelings:

> Just as we do not accept the uncle's claim that the children stay with him, since he is a potential heir, so we do not accept his claim that the children stay with his mother. *For what reason is there to take the children from their poor mother's care and give them over to the care of a strange woman?* Furthermore [...], it is up to the rabbinical court to decide: If they believe it is in the boys' best interest to stay with their stepfather, if they see that he is good-natured, generous, prepared to support them at his own expense, and has their wellbeing at heart, then let them award him custody [...] In any case, since the mother is not claiming maintenance for her children, there is no power on earth that can take her sons from her [...] She and her husband together will raise and educate her children until they are grown up. After due consideration, this seems to me the best course of action.[57]

Interestingly, the sources barely refer to disputes concerning child custody or guardianship. Presumably, such cases never reached the courts, especially if the mother continued living with her children in the same town as her relatives and her husband's family. But problems arose when the mother wished to move to another city. In such cases, obstacles were often placed in her path. Usually, opposition to such a move stemmed from concern for the children's education and economic wellbeing. For boys, emphasis was placed on the need for a male role model to instruct them in Torah and *mitzvot*. For girls, emphasis was placed on the need for a female role model to instruct them in female crafts and modesty. The *posekim* were frequently torn between the child's emotional needs and educational requirements.

[57] MS Jerusalem, *Zera' Anashim*, pp. 42b-44b. Since the preceding and subsequent responsa are signed by R. Samuel Halevi of Egypt, this responsum may also be his.

In at least fifty percent of cases, considerations of the child's emo-
tional needs took precedence.

Note that *none* of the mothers who were refused custody of their
children had remarried. This would seem to indicate that a woman
who had remarried or was about to remarry was more likely to
secure custody of her children. Indeed, the *posekim* stressed the impor-
tance of a family framework for the children, especially for boys,
where the stepfather could serve as a male role model, and care for
their educational needs.[58]

Much injustice and unnecessary pain could have been avoided if a
woman's right to custody had been stipulated in her husbands' life-
time. In cases where a husband appointed his wife guardian of his
property and children, matters were far less complicated,[59] for the
ruling is: "the court does not award custody to women, servants, and
minors, although the father *is* entitled to do so."[60]

The Muslim court in Jerusalem also awarded Jewish women trus-
teeship of their late husbands' children and chattels. In 1562, for
example, an Ashkenazi woman was awarded custody of her eight
children rather than their uncle, who was unfamiliar with the local
vernacular.[61] Another custody case cited in the Shari'a court records,
dated February 1573, relates to a widow of Maghrebi origin:

> His Honor the Shafi'i *qadi* Mahmud has awarded the Maghrebi Jewess
> Nabilah bat Ya'aqub custody of her young children Ya'aqub, Itzhaaq,
> and Hannah, whom, by the grace of God, she bore to her Maghrebi
> husband Joseph ben Meir. She shall also act as trustee of their estate
> from their late father, look after their interests, receive and disburse
> money on their behalf, and represent them in sales, purchases, acquisi-
> tions, transfers, and other types of legal transactions from which they
> stand to profit by law."[62]

In conclusion, we see how both the rabbis and the husbands them-
selves recognized the importance of the mother-child relationship,

[58] Radbaz, I, 429; Alshekh, 38; David, "Molina."

[59] Also, de facto guardians: "A person, even a woman, who looks after orphaned
children, is considered their guardian in all respects" (Caro, *Shulhan 'Arukh, Hoshen
Misphat*, 290, 24). See for example: Mabit, II, 29, 193; Maharit, I, 67; II, *Hoshen
Mishpat*, 79; Alshekh, 128; Galante, Responsa, 97; Gavizon, I, 16.

[60] *Gittin*, 52a. Rambam, *Inheritance Laws*, X, 6. For a general overview and refer-
ences, see Assaf, "Appointment."

[61] Cohen-Pikali, document 412, p. 361.

[62] Ibid, document 414, p. 362. See also document 20, p. 21; document 390, p.
349; document 413, p. 362. See also: Cohen, *Jerusalem*, pp. 132, 137, 140.

and acknowledged that women were capable of taking responsibility for their children. Although this recognition was not always translated into action, more often than not it was, and mothers were granted custody of their children.

When, for various reasons, a mother was unable to raise her children, she had no choice but to forfeit custody of them. Thus, a destitute *agunah* from Jerusalem wanted her two daughters to be brought up by their father who had deserted them. In a similar case, a widow's suitor refused to support her children. In some cases, children from a previous marriage turned out to be a source of tension and conflict in the new marriage.[63] Motherless children were often raised by their grandmothers.[64]

As a rule, relatives (uncles and grandparents) took an active role in bringing up children, especially when it came to their education and schooling.

[63] Alshekh, 70; Mabit, II, 62; MS Jerusalem, *Iggerot Shadarim*, letter 171.
[64] Galante, Responsa, 115; Mabit, II, 110; Castro, *Ohalei Ya'aqov*, 26; Alshekh, 38; Radbaz, I, 123; III, 992.

DAILY LIFE

Housework

The available sources are too meager to provide a comprehensive picture of the home life of Jewish women in the Ottoman Empire in the 16th century. The few letters that have survived were written mainly by widows or single women in distress, seeking assistance from distant sons or relatives. The letters focus on basic needs such as food, clothing, bedding, or shrouds, but offer no insight into the daily life of the correspondents. We must, therefore, supplement the available data with conjecture concerning the daily life of housewives who lived in the alleyways and courtyards of Jerusalem, Safed, Cairo, and other Levantine cities.[1]

One thing is almost certain – the women of the 16th-century Levant did not have much privacy. Many chores were performed in a communal setting. Water, for example, was drawn from a communal well in the courtyard, food was cooked in a communal oven, and amenities were usually also shared. Under such conditions, gossip flourished. Prying neighbors kept their eyes and ears open, eagerly pouncing on any departure from socioreligious norms as a juicy topic for scandal.[2]

Life was not easy for these women. They were expected to perform a variety of tasks, as set forth by the sages: "grinding, baking, laundering, cooking, nursing, making beds, and weaving."[3] R. Yom

[1] The letters of 16th-century travelers hardly deal with day-to-day matters. The 17th century is far more informative in this respect. In particular, note R. Moses Porayit's travel chronicles (1650), which I sometimes refer to in order to complement earlier sources, on the assumption that things had not changed significantly in this area. On daily life in 16th-century Jerusalem according to Shari'a Court documents, see: Cohen, *Jerusalem*; Cohen-Pikali. On daily life in the 17th century, see: Rozen, *Community*, pp. 239-260.

[2] On overcrowded living conditions, see, for example: Mabit, II, 153; III, 53; Maharitatz, 289; Galante, Responsa, 31, 63; Ralbah, 110; "Letters of R. Obadiah of Bertinoro," in Yaari, *Letters*, pp. 137, 143; "Letter by a student of R. Obadiah of Bertinoro," in Yaari, *Letters*, pp. 156, 159. David, "Letter," p. 118.

[3] *Ketubot*, 59b.

Tov Zahalon held that a woman's prime duty was to serve her hus-
band: "The husband even takes precedence over the father, being
likened to a king." In the same vein, Zahalon quotes the Rambam:
"A woman is commanded to venerate and revere her husband, and
to defer to him in all matters. She should relate to him as to a prince
or king, act in accordance with his desires, and refrain from anything
he dislikes [*Marital Laws*, XVI, 20] [...] He is absolutely right! She
should serve him like a king [...] and wait upon him."[4] If a woman
failed to live up to these requirements, her husband was entitled to
take another wife, or to divorce her without paying her *ketubah*.[5]

A large part of a woman's day was spent cooking and baking. In
those days, this meant lighting the oven and keeping the fire going, as
well as grinding the wheat into flour. Wine-making was also a task
women were expected to perform. Many houses had no oven, and
only a few had anything approaching a 'kitchen'. Those who were
lucky had a communal oven in their courtyard. Others, who were
less fortunate, had to make do with the neighborhood oven.[6] Sabbath
and festival eves were a particularly fraught time for women. The
Safed kabbalist, R. Abraham Halevi Berukhim, known as the 'great
patron of the Sabbath,' had his own idiosyncratic way of ensuring
that women completed their cooking for the Sabbath in time:

> Early on Friday morning [...] two hours before dawn, he would urge
> the women to get up and start preparing for the Sabbath, and knead the
> dough. 'If I find anything on the range shortly before the Sabbath,' he
> warned 'I will confiscate it for the poor!' The women took his threat
> seriously, and made every effort to be ready on time. Indeed, just before
> sundown on Fridays, R. Berukhim made the rounds of the houses, and
> true to his word confiscated anything that was still on the range for the
> poor.[7]

R. Obadiah of Bertinoro, who visited Alexandria in the late 15th
century, describes how the women of Alexandria served their hus-

[4] Maharitatz, 231.
[5] For example, Maharitatz, 3; Mabit, III, 51.
[6] Maharitatz, 181; Mabit, I, 291; III, 51; Radbaz, IV, 1130; Galante, Responsa,
15, 31, 62; "Travels of R. Moses Porayit," in Yaari, *Travels*, pp. 277, 281; Badhab,
54, 56, 67; Vital, *She'arim*, *Sha'ar ha-Kavanot*, Exposition on the Passover (6), in anno-
tations of R. Samuel Vital; idem, *Sha'ar ha-Mitzvot*, *Parshat Aharei-Mot* (p. 54); Bena-
yahu, *Ari*, pp. 195, 225; MS Jerusalem, *Iggerot Shadarim*, Letters of Mataron, letter 80,
pp. 375-376; Turniansky, letter 6, p. 205; Cohen-Pikali, document 56, p. 58.
[7] "Letters of R. Solomon Meinstril," in Yaari, *Letters*, p. 205; see also, Radbaz, IV,
1130.

bands on the Sabbath: "The Jews in Muslim countries frequent the bathhouse on Friday afternoons. When they come home, their wives serve them wine, followed by the evening meal, which lasts until nightfall." He contrasts this with the women of Cairo, who were far more independent, only cooking once a week for the Sabbath, and the rest of the week buying ready-made food from the market.[8]

Apart from the inconvenience of having to use a communal oven, women also suffered from a shortage of cooking utensils. Cooking utensils were valuable items which were usually passed down from one generation to another as a legacy or gift. Various household utensils are usually mentioned in litigation over property following death or divorce (unlike dowry inventories, where the main items are jewelry, cash, and fabrics, or various types of clothes). Generally, the sources refer to "pots and bowls" or "household utensils such as copper bowls and cups [...] used by women."[9] The wealthier families used copperware, while the poorer ones made do with earthenware.[10]

The estate of an affluent Jerusalem widow, itemized by the rabbinical court of R. Levi ben Habib in 1533, included the following household items: a copper basin, two copper buckets, two pots, one of which was damaged, over twenty trays of different sizes, a copper container, a small tub and sieve, a copper pestle and mortar, two lids, a ladle, and four different kinds of spoons.[11] These kitchen utensils compare unfavorably with the large sums of money, jewelry, fabrics, and other valuables she left behind.

Besides cooking and baking, women had to provide water for the household's needs. In Safed and Jerusalem, water was drawn from communal wells in the courtyard. In very hot years, water was collected from a spring outside the city. Laundry was washed in natural springs or pools. The Portuguese monk Pantaleo de Aveiro, who saw some Jewish women doing their washing near the spring of Silwan, in Jerusalem, remarked on their abject appearance. Even the youngest

[8] "Letters of R. Obadiah of Bertinoro," in Yaari, *Letters*, pp. 115, 121.

[9] Castro, *Ohalei Ya'aqov*, 120; Radbaz, IV, 1297; Ashkenazi, 14; Maharitatz, New Responsa, 54.

[10] "Travels of R. Moses Porayit," in Yaari, *Travels*, p. 277. See also Rozen, *Community*, p. 251. We learn about the value of copper utensils from the Czech traveler Martin Kabatnik, who visited Jerusalem in 1492. According to him, the authorities forbade minorities to use copper pots (Schur, "Jerusalem," p. 171; Cohen, *History*, p. 43).

[11] Assaf, "Court Provision," pp. 106-108.

of them, with whom he struck up a conversation "did her washing barefoot, like a servant, despite being a woman, and of refined character at that!"[12] Once washed, the laundry had to be carried home and spread on the rooftops to dry. Wash-day usually took place once a week.[13]

As a rule, the women of the 16th-century Levant attached much importance to cleanliness. The Egyptian women even went as far as to order their maids to wash the floor on the Sabbath. R. Jacob Castro of Cairo reluctantly permitted this practice, arguing "Better that they should continue sinning in ignorance, than knowingly. For even if we forbid this practice, they will never agree to leave the house dirty on the Sabbath."[14]

Since women were taught needlework from a young age, most women were competent seamstresses, and made clothes for the family and for themselves. Embroidery and knitting were also popular pursuits.[15]

Some women had a degree of control over household expenses, through the weekly allowance granted them by their husbands. Presumably, in many households, shopping was an opportunity for women to 'get out of the house' and enjoy some freedom. R. Solomon Meinstril of Dreznitz, however, informs us that in Safed, shopping was done by men, including notable Torah scholars.[16] This may have been as much to protect their wives from 'outside influences' as to help them.

The average family in 16th-century Jerusalem, as estimated by Amnon Cohen, comprised six members. Despite the high mortality rate in those times, this assessment is probably accurate, given that bigamy, even in Jewish families, was far more common than is generally thought.[17] Bearing in mind the multiple roles a woman had to

[12] "Travels of Pantaleo de Aveiro," in Ish Shalom, pp. 293-294. See also Galante, Responsa, 31, 62; "Letter by a student of R. Obadiah of Bertinoro," in Yaari, *Letters*, p. 159; Cohen, *Jerusalem*, p. 141; Cohen-Pikali, document 149, p. 153; "Letters of R. Solomon Meinstril," in Yaari, *Letters*, pp. 203, 207. The Silwan spring (*ma'ayan ha-Shiloah*) was also used for bathing (Cohen-Pikali, document 192, p. 181).

[13] Galante, Responsa, 35; Mabit, III, 53.

[14] Castro, *Ohalei Ya'aqov*, 94; Radbaz, I, 318; Caro, Responsa *Beit Yosef*, 49 (=Laws of *Ketubot*, 15)

[15] Radbaz, VI, 2085; Turniansky, letter 2, p. 187; "Travels of R. Moses Porayit," in Yaari, *Travels*, p. 278.

[16] "Letters of R. Solomon Meinstril," in Yaari, *Letters*, pp. 203, 207; Gavizon, II, Appendix 6, 101; Cohen, *Jerusalem*, p. 145.

[17] Cohen, *Jerusalem*, p. 21; Cohen-Pikali, p. 360. See also Chapter 9, "Polygamy."

fulfill as wife, housewife, mother and, in some cases also breadwin-
ner, most women hardly had a moment to spare. The only excep-
tions were a few wealthy women, who could afford domestic help.[18]

The proximity enforced by cramped living quarters and shared
courtyards, although depriving women of privacy, had its compensa-
tions. It encouraged friendship and solidarity. Work was mixed with
pleasure, and provided opportunities for social encounters, even be-
tween men and women. As stated, however, communal life had its
disadvantages. The courtyard, for example, was a hotbed of gossip,
where prying women could poke their noses into other people's busi-
ness. In such an atmosphere, jealousy and rancor flourished, and
quarrels were a frequent occurrence. The sources refer to one such
quarrel which took place in Tiberias circa 1560, in which a Torah
scholar actually ended up hitting the wife of a colleague.[19]

In short, the communal courtyards and alleyways constituted a
social microcosm, with all the positive and negative implications this
entailed. It is safe to assume that despite the tensions of communal
life, there were plenty of opportunities for enjoyment.

External appearance

Mode of dress

The various sources, in particular the travel chronicles of the late
Mameluk period up to the middle of the 17th century, tally in their
description of female fashions in the Ottoman Empire. Some note
the similarity between Muslim and Jewish attire, on the one hand,
and male and female attire, on the other. Although stratified Muslim
society used clothing as a way of differentiating between the various
classes (Jews, for example, were forced to wear a yellow article of
clothing as a sign of their inferiority), Jewish women were indistin-
guishable from their Muslim counterparts, as far as appearance was
concerned. The discriminatory legislation passed by the Ottoman
authorities regarding the way the non-Muslim minorities (*dhimmis*)

[18] Lamdan, *Status*, pp. 399-420. Idem, "Female Slaves."
[19] Mabit, I, 34-35; II, 153, 166; Galante, Responsa, 97 (= Maharit, I, 33); MS
Jerusalem, *Iggerot Shadarim*, p. 108a; Benayahu, *Ari*, p. 201.

were to dress (prohibiting/forcing them to wear certain colors) was not always enforced.

The traveler Arnold von Harff, gives an interesting description of the mode of attire of women in late 15th-century Cairo: "Outdoors, whether walking or traveling, their faces are covered with a black veil, so that they cannot be recognized, although they all seem to know each other. They all dress the same way, in a white robe, and a black veil [...] They are so heavily draped, that even their husbands cannot recognize them [...] Under their robes, the women wear trousers and petticoats."[20]

Meshullam ben Menahem of Volterra, describing the attire of the women of Alexandria and Cairo during the same period, also points out that they wore trousers under their robes, like men. He also mentions that the Jewish women of Hebron covered their faces with a black veil in order to render them indistinguishable from Muslim women, so that they could visit the Cave of the Patriarchs (Me'arat ha-Makhpela) without being recognized as Jews.[21]

The Ottoman conquest of Palestine and Egypt had no effect on female fashion. The immigrant, R. Israel Ashkenazi, described the way the women of Jerusalem dressed at the dawn of Ottoman rule as follows:

> "The women are extremely modest, and are completely covered, without exposing an inch of flesh. When they leave the house, they wrap themselves from head to toe in a white sheet, and black veil. The veil is made of a fine silk which allows them to see without being seen. They are so heavily concealed, even their husbands do not recognize them. For them, exposure of even a tiny bit of flesh is a disgrace. They ridicule the way our women dress [...] Therefore, when I moved here, I made sure that the clothes of my eldest daughter were adapted accordingly. She ended up with two new garments for every old one."[22]

R. Moses Basola, who visited Palestine in the early 1520s, and other 16th-century travelers, corroborated the fact that when Jewish Levantine women left the home, they were heavily cloaked and veiled.[23] This style of clothing stayed in fashion throughout the 17th

[20] Harff, pp. 123-124.
[21] "Travels of Meshullam of Volterra," in Yaari, Travels, pp. 46, 48, 55, 69.
[22] David, "Letter," p. 116.
[23] "Travels of R. Moses Basola," in Yaari, Travels, p. 159; Radbaz, II, 770; Mabit, II, 119; Caro, Responsa Beit Yosef, 4; MS Jerusalem, Tzayyah, 380, pp. 71b-75b; 529, pp. 254a-258a; Cohen-Pikali, document 362, p. 319; Cohen, Jerusalem, pp. 140-141; Schur, "Jerusalem", p. 361.

century. In the early 1630s, the traveler Eugène Roger pointed out that the Jewish women of Jerusalem dressed like Muslim women, and removed their headscarves only when they were out in the fields.[24] And in 1650 R. Moses Porayit wrote:

> Ashkenazic, Sefardic, and even Turkish women and girls, cover their heads and most of their bodies in a transparent spun-cotton scarf called a *lizaar* [...] When they go out, Sefardic and Turkish women also cover their faces with a black transparent veil [...] for reasons of modesty.[25]

These descriptions tally with those of the European Ambassador to Istanbul in the middle of the 16th century:

> The Turks set greater store than any other nation on the chastity of their wives. Hence they keep them shut up at home, and so hide them that they hardly see the light of day. If they are obliged to go out, they send them forth so covered and wrapped up that they seem to passers-by to be mere ghosts and specters. They themselves can look upon mankind through their linen or silken veils, but no part of their persons is exposed to man's gaze."[26]

As stated, another feature of Ottoman fashion was that women and men wore similar garments, at least on the outside. Daniel Finzi, for example, in a letter he sent from Jerusalem in 1588, wrote: "There is no difference in the way men and women dress except for their headgear [...] Both wear long trousers, just as they do here [in Italy] during the *mascari* [carnival], underneath a long gown and cloak."[27] The similarity in male and female fashion inspired the following question, addressed to R. Jacob Castro: "Is a man permitted to wear his wife's cloak [*sayo*] or a woman her husband's cloak, since men's and women's cloaks are identical?" R. Israel Ashkenazi also commented on the similarity between men and women's garments.[28]

According to the traveler Pierre Belon, Jewish women, who were free to go around unveiled, were seen in the markets.[29] But is seems

[24] "Travels of Eugène Roger," in Ish Shalom, pp. 343-344. See also George Sandis' description of 1611 (Rubens, p. 40). See also: Schur, "Jerusalem," p. 382. Etchings in N. De Nicolay's book, published in 1568, confirm these descriptions (see Yohas, p. 124, plates 6-7; Rubens, p. 34, plate 32).

[25] "Travels of R. Moses Porayit," in Yaari, *Travels*, pp. 282-283, and also p. 277. See also Rozen, *Community*, pp. 251-253.

[26] Busbecq, pp. 117-118.

[27] Benayahu, "Letter," p. 232.

[28] Castro, *Ohalei Ya'aqov*, 70; David, "Letter," p. 116.

[29] Belon, III, p. 182 (Hebrew translation in Lusitanus, p. 73). See also Goitein, *Society*, V, p. 310.

that many Jewish women wore a veil, although women of the non-Muslim minorities (*dhimmis*) were not required – and were sometimes even forbidden – to do so, as a mark of disgrace (prostitutes or peasants did not wear veils). The above notwithstanding, it is clear that any self-respecting Jewish woman was heavily cloaked in public, even if she did not actually wear a veil. [30] Whether she did so out of modesty, or out of a desire to remain inconspicuous, is a moot point.

Hair and headcovers

In deference to the rabbinical prohibition on a woman showing her hair,[31] Jewish women wore headscarves in public, but went around bare-headed at home or among relatives. Some allowed wisps of hair to show, but this custom was frowned upon by the more stringent of rabbinical authorities,[32] who feared it might distract men from their prayers. A question originating from Tlemcen in Algeria, and addressed to the sages of Egypt, inquired whether women were allowed to uncover their hair, apart from their braid, for reasons of vanity. R. Moses Alashqar's response is not only instructive of the customs of the times, but bears testimony to his liberal outlook:

> There is absolutely no need for concern regarding a woman's hair [...]
> It is the custom for women today to braid their hair, with strands of hair
> protruding on either side of the face [...] They are also accustomed to
> anointing their hair with perfumes and oils [...] Those who would
> prohibit a woman from exposing her hair in her own home on the
> grounds that 'exposing hair is sinful,' deserve to be rebuked. Obviously,

[30] Originally, the veil symbolized decorum and class distinction, and safeguarded the honor of those who wore it (see Quran 33:59). Over the years, members of the middle classes and villagers who moved to the town adopted the veil, thereby demonstrating their integration into urban society. See: Marmorstein; Stillman, "Attitudes," esp. pp. 348-349; idem, "Genizah," p. 152 (near note 14); idem, "Wardrobe," p. 298; Keddie and Beck, pp. 5-6, 8-9; Lewis, *Jews*, p. 37; Dengler, pp. 229-230; See also: Radbaz, VII, 46; Caro, Responsa *Beit Yosef*, 4; Mabit, II, 119; "Travels of R. Moses Porayit," in Yaari, *Travels*, pp. 282-283; David, "Letter," p. 116; "Travels of R. Moses Basola," in Yaari, *Travels*, p. 159; Meir, p. 117; Ashtor, II, pp. 326-327 (ibid., pp. 210-214, on the discriminatory dress codes for *dhimmis*); Cohen, *Jerusalem*, pp. 140-141. On references to veiling in Talmudic, rabbinical and Gaonic literature, see Friedman, "*Halakha*," pp. 91-99.

[31] *Berakhot*, 24a.

[32] Vital, *She'arim, Sha'ar ha-Mitzvot, Parshat Qedoshim*, p. 56; MS Jerusalem, Tzayyah, 549, pp. 276a-277a. The picture "A Jewess from Constantinople" portrays such a hairstyle (see Yohas, Table 33a, facing p. 192).

they do not know which hair is being referred to [...] According to them, a woman should cover her eyebrows too! [...] Since Jewish women in most countries under Ishmaelite rule have uncovered their heads since time immemorial, it is hard to understand what brought him to question this practice in the first place.[33]

R. Alashqar goes on to say that the custom of oriental and North African women to allow strands of hair to protrude on either side of the face was soon adopted by women of European origin too.

Although oriental women wore their hair long, they were fussy about removing any trace of body hair. The Pietists of Safed spoke of the female custom of removing body hair[34] – a custom also referred to by the traveler Pierre Belon:

> The women of Turkey, irrespective of creed, remove body hair. They do not use a razor, but rather a depilatory cream [...] This cream is used by all women irrespective of age or personal status. It is used by Turkish, Greek, and Armenian women as well as Jewish and Christian ones [...] It is a permanent fixture of all Turkish bath-houses. It is used by the poorest of poor and the richest of rich, throughout Egypt, Arabia, Syria, and Turkey.[35]

From the above, we see that Ottoman women in general, both Jewish and gentile, took good care of their bodies and appearance. The various inventories that are extant indicate that a fair number of Jewish women had a large wardrobe, comprising weekday clothes and Sabbath and festival finery, as well as a prolific assortment of jewelry. The estate of a wealthy Jerusalem widow (see above, 'Housework') comprised, besides kitchen utensils, jewelry and coins, shirts and robes, scarves, women's hats, large and small headscarves, veils, belts and various fabrics.[36] Another Jewish woman from Jerusalem left her daughter, Farihah bat Rubin, an impressive quantity of jewelry and clothes, which were itemized before the *qadi*: "Five pairs of gold earrings [...] a black satin headscarf embroidered with silver thread [...] silver necklaces, a pair of silver anklets, a purple silk gown, a red and yellow gown, a blue satin gown, a green satin gown, a pair of gold thimbles, a pair of gold rings, a yellow and brown

[33] Alashqar, 35.

[34] Lieria Moses, 8.

[35] Belon, III, pp. 197-198 (English translation based on Hebrew translation in Lusitanus, p. 73). This is still the custom among Muslim women and Jewish women of oriental extraction.

[36] Assaf, "Court Provision." See also Maharit, *Even ha-'Ezer*, 37; Cohen, *Jerusalem*, pp. 229-232; Rozen, *Community*, pp. 253-254.

bracelet, a red lamb's wool shirt, a brown and green shirt, an elegant brown shirt, a purple and yellow shirt [...] a pair of gold bracelets, a pair of silver bracelets [...] and three multicolored robes."[37] Similarly, many contemporary catalogues of dowries, legacies or bequests included details of jewelry, clothes, fabrics or 'bed-clothes.' Clothes or bedding were frequently used as bargaining tools during a divorce, separation or inheritance dispute. "A husband who divorces his wife makes sure she does not take with her all her finery and wear them for her second husband, while he is consumed by jealousy," wrote the Radbaz.[38]

Jewelry, like clothes, was a symbol of a woman's socioeconomic status, and was meant to provide her with some financial security in the case of widowhood or divorce. Note, however, that women could wear their jewelry and finery only when among family or relatives. This is clearly apparent from a 17th-century woodcut depicting a Jewish woman from Izmir at home and in the street: At home, the woman is unveiled and adorned in all her finery and jewelry, while outdoors she is so totally shrouded that only her eyes are visible.[39]

Rabbinical legislation to curb extravagance

The rabbis, fearful that excessive extravagance on the part of women would incite the authorities, or at the very least, draw their unwelcome attention to the Jewish community, passed regulations proscribing flamboyance.[40] An Istanbul regulation, for example, stated that "women should not wear gold jewelry, gold necklaces [...] or embroidered garments [...] outside the home in order not to draw attention to themselves."[41] Regulations against ostentation existed in many other places too, both within the Ottoman Empire (Salonika,

[37] Cohen-Pikali, document 323, p. 285.

[38] Radbaz, IV, 1140. See also: Radbaz, I, 287, 338, 366, 579; IV, 1141, 1297; VI, 2255; Maharitatz, 292; Mabit, I, 175, 242, 266; Maharitatz, New Responsa, I, 54; Galante, Responsa, 82; For lists of dowries for brides in Egypt, see: Gottheil-Worrell, document XL, pp. 178-189; Ashtor, III, pp. 110-112; See also: Stillman, "Genizah;" Idem, "Wardrobe."

[39] Yohas, p. 125, photograph 8 (and also p. 180, photographs 7-8, from the early 19th century). Cf. Inalcik, Tables 29-30.

[40] Lewis, *Jews*, pp. 34-38; Meir; Yohas, pp. 120-171; Goodblatt, pp. 127-128; Rubens, pp. 32-69 (alternate pages); Bashan, "Regulations;" Danon, "*Communauté*," p. 254; Galanti, *Histoire*, p. 57; Ankawa, 81, 92; Schipansky, "Luxuries."

[41] Maharit, I, 76.

Istanbul) and outside it (Italy, Morocco). The exceptions were Syria and Palestine, where no such regulations existed, and Egypt, where women were permitted to wear their finery in the street.[42] This was not, as one might think, due to the absence of a wealthy class in these countries, which might have rendered such legislation irrelevant. For although the population in these countries was poor in comparison with other places, it still had some rich families who could afford fine clothes and jewelry. This is corroborated by complaints of the following kind: "In this generation, why do we allow women to go out on the Sabbath bedecked in their jewelry?"[43] and by the fact that in Damascus women were accused not only of highly provocative behavior, but also of going out adorned in public: "They dress immodestly, exposing their breasts, and heaping on jewelry [...] They spray themselves with all sorts of perfumes to titillate people in the markets and streets."[44] Also in Safed, R. Joseph Caro and his rabbinical court tried to introduce a regulation "that women should not go to Meiron arrayed in all their finery." These attempts, however, were meant to prevent moral transgressions, and did not arise from 'political' considerations – such as the wish not to antagonize the authorities.[45] Ironically, just where one might have expected a regulation, none existed.

The reason why these regulations existed in Istanbul and Salonika, and not in Palestine or Egypt, may be because the population of these large cities was more 'worldly' and cosmopolitan, and therefore more likely to be tempted by prevailing fashions. The wealthy Jewish classes in Istanbul – most of whom were Iberian Jews – found it hard to accept the dress code imposed on the *dhimmis*, believing perhaps that their wealth placed them above such restrictions. Jewish women who had contacts with the Sultan's harem and with Ottoman viziers were almost certainly privileged in this respect.[46] However in the final

[42] Radbaz, III, 1044.

[43] MS Jerusalem, Tzayyah, 343, p. 22a.

[44] Sambari, 206 (p. 244 in photocopied edition).

[45] Benayahu, *Ari*, p. 219, and notes there.

[46] For a portrait of Jewish women from 16th century Istanbul, see Yohas, p. 174, photograph 2; p. 193, photograph 1-2; for a portrait of a Jewish woman distributing goods to women of the *harem* (1714), see Rubens, p. 37, photograph 36; for a short review of Jewish courtesans, see Gerber, *Ottoman Empire*, p. 64, and document 39, pp. 108-110; see also Ambassador Busbecq's description of a Jewish Sefardic lady, the friend of the grand vizier Roostem Pasha, whose house he frequented (Busbecq, pp. 147-148). For a letter from Jerusalem to a courtesan at the harem and courts of princes and princesses in Istanbul, see Rozen, "Influential Jews," pp. 429-430.

analysis, the authorities felt bound to intervene. In August 1568, a
firman (Ottoman decree) was sent to the *qadi* in Istanbul, concerning
the mode of attire of the 'heretics.' "Compliance is requested with the
decree [...] that has already been promulgated on this matter [...]
prohibiting women to wear finery, as specified!" A decree passed
some nine years later, in July 1577, specified the fabrics that were
prohibited for use by the *dhimmis*. They were ordered (on pain of
death!!) to wear modest attire, as had always been their custom, and
to refrain from wearing satin and silk.[47]

Note that the emphasis in both *firman*s was on the type of fabric
rather than on the mode of dress. As stated above, Jewish women
wore clothes that largely resembled those of their Muslim sisters. The
difference lay in the type of fabric, and of course the colors that were
proscribed or prescribed. In oriental society, more than in European
society, fabrics were a symbol of socioeconomic status: "It is the way
of the world to stint with food and drink, but not with clothes. On the
contrary, indulgence is more the rule!"[48] Nor should one forget, that
houses in those times were furnished with exotic carpets and luxuri-
ous cushions for reclining on. In short, fabrics and cloths were con-
sidered valuable assets, which were carefully preserved from genera-
tion to generation, and which could, in times of need, be pawned or
sold.[49]

As stated, the leaders of the Jewish community in Istanbul were
fearful that excessive flamboyance by women might endanger the
entire community. Therefore, they not only upheld the *firman*s re-
garding modest attire, but even passed their own regulations to this
effect.

In Palestine, a different situation prevailed. Not only was Safed's
'Golden Age' short-lived, but the uncompromising Pietists there ex-
erted a disproportionate influence on the inhabitants. Therefore,
even those who could afford to wear rich attire refrained from doing
so, and the population as a whole behaved with exceptional modesty.

[47] Gerber, *Ottoman Empire*, document 6, p. 85; document 8, pp. 86-87. See also
Lewis, *History*, pp. 175-176.

[48] Radbaz, I, 579.

[49] See for example. R. Obadiah's description, "Letters of R. Obadiah of
Bertinoro," in Yaari, *Letters*, pp. 114, 116 and also: Goitein, *Society*, I, p. 101;
Stillman, "Genizah," pp. 152-153; idem, "Wardrobe," pp. 297-298; Braude, p. 83;
Yohas, p. 121; Cohen, *Jerusalem*, pp. 80-81, 196-197. On the rapacity of the vizier of
Jerusalem, Muhammad Ibn Farukh and his officials, and his craving for bribes and
gifts of clothes and fabrics, see Rozen, *Ruins*, pp. 92, 108, 147-152.

In Jerusalem, not only were the Jews poor, they were constantly exposed to the vigilant eye of the Ottoman authorities, and could not afford to draw attention to themselves by a flamboyant mode of dress. Indeed, there was a direct correlation between distance from the Ottoman centers of power, and the degree of stringency adopted by the local viziers towards the non-Muslim minorities. Thus, the Jerusalem community had little choice but to act with extreme caution. In places ruled by extortionate and exacting functionaries, the population had no need of regulations to impress on them the importance of caution. The women had no option but to dress with extreme modesty, only allowing themselves a certain degree of latitude when they were indoors among family and friends.

EDUCATION AND SOURCES OF LIVELIHOOD

Girls' education

According to *halakha*, a father has no obligation to teach his daughter Torah, and women, as a rule, have no obligation to study Torah.[1] On the other hand, girls' education was considered important in the period leading up to the Expulsion from Spain, and there were even some women teachers.[2] The available data on women's literacy in the 16th century Levant, however, is fragmentary:

Moses Zussman Tzarit, in a letter to his mother from Egypt, wrote that his young son, Zwillen, was being taught by a female tutor ('*mu'alima marhaba*').[3] The Ari himself instituted separate classes for women.[4] The women of Safed, we are told, used to sit 'in the gallery and pray together with the congregation.'[5] In a document from the Shari'a court of Jerusalem about the conversion of a private house into a synagogue, the *qadi* refers to 'a group of men and women of the Jewish faith who gather in the room, and recite the Torah aloud.'[6] There is also a mid-17th-century reference by a Karaite traveler to a female teacher in Hebron. The same traveler also describes how the Karaite women of Jerusalem were 'regular worshippers, conversant with the liturgy, and always present when the gates

[1] "'And ye shall teach them your children' [Deuteronomy 11:19] – your sons, and not your daughters" (*Kiddushin*, 30a). See also Mishnah, *Sotah*, III, 4; Caro, *Shulhan 'Arukh, Yoreh De'ah*, 246, 6. On the evolution of halakhic approaches to this issue, see review by Berman, pp. 121-122; Mescheloff, pp. 284-288, and notes there. Cf. the education of urban girls in medieval Europe: Shahar, *Childhood*, p. 360.

[2] Goitein, *Education*, pp. 63-70; idem, *Society*, I, p. 28; II, p. 183; Bashan, "Changes," pp. 177-183; Rambam, Responsa, I, 34; II, 276.

[3] Turniansky, letter 3, p. 189. See also "Travels of Moses ben Elijah the Karaite," in Yaari, *Travels*, p. 317.

[4] This can be understood at least from some versions of the life of the Ari, such as the Oxford MS: "and they booked a room for the men on their own and for the women on their own, and they studied day and night." See: Benayahu, *Ari*, p. 201, and note 1 there; ibid, pp. 202-203.

[5] Vital, *Sefer ha-Hezyonot*, 18, p. 10; Sambari, 199 (p. 229 in photocopied edition).

[6] Cohen-Pikali, document 86, p. 88.

of the synagogue were opened' and how elderly rabbanite (non-Karaite) women spent several days each year in the synagogue adjoining the tomb of the prophet Samuel.[7] His contemporary, the immigrant R. Moses Porayit, noted the following Jerusalem custom: 'When the men learn, the women stand outside the synagogue and listen[8] […] These righteous women seize every opportunity to listen in on the men. They never miss a day.' Further on he adds: 'The righteous women stand outside the synagogue and listen to the men studying Torah, and *read* the prayers in the Ashkenazi tongue (Yiddish), until the *kaddish* is recited." Female immigrants to Palestine, he said, would be well-advised to bring with a Pentateuch [*Humash*], festival prayer book [*Mahzor*] and other holy books in Yiddish.[9] Although this seems to imply that Ashkenazi women were literate, we have no way of corroborating this. It is equally possible, in light of the available documentation on female synagogue attendance and participation in prayer and study, that they recited the prayers by heart, or could read but not write.

However, we do have letters written by women which indicate that some women, at least, were literate. In practice, these letters were penned by sixteen women: eleven were written in Hebrew, three in Ladino, and one in Judeo-Arabic. Another batch of letters was written by a woman called Rachel, a widow from Prague, in Yiddish. Among the inventory of letters is a communal letter in Yiddish sent by 28 Ashkenazi women from Jerusalem, in the second half of the 17th century.[10]

Three of these letters were obviously dictated. For example, the letter by Doña Jamila to her son, in Ladino, was written by a professional scribe or acquaintance, as the signature indicates: 'Regards from me, R. Khalifa Ajuman, and regards from your mother, Doña Jamilah.'[11] The spontaneous and colloquial style of another letter, from a Musta'rab woman in Jerusalem to her brother in Egypt, was

[7] "Travels of Moses ben Elijah the Karaite," in Yaari, *Travels*, p. 313.

[8] Literally the expression here is "For men to learn, for women to listen", and it comes from a rabbinical exegesis on Deuteronomy 31:12 (see *Hagigah*, 3a).

[9] "Travels of R. Moses Porayit," in Yaari, *Travels*, pp. 278, 299-300.

[10] Yaari, "Women." These ladies, most of them widows, were seeking financial help from their sisters in Eastern Europe. In their letter, they mention terrible occurrences in Poland, probably alluding to the pogroms of 1648-1650. However, according to Benayahu ("Community," p. 185), the letter is from a later date, about the year 1690.

[11] Gutwirth, "Letter."

faithfully rendered by Yom Tov ben Joseph Ibn Emanuel.[12] Among a collection of letters, most of them written by R. Joseph Mataron, is one – a catalogue of complaints in the first person – whose heading indicates female authorship.[13] It is not clear whether the remaining letters – in particular six Yiddish letters sent by the aforementioned Rachel in Jerusalem, to her son Moses in Egypt – were written or dictated.[14] The fact that a letter was written in a faltering hand is no proof that it was written by the author, since the person who wrote the letter need not have been a professional scribe.[15]

Although there is no way of knowing for sure, one may assume that most women in the 16th century Ottoman Empire were illiterate. This was almost certainly true for the Musta'rabs and the lower and lower-middle classes of other ethnic groups. European immigrants to Palestine, particularly from Italy, would seem to have been better educated.[16] Despite R. Joseph Caro's efforts to encourage women to study, if only the *halakhot* that directly affected them,[17] it would seem that literacy extended to reading the prayers at the most. There is no indication in the sources of the existence of a formal educational framework for women. The only reference to anything of this kind can be found in the '*Hasiduyot*' [pietist regulations] of R. Abraham Halevi Berukhim of Safed, which refers to: 'Peripatetic teachers whose job it is to instruct women and children in the prayers and blessings.'[18]

One cannot even assume that upper class women in Palestine and Egypt were literate as a rule. Even among the upper classes, a girl's

[12] MS Cambridge, TS Glass 16, p. 260. The letter is soon to be published by Abraham David.

[13] MS Jerusalem, *Iggerot Shadarim*, letter 46, pp. 328-329.

[14] Turniansky.

[15] Kraemer, "Spanish Ladies", p. 244; idem, "Letters". Kraemer also provides further references and details about correspondence by women in the 16th century.

[16] Among the Arab-speaking congregations, even the education of boys left much to be desired. See Hacker, "Pride," pp. 577-579; idem, "Patterns," pp. 580-581; David, "Relations," p. 80, and excerpts, in the above articles, from R. Issachar Ibn Susan. On the education of girls in Italy, see Assaf, *Sources*, II, pp. 112-113, 121, 239, *passim*; Adelman, "Education;" Fishman, pp. 214-215; On books that were written and translated for women, particularly in the Rhineland, see: Posner. See also Gudemann, pp. 80-81, 91-92. R. Moses Porayit's recommendation to bring Yiddish books to Palestine (note 9 above) also indicates that women – at least Ashkenazi women – could read.

[17] Caro, *Beit Yosef* on *Orah Hayyim*, end of 47; Caro, *Shulhan 'Arukh, Orah Hayyim*, 47, 14.

[18] Berukhim Abraham, Regulation 17.

education depended entirely on the father's whim. Presumably, where private tutors were hired, girls were also allowed to 'listen in,' although not necessarily so. The Spanish exile R. Isaac 'Akrish, engaged by the Radbaz in Egypt to tutor his grandchildren, mentions only the Radbaz's grandsons as his pupils.[19]

In light of the above, the Radbaz's statement that 'most women cannot write'[20] is probably a faithful reflection of the reality of those times. A woman who could both read and write was certainly exceptional.[21]

The professional education of middle- and upper-class women, whose futures were anyway assured, was geared towards the acquisition of domestic skills such as: home-management, cookery and embroidery. Lower-class or indigent women – particularly widows or *agunot* – who had to support themselves, usually found unskilled work as peddlers or the like. Only very few women studied a specific trade or profession.

The lack of professional education among women in the 16th-century Levant has been ascribed to two factors: halakhic restrictions, and the early age at which they got married.[22] A third, and in my opinion, crucial, factor has been overlooked, namely the prevailing ethos of the times. This claimed that women had no need of an

[19] Introduction by R. Isaac Akrish to three interpretations of the Song of Songs, which he published in Istanbul (see quotation in Havlin, "Creativity," p. 265).

[20] Radbaz, II, 801.

[21] In medieval Christian society too, educated women were the exception. The education of aristocratic women, and women of the petty bourgeoisie, was usually restricted to reading and writing, while lower-class and peasant women received no education whatsoever. At least until the 13th century there was nothing unusual about this, since men too were on the whole uneducated, education being the prerogative of the clergy. The educational discrepancy between men and women widened in the late Middle Ages, when the various educational institutions and universities opened their doors to the sons – but not daughters – of the aristocracy and the bourgeoisie. See: Shahar, *Fourth Estate*, pp. 139-143, 191-195, 220-221, *passim*; Aries, pp. 331-333. As far as Muslim women were concerned, Zeevi (p. 338), who researched the Jerusalem district in the 17th century, concludes that the fact that Muslim women were involved in various economic activities indicated that they had some education, and that some of them were probably literate. On the other hand, Zeevi quotes the Franciscan monk Eugène Roger who wrote that throughout the Holy Land it was hard to find a woman or girl who was 'familiar with a single letter' (ibid, p. 326). Although he was referring mainly to Muslim women, and may have exaggerated, it is clear that this was more or less the case.

[22] Grossman, "Child Marriage," pp. 123-124. On child marriage see also above, Chapter 2, "From Childhood to Marriage – The Burden of a Daughter," note 83.

education, but were meant to dedicate themselves to looking after their husbands and homes. Early marriage in itself provides no real explanation of this phenomenon, since even girls who married "late" usually had no education. One cannot help but feel that had the attitude toward female education been different, marriage as such would not have been an obstacle. In other words, women's lack of education was not so much a consequence of early marriage as yet another means of ensuring male supremacy within a patriarchal society. Women's illiteracy intensified their insularity, and enhanced their dependency on men.

Earning a livelihood

We have seen how almost throughout their lives, women were under the tutelage of men (fathers, husbands, or brothers). The various laws, regulations, and customs were designed to protect the family's interests, and restrict women's economic and financial activity. Women's entitlement to property (usually willed them or bequeathed as a bridal gift) was frequently challenged. The only exceptions were widows or divorcees whose *ketubot* conferred on them a degree of financial independence.[23] This meant that when they remarried, they could insist on keeping some of their property for themselves. Leah, for example, a divorcee from Jerusalem, included only half her *ketubah* from her first husband in her dowry to her second. She kept the other half 'to dispose of as she wished, without her husband having a say in the matter.'[24] In another example, Reuben's wife set aside a portion of her property and savings to marry off her daughter: 'Her husband Reuben knew of the existence of this property and

[23] See, for instance, the Radbaz' ruling: "Concerning a woman who has vowed [...] whether she is obliged to fulfill her vow [...] It is clear that all the woman's property is liened to the husband, and she cannot bequeath it [...] unless it is property over which the husband has no right, or if she is divorced or widowed" (I, 513). For some more examples of legal and business transactions by women which were appealed, see: Radbaz, I, 118; II, 656, 783; IV, 1297; Mabit, I, 339; Maharitatz, 1; Maharitatz, New Responsa, I, 54; II, 154; Galante, Responsa, 15, 58, 97 (On the same subject: Maharit, I, 33), 103; Rofeh, 22; Alshekh, 83; Maharit, II, *Hoshen Mishpat*, 56; *Even ha-'Ezer*, 44; Castro, *Ohalei Ya'aqov*, 101, 131 (p. 187b); MS Jerusalem, Tzayyah, 474, pp. 171b-174b.

[24] Maharitatz, 54.

money, but waived any claim to them.'[25] In another case, a clause was introduced in a *ketubah*, specifying that the wife could dispose of her property as she saw fit 'even if she threw it into the Dead Sea.'[26]

Since women served as guarantors for various payments, it is clear that they had collateral to offer. Usually they stood surety for their husbands, occasionally for a son, daughter, son-in-law or other relative.[27] This practice frequently endangered their entire property and *ketubah*,[28] leading to the introduction of a special regulation in Jerusalem '*that no woman should stand surety, even for her father and husband.*'[29] Presumably, the woman's economic interests were not the only consideration behind this regulation. The decisors, no doubt, also wished to avoid a situation whereby the community would be required to redeem a woman from imprisonment for falling into debt as a result of being forced, more often than not, to stand surety for a relative. In other words, they were anxious to spare the community the onus of repaying her debt. Be this as it may, the community leaders themselves were lax in enforcing this regulation, because of their own straitened circumstances.[30]

The names of women appear in settlements, wills, and endowments to various institutions. The endowments were made to the Spanish, Musta'rab, Maghrebi and Romaniot congregations, and most of the donors, predictably, were widowed or childless women.[31]

[25] Ibid, 152.

[26] Gavizon, II, 75 (89). Similarly: Galante, Responsa, 104; Mabit, III, 210.

[27] Radbaz, I, 451; Maharitatz, 155; Maharitatz, New Responsa, II, 125; Alshekh, 98; Mabit, I, 129, 271, 339; II, 184; III, 26; Maharit, II, *Hoshen Mishpat*, 3; MS Jerusalem, *Iggerot Shadarim*, letter 184; MS New York, ENA 2747,8 (the document was photocopied for me courtesy of Dr. Abraham David); Cohen, *Jerusalem*, pp. 140, 148, 191; Cohen-Pikali, document 325, p. 287; document 399, p. 353; document 444, p. 386.

[28] Galante, Responsa, 70 (=81); Maharitatz, 272; Castro, *Ohalei Ya'aqov*, 109.

[29] Freimann, "Regulations," No. 18.

[30] In the incident described in the Jerusalem Shari'a Court documents, the leaders of the community tried to force a wealthy woman to pay her debts to her husband (Cohen, *Jerusalem*, pp. 76-77; Cohen-Pikali, documents 28-29, pp. 30-32). See also Rozen, *Community*, pp. 239-240.

[31] For example: Maharitatz, 28, 182, 248, 259, 276; Maharitatz, New Responsa, II, 123; Maharit, II, *Hoshen Mishpat*, 53, 94; Radbaz, I, 67; II, 677; III, 992; VI, 2242; Gavizon, II, 55(61), 62(68); ibid, Appendix 6, 89; Pinto, 70; Arha, 25; Rofeh, 20; Alshekh, 87 (see also Mabit, I, 329); Caro, *Avkat Rokhel*, 98 (evidently the Mabit, I, 249, is discussing the same issue, but provides only the responsum); Mabit, II, 112, 160, 165 (identical with 147, except that in 147 a passage is missing, which has been added to the end of 165. No. 202, which has the approval of the rabbis of Damascus, also seems to refer to the same case); Badhab, 97, 107-108; Gottheil-Worrell, docu-

Real-estate, money-lending and other investments

Although some women owned land and fields,[32] more owned apart-
ments or houses, or shares in houses.[33] Some women were capable
businesswomen, managing their own property, renting houses, letting
them out, or buying, selling and renovating property. Some of these
business ventures were very profitable. Others were more modest in
scope, restricted to the sale, purchase, or leasing of a single property
or part thereof. These women were tough businesswomen, squashing
any rival claim to their property, even if it meant resorting to litiga-
tion before the various legal instances.[34] Most of these women were
not even wealthy, but belonged to the middle and even indigent
classes, living off the income they received from letting a room or
attic.

In Cairo, most women involved in real estate were women of
Musta'rab or Maghrebi origin, who owned a flat or part of a house.[35]

ment L, pp. 252-254; MS New York, Capusi, 75, p. 123; Cohen, *Jerusalem*, pp. 146,
225-226 (cf.: Jennings, *Kayseri*, pp. 106-107). Archives of the Cairo Community (see
below, note 35), section 1, entries 9, 33, 49, 52, 71, 75, 78; section 3, entries 147,
162, 190, 252. On women who set up endowments see: Gerber, "Waqf," p. 116;
Cohen, *Jerusalem*, pp. 225-227; Cohen-Pikali, documents 367-368, pp. 324-326. See
also Rozen, *Community*, pp. 135, 239-240, and Benayahu, "Sources," p. 377.

[32] Radbaz, III, 992; VI, 2242; Mabit, I, 129; II, 160; Cohen, *Jerusalem*, pp. 146,
224-225.

[33] Mabit, I, 121, 122, 319; II, 18, 122, 157; III, 53; Radbaz, I, 146; II, 651, 673;
III, 995; IV, 1372; Pinto, 70; Alshekh, 87 (on the same subject: Mabit, I, 329);
Galante, Responsa, 15, 62; Maharitatz, 2, 28, 182; Caro, *Avkat Rokhel*, 98; Maharit,
II, *Hoshen Mishpat*, 3, 66, 79, 94; Ralbah, 25, 61; Gavizon, II, 62(68); ibid, Appendix
6, 89; Ashkenazi, 31; "Travels of R. Moses Basola," in Yaari, *Travels*, p. 137; Cohen,
"Damascus," p. 99; idem, *Jerusalem*, pp. 63, 216-217, 225-226, 229.

[34] Galante, Responsa, 15, 62, 97 (on the same subject: Maharit, I, 33); Mabit, I,
122, 319; II, 18, 157; III, 53; Alshekh, 83; Maharitatz, 2, 26, 289; Radbaz, I, 146; II,
673; Maharit, II, *Hoshen Mishpat*, 64, 66, 79; Ralbah, 25; Ashkenazi, 29; Cohen,
Jerusalem, pp. 63, 128, 212, 216-217; idem, "Damascus," p. 99; Cohen-Pikali, docu-
ment 18, p. 19; document 20, p. 21, document 334, p. 295; document 341, pp. 299-
300; document 357, pp. 314-316; document 364, p. 320; document 365, p. 321;
documents 380-381, pp. 336-339; Kraemer, "Spanish Ladies", p. 263.

[35] The records of the Jewish community of Cairo were revised and catalogued (in
part) by I. Ben-Zeev, who also published some of the documents. For details on the
location and publication of these and further documents see: Ben-Zeev, "Archive";
idem, "Cemetery"; idem, "Hebrew Documents." Ben-Zeev's collection and records
are currently housed in the Zionist Archive in Jerusalem. Ben-Zeev wrote abstracts
of the documents he revised, and numbered them. The numbered abstracts have
been incorporated into registers, which are also numbered. Original documents have
also been classified in numbered files. Hereafter, Ben-Zeev's collection will be re-
ferred to as: The Cairo Archives. Records of real estate owned by women in the 16th

Women also acted as money-lenders – both to Jews and gentiles – considered at the time a fairly safe investment.[36] A question addressed to R. Eliezer Ibn Arha relates how the priests and monks of Jerusalem sometimes borrowed money from Jews, thereby providing a livelihood not only for Torah scholars, merchants and ordinary families, but also for widows and orphans. 'For any man or woman who owned 100 *groshos* [silver coins] could start up in the money-lending business [...] In this city there is no other way of making a profit. There have been money-lenders here since time immemorial, and none of the city's great rabbis saw fit to prohibit this activity in any way whatsoever.'[37]

Women kept good watch over their valuables – coins, jewelry, and silver they had been given as bridal gifts, as well as special vessels, festive clothes, and embroidered fabrics. When they felt their property was in danger of being impounded by the authorities, their husbands' creditors, or their husbands themselves, they usually left it with a trustee for safekeeping.[38] When the house of the Jew Mussa Ibn Abu Jukhar was burgled, among the items stolen were valuables entrusted to his safekeeping by Zawidah bat Nisim. These valuables comprised: 'a blue damask cloth with six silver studs, a brown and green shirt, a small silver cup, earrings, a pair of silver bracelets studded with rubies, a Roman bracelet made of silver, an amber pendant in a silver setting, a small red hat, [...] embroidered in gold,

century and the first half of the 17th century can be found in: Cairo Archives, section 1, entries 32, 56, 57, 59, 66, 67, 76, 80, 88, 103; section A, entry 91; section 2, entry 113; Ben-Zeev, "Hebrew Documents," first document (p. 280); second document (p. 281); third document (pp. 281-283). Ibid, description of documents 179 (p. 273) and 347 (p. 276).

[36] Mabit, I, 298; II, 89, 147 (=165), 148, 150(=161); III, 83; Ralbah, 104; Pinto, 106 (a question on the same subject appears also in Lieria, Responsa, 29*, but the responsum is missing); Alshekh, 135; Galante, Responsa, 54; Maharitatz, New Responsa, II, 116; Cohen-Pikali, document 325, p. 287; Kraemer, "Spanish Ladies", p. 254.

[37] Arha, 13(b). On loans to monasteries, and the ambivalence toward this practice, see: Rozen, *Community*, pp. 86-90. In Egypt too, a woman was rumored to have loaned money to gentiles (Radbaz, IV, 1261). The mother-in-law of R. Moses Zussman-Tzarit of Cairo was also said to have sent her son-in-law honest people who provided sure pledges for money they borrowed (Turniansky, letter 4, p. 199).

[38] Galante, Responsa, 42 (on the same subject: Rofeh, 3; Maharit, I, 45); Mabit, I, 242 (on the same subject: Caro, *Avkat Rokhel*, 164); Pinto, 64; Rofeh, 18; Radbaz, II, 656; IV, 1297; Maharitatz, 1; MS Jerusalem, Tzayyah, 544, pp. 273a-274a; Cohen-Pikali, document 419, pp. 367-368. On the subject of movable property owned by women in Jerusalem, see Cohen, *Jerusalem*, pp. 229-230.

half a [...] decorated in red, a pink headscarf, large silk underwear, and a brown checked garment.'[39]

Sometimes, a woman deposited her jewelry or money with her husband or a trustee not merely for safekeeping, but as an investment.[40] A Jewish woman who borrowed money from an army officer residing in Jerusalem was asked to deposit various valuables with the Inspector of Markets, as surety for the loan.[41] Indeed, in some cases women got themselves into debt and found it hard to repay,[42] or petitioned the rabbinical courts for breach of trust. In one such case, the Alexandria rabbinical court tried to help an unfortunate woman by sending her debtor the following letter:

> You are hereby advised that Simhah, wife of Joseph Laniado, appeared before us, claiming she gave you forty-three florins to trade on her behalf. She has currently lodged a complaint with us for default of payment [...] We hereby order you, under pain of excommunication, to dispatch the money owed her with the first trustworthy messenger, for she is poor and in desperate need of the money.[43]

As stated, the main, if not the only, investment channels open to women were property dealings or money-lending. These activities, as well as enabling them to preserve the value of their money and their modesty, did not require any formal training on their part.

Business and Commerce

Indigent Jewish women, who had no property or money of their own to invest, were usually engaged in petty commerce. They traded mainly in textiles (woolen, linen, and silk), and foodstuffs (wine, olive oil, and spices) and sold foods such as yogurt and *pitta* in the market. The sources relate that the neighbor of R. Abraham ben Fuah of Safed 'had business dealings with R. Abraham's wife who was a

[39] Cohen-Pikali, document 56, p. 58; Cohen, *Jerusalem*, p. 125.
[40] Radbaz, III, 955; VI, 2245; Maharit, I, 115; Maharit, New Responsa, 22; Galante, Responsa, 29, 104; Mabit, II, 94; Maharitatz, New Responsa, II, 219; Maharitatz, 9.
[41] Cohen, *Jerusalem*, p. 229.
[42] Maharit, I, 115; Maharitatz, IV, 235; Mabit, III, 98; Rofeh, 22; Galante, Responsa, 58.
[43] MS New York, ENA 3616, p. 7.

shrewd businesswoman,'[44] and that a widow from Safed used to visit the outlying villages to buy vegetables and other goods to sell in the market.[45] In another case, the rabbinical court granted a widow custody of her children 'since she was a skilled businesswoman, and earned enough to support her children, despite the fact that she did not go out to work.'[46] Another widow successfully managed her husband's business, and enlisted the help of her eldest son to sell their merchandise abroad.[47] In another case, a married but childless woman was described as 'a shrewd businesswoman' who had managed to amass a tidy profit.[48] A woman is also mentioned in connection with renting a stall in the Jerusalem market.[49] One of the Mabit's responsa involves a financial dispute between a female merchant and a "griega" (Greek woman) with whom she did business. Substantial amounts were involved. Although the place is not specified, the dispute would seem to have taken place in Safed or Aleppo.[50]

The traveler Pierre Belon, who visited Turkey and the Balkans in the middle of the 16th century, relates how Jewish women ran handicraft and haberdashery stalls in the Ottoman markets, charging grossly inflated prices. As well as selling their own wares, they acted as brokers for Muslim women whose religion forbade them to trade in public:

> The Jewish women, who are free to go around unveiled, can usually be found in the markets of Turkey selling needlework. And since Islamic law forbids Turkish women from trading in public, Jewish women act as their brokers. Usually they sell: towels, kerchiefs, spoons, white belts, cushions, and other valuable items such as: various kinds of bed canopies and bed-clothes, which the Jews purchase from them and sell to others.[51]

[44] Benayahu, *Ari*, p. 237.

[45] Galante, Responsa, 31.

[46] Gavizon, I, 16.

[47] Pinto, 71.

[48] Radbaz, I, 67.

[49] Cohen, *Jerusalem*, p. 211.

[50] Mabit, I, 286 (For identification of location, see Lamdan, *Status*, p. 674). See also, Galante, Responsa, 63, 70 (=81); Radbaz, I, 398; Badhab, 67; "Travels of R. Moses Basola," in Yaari, *Travels*, p. 151; Cohen, *Jerusalem*, p. 69, note 63; pp. 71, 140, 148 (about a woman who pawned fabrics and silk), pp. 198-200, 204; idem, "Damascus," p. 98; Cohen-Pikali, document 248, p. 233; document 426, p. 372; Assaf, "Documents;" Kraemer, "Spanish Ladies", p. 249.

[51] Belon, III, p.182 (English translation based on Hebrew translation , Lusitanus, p. 73).

It is clear from his description that Jewish women played a far more active role in commercial life than did their Muslim sisters.[52]

Not all women were quite as successful. Beyla bat Simeon, of Jerusalem, who had a textile, jewelry and pearl business, fell into serious debt and was imprisoned. A Jewess by the name of Habiba was arrested for selling sugar and almonds at an exorbitant price.[53] In yet another case, Dina, whose husband went abroad and left her money to trade with in his absence, lost all her money.[54] Most of these women were not engaged in business in a big way. Most were simply peddlers or stall-keepers in the market. They had nothing in common with the courtesans of Istanbul, who were 'like merchant ships bringing back their wares [...] amassing wealth and riches [...] from the fruit of their hands.'[55]

[52] Zeevi's enlightening study of the *sancak* of Jerusalem in the 17th century shows that many Muslim women were also involved in business transactions of various kinds, such as purchases and sales, and money-lending. On many an occasion, they even appeared in person before the judge to defend their rights. His findings, based mainly on the Shari'a court records, led him to the conclusion that "women effectively ran their own social, economic and cultural system, which was sometimes richer and more advanced than its Western counterpart. Although this system was totally segregated from the male system, it was just as dynamic." In light of this finding, Zeevi believes there is room for revising the general impression formed by travelers from the West regarding the status of women in Islam (according to their testimony, Muslim women were closeted in their homes, and barred from economic activity) (Zeevi, pp. 334-340).

Although these conclusions are fascinating, the impression gained by the travelers is understandable: Zeevi himself stresses that the socioeconomic system of the women was totally divorced from that of the men, and that access to it by men was extremely restricted. Moreover, the type of activities he cites by way of example are the purchase and sale of property, and money-lending – activities that did not necessitate public appearances, but could be conducted from the home or through a broker (*waqil*). Even large-scale transactions were confined to these kinds of activities, and were conducted covertly, so that visitors from the West would have had no inkling of their existence.

Zeevi's conclusions regarding the women of the Jerusalem *sancak* correspond to Jennings' conclusions regarding the women of Kayseri: Muslim women participated in economic life only with respect to property transactions and money-lending (Jennings, *Kayseri*, p. 65). On the other hand, see Shahar's conclusions regarding urban women in Christian Europe from the 13th to 15th centuries: They specialized in dozens of professions, belonged to certain guilds and were involved in commerce and property transactions. Their economic activities were extremely varied, although they usually did not belong to affluent or aristocratic families (Shahar, *Fourth Estate*, pp. 171-177). On the prolific economic activity of women in the Genizah period, see Goitein, *Society*, I, pp. 127-130, 256; II, p. 107.

[53] Ibid, p. 71; Cohen-Pikali, document 248, p. 233.

[54] Mabit, II, 184.

[55] Maharit, II, *Hoshen Mishpat*, 67; for a brief account of habituées of the harem and the courts of Istanbul, see Rozen, "Influential Jews," p. 395, and letter 132, pp. 429-430; Bashan, "Testimonies," pp. 65-66.

Crafts and other professions

Alongside the female money-lenders, vendors, and property dealers there were also female artisans and professionals. A rather exceptional woman from Aleppo was a licensed steel welder (skilled in the art of '*aziero*'). After her husband died, she decided to take on a partner. 'You need two people in the welding business, one to manage the oven and remove the molten steel, and the other to weld.' [56] She found a partner in the person of Reuben, whom she instructed in the secrets of her trade. Fearing he might pass on these secrets to others, she employed him on the understanding 'that he would not set up business with any person, Jew or gentile, other than herself, in Tsobah (Aleppo), or any of the areas under the jurisdiction of the governor of Aleppo.' After a while, the two no longer saw eye to eye, and agreed to go their own way, after first dividing their work tools between them. The widow, Leah, subsequently entered a new partnership with gentiles, while Reuben, notwithstanding his undertaking, also set up in business with others. The widow sued him for breach of contract. When the case was brought before the sages of Safed, R. Moses Alshekh upheld the widow's claim that Reuben was forbidden to ply the same trade. R. Moses Trani and R. Joseph Caro, however, claimed that Reuben himself was entitled to practice the trade, but was forbidden to take on an active partner. He could take on a sleeping partner as an investor, but was not allowed to teach him the profession. As for the widow, although she was allowed to enter into a partnership with others, 'the congregation would be well-advised to pass a regulation forbidding her to work together with gentiles, so that her trade would be kept within the Jewish community.' [57]

Jewish women also worked as weavers, embroiderers, and seamstresses. The Radbaz points out that women embroiderers in Egypt

[56] Benayahu ("Controversy," p. 77) suggests that the profession in question may have been candle-making, but candle-making does not require two people and a large kiln, as described in the question, and no professional secrets are involved. At first, I thought the reference was possibly to a metal foundry manufacturing iron or steel chains and the like (see Lamdan, *Status*, p. 678, note 1), but more recently I came across an exact definition in R. Samuel Jaffe's exegesis of *Bereshit Rabbah*: "[...] the cementing of metals, through soldering, known as *aziero* in Ladino, which holds the pieces together so they do not break" (*Sefer Yefeh Toar*, Section 49: 19, p. 97a). The reference here is, undoubtedly, to metal welding.

[57] Alshekh, 57; Mabit, II, 27.

had their husband's permission to practice this profession, and did so because of their straitened financial circumstances. [58] The widow Rachel, who lived in Jerusalem, wrote to her son that 'your Beyla [her grand-daughter] has a talent for silver and gold embroidery. If your wife has too much work, she can help her out.'[59] (The allusion is probably to silver and gold filigree.) In an interesting aside, R. Moses Porayit, who visited Palestine in the mid 17th century, advised potential emigrants to Palestine to take with 'Spanish needles and large and small pins [...] as well as knitting needles,'[60] indicating a possible shortage of such items.

Women also worked as wine and cheese-makers,[61] town-criers and brokers,[62] beauticians and cosmeticians,[63] and in Egypt – teachers of young infants.[64] There were, naturally, *miqveh* supervisors,[65] and women who dealt in medicine and midwifery.[66] The sources also mention a widow who hired herself out as a servant (and was subsequently impregnated by her master).[67] The Responsa mention an unusual source of livelihood provided by a rare breed of cat, a civet ['*al-ghaliya*' cat]. (The owner of this valuable cat bequeathed it to her

[58] Radbaz, III, 919(481); Ralbah, 27; Benayahu, *Ari*, pp. 113, 167, 224; Pachter, "*Hazut Kasha*," p. 182; Cohen, *Jerusalem*, p. 195; Ashtor, II, p. 341. David Dei Rossi wrote in 1535, after arriving in Safed: "any man or woman engaged in the wool trade earns a handsome living" ("Letter of David Dei Rossi" in Yaari, *Letters*, p. 184).

[59] Turniansky, letter 6, p. 205.

[60] "Travels of R. Moses Porayit," in Yaari, *Travels*, p. 278. Also, in one of the letters of the aforementioned widow, she begs her son to send her daughter small needles (Turniansky, letter 2, p. 187).

[61] Badhab, 67; Benayahu, *Ari*, p. 178, note 4. In the city of Bursa, Anatolia, a Jewish woman is mentioned as belonging to the cheese- and yogurt-makers guild (Gerber, "Bursa," p. 258).

[62] Cohen, *Jerusalem*, p. 209; Cohen-Pikali, document 202, p. 194. The term "*dalal*" mentioned in the documents can mean, broker, middleman, or town-crier. Gerber ("Bursa," p. 258) and Ben-Zeeb ("Hebrew Documents," p. 283) translate "*dalala*" as broker. MS Cambridge, TS Glass 16, p. 260, mentions a woman by the name of Seraq al-Dalala. Her name may have alluded to her profession.

[63] Cohen, *Jerusalem*, pp. 167, 224; Cohen-Pikali, document 353, p. 310.

[64] The "*mu'allima marhaba*" taught the young grand-son of the widow Rachel of Jerusalem (Turniansky, letter 3, p. 189). A Karaite traveler from the mid-17th century relates that he came across a woman teaching infants in Egypt ("Travels of Moses ben Elijah Halevi the Karaite," in Yaari, *Travels*, p. 317). In an earlier period, there are references to female tutors in Egypt in the responsa of the Rambam, I, 35, 45. See also Goitein, *Education*, pp. 69-71.

[65] Maharit, II, *Even ha-'Ezer*, 19; Maharitatz, New Responsa, II, 185.

[66] Radbaz, I, 410; IV, 1188; Ralbah, 52; Maharitatz, 40; Gavizon, II, 72(84); Alashqar, 89.

[67] Radbaz, IV, 1190.

son. Since the latter was out of town at the time, the daughter was asked to look after it in the interim, in return for being allowed to use the musk for perfume over a specified period of time. The son, returning to the city sooner than expected, claimed the animal back from his sister, fearing that his sister was not feeding it properly.[68]) Many soothsayers and fortunetellers were women.[69] And let us not forget that oldest of female professions – prostitution. A certain "notoriously promiscuous woman" in Cairo is mentioned, "who consorted with Jews and gentiles whose names have been publicized [...] and even admitted to having a constant stream of visitors".[70]
Women who plied trades or practiced crafts in order to supplement their income are mentioned in other sources, although their profession is not always specified.[71]

'Her handiwork belongs to her'

The fact that Jewish women in Palestine and Egypt were active participants in the economic and commercial life of these countries can be explained, inter alia, by the conditions of the *ketubah* relating to their right to the proceeds from their handiwork. In this, the Musta'rab custom differed from that of the European immigrants: In most Jewish communities, the *ketubah* contained the clause: 'her handiwork belongs to him, and he is responsible for keeping her clothed.'[72] However, the *ketubah* of the Musta'rabs in Palestine and

[68] Mabit, II, 137. The manufacture of perfume (*ghaliya*) through the extraction of musk from muskrats by Egyptian Jews is mentioned also in Castro, *Ohalei Ya'aqov*, 22.

[69] Vital, *Sefer ha-Hezyonot*, 5-6 (p. 3); 12 (pp. 6-7); 18 (p. 10); 3 (p. 85); 7-8 (p. 87); 53(52) (p. 120).

[70] Gavizon, I, 5. For further cross-references, see below, Chapter 8, "Social Norms versus Reality."

[71] See, for example: Radbaz, IV, 1261; Mabit, I, 312; III, 42; Benayahu, *Ari*, pp. 192, 271; MS Jerusalem, *Iggerot Shadarim*, no. 171, pp. 200-202; no. 185, pp. 216-217; MS Jerusalem, *Sefer Tikkun Soferim*, 73, pp. 81a-82b; David, "Genizah," document 16, pp. 52-53; idem, "Sholal Family," document 5, p. 402 (see also p. 387).

[72] The sages ruled "her maintenance in exchange for her handiwork," (*Ketubot*, 47b; 58b-59a), while "her clothing" is a later addition. The *Shulhan 'Arukh* says that "clothing" is included in maintenance (Caro, *Shulhan 'Arukh, Even ha-'Ezer*, 9, 4) The difference in phraseology is significant, since food is a vital necessity (see Friedman, *Polygyny*, p. 103, note 40; Goitein, *Society*, III, pp. 134-135); On the husband's right to his wife's handiwork, see Epstein, *Marriage Contract*, pp. 98-102; Elon, *Jewish Law*, pp. 467-468.

Egypt stipulated: 'her handiwork belongs to *her*, and he is obliged to provide a certain sum each year to cover her clothing needs.'[73] This condition no doubt encouraged Musta'rab women to seek economic independence. R. Joseph Caro confirmed, albeit somewhat begrudgingly, 'that they [the Musta'rab men] are not entitled to their wives' property. Even if he [the husband] is in dire poverty, or languishing in jail, his wife does not let him use her property.'[74] Not all husbands accepted this situation with equanimity, as the following question to the Radbaz indicates:

> Concerning the custom in Egypt, whereby the husband stipulates that the wife's handiwork belongs to her, and that he is responsible to pay her a yearly clothing allowance: Let us suppose that the wife is a good worker, and does not use up all her clothing allowance, but puts money aside, and becomes a money-lender, lending money to gentiles for interest, can the husband claim the usufruct thereof? [Answer]: The husband has no grounds for such a claim since [...] he has already waived any claim to her handiwork. Therefore he is not entitled to her handiwork or the usufruct thereof [....] Moreover, since it is the custom here for a woman to use her earnings to help relatives or marry off daughters, or in any other way she see fit, and since the *ketubah* stipulates that her handiwork is hers, the husband, by marrying her, automatically endorses this custom. For when a man gets married, he takes on the local custom, even if it contravenes *halakha* [...] or is not explicitly specified.[75]

Presumably, the custom of adding this condition to the *ketubah* was influenced by the Muslim society in which the Musta'rabs lived. The traveler Meshullam of Volterra described the Muslim custom as follows: 'The man gives a bridal gift to his wife, and from that day on, he is obliged to feed her, but she is responsible for her clothing and all other needs.'[76] The Jerusalem Shari'a court records testify to the fact that women insisted on their right to a bridal gift and their prerogative to dispose of it in the manner they saw fit, even suing their parents or husbands if need be.[77]

[73] Radbaz, IV, 1141. See also: MS Jerusalem, *Sefer Tikkun Soferim*, p. 14b (for a photocopy of the document see Rozen, "Musta'arabs," p. 86). On the formulation of the condition in the Genizah marriage deeds, see Friedman, *Polygyny*, p. 103, note 40; idem, "Polygamy," p. 355, note 174.

[74] Caro, Responsa *Beit Yosef*, 21 (=Laws of *Ketubot*, 2, p. 82).

[75] Radbaz, IV, 1261.

[76] "Travels of Meshullam da Volterra," in Yaari, *Travels*, p. 76; ibid, p. 46.

[77] Zeevi, pp. 332, 335. In the early 20th century, R. Raphael Aaron ben Shimon of Cairo pointed out that this Musta'rab custom had already been abolished, and

In conclusion, Jewish women had a contribution to make to economic and commercial life in the East Mediterranean basin. Their contribution was mainly in the field of business, real estate, handicrafts and petty commerce. In this respect they differed from Muslim women, or Christian women living in Muslim society, whose main livelihood came from property transactions and moneylending. Although economic activity in and of itself gave women a certain independence, most working women, irrespective of personal status or ethnic background, were not wealthy. On the contrary, most belonged to the lower and middle classes, for whom working was a necessity. From the cases discussed in the sources, it is clear that the businesses run by women were small-scale, home-based industries. The type of professions women took up – with a few exceptions – indicate that women were perceived primarily as housewives. Work was seen as a last resort, and was restricted to traditionally 'female' occupations, such as embroidery, sewing, peddling and petty commerce, which did not require special training. The more affluent women took on different types of occupations, such as property dealings or money-lending. According to the sources: 'Our women are not accustomed to doing business when their husbands are around. But when their husbands are away, they do business from their homes.'[78] Note that mixing with the public, for whatever reason, was considered unseemly behavior for any woman, irrespective of class.

Despite the social convention that a woman's place was in the home, her job often required her to mix with others, in markets, streets and villages. The Sages, discomfited by this practice, passed a regulation in Jerusalem (of which, unfortunately, only a fragment remains) with the explicit injunction: '*that women should not engage in business* [...]'[79] By business, one can assume, they meant financial transactions, commerce, or peddling.

Although most female money-lenders or real estate investors were widows, some married women had a good business sense too. Of the 112 women cited in property or financial disputes (excluding those who acted as guarantors for their husbands), 44 were widows, 27 were married, 4 were divorced, 3 were single, and 34 were of un-

added: "Thank God, because it is a contemptible custom borrowed from Arab gentiles" (Ben Shimon, *Nahar*, II, p. 194).

[78] Mabit, I, 190.

[79] Freimann, "Regulations," No. 8; ibid. pp. 209, 212.

specified status. With respect to female merchants, while the picture is not very clear, it would appear that equality of a sort existed between married women trying to supplement their family's income, and widows and *agunot* working to support themselves. References to businesswomen in the sources specify nine married women, and eight widows and *agunot*. In over twenty cases, the personal status of the women is not specified.

CHAPTER EIGHT

SOCIAL NORMS VERSUS REALITY

In Jewish society, as in Muslim society, encounters between men and women always bore sexual implications. The concept of platonic friendship between men and women did not exist. Therefore, men and women (other than first-degree relatives) were segregated. In middle- and upper-class families especially, young women and girls of 'good breeding' were kept closeted in their homes. As we have already seen, innocence and modesty were considered basic virtues, and were prerequisites for finding a suitable match or, in the case of a married woman, for safeguarding her reputation. However, despite this attempted segregation, there were many opportunities for women and men to meet. Indeed, the establishment's constant battle to prevent violations of religious or societal norms in itself is indicative that such violations were not uncommon.

Opportunities for encounters between the sexes were provided mainly by family celebrations (engagement or wedding parties), festivities associated with religious ceremonies (circumcision and other religious rituals), and festival meals. Usually the wine flowed freely on such occasion, weakening social constraints. In some communities mixed dancing was common at such events, to the extent that the rabbis were forced to enact regulations banning this serious 'violation' of religious norms.[1]

R. Jacob Castro describes how such a regulation came into being in Cairo. According to him, it was 'an ancient custom' for gentile girls to play and dance at weddings. The Jewish men, captivated by their beauty, ended up committing a variety of transgressions. For this reason, the rabbis passed a regulation that only members of the Holy Society (*hevra kedosha*[2]) were permitted to entertain at weddings,

[1] For example, Castro, *Ohalei Ya'aqov*, 71; Pinto, *Yoreh De'ah*, 16, 32; Radbaz, I, 329; Mabit, I, 241; Benayahu, *Ari*, p. 216; Idem, *Beauty*, pp. 35-36, 47; Bornstein-Makovetzky, "Arta," p. 145; Rozen, *Community*, pp. 239-240; B. Rivlin, "Family," pp. 86-87; Aligieri, *Yoreh De'ah*, 6.

[2] Volunteers from the *Hevra Kedosha* had a dual function: Performing the burial rites and entertaining bride and groom. See Bornstein-Makovetzky, "Community," pp. 181-195.

in order to "deliver Jewish men from the clutches of these gentile women, by barring them access to Jewish terrain."[3] Evidently, this regulation was introduced by the Radbaz himself: "He abolished the custom of hiring gentile girls [...] to play and dance at weddings and celebrations [...]. *Instead, it was decided that the hevra kedosha would be divided into two groups [...] one to bury the dead, and the other to entertain bride and groom.*"[4] This regulation was observed for about sixty years, until a bride complained that a drummer of the *hevra kedosha* had touched her leg during the ceremony when the bride is escorted to the groom. The *hevra kedosha* was subsequently banned from playing at weddings for five years. In 1592, in a ceremony that was enacted in the presence of most of the city's sages, the ban was extended for a further ten years.

It soon became obvious, however, that the game was not worth the candle as disputes and conflicts at weddings became commonplace: "The barriers have been breached. Much unseemly behavior takes place at weddings, when all the renegades and rakes convene [...] to play and dance and sing before the bride." In view of this situation, R. Jacob Castro, who had lent his signature to the ban, now argued for its rescission. Refusing to sanction the presence of such "depraved men" at his daughter's wedding, he invited members of the *hevra kedosha* instead, as had formerly been the custom. He argued that the *hevra kedosha* regretted its previous improprieties, and had since undertaken to dispatch only upright and God-fearing men to provide entertainment at weddings. They had also decided "to send along fewer men, so as to preserve decorum." In light of the above, he argued, there was no longer any danger.[5]

The frequent amendments to regulations governing celebrations in Egypt are indicative of the conflict between the tendency toward natural exuberance on the part of the public, and attempts by the sages to curb this exuberance, for fear of where it may lead.

In Egypt, where it was standard practice for women to work in factories, legislation was introduced to prevent the sexes from fraternizing. Even in the pre-Ottoman period, the *Neggidim* introduced legislation banning Jewish women from working in non-Jewish factories, to prevent immoral behavior. Since, however, most women disre-

[3] Castro, *Ohalei Ya'aqov*, 60.
[4] Sambari, 218 [should be 219], p. 256 (photocopied edition).
[5] See note 3 above.

garded the regulation, it was amended, in the days of the Radbaz, as follows: "*Men and women embroiderers are henceforth forbidden to sit at the same work table*" and "*only older women – aged forty or over – are allowed [to ply this trade].*"[6]

A similar concern in connection with the fraternizing of the sexes in the synagogue courtyard before and after the service, occasioned the following Jerusalem regulation: "*No woman is allowed to stay for the closing kaddish* [signaling the end of the service], *of the morning, afternoon or evening prayers.*"[7]

Group trips to the city outskirts, customary in Aleppo and Damascus, were also seen as occasions for potential dissipation. Eventually, the rabbis of Damascus introduced a regulation "*that no woman was to leave the city gates other than to accompany the dead.*"[8] Likewise mass pilgrimages to the tombs of holy men. One of the regulations that R. Moses Basola copied from the wall of a synagogue in Jerusalem in 1522 stated: "*Drunken people may not visit the tomb of Samuel the Prophet, may he rest in peace, in Rama, and it is forbidden to drink wine while staying there.* For since men and women are in the habit of drinking while there and becoming intoxicated, this regulation has been introduced to prevent transgression. For although the local custom is for women to go out veiled and cloaked, this custom is not observed by women visiting the site."[9]

In Safed, R. Joseph Caro and his court made a similar attempt to prevent 'unseemly behavior' during pilgrimages, by introducing the following regulation: "*Women should not dress up in their finery to go to Meiron [the tomb of Rabbi Simeon bar Yohai], and [even] if they wear weekday clothes – they should not stay there overnight, with the exception of older women.*" The Ari, however, countered: "Should we go against the Rashbi

[6] Radbaz, III, 919. Similarly, older women were not required to wear a veil ("Letter of David Dei Rossi" in Yaari, *Letters*, p. 184; "Travels of R. Moses Porayit," in Yaari, *Travels*, pp. 283).

[7] Freimann, "Regulations," No. 2, p. 208. In the Genizah period too, the synagogue served as a social meeting place. For a brief review, see Goitein, "Position," p. 179.

[8] Vital, *Sefer ha-Hezyonot*, III, 7 (p. 87); Ashtor, II, p. 342.

[9] "Travels of R. Moses Basola," in Yaari, *Travels*, pp. 159. On mass pilgrimages to Meiron and to saints' tombs in the Galilee, see "Travels of R. Moses Basola," in Yaari, *Travels*, pp. 155-157. Also in Yaari, *Travels*, "Travels of Meshullam of Volterra," pp. 74-75; "Travels of R. Moses Porayit," p. 301; "Travels of Moses Ben Elijah the Karaite," p. 315. Benayahu, "Devotion," pp. 27-30.

[Rabbi Simeon bar Yohai] himself, especially since this has been the custom for so many years!..."[10]

Apart from ritual celebrations, men and women had plenty of opportunities for mixing in daily life, since privacy in 16th-century life was a rare commodity. Many families lived in the same courtyard, and shared a communal well, oven, and outhouse. Under such circumstances, it was inevitable for neighbors to meet each other while going about their daily business. Men and women also met while shopping in the market, in their dealings with the various authorities, on their way to the bathhouse or spring, on journeys and the like.[11] The traveler Pantaleo de Aveiro, for example, describes an encounter with a Jewish woman of Portuguese origin who was washing clothes in the Silwan pool in Jerusalem. He began conversing with her, much to the disapproval of her elderly companion, who ordered him to leave when she felt that he had overstayed his welcome.[12]

To ward off temptation, the Safed kabbalists advised men *"to make every effort to avoid looking at women, or even at their clothes."* For the same reason, they also tried to marry off their children as young a possible.[13] Another regulation stipulated that any bachelor aged 20-60 who moved to Jerusalem, had to get married within a year of his arrival, since "there is no guardian against immorality" (*Ketubot,* 13b). Any bachelor who failed to get married within a year, would be required to leave.[14]

The Expulsion of the Jews from Spain, their subsequent migrations, the breakup of families, and the encounter with members of other diasporas, took their toll on hitherto unchallenged norms and

[10] Benayahu, *Ari,* p. 219, and notes there. (Comapare with R. Hayyim Azulai's versions, as brought by T. Friedman in *Sefer Hida* [Jerusalem, 1959], p. 13).

[11] For example: Mabit, I, 14; Castro, Ohalei *Ya'aqov,* 52; Caro, *Avkat Rokhel,* 58; Maharitatz, 192; A. Cohen, *Jerusalem,* pp. 140-159; MS Responsa Ibn Tzayyah, 370, pp. 51a-52b.

[12] "Travels of Pantaleo de Aveiro," Ish Shalom, pp. 293-294

[13] Toledano, pp. 48-51, regulations 7 and 18 (predating 1577). See also recommendations of the kabbalist R. Elijah de Vidas (De Vidas, *Tozeot Hayyim,* pp. 14b-15a); Berukhim Abraham, 12, p. 298 (for another version, see Hallamish, Text, 31, p. 92.)

[14] Shohat, p. 396, and references there. The exact date of the regulation is unknown, but the sources describe it as an ancient regulation. According to the traveler Moses Porayit, who visited Jerusalem in the mid-17th century, bachelors were advised against staying in Jerusalem ("Travels of R. Moses Porayit," in Yaari, *Travels,* p. 285). R. Moses Hagiz also mentions complaints of "bachelors being forced into matrimony" in Jerusalem (Hagiz Moses, p. 33b).

mores. The Spanish and Maghrebi (North African) Jews were accused of being lax in matters of morality.[15] Safed was rumored to be in the throes of a moral collapse,[16] and the communities of Damascus and Egypt gained notoriety for their moral dissipation.[17] The shared sense of loneliness and loss among the refugees created a bond between the sexes, which defied social and moral constraints.[18] Women who had become separated from their husbands or families, or *agunot*, allowed themselves a freedom that would have been impossible under ordinary circumstances in their natural environment.

This explains why the 16th-century sages were so preoccupied with the issue of immorality. Some, seeing it as the cause of national disasters, frequently bemoaned the "decadence of the generation," and demanded a tightening of the laws: "In this depraved generation [...], where immorality is rife, it is best that people remain ignorant even of what is permitted!"[19]

This moral decline moved the community leaders of Safed to establish a "modesty committee" [*Va'ad Berurei 'Aveirot*], an institution imported by the Spanish exiles to various places in the Ottoman Empire. The function of this "modesty committee" was to maintain moral standards in the city, by investigating alleged cases of immorality, and punishing the culprits.[20] This it sometimes did with such inordinate zeal that R. Moses Trani (the Mabit) was moved to protest: "The leaders and sages appointed in some communities to stamp out immorality and to castigate sinners, often disregard serious transgressions, while being overly strict over petty misdemeanors, such as the matter in hand, which does not even contravene a rabbinical injunction!"[21] Even the Ari, who was himself a member of the

[15] Radbaz, I, 48; VII, 59; Ashtor, II, pp. 525-526. On the low moral caliber of Spanish Jewry, see also Assis, "Crime."

[16] Vital, *Sefer ha-Hezyonot*, I, 22 (p. 24); Idel, p. 122-123.

[17] MS London, Garçon, p. 157; Vital, *Sefer ha-Hezyonot*, I, 24 (pp. 32-35); ibid, III, 53 (pp. 120-121); Sambari, 206 (pp. 243-244 in photocopied edition).

[18] Benayahu, "Sermons," pp. 44, 203.

[19] Radbaz, IV, 1296 (=VII, 33); ibid, I, 196; III, 850 (=407), 873; Alashqar, 89; Rosanes, II, pp. 182-185; Benayahu, "Sermons," pp. 173, 180-181 (see also Hacker, "Pride," p. 552, note 31; Benayahu, *Ari*, p. 200, note 1; Idel, pp. 122-124).

[20] Benayahu, *Ari*, pp. 159-160. In various communities in Spain, similar institutions existed already by the mid-13th century. Indeed, these institutions were so intimidating that some even said that they taught the Inquisition a thing or two (Baer, pp. 138-139, 150, 266; Benayahu, *Ari*, p. 108, notes 3-4; Epstein, *Studies*, p. 38; Newman, pp. 135-136, 144-154; Castro, p. 534).

[21] Mabit, II, continuation of 209.

said committee, tried to clear the name of a woman of Safed which
had been blackened by one of the more zealous members of the
committee. As stated above, the Ari had also opposed the ban on
women visiting Meiron.[22]

Under the guise of safeguarding morals, and with rabbinical back-
ing, the right to privacy was violated. In such a climate, slander and
hearsay flourished. Prying neighbors were only too happy to air their
suspicions, or testify in court. Consequently, women as a whole had
to be extremely careful not to provide would-be gossip-mongers with
fodder.[23] Many marriages foundered and many matches were re-
voked on the basis of such gossip.[24] The following story is a case in
hand:

> This story concerns one Reuben, who already in the past has been
> suspected of pursuing a married woman with intent to committing adul-
> tery. An old woman has now come forward to testify against him. She
> says that at midnight one night, she saw Reuben go to the outhouse
> under cover of darkness. Because she suspected Reuben of adultery with
> this woman, she ran to the woman's house to find out if she was home.
> Upon discovering that she was not, she immediately ran back to the
> outhouse [...] and made as if to enter [...]. The old woman claims that
> she heard the voice of the married woman inside the outhouse [...] and
> saw her, with her own eyes, leave the outhouse and run home [...] The
> old woman did not move until she saw Reuben, with her own eyes,
> leave the outhouse."[25]

The woman's testimony was corroborated by other women who had
seen the exploits of Reuben and his adulterous lover. In the end, R.
Hiyya Rofeh, who was adjudicating the case, had to decide whether

[22] Benayahu, *Ari*, pp. 159-160, 219. The stricter member was R. Samuel de
Uceda.

[23] On a married woman of Safed who was forced to leave the neighborhood
because of the importunings of a man named Moses Catalan, see: Caro, Responsa
Beit Yosef, Laws of *Kiddushin*, 2; Mabit, I, 291. On prying neighbors, see also
Maharit, II, *Even ha-'Ezer*, 1 (Istanbul); Alashqar, 3 (Corfu). On the privacy of the
individual in the *sancak* of Jerusalem in the 17th century, see Zeevi, pp. 320-324. In
an article on the meaning of 'privacy' in Muslim society of 18th-century Aleppo, and
the enforcement of social and moral control, Marcus (pp. 169, 177) emphasizes that
the strict socio-religious norms were not peculiar to Muslim society, but were com-
mon to Jewish and Christian society too, and were based on conventions that had
evolved through the centuries.

[24] For example: Radbaz, I, 398; IV, 1357; VII, 10; Maharitatz, 108; Maharitatz,
New Responsa, I, 9; Maharit, II, *Yoreh De'ah*, 49; Badhab, 106; Dei Rossi Azaria, p.
394.

[25] Rofeh, 23.

to banish Reuben from the vicinity of the woman. It is interesting to note that in this case, public pressure was directed at the man, not the woman. It was he who was cast in the role of seducer, and there was no attempt whatsoever to take any action against the woman.

The following, equally fascinating, case was brought before R. Yom Tov Zahalon:

> The story concerns one R. Moses Adrotiel, who five or six years ago left home on a journey and abandoned his wife. Rumor had it that his wife was prostituting herself with all and sundry, although there was no reliable evidence to this effect. She was accused, in particular, of fornicating with gentiles [...]. She was admonished by her neighbors, and by certain Torah sages, [...] but to no avail [...]. She would make her way to her gentile lover's house by night. On one occasion she was seen by a Jew who called his friend, saying: "Come with me and I will show you that so-and-so is committing adultery with a gentile! She has gone into his house. All we have to do is wait for her to come out." [...] After both of them had waited for a while, the second witness, eager to go home, said: "Perhaps it is all a mistake, for night has long since fallen." [...] As they were talking, the sinful woman emerged, followed by the adulterer, who proceeded to embrace and kiss her before their eyes. [...] The second witness, unable to contain himself, shouted at them saying: "Haven't you had enough?" [...] The gentile then came to the neighbor's house to retrieve his belongings, and the horse which was tethered there. He said to the neighbor: "Here is my *yağmurlok* [Turkish for raincoat]. I left it at home but want to take it with me." At this, the neighbor and a friend who happened to be passing by, pricked up their ears, for surely this was proof of the sin they had committed. He must have taken the *yağmurlok* with him to place on the ground for her to lie on when he slept with her. For otherwise, he would have left the *yağmurlok* there with all his other belongings [...] Surely no further proof of their crime was necessary.[26]

In this case, the Maharitatz had to decide whether the woman, as an adulterer, was forbidden to her husband. In the end, he left the decision up to the husband: "Her husband should be informed of what has happened. Perhaps he will cast her out. In any case, she has forfeited her *ketubah* and any conditions therein."

In 1557, the wife of a Torah scholar in Safed was accused by an unscrupulous youngster of "an immoral act." The Mabit, R. Shem Tov Bibas and R. Hayyim Haver, ruled that the boy was disqualified from giving testimony in this case, due to bad character and a history of similarly false accusations. They not only declared the wife permis-

[26] Maharitatz, 192.

sible to her husband, but even attempted to allay his suspicions with
arguments such as: "Her wise husband should take no notice of this
malicious fellow, and certainly not trust him [...], especially as he
knows his wife is incapable of such behavior. Has he himself not
testified that in ten or more years of married life, he has never had
cause for complaint, has never had reason to suspect her of any
wrong-doing, and that she obeys him implicitly?"[27] The husband,
however, refused to accept their decision, and approached another
bench of *dayyanim*, comprising R. Eleazar ben Yohai, R. Abraham
Aruety, and R. Jacob Yirgas. He presented them with the testimonies
of people who had followed the woman one night to the house of a
man named Joshua ben Menasheh. It later transpired that the pur-
pose of her visit was to borrow money. Nevertheless, this second
court ruled that the woman should forfeit her *ketubah* and her main-
tenance – which had evidently been the husband's intention all
along. The case was again referred to the Mabit, who strongly sup-
ported the rights of the maligned woman, and proceeded to system-
atically refute all the incriminating evidence. He likewise disqualified
the *dayyanim*'s decision, claiming that they had failed to adequately
investigate the characters of the witnesses.

In a similar case in Egypt, R. Meir Gavison and R. Hayyim Kafusi
attempted to clear the name of R. Abraham Castro's widow, when
his heirs accused her of conceiving in sin.[28] In Jerusalem, four leaders
of the community testified before the *qadi* concerning the 'virtue' of a
woman, Qamar bat Jacob, whose name had been sullied.[29] These
sources, too, testify to a climate where distrust and prying were com-
monplace.[30]

Thus, despite the various regulations and prohibitions, and despite
the self-appointed watchdogs of social morality, deviations from the
socio-religious norms were fairly frequent. Married women betrayed
their husbands, sometimes in a deliberate flaunting of convention. In
one case, a woman, disregarding the threats of her jealous husband,
left home to move in with a man she was supposedly having an affair

[27] Mabit, I, 287.
[28] Gavizon, II, 72(84).
[29] Cohen, *Jerusalem*, p. 143; Cohen-Pikali, Document 175, p. 169.
[30] Mabit, 209 (end of responsum); Radbaz, I, 321; II, 743; III, 873, 561, 974; IV,
1342, 1357; VII, 10; Maharit, II, *Yoreh De'ah*, 49; MS Responsa Ibn Tzayyah, 331 (p.
20a); 359 (p. 30a); 548 (pp. 275b-276a); 598 (pp. 338b-339b); MS *Zera' Anashim*, pp.
200a-201b; Badhab, 106; Benayahu, *Ari*, pp. 237-239.

with.[31] In another case, a woman had a highly romantic affair with 'a man of our people [...] who was so captivated by her physical charms, that he vowed to be a Nazirite like Samson, until he could marry her [...]. She, for her part, declared her intention to act in such a way that her husband would divorce her, if her lover promised to marry her." For some reason their plan foundered, and the man's vow had to be annulled.[32]

The sources speak of single, divorced, and engaged women who became pregnant, and also refer to Jewish prostitutes. Damascus, in particular, were notorious for its immorality as the following indicates:

> They [the women of Damascus] go brazenly dressed, adorned with cheap jewelry [...]. They expose their breasts and pad their corsets to make their breasts seem larger [...]. There are forty-eight known cases of fornication with gentile women, adultery, and homosexuality [...] The renegade daughter of Qumeiri fornicates with Joshua Queriesh, among many others [...]. Raphael Kuleif and his son, Michael, sin with Jewish and non-Jewish women alike [...]. As to the wife and daughter of Meir Peretz, they are both notorious prostitutes and lead the public astray.[33]

In another case of debauchery, Leah, a single woman "fornicated with Simeon and ate and drank with him in the company of a group of similarly debauched people. Rumor had it that she prostituted herself not only with Simeon, but with them, and others too. When she subsequently became pregnant, and bore a son, she claimed that Simeon was the father of her child [...], and he too admitted before several people that he was the father [...]. It has now become impera-

[31] Gavizon, II, 58(64).

[32] Alshekh, 47; Further examples: Maharitatz, 130, 192; Maharitatz, New Responsa, I, 99; Pinto, 36, 38; Radbaz, II, 743, 746; III, 873, 975; IV, 1348, 1357; VII, 10; Mabit, I, 287; Rofeh, 23; Alashqar, 88 (82, 77, and 94 on the subject of a married woman from Candia who committed adultery); Badhab, 106; Benayahu, *Ari*, pp. 237-238.

[33] Vital, *Sefer ha-Hezyonot*, pp. 33-34; Sambari, 206 (p. 244 in photocopied edition). For other examples, see: Radbaz, I, 263; ibid, end of III, responsum of R. Hayyim Capusi (unnumbered); In Jerusalem, the community demanded the expulsion of Sultana bat Rubin, a Jewess who had converted to Islam, because of her promiscuous behavior (Cohen, *Jerusalem*, p. 142); In 1658, a French traveler mentioned Jewish prostitutes in Sidon (Schur, "Jews," p. 121). Earlier references can perhaps be found in the lexicon of useful terms compiled by the traveler Arnold von Harff, who visited Jerusalem in the end of the 15th century, which contains the following entry (in poor Hebrew transcription): "Woman, let me sleep with you tonight" (*The Pilgrimage of Arnold von Harff*, [tr. and ed. by M. Letts], p. 220).

tive to clarify the boy's status: For if he is Simeon's son, he will inherit him, and recite the mourner's *kaddish* over him, and Simeon's wife will be exempt from a levirate marriage or *halitzah*."[34] In a similar case in Egypt, Jews and gentiles were known to frequent the house of a loose woman. When she became pregnant, she claimed Reuben was responsible. Several years later, Reuben withdrew his former admission of paternity, which had even been upheld in a gentile court, claiming that he had been intimidated by the woman's connections with powerful people, and that therefore his admission had been provided under duress. Once the child was eight years old, he ceased paying maintenance for him, and their ways parted. However, when the child reached the age of twenty, the woman claimed his right to inherit along with Reuben's other, legitimate, heirs. R. Meir Gavison and R. Yehiel Refayah, however, rejected the woman's claim, on the following grounds:

> The woman had a constant stream of visitors, who use to wine and dine with her [...]. It just took a bit of wine and bad company for the inevitable to happen. The woman became pregnant [...] And just as she gave herself to him, she gave herself to others who frequented her house [...] This woman is totally immoral and promiscuous, as many will testify.[35]

The halakhic issues raised by acts of immorality revolved around the status of married women vis-à-vis their husband or lover, and also, as in the above cases, the status of children born of such liaisons, and their inheritance rights.

The sources confirm that the desire to protect moral and religious norms and the status quo overrode the need to protect the privacy of the individual. There was an ongoing conflict between social and halakhic requirements, and the individual's needs and feelings. Note that just as there were "offenders" who flouted socio-religious norms, there were also "fundamentalists" who attempted to safeguard public morality by introducing more constraints.

The fact that social conventions were so widely and sometimes brazenly violated, was to a large extent the result of the high degree of social and geographic mobility that typified the migrant Jewish society of the times. The Jewish authorities' inability to contain growing immorality was partly due to the fact that the "offenders" always

[34] Radbaz, III, 961.
[35] Gavizon, I, 5.

had the option of resorting to Muslim courts. Thus, while some ignored halakhic rulings, or switched back and forth between rabbinical courts (see above), others totally sidestepped Jewish courts in favor of Muslim ones. In extreme cases, they even converted to Islam. This disproves R. Israel of Perugia's proud assertion, written in Jerusalem shortly after the Ottoman conquest, that appeals to Muslim instances were few and far between. "If there is the odd miscreant who dares to turn to a Muslim court, the entire community immediately turns against this depraved person and bribes the Muslim governor to give him lashes [...]. The felon is then excommunicated until he repents and pays financial compensation to the community."[36] This description is somewhat farfetched. The documents of the Shari'a court of Jerusalem and sources in Egypt and elsewhere show the opposite – that there were frequent petitions to Muslim courts on a wide variety of issues. Indeed, the leaders of the community themselves often resorted to the Muslim instances.[37] As a rule, recourse to gentile courts in the 16th (and other) centuries was far more prevalent than is generally believed. The practice was condemned by rabbis and community leaders, who tried, rather unsuccessfully, to curtail its prevalence through regulations.[38]

Although Jewish women resorted to Muslim courts on various civil matters, they did so primarily to circumvent the strict marital and inheritance laws laid down in *halakha*. Before the Shari'a court of Jerusalem, women received the same treatment as men.[39] The main

[36] David, "Letter," p. 112.

[37] Radbaz, III, 873, 961; IV, 1357; VII, 52; Pinto, 38; Maharitatz, 231; Gavizon, II, 46(52); On the situation in Safed, see: Idel, pp. 122-123; Bornstein-Makovetzky, "Community," pp. 146-147; Cohen, *Jerusalem*; Cohen-Pikali; Shmuelevitz, pp. 73-80; Rozen, *Community*, pp. 137, 157, 162-167, *passim*. Members of other religions too, such as members of the Armenian-Orthodox and Greek-Orthodox churches, used Muslim legal instances even in marital and family law. They were treated in the Shari'a courts no differently from their Muslim counterparts (Jennings, *Zimmis*, p. 250 ff.)

[38] Hacker, "Autonomy," esp. p. 382 ff; Assis, "Jews"; Shatzmiller; Shmuelevitz, pp. 41-80; Friedman, "Intervention"; idem, *Jewish Marriage*, I, p. 335; Gil, pp. 136-140; Bornstein-Makovetzky, "Arta," pp. 137-140; Gerber, "History," p. 31; Duran, II, 292, *Tikkun* 8; Freimann, "Regulations," p. 208; "Travels of R. Moses Basola," in Yaari, *Travels*, pp. 158; Danon, "Communauté," p. 112-114. On Jewish conversion to Islam, see: Cohen, *Jerusalem*, pp. 82-85, 133, 142; Cohen-Pikali, pp. 127-130; Bornstein-Makovetzky, "Conversion."

[39] Cohen, *Jerusalem*, pp. 142, 150. For documents relating to a variety of issues, see Cohen-Pikali, index. Jennings also reaches the conclusion that the Kayseri court did not discriminate between men and women (Jennings, Kayseri, pp. 58-59, 61, 72). At

actions brought before the Muslim court were: divorce suits in the case of recalcitrant husbands, suits against extortionate levirs (brothers-in-law) in the case of levirate marriages,[40] payment of *ketubot*,[41] and marriage in cases where there was a halakhic obstacle.[42] Likewise, women petitioned Muslim courts in order to validate legal transactions performed by them, or on their behalf, such as wills, trusts, or gifts,[43] and occasionally, as a means of putting pressure on the husband during a marital dispute.[44]

Thus we see that Jewish women in the 16th-century Levant, particularly if they were rich or had support, were not totally powerless. If they insisted on their rights, and disregarded the mainstream social climate that condemned recourse to gentile litigation, they frequently found a sympathetic ear in the *qadi*.

least theoretically, under Muslim law women may inherit from their parents, husbands, or offspring, and do not require the husband's agreement for carrying out property transactions on their own property. Divorce petitions filed by Muslim women are also viewed more favorably. See, Quran, chapter 4, verses 8-15, 23-24, 125-130, 175 ff; Marsot, pp. 262-263; Also, "Travels of Meshullam of Volterra," in Yaari, *Travels*, p. 76.

[40] For example: Gavizon, II, 87 (in connection with the Ankari divorce case, in which other decisors were involved. See below, Chapter 11, "Women and Divorce"); Ashkenazi, 15 (also Maharitatz, 40, on the same subject); Maharitatz, New Responsa, II, 210; Caro, Responsa *Beit Yosef*, 45 (=*Divorce Laws*, 3); Mabit, I, 22, 76, 80, 166; Radbaz, VI, 2095.

[41] For example: Pinto, 73; Rofeh, 12; Maharitatz, 50; Galante, Responsa, 40, 96; Maharit, I, 45 (on the same subject: Rofeh, 3; Galante, Responsa, 42); Radbaz, I, 383; IV, 1190; Mabit, I, 96, 130; MS London BM Or. 10118, p. 10; Cohen, *Jerusalem*, pp. 128, 137; Cohen-Pikali, Documents 397-398, p. 352; Document 408, p. 358.

[42] For example: Radbaz, III, 873, 961; IV, 1357; VII, 52; Mabit, II, 93; Gavizon, 5; Cohen-Pikali, Document 387, p. 347; Document 391, p. 349. In the case of the marriage of an *agunah* from Safed, R. Joseph Caro accused the Mabit of trying to validate the marriage illegally through a gentile court (Caro, Responsa *Beit Yosef*, 134a). See also Benayahu, "Controversy," pp. 36-37; Freimann, *Betrothal*, pp. 351-355.

[43] Mabit, II, 18; Maharit, II, *Hoshen Mishpat*, 66; Cohen, *Jerusalem*, pp. 225-226; Cohen-Pikali, Document 358, pp. 316-317; Document 412-414, pp. 361-362.

[44] Maharitatz, 231; Cohen-Pikali, Documents 392-393, p. 350.

CHAPTER NINE

POLYGAMY

"A person who loves two women will never gain their whole-hearted affection, because they are rivals. In order for a woman to love her husband with all her heart, she must see that he loves no-one in the whole world but her. Only then will she love him completely."[1]

Although Jewish law does not forbid polygamy, according to one opinion, advanced by Rav Ammi, "whosoever takes in addition to his present wife another one – must divorce the former and pay her the amount of her *ketubah*." Raba, on the other hand, argued that a man could marry more than one wife provided he had the means to maintain them.[2] Researchers believe that this controversy was the result of conflicting traditions in Palestine and Babylon, which continued even in the post-Talmudic period.[3]

In Jewish Levantine society, polygamous and monogamous traditions existed side by side. Despite the fact that polygamy was fairly wide-spread, monogamy was often advocated. From the Gaonic period, and especially from the 12th century on, it became increasingly commonplace to introduce a monogamy clause in the *ketubah*, precluding the husband from taking a second wife without his first wife's consent. Attached to the clause were certain qualifications. For example, if the woman failed to bear children within a specified period of time (usually five or ten years), the husband was entitled to take a second wife (even without her consent). Or, if the first wife wished to divorce her husband after he took a second wife, the husband must

[1] De Vidas, *Reshit Hokhma, Sha'ar ha-Ahava*, Chapter 4, p. 70a.

[2] *Yevamot*, 65a. See also Raba's saying in *Yevamot*, 63b: "A bad wife, the amount of whose *ketubah* is large – [should be given] a rival at her side" (trans. I. Epstein). The Rambam in *Marital Laws*, XIV, 3, is of a similar opinion.

[3] The sociohistorical background of this subject has been exhausted in the research literature. Among the most recent studies are: Friedman, *Polygyny*, Introduction (pp. 1-53), and pp. 19-22 (bibliography); Assis, "Ordinance," and various references therein; Havlin, "New Light"; Falk, *Marriage*, pp. 4-31. On the possibility that the clause: "And he is responsible for their maintenance" may have been a later addition, see Friedman, *supra*, p. 7, note 18.

comply and pay her *ketubah* money ('Fustat Custom').[4] Such was the custom in Egypt,[5] Palestine,[6] Aleppo[7] and Damascus.[8]

However, in Palestine and Egypt, the inclusion of such a clause was by no means axiomatic, and was never considered 'local custom.' It depended solely on the decision of the marriage partners. Failure to specify such a condition in the *ketubah* meant that the husband was free to marry more than one wife, according to the custom.

Bigamy and polygamy in Jewish society were no doubt influenced by the dominant Muslim culture, and were prevalent in other Muslim countries too, such as Moorish Spain.[9] On the other hand, Jewish society in the Rhineland, France, and Christian Spain was basically monogamous. In Germany, two regulations, attributed to Rabenu Gershom Meor ha-Golah, were passed (known as: 'Rabenu Gershom's ban' or '*takkanot* Ragmah') that were to become the cornerstone of Ashkenazi Jewish family life. The first forbade bigamy, while the second forbade divorce without the wife's consent.[10] Al-

[4] Friedman, "Divorce"; Idem, *Polygyny*, pp. 18-23, 28-46, and documents on pages 55-82; Gulack, *Treasury*, Deeds 30, 32, 34, 46, and p. 23; Freiman, "Critique"; Idem, *Betrothal*, pp. 50-51; Friedman (*Polygyny*, p. 8) emphasizes that all the sources in Talmudic literature that condemn polygamy originate from the Palestinian sages.

[5] Castro, *Ohalei Ya'aqov*, 129 ("For surely when he takes a second wife, he is aware of the monogamy clause and of the local custom which is to include such a clause"); ibid, 31, 117, 120; Radbaz, I, 126, 178, 260, 374, *passim*; Gavizon, I, 2, *passim*.

[6] Azulai, *Hayyim Shaal*, II, 38, (Ot 48) ("Here in Palestine, it is standard practice to include a condition in the *ketubah* as follows: And he shall not take another wife in her lifetime, unless ten years have elapsed without her bearing a child"); Maharitatz, New Responsa, I, 37; II, 181(=211); Mabit, I, 101; II, 50, 222; III, 51. Further references to customs in Palestine can be found in Sithon, *Even ha-'Ezer*, Laws of Procreation, 1, 11 (p. 122). R. Joseph Caro's recommendation in the *Shulhan 'Arukh* (*Even ha-'Ezer*, Laws on Procreation, I, 11): "Optimally, a regulation should be introduced to ban or excommunicate someone who takes a second wife."

[7] Maharit, II, *Hoshen Mishpat*, 98.

[8] R. Joseph Ibn Tzayyah wrote: "The age-old custom of including a clause in the *ketubah* applies if it has been kept from generation to generation according to rabbinical and ancient custom. For such a custom even overrides explicit *halakha*" (MS Jerusalem, Tzayyah , 524, p. 249b).

[9] Friedman, *Polygyny*, p. 19, and note 57 there (see also ibid, p. 344, in the addenda to p.19), and p. 26; Havlin, "*Takkanot*," p. 205, and note 12 there; Assis, "Ordinance," pp. 274-275 and note 179 there; Littman, "Family," pp. 230-231. The Rashba says that the Rambam "would seem to permit polygamy, according to the custom of the Ishmaelites" (Rashba, IV, 314).

[10] Maharam, Prague, p. 159b. On the *takkanot* of Rabenu Gershom and their various versions, see: Finkelstein, pp. 20-34, 111-147; Havlin, "*Takkanot*," (see also ibid, p. 202, for references to other manuscript sources and for a further bibliography); Grossman, *Sages*, pp. 132-149; Friedman, *Polygyny*, pp. 19-21; Elon, *Jewish Law*, p. 633, note 13; Baron, pp. 96-98 and note 156 on p. 287; Kahane, "Judaism,"

though these regulations were not accepted in Christian Spain or in southern France, similar local laws existed in most communities.[11] In practice, the difference was that in places where Rabenu Gershom's ban had spread, it was not even necessary to include an explicit monogamy clause in the *ketubah*, while in Spain it was customary to include such a clause.[12]

The coexistence of both a monogamous and polygamous tradition in the Levant was a consequence of the demographic fluctuations so typical of the 16th century. On the one hand, there was Rabenu Gershom's ban (applicable to the Rhineland only) and the Sefardic custom of introducing a monogamy clause in the *ketubah* (barring a childless marriage). On the other hand, polygamy was the norm among the indigenous community, and the inclusion of a condition in the *ketubah* merely optional. The existence of two such different norms, and unresolved issues relating to Rabenu Gershom's ban, created loopholes in the law which were exploited by men to their own advantage.

Rabenu Gershom's Ban

The loopholes regarding Rabenu Gershom's regulations derived from the fact that, in their original version, they left two unresolved problems: First, could the regulations be waived for the sake of a commandment (such as: the commandment of procreation, a levirate marriage, etc.) or if divorce was mandatory (for example: a woman who transgressed *halakha*, committed adultery, or refused to cohabit

pp. 308-309. Finkelstein (*supra*, pp. 377-379) and Grossman (*supra*, pp. 148-149) see a correlation between the participation of Ashkenazi women in economic life and their superior status, as expressed by Rabenu Gershom's regulations. Friedman (*supra*) posits a possible link between Palestine *halakha* and Rabenu Gershom's ban. Below, I shall use the expression "Rabenu Gershom's regulations" or "Rabenu Gershom's ban" to denote the two regulations, one relating to polygamy and the other to divorce.

[11] Havlin, "*Takkanot*," pp. 205-213; Baer, pp. 140-141; p. 507, note 58. Assis' article ("Ordinance," p. 152, note 7; pp. 259, 269-272, and *passim*) shows that bigamy in countries under Spanish rule was far more widespread than was hitherto thought. He based this conclusion on a comprehensive review of the Responsa literature and foreign sources, in particular royal decrees permitting bigamous marriages for Jews, when the law of the land prohibited them. For the regulations of Moroccan Jews on this issue, see: Ankawa, II, 36-41. Polygamy did not exist in the Jewish communities of Italy and Greece (Bornstein-Makovetzky, "Arta," p. 151).

[12] Ben Lev, I, 2.

with her husband). Second, when did the regulations expire? The
uncertainty stemmed from a tradition that R. Joseph Colon, at the
second half of the 15th century, brought in the name of the Rashba
(R. Solomon ben Aderet): "The Rabbi [Rabenu Gershom] did not
intend his regulation to apply absolutely to all women and all men
everywhere. His main purpose was to prevent a situation whereby
lecherous husbands could divorce their wives at will. But he never
imagined that his regulation would be also applied to women who
deserve, according to the Sages, to be divorced and forfeit their
ketubah [...] or women who had been married for ten years without
offspring [...], especially as we have heard that he set a specific time
limit, namely the end of the fifth millennium."[13] Accordingly, not
only were the regulations invalid in certain cases, in practice their
overall validity had expired by the end of the fifth millennium of the
Jewish era, namely 1240. According to another tradition, however,
the regulations were enacted in perpetuum ("until the advent of the
Messiah"). In any case, by virtue of their antiquity later generations
continue to observe them.[14]

 This lack of clarity occasioned fierce legal disputes and rabbinical
polemics. An example of such a polemic took place in the 1560s
between the rabbis of Palestine and Egypt, when an Ashkenazi Jew
residing in Egypt wished to take an additional wife without good
reason. The Sefardi sage, R. Isaac di Molina (rabbi, dayyan, and
head of yeshiva in Egypt), together with the Ashkenazi sages, casti-
gated the man for his ignoble design. The latter subsequently re-
lented, and promised to abide by Rabenu Gershom's ban. Later,
however, unable to stand by his commitment, he sought permission
to take a second wife from the Safed sages, under the leadership of
R. Joseph Caro. In their concise responsum, they stated that since
Rabenu Gershom's ban had expired at the end of the fifth millen-
nium (1240), the man was permitted to do as he wished. Signatories
to the decision were : R. Caro himself, R. Israel ben Meir (Di Curiel),
R. Isaac Arama, R. Eleazar ben Yohai, R. Elisha Gallico, R. Solo-
mon Absaban, R. Moses Alshekh, and R. Moses Scandari. The
Mabit's signature was conspicuously absent!

[13] Rashba's responsum from MS, see Havlin, "*Takkanot*," pp. 230-231.
[14] These matters have been discussed at length by decisors and researchers. For a
discussion and references, see Havlin, "*Takkanot*", pp. 210-211, 218-219, 229, and
notes there. For references to the controversy between the decisors, see also Gavizon,
II, 233, editor's notes.

Following this responsum, the man in question went ahead and took a second wife. Soon, however, the ruling was challenged by a group of Ashkenazi sages. R. Joseph Caro's reply to them was published in his book of Responsa, *Beit Yosef*. At the same time, R. Isaac di Molina delivered a responsum that demolished the ruling of the Safed sages, and insisted the man be excommunicated until he agreed to divorce his wife. He argued that Rabenu Gershom's ban was not simply a 'custom' as Caro and others claimed, for if that were the case, all the laws relating to the ban that had been introduced after the fifth millennium should have been either amended or abolished. To these arguments, R. Joseph Caro retorted that R. Isaac di Molina had obviously been influenced by slanderers and agitators. In any case, he continued, no Ashkenazi had ever been excommunicated for taking two wives. Finally, why was a Sefardi rabbi intervening in a case that was under Ashkenazi jurisdiction? ("How does he presume to pronounce in a matter that is outside his purview, since he is a Sefardi, and the Sefardim never accepted Rabenu Gershom's ban"). Caro evidently 'forgot' that neither he nor his co-signatories were Ashkenazi, either. Caro's view was endorsed by R. Israel di Curiel and the Mabit, although the latter entertained certain reservations which were deliberately omitted from the responsum printed in the *Beit Yosef*! Evidently, the Mabit himself was of the opinion that Rabenu Gershom's ban was still valid. He therefore refused to sign Caro's initial ruling although he refrained, at this stage, from any public show of disapproval. On the contrary, he even urged R. Isaac di Molina not to be unduly stringent. Later, when the details of the case came to light, he openly supported di Molina's request for excommunication of the Ashkenazi.[15]

[15] For Caro's first ruling, see Caro, Responsa *Beit Yosef*, 45 (=Laws of *Ketubot*, 14), pp. 155-160; For his second ruling, see: ibid, pp. 160-163; For the rulings of R. Israel di Curiel and the Mabit, see ibid, pp. 163-164. For the full text of the Mabit's responsum, see Mabit, II, 16. (Note that this is not the only time that the editors of Caro's responsa took the liberty of adapting them as they saw fit! The Mabit's responsum, brought in Caro's *Avkat Rokhel* (195), on R. Moses Provençal's ban was also 'tailored,' but brought in full in the Mabit's Responsa (283). On the same issue, see also: Green, p. 227). Benayahu ("Controversy," pp. 70-73), discusses this issue, and even points out the differences between the Mabit's responsum as printed in *his* book and as brought down in Caro's Responsa *Beit Yosef*. Benayahu, however, attributes this discrepancy to the ambivalent relationship between Caro and the Mabit, and did not emphasize the fact that the Mabit effectively supported Rabenu Gershom's ban. (On the complex relationship between the two sages, see ibid, and also Benayahu, "Mabit," pp. 12-17; Dimitrovsky). For a discussion of the subject, see

Thus, the polemic was not confined to Ashkenazi and Sefardi decisors, or the Safed and Egyptian sages: It raged among the Sefardi sages themselves. As we saw, Rabenu Gershom's ban was upheld not only by R. Isaac di Molina, but by none other than the Mabit himself, R. Caro's longtime colleague and sparring partner.

The leniency of the Safed sages concerning polygamy among Ashkenazi Jews led to a further polemic among the sages of Egypt, in which R. Jehiel Ashkenazi was involved.[16] "In Safed, too, bigamy has been prohibited, but for our sins this prohibition has not been observed [...] and the princes and rulers are to blame." In many instances, he continued, people were seeking to take a second wife under false pretenses. Their pretexts must be treated with skepticism, he cautioned. "All those who took a second wife in Ashkenazi countries claimed to find fault with their first wife. Each sought endorsement for his claim, until 'his staff declared unto them' [play on words based on Hosea 4:12, implying that they sought a lenient ruling]."[17]

R. Obadiah of Bertinoro, residing in Palestine in the late 15th century, was asked about an Ashkenazi who sought to take a second wife since his first wife, who had not born any children during a ten-year period, refused to divorce him. He ruled that Rabenu Gershom's regulations "are fixed from generation to generation" and permitted bigamy only for the sake of a commandment, or if divorce was a halakhic imperative. This responsum was quoted by R. Isaac di Molina and R. Jehiel Ashkenazi, and also by R. Joseph Caro and R. Meir Gavizon.[18] Caro, in his responsum, mentioned a case that took

Havlin, "*Takkanot*," pp. 240-244 (and on pages 245-250, R. Isaac di Molina's responsum); Westreich, pp. 190-205 (see ibid, note 776 on the Mabit's responsum); See also, in brief, David, "Molina," pp. 555-556. The issue is described also in Responsa *Ginnat Veradim*, *Even ha-'Ezer*, Rule 1, 9. For my own view of how the polemic evolved, see Lamdan, *Status*, p. 472 ff.

[16] The attempt to link this issue to the above issue is implausible (See Westreich, *Grounds*, p. 203, note 781; Lamdan, *Status*, pp. 477-479.)

[17] The responsa of R. Jehiel Ashkenazi can be found in MS Jerusalem, Misc., pp. 58-59, and have been partly published by Assaf ("Responsum"). For a further extract, see Havlin, "*Takkanot*," pp. 206-207. The responsum was famous at the time, and is referred to in many sources (for references, see Havlin, *supra*, p. 228, note 87. Also relevant is the responsum of R. Judah Hami in Gavizon, I, 10. See also Benayahu, "Controversy," p. 74, note 359). The Mabit, in his full responsum as brought in *his* book (II, 16), also mentions R. Jehiel's responsum and bases his own on it. On R. Jehiel Ashkenazi, see David, "Castellazzo"; idem, "Community," p. 29.

[18] Caro, Responsa *Beit Yosef*, 90 (= Laws of *Yibum* and *Halitza*, 2); Gavizon, , II, 65(71). See also Sithon, *Even ha-'Ezer*, p. 122.

place in his time in Jerusalem, when an Ashkenazi sage took a second wife for no good reason, and the Ashkenazi sages of Jerusalem, including the elderly R. Kalonymus, did not demur.

Infractions of Rabenu Gershom's ban were commonplace, as is also indicated by the following passage by R. Jehiel Ashkenazi:

> Here, too, in Jerusalem may it speedily be rebuilt [...] an Ashkenazi took a second wife, on valid grounds. However, his second wife was a 'killer wife' and he did not live long [...] In Egypt too, a scholar deserted his wife in the Land of Edom (Italy), and heedless of the ban [...] married another woman in Egypt [...] – and 'his widows do lament him' [cf. Psalms 78:64]. The son of R. Jacob Pollak of Jerusalem, may he rest in peace, suffered a similar fate [after taking a second wife] with no grounds of "rebelliousness" or extortion. Similarly, a certain trickster of Safed consumed [his wife's] portion and within a month divorced her [cf. Hosea,5:7].[19]

Most sages in Palestine and Egypt, even those who believed that Rabenu Gershom's ban was still valid, agreed that the ban was not applicable if a woman was insane, or suffered from epilepsy.[20] Similarly, it was not applicable if the man had not yet fulfilled the commandment 'to be fruitful and multiply'[21] or if the wife was considered 'rebellious'. According to the Radbaz, the commandment of procreation was fulfilled only after the birth of a son *and* a daughter. He also claimed that even if there were children, the husband could take a second wife if his first wife denied him his conjugal rights.[22]

In conclusion, every sage in the 16th-century Levant found ways of circumventing Rabenu Gershom's ban under certain conditions.

[19] Assaf, "Responsum."

[20] Gavizon, I, 10; Radbaz, I, 53; Maharitatz, 3; Maharitatz, New Responsa, I, 48.

[21] R. Abraham Halevi's Responsa *Ginnat Veradim* (*Even ha-'Ezer*, Rule 1, 9) brings the responsum of the sages of Jerusalem of the second half of the 17th century, in which they permit R. David Colon of Alexandria to take a second wife in order to fulfill the commandment of procreation. The responsum refers to similar permits that had previously been granted to R. Mordecai Bofil Ashkenazi of Safed, to R. Naphtali Ashkenazi of Jerusalem (early 17th century), and to R. Nathan Shapira (Jerusalem, mid-17th century). R. Moses Galante, too, before his death, approved of R. David Colon taking a second wife. The sages of Hebron and R. Abraham Levi of Cairo also gave their consent. One hundred signatures were collected and sent to Alexandria in order to placate R. David Colon, who refused to take a second wife without the sages' approval. See also Mabit, III, 6; Radbaz, I, 126; II, 700; Castro, *Ohalei Ya'aqov*, 51 (and quotation from the Radbaz there); Maharitatz, New Responsa, II, 239; Alashqar, 95.

[22] Radbaz, II, 700; Castro, *Ohalei Ya'aqov*, 51; Mabit, I, 210, 245.

Even the most stringent of them all, R. Jehiel Ashkenazi, permitted bigamy if the first wife 'became insane' or seriously ill. Others, such as R. Obadiah of Bertinoro, R. Isaac di Molina and the Mabit permitted bigamy for the sake of a commandment, and in cases where divorce was halakhically mandated. R. Joseph Caro, and a large following of Safed sages, believed that the ban had completely expired, and that therefore there was no reason to forbid bigamy among Ashkenazi Jews any longer.[23]

Divorcing a woman without her consent was treated in a similarly cavalier fashion. If the sages ruled that there was justification for taking another wife, and the first wife objected, the husband was allowed to divorce her unilaterally. Any controversy on the subject related to payment of the *ketubah*, not to the validity of the divorce itself.[24]

The Monogamy Clause

As stated, in places where Rabenu Gershom's ban was not accepted, a condition was usually included in the *ketubah*, precluding the husband from taking another wife unless otherwise stipulated. In any case, if the first wife objected to her husband taking another wife, she was entitled to a divorce with full payment of her *ketubah*.

The condition had to be written clearly and explicitly to be legally valid. In one case, a minor was married on condition that if she failed to bear a child over a period of ten years, her husband could take a second wife. The husband claimed that the ten year period began from the wedding itself, not from puberty. Since the clause in the *ketubah* had failed to explicitly state when the ten-year period began, the husband's claim was upheld. "By law he is entitled to take several wives. They [the wife's family] have now submitted a claim which rests on the [*ketubah*] condition. Since they drew up the condition in

[23] R. Abraham Halevi of Egypt, on the other hand, of the mid-17th century, claimed that Ashkenazi men who settled in oriental countries, could adopt all Sefardi customs, with the exception of polygamy (*Ginnat Veradim, Yoreh De'ah*, Rule 3, end of No. 5). Halevi explained that since Rabenu Gershom's ban was incumbent on each person, individually, it made no difference where the person lived. However, since all other Ashkenazi customs were place-related, by moving the prohibitions no longer applied.

[24] For example, Gavizon, I, 6; II, 65(71); Radbaz, I, 53; Maharitatz, 3.

the first place, it was up to *them* to find an unambiguous formulation. Since they did not, their case cannot be upheld."[25]

In order to ensure the condition was adhered to, the husband was asked to take an oath "as a precautionary measure, since most people are reluctant to violate their own oaths."[26] In a letter to Cairo concerning a man who had deserted his wife and wished to take another, the sages of Jerusalem called for "an announcement to be broadcast throughout the communities of Egypt warning against giving a sister or daughter in marriage to this man. For they will certainly be transgressing the prohibition of placing a stumbling block before the blind. For this man has sworn not to take a second wife."[27] Nevertheless, the monogamy clause was considered less binding than Rabenu Gershom's ban. This was because the ban – assuming it still applied – existed in its own right, independently of the woman's wishes. A condition or an oath, on the other hand, could be waived by the woman, enabling the husband to take a second wife.

Indeed, there were instances in which a woman allowed her husband to take a second wife, usually for financial compensation.[28] If the wife refused to waive the condition, especially if the husband had sound reasons for wanting to take an additional wife, the sages recommended gentle persuasion and ways of 'bringing her round.' If these did not work, the rabbis annulled the vow.

In one case, Reuben wished to take a second wife, claiming that he had only one child by his first wife, who was forty-five years old. He did not want to divorce her, since he loved her, and also because he was reluctant to pay her *ketubah*, which was a considerable sum. She, however, refused to give her consent. The Radbaz wrote:

> What is Reuben to do in order to fulfill the commandment of procreation? Let him use the gentle art of persuasion in ways that usually work with women of her age. For example, he can offer to add to her *ketubah*, buy her clothes, or arrange separate living quarters for the second wife,

[25] Radbaz, VI, 2293.

[26] Ibid, IV, 292. See also MS Jerusalem, Tzayyah , 524, pp. 247b-249b; Mabit, II, 222.

[27] Benayahu, "Sources," Letter 46, p. 371.

[28] Radbaz, I, 233, 404; Berab, 58 (Radbaz' responsum); Mabit, II, 14, 222; Caro, *Avkat Rokhel*, 102; Vital Samuel, 11 (Safed, 1646). A question sent to Safed by the community of 'Aana in Iraq brings the text of a settlement between a man who wanted to take a second wife, and his first wife. Among the signatories of the settlement is R. Jacob Ashkenazi, an emissary from Jerusalem (Maharitatz, New Responsa, I, 3).

and so on. If she still refuses, he is *anus* [compelled] [...] and released from his vow, even if she strongly protests.[29]

In a similar case, the Mabit found a roundabout way of absolving the vow of a man whose wife became blind after many years of marriage. Usually, conditions and vows held good, even in cases of *force majeure*, especially if the couple had children. However since this woman's blindness meant she could no longer minister to her husband, he was permitted to take a second wife:

> Since her blindness prevents her from fulfilling some of her duties to-wards him, such as her handiwork; and since she is unable to do what she was formerly capable of doing; and since she not only does not find things [by Jewish law anything a woman finds belongs to her husband] but actually loses them; and since she is unable to perform the tasks that *some* women perform for their husbands, such as cooking and baking; and since she is unable to properly discharge those duties that *all* women perform for their husbands [...] Since this blind woman is unable to discharge her duties, therefore his vow may be annulled [...] since this was a circumstance he could not reasonably have foreseen when he made his vow.[30]

Rabbi Elisha Gallico did not agree with the Mabit, and claimed that Reuben's vow was binding. R. Moses Alshekh, on the other hand, argued that not only was the husband allowed to take another wife, but that there was no need even to have his vow annulled.[31]

In 1533-1534, a dispute broke out between the sage R. Nissim Ankari of Cairo and his wife, Esther bat R. Maʿathuq, of Jerusalem.[32] Before marrying him, she had insisted on a monogamy clause in the *ketubah*. Shortly after they got married, Ankari remarried his former two wives in private ceremonies, in defiance of local *takkanot*. Esther

[29] Radbaz, I, 327. See also ibid, 458; IV, 1075; VI, 2115; Castro, *Ohalei Yaʿaqov*, 31; MS Jerusalem, *Zeraʿ Anashim*, p. 587a.

[30] Mabit, III, 51.

[31] Alshekh, 86. These two responsa are quoted in *Beʾer Mayim Hayyim*, 7, in the responsum that R. Samuel Vital sent to Damascus in the year 1649, on a very similar matter. Vital ruled that a bench of three judges could dissolve the husband's vow.

[32] For the litigants' arguments and the judges' reasoning, see Ralbah, 26-27; Radbaz, IV, 77 (and ibid, for an abridged and anonymous version of the Radbaz' responsum). For a chronology of events, see Bornstein-Makovetzky, "Community," pp. 159-160. R. Nissim Ankari was one of the sages of Cairo in the first half of the 16th century, and should not be confused with the Nissim Ankari in the case of the questionable divorce (see below, Chapter 11, "Women and Divorce," note 27) who lived in the late 16th and early 17th centuries. For further details about him, see introduction to Gavizon's Responsa, p. 87, under 'Ankari'.

subsequently left him, demanding payment of her *ketubah* and incre-
ments, and a valid bill of divorce. R. Nissim refused. R. Jacob Berab
and his court tried to mediate between the couple and force the
'rebellious' wife to return to her husband, but when she refused,
Berab ruled in favor of R. Nissim, basing his decision primarily on a
'clerical error' in the marriage deed (*ketubah*). The Radbaz, on the
other hand, ruled in Esther's favor, claiming that the intention of the
clause was clear, even if the wording was not.

A confidential letter written by R. Levi ben Habib (Ralbah) of
Jerusalem to R. Samuel Halevi of Egypt (and also, apparently, to R.
Moses Alashqar) shows that R. Nissim Ankari traveled to Jerusalem
and Safed in order to muster support for his position, and in particu-
lar, in order to obtain permission to remarry his first wife.

The way he argued his case provides some insight into how
women of the times were viewed, at least by some of the sages: "[He
claimed] he sorely needed her services, since she was an older, more
experienced woman who knew how to look after the house, unlike his
most recent wife, who was young, and therefore inexperienced in
household matters." Since the wife's main function was to serve her
husband, an older, more experienced housewife was an asset. As far
as other services were concerned – obviously a younger woman was
preferred. Although the Ralbah refused to openly contest the
Radbaz's ruling, he stated privately that in his opinion the *ketubah*
condition was improperly worded and therefore invalid. Conse-
quently, he argued, no effort should be spared to persuade Esther
and her father to allow R. Nissim to remarry at least his first wife.

At the other end of the scale, R. Yom Tov Zahalon harshly be-
rated a man who not only broke his oath to remain monogamous,
but refused to grant his first wife a divorce: "He must be forced to
divorce his second wife, and start again with his first [...] Such an
abomination is unheard of – to take a second wife when the first is
nursing and pregnant. It is the spirit of lust that has caused him to
break his vow."[33] The above notwithstanding, the first wife was enti-
tled to insist on a divorce, and even 'rebel,' without forfeiting her
ketubah.

[33] Maharitatz, New Responsa, I, 37.

Bigamy in the case of Levirate Marriage

Bigamy was an issue in the case of levirate marriages (see Chapter 14), when the levir (brother-in-law of a childless widow, who has a duty to marry her) was already married. The sages of Palestine and Egypt usually did not differentiate between an unmarried or married levir in such cases.[34] The Radbaz, for example, claimed that the commandment of *yibum* took precedence over *halitzah* (ceremony exempting the levir from the levirate marriage), even if the levir was married, or had sworn not to take another wife. He was careful to emphasize, however, that his ruling did not apply to Ashkenazim, who anyway held that *halitzah* took precedence over *yibum*.[35] Both the Ralbah and the Maharit (R. Jospeh Trani) concurred.[36] Other rabbis, both Sefardi and Ashkenazi, ruled that if the levir was married, *halitzah* took precedence.[37] In a controversial case that took place in Palestine in 1565, R. Joseph Caro upheld the Ashkenazi sages of Jerusalem, who excommunicated a married levir who refused to grant *halitzah*. The Radbaz, however, claimed that *yibum* took precedence. Although the Mabit upheld the woman's position, he was careful not to contest the Radbaz's ruling openly.[38]

There was, therefore, no hard-and-fast rule regarding bigamy in the case of levirate marriages. The Safed sages usually favored *halitzah* if the levir was married, while the Jerusalem sages, led by the Radbaz, favored *yibum*, even if the levir was married. There were, however, exceptions, such as the Mabit of Safed, who disagreed with the Radbaz, or R. Jacob Castro, the Radbaz's disciple, who disagreed with his mentor.

As stated, the coexistence of monogamous and polygamous tradi-

[34] The latest document in Friedman's collection (*Polygyny*, pp. 148-151), is a *yibum* agreement of 1482 between Faraj, the widow of R. Solomon ben R. Joseph ha-Naggid, and his brother Yeshu'a. The widow agreed to marry her levir only if her rights were safeguarded, if she were granted equal status to that of R. Yeshu'a's first wife, and if her levir agreed to fulfill her husband's obligations toward her. For earlier publications, see ibid, note 1. On the aforementioned brothers, see Mann, *Texts*, p. 428; Ben-Zeev, "Cemetery," p. 14.

[35] Radbaz, I, 114, 457; II, 655.

[36] Ralbah, 36 (p. 21b); Maharit, I, 118.

[37] Caro, Responsa *Beit Yosef*, 94 (=Laws of *Yibum* and *Halitzah*, 4); Mabit, I, 146; III, 172; Castro, *Ohalei Ya'aqov*, 117 (which cites the rulings of other contemporary sages).

[38] Caro, Responsa *Beit Yosef*, 90 (=Laws of *Yibum* and *Halitzah*, 2).

tions gave rise to halakhic controversy in many other cases too.[39] Among the Musta'rabs and Maghrebi (North African) Jews, who had never accepted Rabenu Gershom's ban, and had not been exposed to the influence of Christian-monogamous society, polygamy was sanctioned, both by the man in the street and by rabbis and public figures.[40] Moreover, even Jews who came from Christian countries quickly adopted the local custom in such matters. As stated, the condition and oath not to take a second wife, although widespread in Palestine and Egypt, were not considered 'local custom'. Therefore, unless explicitly prohibited in the *ketubah*, a non-Ashkenazi husband could take another wife. And even when explicitly prohibited in the *ketubah*, pretexts could be found for circumventing the prohibition. These pretexts were usually sanctioned by the rabbis. However, Ashkenazim also managed to find loopholes in the law, and quite a number exploited the academic controversies between the sages, in order to circumvent Rabenu Gershom's ban. In addition, it should be remembered that the cases which reached the courts were only the tip of the iceberg. There were certainly far more cases of polygamous marriages that worked, or at least never reached litigation.

Bigamy from the wife's perspective

As stated, despite the various conditions and bans, polygamy was fairly common in the 16th-century Levant. Some women were strong enough to contest it, as shown by the complaint lodged with the Shari'a court on 22 July 1582 by a Jewish man: 'Before his Honor [...] Mahmud Effendi [...]: Shuba ben Da'ud, of the protected Jewish minority in the glorious city of Jerusalem, has filed a suit against his

[39] Maharitatz, New Responsa, II, 193, 213; Gavizon, I, 1, 2; Castro, *Ohalei Ya'aqov*, 129; Radbaz, I, 53, 374; MS Jerusalem, Tzayyah , 362, pp. 31b-32a.

[40] My conclusion differs from that of M. Littman who believes that in the East, including Egypt, bigamy was not widespread (Littman, "Relations," p. 35; idem, "Family," pp. 230-231). Most examples he brings from the Radbaz and from R. Jacob Castro, actually support the theory that polygamy existed. Corroboration for my contention can be found not only in the Responsa literature, but also in other sources, such as the letters and documents of the Shari'a court of Jerusalem. See: Cohen, *Jerusalem*, pp. 63, 148-149; Cohen-Pikali, Document 165, p. 163; Document 406, p. 357; Document 428, p. 374; Rozen, *Community*, Letter 31, p. 422. On polygamy during the Classical Genizah period, even among famous men, see Friedman, *Polygyny*, pp. 1-6, and note 5 there.

wife Sultana, daughter of Ibrahim the Jew, for refusing to live in his house and for not obeying him. Moreover, she refuses to cohabit with him and resides with her brother. [Sultana] was questioned on the matter and replied that she is staying with her brother because [Shuba] took another wife from Safed."[41]

Yet, for all the women who objected to a "rival wife," there were as many who were won round to the idea by their husbands. Others were simply presented with a *fait accompli*, and had no alternative but to try and come to terms with it. The fact that the first wife was older or more experienced did not necessarily make her top of the pecking order. Young, self-confident wives had no difficulty in holding their own.[42]

Usually, the wife's consent was conditional on the provision of separate living quarters by the husband for the rival wife. This condition was crucial, bearing in mind the fact that most families shared a courtyard and communal facilities, such as outhouses, ovens, and wells. Under such conditions, if the wives were not prepared to peacefully coexist, daily life could become an ordeal.[43]

The following testimony sheds some light on the complexity of the situation, and in particular, on the overcrowded living conditions. Nine months after the rival wife moved in (with the first wife's consent), the latter claimed "that she could no longer stand the rival wife's jealousy, especially in her presence, [and wanted] him to find her separate living quarters. She claimed that the husband slept with each wife in the presence of the other [...] and that the situation was no longer tolerable. The husband denied this emphatically, stating that each wife had her own room, and that it was all a pack of lies."[44]

[41] Cohen-Pikali, Document 406, p. 357.

[42] For example: Gavizon, II, 84; Pinto, *Yoreh De'ah*, 22, 69. See also Friedman, *Polygyny*, pp. 19-22, and note 58 there. Sometimes the wife herself suggested the husband take a second wife to enable him to fulfill the commandment of procreation without divorcing her (ibid, pp. 23-25, 164).

[43] According to the Rambam (*Marital Laws*, XIV, 3), the husband is not allowed to force both wives to live in the same courtyard. The issue of separate housing is emphasized also in Islam, together with other conditions ensuring both wives equal status (Quran, 4:3; Goitein, *Introduction*, p. 133; For more on the Muslim influence, see Friedman, *Polygyny*, Introduction, pp. 51-52). On the attitude of the sages, see for example: Radbaz, I, 327; III, 991; Maharitatz, 3; Responsum of R. Zerahiah Gota, MS Jerusalem, *Zera' Anashim*, p. 587a.

[44] Radbaz, III, 849. Cf. the attitude of a Muslim judge in Jerusalem, who rejected the divorce petition of a woman who had sexual grievances, and was more inclined to believe the husband's assertion that she was telling lies (Cohen, *Jerusalem*, p. 145).

The Radbaz, who suspected the wife of inventing the story in order to get a place of her own, recommended attempting a reconciliation.

Conflict between rival wives was triggered by the necessity of sharing domestic arrangements, or simply by sexual or financial jealousy.[45] The threat of taking another woman was often used by the husband to score a point in an argument.[46]

If bigamy was difficult to tolerate, polygamy was far worse. Even the Radbaz pointed out that "if one rival wife was trouble [for the first wife], two were double trouble" – thus playing on the Hebrew word *tzarah* (a rival wife), which also means 'trouble'.[47] The sages advised against marrying more than four wives, to ensure that each wife received her conjugal rights each month.[48] But this was not the only reason why polygamy was scarce. Polygamy placed a serious economic burden on the husband, who was responsible for feeding and housing all his wives. Most of the halakhic sources and documents of the Jerusalem Shari'a court discuss bigamy only.[49] Nevertheless, polygamy did exist in more affluent circles.[50]

Only a few rabbinical authorities showed some understanding of the feelings of wives in bigamous marriages, and of these, only a handful were prepared to actively uphold their demands for a divorce and payment of the *ketubah*. Although some testimonies indicate sen-

[45] Radbaz, III, 991; Mabit, I, 75; Gavizon, I, 1; II, Appendix 6, 93; Maharitatz, New Responsa, I, 37; *Darkhei No'am*, I, *Even ha-'Ezer*, 7; MS Jerusalem, *Zera' Anashim*, pp. 1a-2a; Cohen, *Jerusalem*, pp. 148-149. In a *yibum* agreement drawn up in Cairo in 1482, the levir undertook "to grant equal conjugal rights to both wives, and spend one night with one wife, and the other night with the other" (Ashtor, III, Document 64, pp. 112-115).

[46] Radbaz, VI, 2115. The Mabit advised Samuel Bindig, a recalcitrant levir from southern France, who refused to come to Safed or Tripoli in order to marry his sister-in-law or at least grant her *halitzah*, on the pretext that his own wife objected, to promise his wife "that he would not marry the woman in question, but would grant her *haltizah*, and thereby perhaps appease his wife, since women are jealous of each other. If this failed, he should threaten her by saying that if she did not let him go, his sister-in-law would come, and he would marry her, and she would have to put up with a rival wife." (Mabit, III, 152). See also MS New York, Capusi, 19.

[47] Radbaz, I, 233.

[48] *Yevamot*, 44a.

[49] Studies of the *sancak* of Jerusalem in the 17th century also show that bigamy was far more common in Muslim society than was polygamy (Zeevi, p. 110).

[50] Berab, 4; Mabit, I, 76, 335; II, 124; Radbaz, I, 457; Caro, *Avkat Rokhel*, 92; Alshekh, 135; Ralbah, 26-27; MS Jerusalem, Tzayyah , 419, pp. 93a-94b. See also Friedman, *Polygyny*, pp. 3-4, and note 6 there. On a man who sought to marry four women, see ibid, Document C-1, dating back to 1291/2, pp. 100-105.

sitivity to the plight of the wife (R. Yom Tov Zahalon: "Having to
put up with a rival wife is certainly worse than being hit!"[51]), most of
the rabbis were indifferent, as witnessed by their failure to take posi-
tive action to prevent bigamy.[52]

An example of such indifference can be found in the attitude of
the Ralbah (R. Levi ben Habib) in the case of R. Nissim Ankari (see
above). As stated, Esther and her family strongly objected to him
remarrying his former wives, while the Ralbah, in a private letter to
R. Samuel Halevi of Egypt, expressed surprise and indignation that
the woman stood her ground. According to him, there was no future
for Esther in Jerusalem. Her sister, for example, had married a ne'er-
do-well, who exploited her and had stolen all her clothes and jewelry.
Had Esther stayed in Jerusalem, she would have fared no better. She
should, therefore, be grateful that she had been fortunate enough to
marry not only a Torah scholar but also a wealthy man, and should
not cavil at trifles:

> I would remind her of the old days [...] when she was living in Jerusa-
> lem, this holy city, when she had neither bread to eat [...] nor garments
> to ward off the cold [...] But now, thank God, she has been lucky to find
> a husband who is wise, and can afford to feed and clothe her as she
> wishes [...] She should therefore serve him with love, and if he brings in
> a rival wife, she should not make an issue of it.[53]

To a large extent, the sages believed that the success of a bigamous
marriage depended on the wife. They also believed that in most
cases, the wife would come to terms with the situation, especially if
she were offered compensation, such as an increment to her *ketubah*.
"It is common knowledge that if a man wishes to take a second wife,
and asks his first wife's permission and adds to her *ketubah*, his inten-
tion in adding to the *ketubah* is that she should live in harmony with
him and with the rival wife. For he could just as easily have divorced
her and taken another wife without paying an increment. However,

[51] Maharitatz, New Responsa, I, 37. See also R. Samuel Vital, in a case in which
the second wife died, and the first refused to absolve her husband from his vow: "Did
the Torah command each man to take ten wives in succession, until he begets
offspring? Surely only one, as the verse says "I will make him a helpmeet for him."
The word helpmeet is in the singular, implying one wife, not two!" (Vital Samuel,
11).

[52] Castro, *Ohalei Ya'aqov*, 120; Maharit, II, *Hoshen Mishpat*, 98; Gavizon, I, 1, 2;
Vital Samuel, 11; Maharitatz, New Responsa, II, 193, 213.

[53] Ralbah, 27.

the fact is that he wants her and the second wife too – whether to bear children, or for other reasons [...] If, however, she is fractious and asks for a divorce, she will not get the increment, since the intention was that she should live harmoniously with him and with the other wife."[54] In another case, when a wife objected to her husband divorcing the rival wife and taking another in her place, the Radbaz rather insensitively, argues: "Why should the first wife care who the rival wife is? [...] Who knows, the second may be even nicer than the first?"[55] In the case of the blind woman (see above) who could no longer discharge her duties, the Mabit, who was in favor of absolving the husbands' vow, was convinced that the wife would see the positive side of the arrangement: "Even though the arrival of a new wife is a cause for arguments and conflict, the fact that the new wife would be serving her husband in her stead should overrule any resentment she might feel towards her."[56]

The rabbis were inconsistent in the importance they attached to the emotional state of the rival wives in their rulings, but such considerations were generally a secondary factor.

Cooperation also existed between wives in polygamous marriages, but usually when the source of conflict – the husband – was absent for long periods of time, or after his demise. In such cases, old jealousies and grievances were put aside, in the joint endeavor to preserve their common economic interests. Each wife was awarded her share in the deceased's estate, as determined by *halakha* and the conditions of the *ketubah*. Usually payment of the *ketubah* preceded maintenance claims. Property which the wives had brought to the marriage was returned, while assets obtained after the husband had married both wives were divided equally between them.[57] When inheritance cases in bigamous marriages were brought before the Shari'a court, "the estate was divided in all cases in an orderly fashion, according to the principles of Islamic law."[58]

R. Moses Alshekh mentions a case of collaboration between *four*

[34] Mabit, II, 14; Radbaz, I, 327.
[35] Radbaz, I, 233. See also ibid, III, 991.
[36] Mabit, III, 51.
[37] For examples of inheritance settlements according to *halakha*, see: Radbaz, I, 212, 275; II, 671; III, 959; Maharitatz, New Responsa, I, 51, 95; Maharit, I, 128. For examples of inheritance disputes, see: Pinto, 69; MS New York, Capusi, 32, p. 58.
[38] Cohen, *Jerusalem*, p. 148.

widowed wives, who tried to conceal objects from the rabbinical court emissaries who had come to draw up an inventory of their late husband's property. Leah, who as the oldest and most experienced wife had been appointed trustee of her husband's chattels, was the ring-leader. The other wives conferred with her, and agreed to conceal the objects. They later confessed, but blamed Leah for their misconduct.[59] In another case, Reuben's two wives, who had been deserted because Reuben was no longer able to support them, planned a joint course of action: "The one said to the other: Behold you see how our husband has forsaken us to go wandering round the world, leaving us penniless. The time has come for us to look after our own interests, and consider what course of action we must take, until the Holy One Blessed Be He takes pity on our husband, and restores him to his former wealth, so that our home is not destroyed more than it is already. The other then said: Tell me what you think we should do [...]"[60] Evidently, in times of trouble, the wives closed ranks.

Considering the prevalence of polygamy in Jewish society, there were relatively few cases of friction between wives in polygamous marriages. Most disputes arose over the husband's violation of his commitment to remain monogamous. However when faced with the *fait accompli*, the wife usually came to terms with it as a normative event. Usually, preliminary arrangements were necessary to smooth the logistics of the parallel relationships. There may even have been some women who not only came to terms with the situation, but were even relieved to share the household chores with other women![61]

[59] Alshekh, 135 (Caro, *Avkat Rokhel*, 92, and Mabit, I, 335, are apparently discussing the same issue).
[60] Maharitatz, New Responsa, 44.
[61] See, for example, Mabit, III, 51.

MARITAL DISPUTES

Most of the information on marital relationships in 16th-century Jewish Levantine society comes from sources which, by their nature, focus on marital conflict. Naturally, in the absence of a comparative standard, the data cannot be used for statistical purposes. However, they can be used as a means of ascertaining the major causes of marital disputes and the main grounds for divorce, as detailed below.

1. *Polygamy*

As we have seen, polygamy was fairly commonplace in 16th-century Jewish Levantine society. One may assume that in most cases, the wife came to terms with the fact that she had a rival, and there was therefore no need for litigation. In a number of cases, however, the wife took exception, especially if the *ketubah* contained a monogamy clause.

Childlessness was a common and effective pretext for receiving rabbinical permission to take another wife. There were, however, a number of women who attempted to prove that their childlessness was the husband's fault. Failing this, they demanded a bill of divorce and full payment of the *ketubah*. The husband, for his part, insisted that the problem was the wife's, or accused her of using witchcraft to rob him of his sexual potency.[1] Usually, the *dayyanim* advised the husband to try and 'use persuasion' in order to bring his wife round, even if he had vowed to remain monogamous, or had included a monogamy clause in the *ketubah*, or was Ashkenazi and therefore subject to Rabenu Gershom's ban.[2] Note that women who petitioned for divorce on the grounds that their husbands were infertile, often had to contend with judicial foot-dragging.

[1] Radbaz, I, 260, 327; VI, 2293; Castro, *Ohalei Ya'aqov*, 120; Ralbah, 33; Mabit, II, 206; Ashkenazi, 15; Maharitatz, 40; Alashqar, 89 (The dispute may possibly have taken place in Candia. Cf.: Radbaz, IV, 1188). For further references, see Stahl, *Family*, p. 280 ff.

[2] See: Ralbah, 33; Radbaz, I, 260; Maharitatz, 40, 193, 220; Ashkenazi, 15; Mabit, II, 206; Gavizon, II, 42(43); Cohen-Pikali, Document 406, p. 357.

2. *Desertion*

Another common ground for divorce was desertion, which seems to have been fairly commonplace. A letter sent by the *parnasim* (leaders) of the Jerusalem community to the Safed sages, describes the plight of a deserted woman: "Bitter of soul and sad of spirit [...] The woman and her two children have been left penniless. They have no-one to turn to. They have neither clothes nor food. He [the husband] has turned his back on them, and has not remembered to send them even the smallest sum to keep his wife and two daughters alive."[3] Rabbinical litigation includes the case of a husband "who deliberately left home [...] leaving his wife and daughter in a state of total destitution," and another of a man who fled Damascus "leaving his wife, Dinah, in a state of *igun*. He never even bothered to send his wife a letter, until the poor, starving woman, was forced to return to Safed and ask for help from her relatives."[4] Some businessmen or emissaries who frequently traveled abroad for long periods, sometimes for years at a stretch, never bothered to send money for their wives and children.[5]

3. *Neglect*

Many divorce suits were filed by women against work-shy husbands who failed to support them.[6] On several occasions, these women resorted to Muslim courts, where their cases were more likely to get a sympathetic hearing.[7]

[3] MS Jerusalem, *Iggerot Shadarim*, letter 171, pp. 200-202.

[4] Mabit, I, 239; Maharitatz, 207.

[5] Maharitatz, 177, 192; Benayahu, "Genizah," Document 12, p. 253 (which recounts how a young man from Safed was compelled to leave his wife during the first year of marriage to raise money to ransom his parents from captivity. Despite his good intentions, he failed to provide for his wife, but left her destitute); Mann, *Jews*, II, p. 309 (Mann attributes the text he published to the 13th century or later [ibid, p. 242]. However, it was probably written in the 16th century.)

[6] Mabit, I, 269; Caro, *Avkat Rokhel*, 185; Maharitatz, New Responsa, II, 240; Maharit, I, 113; II, 15; MS Jerusalem, Tzayyah, 413, p. 86a.

[7] See, for example, MS New York, Capusi, 19, pp. 40b-42a, on the dispute between R. Isaac di Molina's son and his wife. Also: Cohen, *Jerusalem*, p. 145; Cohen-Pikali, documents 392-393, p. 350; document 408, p. 358. The deed "for the sale of the husband's assets by the community for his wife's upkeep, when the

A sick or disabled woman, or a woman suffering from post-natal depression, was particularly vulnerable. In the best case, the husband agreed to grant her a divorce without undue extortion. In the worst, he abandoned her, or refused to cover the costs of her medical treatment.[8] The judges usually advised the husband to divorce a wife with a physical defect or disability, and pay her the *ketubah*.[9] If a sick wife objected to a divorce or to a rival wife, the husband was permitted to divorce her against her will, even if he was unable to pay her *ketubah* and increments.[10] If, however, the husband was sick, and his wife petitioned for divorce, many obstacles were placed in her path.[11]

4. *Extortion*

Some disputes were prompted by the husband's attempts at extortion. Many husbands used threats, libel or slander – and sometimes even violence – in order to pressurize their wives into agreeing to a reduction of the *ketubah* sum.[12]

> Simeon [...] used to hit and tyrannize his wife [...] Every day he would concoct a pretext to quarrel with her, in order to force her to detract [...] from her dowry. And yet, however much she reduced the amount of her *ketubah* [...] it was never enough [...] Finally, unable to tolerate the quarrels and the beatings which she suffered in private and in public [...] she vowed to do as he asked [...][13]

husband has absconded and left her penniless," can be found in MS Jerusalem, *Sefer Tikkun Soferim*, 73, pp. 81a-82b.

[8] Alshekh, 132; Caro, Responsa *Beit Yosef*, 50; Mabit, II, 20; III, 92; Pinto, 46 (see ibid, on the difference in medical liability for a married woman and a widow).

[9] Maharitatz, New Responsa, I, 15; Radbaz, VII, 46.

[10] Gavizon, I, 10 (see ibid, editor's notes 19-20).

[11] See for example Maharit, I, 113. See Chapter 11, "Women and Divorce," for greater detail.

[12] Radbaz, III, 1055; IV, 1185, 1246; Maharitatz, New Responsa, II, 172; Mabit, I, 2; MS Jerusalem, Tzayyah, 307, p. 12. I shall deal below in greater depth with the subject of husbands who refused to grant a *get* in order to extort money from their wives.

[13] Gavizon, I, 3. The responsum further tells us that the poor woman vowed "never to have sexual relations with any man but him [her husband [...] for the next fifty years, even if he dies [...] And as a matter of fact, her husband Simon died eight years ago, and this woman is still tied to him like a dog [for she cannot remarry] [...] Would it not be better to cancel her vow so that she shall not remain an *agunah* [...]"

R. Moses Berab, one of the Safed sages, also defrauded and abused his wife. Details of his behavior only became known after his death, when his wife petitioned for maintenance:

> "She claims that he behaved toward her in an unseemly manner [...] She gave him almost one thousand gold coins [...] and he promised to give her a generous *ketubah* with a large supplement as behooves her [...] He, however, deceived her, squandered her money, and failed to write her a *ketubah* with the increment as promised [...] She claims that he used to beat her so that she would forfeit the sum, and waive her demands that the sum be included in the *ketubah* and increment. The fearful wife, anxious to avoid arguments which often resulted in her being locked out of the marital home, succumbed [...]"[14]

After it was proved beyond a doubt that a woman had waived her rights under duress, the rabbinical court revoked the waiver retroactively.

5. *Moving*

When a husband wished to move to another city or country to earn a living, the wife was expected to fit in with his plans. Her refusal to do so not only destroyed the marriage but often cost her the *ketubah* and increment.

A responsum by R. Moses Galante and R. Moses ben R. Israel di Curiel, concerned a young woman from Aleppo who refused to move with her husband to Tripoli, where he had found work. The question put to the sages was: "Does the marginal benefit the wife derives from living near her family in Aleppo justify Reuben's loss of a livelihood?" Of one accord, they ruled that a husband could demand that his wife follow him if he moved to another town or district in the same country.[15] If she refused, he could divorce her (after giving her her "raiments" as specified in her dowry) without *ketubah* or increment.[16] Similarly, a wife had to follow her husband from Cairo to Damietta, or from Safed to Jerusalem.

Moving from Cairo to Gaza was slightly more complicated, as Gaza was outside the *eyalet* (province) of Egypt. However, if the wife

[14] Maharitatz, 172.
[15] *Ketubot*, 110a.
[16] Galante, Responsa, 55; Vital Samuel, 24.

had in the past willingly lived in Gaza, she could no longer move back to Egypt against her husband's wishes. A woman who nevertheless did so, was considered a "rebellious" wife.[17]

A clause in the *ketubah* or a vow whereby the husband undertook not to move away from his wife's home town, were not always effective. In the above case, for example, the Radbaz ruled: "In my opinion, he can insist she follow him [...] A woman usually agrees to move for the sake of the husband's livelihood. Since this woman, however, refuses, her opinion is disregarded and his vow is dissolved."[18]

A husband's wish to emigrate to Palestine was also considered justifiable grounds for annulling any previous vow or prenuptial condition. If no such condition existed, there was even less cause for refusal.[19] A woman who nevertheless refused to follow her husband lost her rights, and her husband could not be compelled to grant her a divorce. It was within his power to render her an *agunah* if he so wished. The husband himself was entitled to take an additional wife after he had emigrated "unless he was acting under false pretenses, and his wish to emigrate was simply a pretext for his desire to take an additional wife."[20]

Unlike the tolerance shown toward men who wished to emigrate to the Holy Land – even if this meant breaking up the family – women who wished to do so were treated less generously. It was assumed that their real intention was to force the husband into granting a divorce and paying the *ketubah*. Therefore, even though the rule is: "Everyone [be it husband or wife] is entitled to compel his/her spouse to move [literally: to go up] to the Holy Land" and that a husband who refused had to grant his wife a divorce and full *ketubah*,

[17] Alshekh, 88; Maharitatz, 5, 292.

[18] Radbaz, I, 509. See also, Galante, Responsa, 75, 87; Mabit, II, 57; Radbaz, I, 435.

[19] *Ketubot*, 110b, and annotations of the *Tosafot*.

[20] Castro, *Ohalei Ya'aqov*, 51, which quotes the Radbaz's ruling. See also: Mabit, I, 139, 245; III, 75; Maharitatz, 227, 242; Galante, Responsa, 44; Castro, *Ohalei Ya'aqov*, 51; MS Jerusalem, *Sefer Tikkun Soferim*, right lapel, which cites R. Bezalel Ashkenazi and the Radbaz. Note that since halakhically Gaza was not considered part of Palestine proper, a husband's petition to obligate his wife to move with him from Cairo to Gaza or else allow him to marry a second wife, was rejected (Maharit, I, 47). On the right to compel her to move to Palestine, or anywhere else in the same country for that matter, see: Soloveichik; For examples of the opinions of various 16th-century decisors, see: E. Rivlin, "History," pp. 102-107.

in practice this was rarely applied. The Radbaz held that a woman's wish to emigrate should always be treated with extreme caution. Only those who renounced a divorce or financial settlement, thereby 'proving' their sincerity, should be permitted to emigrate. The Radbaz was concerned lest a precedent be set for other women desirous of obtaining a divorce through these rather unconventional means.[21]

6. *Jealousy*

Since privacy was virtually unknown in 16th-century Levantine society, it is doubtful whether any information, however intimate, could be kept hidden. Prying neighbors were quick to detect and report anomalous behavior and the most personal issues very soon became public knowledge. It is not surprising that jealousy flourished in such a climate, as the following anecdote illustrates:

> A man quarreled with his wife, because he suspected her of consorting with dissolute men, and warned her not to speak to one of them whom he named. Unable to stand it any longer, one day when he was away she took all her possessions, and some of his too, and went back to her parents' home. In the courtyard of her parents' home lived some undesirable characters, including the very man her husband had been jealous of. She sent emissaries to tell him [her husband] that according to the *ketubah* [condition] he had to live where she wished [...] The husband, however, argued that he wished to live only among decent people.[22]

This strong-minded woman was pronounced a "rebellious" wife by R. Meir Gavizon.

Women were also prone to jealousy. In one case, a woman forced her husband to swear that he would not touch her young relative who lived in the house.[23]

[21] Radbaz, III, 852. The Maharam of Rothenburg (13th century) also ruled that a woman cannot oblige her husband to follow her to Eretz Israel, but for another reason: In his opinion, a woman can oblige her husband to follow her to Eretz Israel only as long as the Temple exists, since then it is a biblical commandment. But 'in these days' only the husband has the right to do so, in the same way as only he has the right to compel his wife to follow him if he moves to another place in the same country. See also Soloveichik, p. 45.

[22] Gavizon, II, 58 (64). See also: Maharitatz, 192; MS Jerusalem, *Zera' Anashim*, pp. 200a-201b; Badhab, 106. For greater detail, see Chapter 8, "Social Norms versus Reality."

[23] Maharit, II, *Yoreh De'ah*, 22.

Jealousy sometimes led to divorce or to the husband's 'punishing' his wife by refusing to grant her a divorce, thereby leaving her an *agunah*.[24]

7. *Debauchery*

Debauchery was one of the most frequent causes of conflict between husband and wife. In a dispute brought before R. Yom Tov Zahalon, the husband was accused of "unspeakable debauchery and dissipation [...] and fornication under the influence of drink."[25] Another wife accused her husband of turning every day into a feast day.[26] Zechariah Adani of Egypt was accused by his father-in-law of getting drunk on *arak* and wine, and the anxious father-in-law demanded he divorce his daughter.[27]

8. *Violence*

Violence, together with debauchery, were the main grounds for divorce. Although the original cause of the violence was not always clear, it was often an indication of deep-seated marital strife. A letter from Jerusalem describes a husband who quarreled with his wife, "banished her from her home, and threw all manner of unrepeatable insults at her."[28] A particularly bad case of violence was that of Nissim Ankari against his wife Nehama bat Isaac Ibn Lahdab:

> Years had passed and yet they were still quarreling furiously [...] He was an argumentative, short-tempered man who treated his wives with arrogance and contempt. Indeed, they were not the only ones to suffer at his hand – anyone who came into contact with him suffered from his ill temper [...] All her days were spent in heart-breaking arguments, so much so that people tired of trying to make peace between them. The wicked man hit his wife in secret, and complained about her in public.[29]

[24] Maharitatz, 193; Radbaz, I, 321; IV, 1348, 1357(=VII, 11); VII, 10, 30; Alashqar, 88; MS Jerusalem, Tzayyah, 359, p. 30a.

[25] Maharitatz, 229.

[26] Mabit, II, 168.

[27] Castro, *Ohalei Ya'aqov*, 92 (145b).

[28] MS Jerusalem, *Iggerot Shadarim*, letter 206, p. 241.

[29] Gavizon, II, 87. Note that in another version, Nehamah is accused of constantly picking quarrels with her husband, of "rebelling" against him and of stripping him of all his assets. For this reason, the sages of Egypt published a "declaration of rebellion" against her. See Castro, *Ohalei Ya'aqov*, 131.

A similarly destructive relationship existed between R. Joseph Franco of Jerusalem and his wife, as R. Levi ben Habib testified:

> "[...] Day and night, they never cease quarreling, or pulling each other to pieces. It is hard to describe what goes on between them [...] on several occasions I saw marks on their faces, and heard them cursing each other and hurling abuse at one another. The whole town knows that they don't even live together as man and wife.[30]

As stated above, even the Safed sage R. Moses Berab used to beat his wife.[31]

Interestingly, the names of the parties concerned are specified in the above three cases – which are probably the most serious instances of wife-battering cited in the Responsa literature of the times. Obviously, these cases were so well-known that there was no need to hide the identity of the litigants under the aliases of Reuben and Leah, as was customary.

The names of husband and wife are also specified in a "reconciliation deed" drawn up by the sages of Cairo in 1607, between R. Joseph Pico and his wife Esther bat R. Solomon Kajiji, in which the husband undertook:

> [...] to henceforth refrain from hitting his wife Esther under any pretext whatsoever. He was likewise to refrain from upsetting her, deriding her, cursing her, or calling her names, or from cursing his father-in-law R. Solomon, or his mother-in-law for any reason whatsoever. He was further enjoined to treat his wife Esther with respect, both in private and in public, as behooves upright Jews [...] If, Heaven forbid, he failed to do any of the above [...] his wife Esther had complete authority to sue him in a gentile court for the entire sum of her *ketubah* [...] He also undertook to grant her a statutory divorce, and to terminate the marriage within twenty-four hours of her filing for divorce, without any protest or obstruction on his part, and without any appeal, objection or delay whatsoever. In this case, the aforementioned R. Joseph agreed to trust the testimony of a neighbor, as the equivalent of the testimony of two valid witnesses.[32]

Both Jewish and Muslim courts handled complaints of violence or wife-battering.[33] Although in many cases the couple were adults, a

[30] Ralbah, 124.
[31] Maharitatz, 172.
[32] MS London, BM Or. 10118, p. 10.
[33] Radbaz, I, 235; III, 888; IV, 1228; Mabit, I, 267; II, 37; Caro, Responsa *Beit Yosef*, 49 (Laws of *Ketubot*, 15), 61-64 (=*Divorce Laws*, 10); Gavizon, I, 3; Cohen, *Jerusalem*, p. 142; Cohen-Pikali, document 395, p. 351; Benayahu, *Ari*, p. 216.

correlation between violence and child marriage probably existed. Husbands who were several years older than their wives felt free to hit them if they disobeyed. Once they got used to this bad habit, they found it hard to stop. [34]

9. *Miscellaneous*

Violence, debauchery or jealousy were not the only causes of marital conflict. Husbands picked fault with their wives for many reasons. For example, a husband took his wife to task for absent-mindedly losing jewelry or causing damage to property;[35] another, for acting hysterically on a sea voyage, thereby "exceedingly incensing her husband".[36] Yet a third quarreled with his wife because the garment she sewed for him was crooked.[37] Arguments broke out between Reuben, a tax-farmer, and his wife, who feared for their economic future.[38] In another case, a woman's failure to trust her husband to pay her *ketubah* was a cause for argument.[39]

Sometimes, disputes were triggered by a husband making sexual demands on his wife at a time when she was ritually impure.[40] Yet another cause of marital strife was ethnic conflict, such as the case of a Sefardi woman who, having married an Ashkenazi "in a fit of madness," divorced him after a month.[41] These are but a few examples of situations which rendered married life intolerable.[42]

When there was friction between husband and wife, the husband usually made sure that the wife would not benefit from his death. To this end, he would sell or pledge all his valuables, and sometimes even hers, leaving her utterly destitute.[43]

[34] Grossman, "Child Marriage," p. 124; ibid, "Violence"; Lamdan, "Child Marriage", p. 56, and above, Chapter 2, "From Childhood to Marriage – The Burden of a Daughter."

[35] Mabit, II, 72, 77 (on the same subject: Radbaz, VI, 2244); Maharit, I, 30.

[36] Mabit, II, 117.

[37] Radbaz, VI, 2085.

[38] Pinto, 73.

[39] MS Jerusalem, Tzayyah, 426, pp. 101b-102a.

[40] Mabit, II, 47; Lieria, Responsa, 25.

[41] Maharitatz, 276.

[42] Mabit, I, 344; Radbaz, I, 384; Alshekh, 8; Gavizon, II, 42(43), 90; II, Appendix 6, 101; Maharitatz, 242; Maharitatz, New Responsa, I, 25(2); Castro, *Ohalei Ya'aqov*, 50; Alashqar, 31.

[43] Radbaz, I, 337; VI, 2183; Arha, 19; Ralbah, 27, p. 15a; Maharitatz, 271.

It was not uncommon for a husband, in the heat of an argument, to take upon himself "a vow of abstinence [the Nazirite vow]," or to swear he would divorce his wife, or take an additional wife. This phenomenon was prevalent not only in the 16th century. Anything, from an ongoing 'state of war,' to a momentary fit of anger, could trigger such a response. Occasionally, such a vow was taken in jest or under the influence of liquor.[44]

Frequently, the vow was used to provoke the wife, and was not meant seriously. Be this as it may, it was not always easy to find a halakhic way of dissolving it.[45]

Nevertheless, in the name of "marital peace" the sages sometimes bent over backwards to find a technical or other loophole for dissolving the Nazirite vow.[46]

If the rabbis were unable to find a loophole for dissolving the vow, the couple had no alternative but to divorce. In some cases, the couple wished to get back together again. This triggered a variety of questions concerning the conditions of the new *ketubah*, the blessings the husband had to recite at the new wedding ceremony, inheritance laws, and the halakhic implications of remarrying one's ex-wife.[47] Immoral behavior between divorced couples led to the enactment of a regulation in Jerusalem in 1520 *"that no man may enter the courtyard of his divorcee without the court's permission."*[48]

This regulation, as well as the many responsa dealing with men who sought to remarry their ex-wives, indicate the prevalence of this

[44] For examples of vows by husbands following quarrels with their wives, see: Mabit, I, 104, 152 (cf. Radbaz, VI, 2115); II, 90; III, 65; Radbaz, I, 42, 161, 221; IV, 1195; Galante, Responsa, 18; Maharitatz, 45; Caro, *Avkat Rokhel*, 178; Maharit, I, 89; Gavizon, I, 1, 2; Pinto, *Yoreh De'ah*, 21; Badhab, 77.

[45] *Nazir*, 13b; Rambam, *Kesef Mishneh*, Nazirite Laws. For references relating to Nazirite vows and vows in general, see editor's notes to Gavizon, I, 1-2.

[46] Gavizon, I, 1; Mabit, II, 9 (p. 8b); Badhab, 82; Ralbah, 124; Caro, *Avkat Rokhel*, 177; Radbaz, III, 982; IV, 1195; Radbaz, New Responsa, 153. R. Samuel Vital queried the Radbaz's ruling (Vital Samuel, 80).

[47] Maharitatz, 143, 247; Radbaz, I, 53, 374; III, 974, 997, 998; IV, 1075, 1195, 1334, 1346, 1348; VII, 10, 13, 64; Radbaz, New Responsa, 153, 199; Castro, *Ohalei Ya'aqov*, 125, 129; Mabit, II, 57; Maharit, I, 64; Vital Samuel, 80; Alashqar, 88. See "*ketubah* for divorced woman remarrying her former husband" and also the text of a divorce bill for a woman who divorced "and wishes to ensure that her former husband will not remarry her" in MS Jerusalem, *Sefer Tikkun Soferim*, 4, pp. 17b-18a, p. 136b. The testimony of a Jewess before the Shari'a court of Jerusalem to the effect that since her divorce, she had not married anyone else, may be in connection with the couple's wish to remarry. See: Cohen-Pikali, document 391, p. 349.

[48] Badhab, 103.

phenomenon, and prove that the threat of divorce and sexual abstinence was used to pressurize the wife into submission. Note that it was extremely rare for a woman to refuse to remarry her husband after he had divorced her.[49] Usually she agreed with alacrity, even if their marriage had been unhappy. This lends credence to the theory that being married, however problematic, was considered preferable to being unmarried.[50]

Statistical breakdown and analysis

In a study of 115 cases where the cause of marital breakdown was known, the main grounds for complaint were as follows:

Cause	Number of cases	%
Violence, debauchery, extortion	30	26.1
Bigamy	20	17.4
Desertion or neglect	14	12.2
Moving	13	11.3
Jealousy	12	10.4
Emigrating to Palestine	8	6.9
Miscellaneous	18	15.7
Total	115	100%

According to these data, the main reason for marital breakdown was violence, extortion and debauchery. Although we cannot draw inferences about societal norms on the basis of the above table, it indicates that violence was common in Jewish society. Moreover, it is safe to assume that legal action was taken only as a last resort, after the woman had suffered abuse for many years, and family members and neighbors had done all they could to help. Less serious cases never even reached the courts. Women who were exploited or deserted by their husbands, were helpless, and to a large extent dependent on the

[49] Radbaz, III, 982, brings an exceptional case of a woman who refused to remarry her husband. Her husband managed to trick her into doing so.

[50] See Chapter 12, "Widowhood."

mercy of the *dayyanim* and local *parnasim*. However, even if the latter wished to help, they were hampered by their inability to enforce laws.[51]

The fact that more than 17% of disputes arose over the issue of bigamy is in itself telling! It shows that bigamy in Jewish society in Egypt and Palestine was far more wide-spread than is usually thought. One may assume that many men who had vowed to remain monogamous, could not withstand the 'temptations' of the Mediterranean society in which they lived, and sought ways of obtaining an annulment of their vows. Alternatively, some sought to divorce their first wife on various pretexts in order to marry someone else. As we saw above, even Ashkenazi men tried to circumvent Rabenu Gershom's ban. In most cases, a husband who wished to take an additional wife got his way, despite opposition from his first wife.

Another cause of marital strife, accounting for 10% of disputes, was sexual jealousy. Usually, although not always, the husband accused the wife of 'cheating' on him, and based his accusation on testimonies of neighbors and gossip-mongers. Sometimes the husband used this pretext to divorce his wife without paying her *ketubah*.

The fact that refusal to move or emigrate to Palestine constituted over 17% of the grounds for divorce indicates that most women had a strong desire to live near their family of origin. Proximity to parents and siblings not only made the transition to life with a virtual stranger easier for the young brides, but the knowledge that there was someone to care for them in times of need also gave them a sense of stability and security. A father or brother provided a support without which women would have found it hard to cope with the social and halakhic problems attendant on a broken marriage. Moreover, socializing with relatives and family celebrations were the only permitted forms of entertainment for women. This may have contributed to their reluctance to leave their childhood environment.

Although in most cases of abuse it was the woman who was abused by her husband, the reverse was sometimes the case. R. Yom Tov Zahalon speaks of a woman who used to disparage her husband to his face, and of another who used to curse and insult her husband, and threatened to denounce him to the gentile courts. The *qadi* of the Jerusalem Shari'a court tried to effect a reconciliation between a husband and wife in a case where the wife used to curse and hit her

[51] See: Graetz.

husband.[52] There were women who dominated their husbands, either because they were richer or because their husbands were weak. There was even a case of a woman who abandoned her blind husband. The husband's distress is patent in the letter he sent her, begging her to return and fulfill her marital obligations.[53]

Sexual abstinence was one of the most effective tools used by women to punish their husbands. The fact that the woman was responsible for observing the laws of impurity gave her a certain amount of power. If her husband angered her for any reason, she could pretend she was menstruating in order to refrain from cohabiting with him, and thereby "take revenge" on him.

> Reuben wanted to cohabit with his wife, but his wife claimed she was impure. The next day she said: 'I am pure. I only told you I was impure yesterday because I was angry with you.' Is she to be trusted or not? [...] [Answer]: If the woman is generally short-tempered and irascible, and usually refuses to cohabit with her husband when they quarrel, she is believed. Otherwise, she is not believed.[54]

Refraining from sexual relations was a more effective weapon than leaving ones husband, since a woman who left her husband and refused to return home was considered a "rebellious" wife and lost her *ketubah*. Moreover, since the manipulative use of sex was hard to prove in court, women could get away with it more easily.

Despite some quite serious problems that emerged in the course of litigation, many couples tried to salvage their marriages. Women were expected to be patient and forgiving of the husband's misdemeanors. This is corroborated by R. Joseph Alsayag's interpretation of the verse "She doeth him good and not evil all the days of her life" [Proverbs 31:12] in a sermon he delivered at his mother's grave:

> Of course a couple will sometimes quarrel, and he will say unpleasant things to her. But the wife's good nature, humility and kindness do not allow her to remember the hurtful things he says. On the contrary, she forgives and forgets. When he is nice to her, on the other hand, she remembers, and is nice back. And this [is why it says] "all the days of her life": Even though there are arguments sometimes – she always does him good, never evil.[55]

[52] Maharitatz, 162, 231; Radbaz, VI, 2095; Cohen, *Jerusalem*, p. 145.

[53] Gutwirth, "Family," p. 214; Maharitatz, New Responsa, I, 54, p. 116; Gavizon, I, 36.

[54] Radbaz, IV, 1338, and ibid, 1075.

[55] MS Amsterdam, Rosenthaliana, p. 362a. Cf. decision of R. Jehoseph Lieria (Lieria, Responsa, 25), and efforts at reconciliation in the case of Esther and Nissim Ankari, in Chapter 9, "Polygamy."

When the efforts of the *dayyanim* and family to effect a reconciliation were of no avail, the couple sometimes had recourse to more popular methods, such as amulets and charms designed "to make peace between man and wife" and "to promote love between husband and wife."[56]

As already pointed out, the relationship between the couple evolved after, rather than before, the marriage, through a process of mutual adaptation and resignation. Both the couple and their respective families knew exactly what to expect, and "love" – albeit acknowledged in songs, popular idioms, and charms and amulets – was no consideration in match-making procedures. Even more pragmatic considerations were not always guarantees of the success of a marriage, as the above cases testify. Possibly rabbinical rulings which tended to favor men, or rabbinical statements about women, encouraged – if not actually created – a climate of contempt toward women. It is not surprising that in such a climate, abuse, exploitation and even violence flourished, especially when there were few punitive restraints.

On the other hand, we must not lose sight of the fact that most couples probably led a fairly harmonious life, even if devoid of romantic love. Although many women went through several marriage cycles in the course of their lives, there were also many whose marriages endured. Obviously, the quality of married life depended to a large extent on the character, personality and adaptability of the partners. One should not forget that the picture painted by the Responsa literature was exceptional rather than normative. Most women fared far better than those who resorted to litigation. Indeed, in the course of their joint life most couples learned to appreciate each other, trust each other in financial matters, and even cherish each other. Women of valor who cheerfully dispensed their obligations toward husband and family were highly prized.[57]

[56] MS London, *Shoshan Yesod ha-'Olam*, 432, p. 186; 587, p. 264; 632-633, p. 266; 695, p. 276; 893 (appears only in index [text missing in manuscript], as "charm against hostility between husband and wife at night"); 1184, p. 458; 1619 (only in index); 1646 (only in index); 1846, p. 526; All in all, ten remedies out of a total of 112 remedies relating to women in *Shoshan Yesod ha-'Olam*, are for improving the marital relationship. See also MS London, BM Or. 10162, p. 30.

[57] See Chapter 4, "Married Life."

CHAPTER ELEVEN

WOMEN AND DIVORCE

The institution of marriage is of paramount importance in Jewish society, both on an individual and national scale, and every effort is made to safeguard its integrity. Although divorce is permissible within Judaism, it is not condoned: "Even the altar sheds tears over he who divorces his first wife."[1] A *get* (bill of divorce) is one of two ways in which the marriage bond is dissolved for the woman (the husband's death being the other). The enormous attention to detail in the *halakhot* relating to divorce, and the importance of accuracy in the wording, dispatch, and delivery of a *get* are indications of the seriousness with which divorce is viewed by Jewish society. The above notwithstanding, the Torah advocates divorce if a woman is no longer attractive to her husband, or if the marriage has broken down irretrievably: "When a man taketh a wife, and marrieth her, then it cometh to pass, if she find no favor in his eyes, because he had found some unseemly thing in her, that he writeth her a bill of divorcement, and giveth it to her hand, and sendeth her out of his house" (Deuteronomy 24:1). The sages interpret this verse as an imperative. Indeed, some even conclude that the husband has a moral duty (*mitzvah*) to divorce his wife, if she is abhorrent to him, or if she goes astray.[2]

Thus, in Jewish law, marriage is not a binding institution for the husband. As for the wife, the situation is far more complex: "In matters of divorce, the status of men is different to that of women. For while a woman may be divorced whether she gives her consent or not, men divorce only at will."[3]

[1] *Gittin*, 90b.

[2] See the difference of opinions between the Shamai and Hillel schools (*Gittin*, 90a). For a review of the differences of opinion between the early and later sages, see Bakshi-Doron, and the concluding sentence of his article: "The basis of the law of divorce is the verse 'If she find not favor in his eyes,' for marriage according to the Torah is not meant to fetter the husband, but to be willingly entered into. If the husband's heart is not in it, it is a *mitzvah* to divorce, and make a clean break." See also Falk, *Marriage*, pp. 96-97; Elon, *Jewish Law*, pp. 251-252.

[3] Mishnah *Yevamot*, XIV, 1. See also: *Gittin*, 49b; *Yevamot*, 112b; Rambam, *Divorce Laws*, I, 1-2. In studies based on Genizah documents, M.A. Friedman points out an

Despite the above, the sages conceded that under certain circumstances the husband could be compelled to grant his wife a divorce. The grounds for a compulsory divorce are cited in the Mishnah as follows: "These are they that are compelled to put away their wives: he that is afflicted with boils, or that has a polypus, or that collects [dog's excrements], or that is a coppersmith, or a tanner."[4] A *get* granted under coercion for any of these reasons is considered lawful and valid. There are, however, other cases, where it is said: "he *shall* divorce her" (rather than "he is *compelled* to divorce her"). Most of the *Tosafists* take the statement "he shall divorce her" to mean that a *get* is only advisable, but not compulsory. In such cases, a divorce granted under coercion is considered unlawful and invalid.

There was considerable disagreement among the decisors as to whether the Mishnaic list of grounds for a compulsory divorce was a 'closed' list or an 'open' one (i.e., whether it was possible to add similar cases, by inference, to the list). Most of the decisors conceded that while a husband could be *urged* to divorce in similar cases, and could even be ordered to pay maintenance until he relented, no other means of coercion could be used.[5]

Grounds for divorce

Repulsion (Incompatibility)

One of the key issues debated by the sages was whether a husband can be compelled to grant a divorce on grounds of incompatibility,

ancient Jewish tradition, whereby a woman could file for divorce even against her husband's wishes. See, Friedman, "Proceedings"; Idem, "Termination"; Idem, *Jewish Marriage*, I, pp. 312-346; Idem, "Intervention," pp. 217-219; Idem, *Polygyny*, pp. 52-53.

[4] Mishnah *Ketubot*, VII, 10 (translation: H. Danby, *The Mishnah*, Oxford University Press, first edition 1933). The latter four cases are connected with offensive smells: bad odor which derives from nasal polyps, leather processing (for which dog's dung is used), copper refining and smelting (for which urine is used). This is explained in the Gemara (*Ketuboth*, 77a).

[5] See: *Ketubot*, 63b-64a; Ibid, 77a; *Kiddushin*, 50a; Rambam, *Marital Laws*, XXV, 11; Ibid, *Divorce Laws*, II, 20; Caro, *Shulhan 'Arukh*, *Even ha-'Ezer*, *Gittin*, 154; "Divorce under duress" in Talmudic Encyclopedia, Vol. 5 (1963), pp. 698-707; "Divorce," ibid, Vol. 6 (1965), pp. 415-426. For general reviews and decisors' opinions, see: Basri; Israeli; Gelbard; Warhaftig, "Coercion"; Idem, "Compensation"; Elon, *Jewish Law*, pp. 541-546; Silberg, pp. 104-122; Schereschewsky, pp. 372-390; Weinroth, p. 320 ff; Friedman, "Proceedings".

when the wife says: "He is repulsive to me" (in Mishnaic terms: *mi'us* [repulsion] – making it impossible for the wife to live and cohabit with him). The sages were careful to draw a distinction between a woman who genuinely cannot bring herself to cohabit with her husband, and a woman who refuses to cohabit with her husband, presumably temporarily, because she is angry with him ("I like him but wish to torment him").

In the latter case, the rabbinical court issues warnings for a period of twelve months in the hope that she may change her mind. During this period, the husband is not obliged to maintain her, and the amount of her *ketubah* is reduced in stages. If she persists in her "rebellion," (refusal to cohabit), she forfeits her *ketubah* and is obliged to return everything she received from her husband.[6]

If, however, the wife genuinely finds the husband repulsive, the husband – according to a regulation that was enacted during the Gaonic period – must divorce her forthwith, return her dowry, and compensate her for any loss or depreciation in her inalienable goods (*nikhsei tzon barzel*).[7] This regulation, known as Law of the Academy (*dinna di-mativta*), was endorsed by Rabenu Gershom Me'or ha-Golah.[8] Likewise, the Rambam maintained: "*If she says she finds him repulsive and cannot cohabit with him, he should be compelled to divorce her immediately, since she is not like a captive to submit to intercourse with someone repulsive to her, and she shall leave without her ketubah.*"[9]

[6] The sages and commentators of the Talmud were divided regarding the laws and legal implications of the "rebellious wife." See: *Ketubot*, 63a-64a. For reviews on the subject see: Weinroth (pp. 30-32, 223, et al.), who emphasizes the flexibility of halakha towards the rebellious wife; Schipansky, *Takkanot*, II, pp. 267-280. For a summary of the various interpretations see ibid, III, p. 356 (according to the Responsa of the Tashbetz), and pp. 360-367 (on differences of opinion between earlier and later decisors). For the background, halakhic view, and legal and material implications of the "rebellious wife," see: Ben Shimon, *Bat*; Schapiro; Bardea; Schereschewsky, pp. 245-260; Kerlin, pp. 50-60; Epstein, *Marriage Contract*, pp. 94-96; Elon, *Jewish Law*, pp. 541-546; p. 637, note 37; Friedman, "Proceedings"; Idem, *Jewish Marriage*, pp. 29, 323-334; Idem, *Polygyny*, p. 29; J. Rivlin, "Gift", p. 171; Westreich, *Grounds*, pp. 14-20.

[7] See *Hilkhot ha-Rif* on *Ketubot*, 63a, which brings a Gaonic regulation on this subject, and "*Shiltei ha-Giborim*" there; Kerlin, pp. 58-59; Levin, p. 189 ff. (see for example sections 471, 473, 478); Schipansky, *Takkanot*, III, pp. 335-356; Tykocinski, pp. 11-29; Friedman, "Divorce," pp. 105-106.

[8] Ragmah, 40-42; Maharam, Lvov, 443; Maharam, Prague, 443, et al.; Grossman, *Sages*, p. 148. See discussion in Westreich, note 6 above.

[9] Rambam, *Marital Law*, XIV, 8.

This 'liberal' regulation was not accepted by most decisors, par-
ticularly Rabenu Tam (12th century). Thus, a husband was not usu-
ally compelled to grant an instant *get* even if the grounds of incompat-
ibility were substantiated, and even though – according to the
Rambam's regulation – he was not required to pay his wife's *ketubah*
(the wife, however, was entitled to keep her dowry).[10]

Likewise, the 16th-century sages of Palestine and Egypt were
strongly opposed to compulsory divorce on whatever grounds, espe-
cially on emotional grounds which were hard to prove, such as "He
is repulsive to me." They were therefore reluctant to apply the ruling
of the Gaonim or the Rambam in this matter.[11] The above notwith-
standing, some women still tried to rest their case on the Rambam's
ruling.

One such case, presented to the Safed sages, concerned a girl not
yet twelve who three months into her marriage found her husband
repulsive and refused to let him near her. "[...] The bride's family
claims that as she is not yet twelve, she should not be adjudged a
'rebellious wife.' And even if she should be so adjudged, they demand
that her dowry be returned, and that he be compelled to grant her a
divorce, as stipulated by the Rambam." Against this claim, the
groom's family maintained: "The bride is taller, stronger, and
healthier than the husband and could easily pass for fourteen [!] As
regards her plea of incompatibility, the Rambam's ruling on this
matter, as brought in the *Beit Yosef*, has been challenged by the later
decisors. How then can the court base its decision on the Rambam in
this matter, and compel the husband to grant a *get* and return her
dowry?" In the event, R. Moses Alshekh pronounced the girl a "re-
bellious wife" to all intents and purposes. Therefore, he ruled, "she
hereby forfeits her right to maintenance, and her *ketubah* is dimin-
ished. Moreover, upon her majority, she shall be pronounced a rebel-
lious wife with the appropriate warnings and public announcements

[10] For example: Rashba, I, 572-573, 1192, 1235; VII, 414; Rashba – Ramban,
138; Rambam, *Marital Laws*, XIV, 14. For a summary of the various halakhic ex-
egeses on this subject, see Arussi, pp. 126-131, who also brings quotations from the
rulings of Rabenu Asher (Rosh), who argues with the Rambam; Friedman, "Pro-
ceedings," p. 21. For a list of decisors who favor coercion, see Weinroth, pp. 353-
357.

[11] Their view was expressed, inter alia, by R. Bezalel Ashkenazi (*Shittah Mekubetzet,
Ketubot*, 63b) and R. Joseph Caro (*Shulhan Arukh, Even ha-'Ezer*, 77b-c; *Kesef Mishneh* [on
the Rambam], Marital Laws, XIV, 8).

[...] If she fails to substantiate her claim, she stands to lose even her dowry, unless she took possession of it for her maintenance."[12]

In a similar case, which took place in Egypt, a recently-married woman demanded a divorce, due to friction with her husband. The husband claimed that the wife's parents had incited her against him, and had instructed her to plead that he was repulsive to her. He not only refused to grant a divorce, but even demanded permission to take a second wife to fulfill the commandment of procreation, despite the fact that he had vowed to remain monogamous. Although R. Yom Tov Zahalon accepted the plea of 'revulsion,' he was also reluctant to apply the Rambam's ruling on compulsory divorce, on the grounds that it had not yet been endorsed by the Egyptian sages. R. Meir Gavizon was consulted on the same matter, and reached a similar conclusion.[13] The Radbaz explains the reluctance to apply the Rambam's ruling as follows: "The convention in all communities of Israel is not to follow the Rambam in this matter, since it has been shown [...] that there is a need for a preventive law [gadder] to stop a woman who has set eyes on another man from seeking a divorce."[14]

The above notwithstanding, the Radbaz himself occasionally rested his case on the Rambam, for fear that if a woman were denied a get, she could fall into bad ways.[15]

Thus, the sages of Palestine and Egypt, who held the Rambam as the supreme halakhic authority on all other matters, contested his ruling concerning a woman's right to demand a compulsory divorce on grounds of incompatibility. The few Palestine sages who supported the Rambam were definitly in the minority. Among them was R. Moses Bisoudia, as witnessed by R. Yom Tov Zahalon: "I heard that our revered teacher R. Moses Bisoudia may he be remembered for everlasting life has, together with the sages of his time, compelled

[12] Alshekh, 8, and see R. Hayyim Benveniste's reaction (*Keneset ha-Gedolah*, 77, 10) to this responsum, namely that the reference here is not to a wife who finds her husband repulsive immediately after their marriage, in which case she is not considered a "rebellious wife," but rather to someone who has lived with her husband for at least several months, and only then declares that she is unable to cohabit with him.

[13] Maharitatz, New Responsa, II, 172; Gavizon, II, 42[43].

[14] Radbaz, IV, 1331. Also: ibid, I, 205, 260.

[15] Ibid, 187. The Radbaz brought the same argument in validating an erroneous *get* (I, 469) and also in authorizing *agunot* (see Chapter 13, "Agunot").

a man to divorce his wife on grounds of revulsion, as the Rambam –
the undisputed authority – has ordained."[16] R. Yom Tov Zahalon
himself, however, was not prepared to follow in his rabbi's footsteps,
without the approval of his colleagues.

R. Isaac Don Don of Aleppo, when questioned about the validity
of the Gaonic regulation in connection with the property entitle-
ments of a "rebellious wife," had the following to say:

> It [the regulation] has not been accepted by most Jews in most places
> [...] You need simply question wayfarers as to whether the Law of the
> Academy [Gaonic regulation] has been applied in their country: [You
> will find that] it has not been applied in the whole of Turkey, nor in
> Palestine, Egypt, Damascus, Aleppo, North Africa or Spain. Should we,
> therefore, invoke this regulation, when our mentors have not? [...] As to
> her taking possession of the gifts her husband gave her [...] such posses-
> sion is not valid, since everything in the house belongs to the husband
> [...] If she claims it is hers, the burden of proof is on her [...] This must
> be so, since otherwise the husband of a rebellious wife would be left
> without a penny. She would simply steal everything from under his
> nose.[17]

From the above we see that a woman who pleads revulsion, is sus-
pected not only of having set eyes on another man, but also of fabri-
cating this claim in order to strip her husband of all his possession.
Under such circumstances, the rabbis felt that leniency was out of the
question.

The plea of revulsion was disregarded even when the husband was
an epileptic. Although a man could divorce his wife on the grounds
that *she* suffered from epilepsy, the reverse was not true. According to
Jewish law, an epileptic man can be pressurized (through raising the
maintenance payments to his wife) but not coerced into granting a
divorce.[18]

There was a further reason for the sages' skepticism toward the
plea of incompatibility: They were afraid of setting a precedent that

[16] Maharitatz, New Responsa, I, 37. Ibid, 99; Maharitatz, 229. R. Moses Bisoudia
was one of the Safed sages, who lived for a while in Tripoli (Syria) and apparently
also in Damascus (Maharitatz, New Responsa, I, 82; Benayahu, "Revival," p. 262;
Idem, "Sermons," pp. 101-102; Rosanes, II, p. 142). R. Joseph Trani also expressed
his willingness to rule in favor of a compulsory *get*, but only with the backing of his
colleagues (Maharit, I, 113).

[17] MS Jerusalem, *Zera' Anashim*, pp. 194a-199a. See also: Rambam, *Marital Laws*,
XIV, 8; Radbaz, I, 205, 364; Badhab, 99. On the Gaonic *takkanah* on financial
matters, see Schipansky, *Takkanot*, III, pp. 348-351.

[18] Mabit, III, 212.

might be abused by other women. They feared that such a precedent would be used as a pretext by "all women" in order to steal their husband's property. Therefore, the wife's pleas of revulsion or incompatibility was not usually accepted *per se*. The sincerity of "rebellious wives" was considered questionable at the outset.

The following responsum by the Radbaz is probably representative of the attitude of most contemporary decisors to the plea of revulsion. In the case at hand, a woman claimed she could no longer tolerate her husband's abuse. The Radbaz, although accepting the woman's testimony, nevertheless tried to point out the positive aspects of their marriage: "[…] Although he beats her sometimes, he also spoils her from time to time. And if he sometimes humiliates her, he also honors her by buying her nice clothes." Implicit in the Radbaz's responsum is the attitude that the wife should not be too hard on her husband, since men are by nature quick-tempered, and a beating or two by a husband is not the end of the world. Also implicit is the attitude that women are by nature 'forgiving', and are easily brought round by gifts. In any event, battering or abuse were not considered grounds for 'revulsion.' The only remedy in such cases was pressurizing the husband through a series of measures, including litigation in a gentile court, in the hope that in the end he would see reason.[19]

In conclusion, the claim of 'revulsion' ["He is repulsive to me"], even if substantiated, was not considered sufficient grounds for divorce. The fear of widespread abuse of the pleas of 'revulsion' overrode considerations of individual suffering.

Infertility

Although the biblical verse "Be fruitful and multiply and replenish the earth" (Genesis 1:28) appears to be God's blessing to men and women, the rabbis interpreted it as a binding injunction applicable to men only.[20] By inference, a childless man is entitled to divorce his

[19] Radbaz, IV, 1228. See also ibid, I, 327, 458, 509; IV, 1075; VI, 2115, et al. Cf. R. Jehoseph Lieria's ruling of the mid-17th century: "The woman must be gently persuaded to show forbearance and patience. Perhaps through her, he will mend his ways […] and there will be no need to divorce" (Lieria, Responsa, 25. See also ibid, 51). On the ambivalence in rabbinical decisions in this respect see: Graetz (especially note 12); Adelmann, "Wife-Beating".

[20] See Westreich, "Right"; Biale, p. 52.

wife against her wish, or take a second wife, in order to fulfill the commandment of procreation, while a childless woman cannot demand a divorce on such grounds. The only argument she can invoke in her favor is that she needs a child to support her in her old age and to arrange her burial.[21] Even though this argument was accepted by the decisors, they were in no hurry to compel the husband to divorce in such cases.

R. Joseph Caro argued, that even though a husband may be compelled to grant a divorce if the couple is childless, he may postpone the case if he wishes to take a second, or even third wife, in order to determine if the problem is his or his wife's. R. Yom Tov Zahalon, on the other hand, took strong exception to this rule: "It is unfair to expect the woman to wait indeterminately until her husband proves his case. [...] She may grow old in the meantime, and be unable to bear children, or die, without progeny to bury her [...] If he is allowed to takes a second or even third wife in order to prove his fertility, it could take ages until her case is brought to trial." Despite these cogent arguments, the Maharitatz himself was reluctant to mandate a compulsory divorce. He advised caution, on the grounds that the woman might be using her childlessness as a pretext for laying hands on her *ketubah* prematurely, or may be motivated by jealousy towards a rival wife: "She may be angered by the fact that he took another wife, and wished to spite him by proffering fictitious allegations that her husband is impotent, and the like, and that she needs a support in her old age. Therefore, coercion is not indicated."[22]

In a similar case, the ambivalence of R. Yom Tov Zahalon is once again apparent:

> It is not fair to expect a woman to wait indefinitely. Even though the commandment of procreation is not incumbent upon her [...] it is not right to act in this manner. It is one thing to bypass the ruling of the Rif, Rambam and Rashbam, namely the Gaonic regulation mandating compulsory divorce, in order to prevent abuse of the law [*ligdor gadder*], as ordained by the later sages. It is quite another to allow this unfortunate woman to spend the rest of her life in desolation. [...] What future is there for this poor woman if after all the warnings and threats, bans and curses, she is seen to be acting in good faith, and not at the bidding of others? If she truly find this man repulsive, why should she be pun-

[21] *Yevamot*, 65b.
[22] Maharitatz, 193. See Caro, *Shulhan 'Arukh, Even ha-'Ezer, Gittin*, 154, 6.

ished on this account? It is not fair that the woman should remain desolate. On the other hand, the husband cannot be compelled to divorce her, since this would contravene the ruling of the later sages (*Aharonim*). In my humble opinion [...] the following should be done: He should be forbidden, by oath, to take another wife until he divorces his first wife.[23]

Thus, although the Maharitatz felt compassion for the childless woman, he was nevertheless unwilling to compel the husband to divorce, preferring to use indirect pressure instead.

Neglect of marital duties

A husband who failed to live up to his marital commitment to provide his wife with food, raiment or conjugal rights could be compelled to grant a divorce.[24] Indeed, women often got a favorable hearing in such cases.

Barukh ben Jacob, who was forced by a gentile court in Beirut to grant his wife a divorce, was "a man who defaulted on the biblical commandments of maintenance and cohabitation. He has left his wife an *aguna* for some years now, while he wanders from city to city. Wherever he goes, he takes a new wife. He has never sent his wife anything [...] and has never come near the home [...] There is no way of compelling this man to pay maintenance to his wife, for one of the reasons he is constantly on the go is in order to avoid being traced by creditors." In light of this serious misconduct, the Mabit ruled that the compulsory divorce, obtained through the offices of the Muslim court, was valid, especially since the woman was prepared to waive her entire *ketubah*.[25]

R. Yom Tov Zahalon was also required to adjudicate in the case of Nissim Zandon, who claimed that he had divorced his wife under duress. In due course, when it came to light that the husband had been abusive towards her, R. Yom Tov Zahalon ruled that the divorce was valid. Even in such a case, however, the man had to be appeased with money. In any event, his behavior toward his wife justified a compulsory divorce: "Every day he threatened to go far

[23] Maharitatz, New Responsa, II, 172.

[24] Caro, *Shulhan 'Arukh, Even ha-'Ezer, Ketubot*, 76, 11; Ibid, *Gittin*, 154, 3. See also: Epstein, *Marriage Contract*, pp. 93-103.

[25] Mabit, I, 76.

away to the lands of Ashkenaz and the diaspora, and leave her an *aguna*. In the end, he carried out his threat. This alone justifies a compulsory divorce, in order to release her from her *aguna* status [...] Moreover, it is apparent from the question that he is not willing to feed and clothe his wife [...] This, too, justifies a compulsory divorce [...] Finally, an abusive husband may also be coerced into providing a divorce, according to some decisors. Therefore, on all these counts, the divorce is valid."[26]

The case of Nissim Ankari and his wife Nehamah bat Isaac ibn Lahdav precipitated a fierce polemic between the sages of Palestine and the sages of Egypt. Nissim was described in the following terms: "He is a quarrelsome and churlish man who is abusive towards his wives [...] He has threatened to go to the lands of Ashkenaz and the diaspora and leave her an *aguna*." Finally, succumbing to several years of pressure, which included a hearing in a gentile court, he agreed to divorce his wife in return for a handsome fee. However, the *get* was challenged on the grounds that it was provided under duress and was therefore invalid. The main authority invalidating the *get* was R. Jacob Castro, whose ruling was upheld by R. Benjamin Kajiji, R. Solomon Alfaranji and R. Abraham Castro. Among those validating the *get* were: R. Hayyim Capusi, R. Abraham Monson, R. Yom Tov Zahalon, R. Hiyya Rofeh, R. Moses Galante, R. Jacob Abulafia and R. Moses Kastilatz.[27]

Jacob Zarkon of Safed, who was accused of heresy and homosexuality, was also ordered through a gentile court to divorce his wife before he was expelled from the city, so that she would not remain an *aguna* and destitute. When he later argued that the divorce had been obtained under duress while he was under arrest, both the Mabit and R. Jacob Berab countered that his arrest was due to his immoral conduct and not to his refusal to grant a divorce. Moreover, had he

[26] Maharitatz, New Responsa, II, 240.

[27] Gavizon, II, 87. The anecdote is mentioned in many sources (in published and manuscript form). See source references in the editor's note to the question. I would only point out that according to the wording of the question as put to R. Jacob Castro and those leaning toward stringency, the woman was accused "of constantly quarreling with her husband, R. Nissim Ankari, of rebelling against him, and of stealing from him" (Castro, *Ohalei Ya'aqov*, 131). The Nissim Ankari here should not to be confused with the sage R. Nissim Ankari, famous in another context (see above, Chapter 9, "Polygamy"). This one may have been his grandson. On the quarrels between Nissim Ankari and Nehamah his wife, see also Chapter 10, "Marital Disputes."

wished, he could have chosen to stay in prison rather than agree to divorce. Although his prison term was reduced for agreeing to grant a *get*, he nevertheless had a choice in the matter. Therefore, the *get* had not been granted under duress, and the woman was allowed to remarry.[28]

The above cases show that although divorce pleas on grounds of failure to provide for the wife were not always successful,[29] the sages were exceptionally flexible on this matter, and exploited all existing halakhic options – even recourse to a gentile court – to the full, in order to pressurize the husband into granting a divorce.

The rabbis were less inclined to be flexible in divorce suits occasioned by the husband's failure to meet his sexual obligations towards her. As well as the sensitive nature of the issue, serious financial considerations were at stake, such as her entitlement to her *ketubah* if the claim were upheld. In such cases, the *dayyanim* were reluctant to compel the husband to divorce, even if the wife's claim was substantiated, in the hope that the situation might improve.[30]

It is in this light that we can understand R. Levi ben Habib's recommendation regarding a woman who, shortly after her marriage, filed for divorce claiming payment of her *ketubah* and increment, on the grounds that her husband was impotent. The husband denied her claims, arguing in his defense that he believed a spell had been put on him. According to the Ralbah, there were five controversial issues in the case: (a) Is the woman's testimony reliable on such a count? (b) Is a precondition necessary for her testimony to be believed? (c) If her testimony is reliable, what are her rights (payment of *ketubah*, dowry and increments)? (d) Must she appear in court in person, or may she send someone to represent her? (e) If she is reliable, must the court give an immediate ruling, or may it defer its decision? After serious consideration of the matter, he finally concluded:

> It is the court's prerogative to dismiss this woman with its left hand [the strict letter of the law] if she insists on divorce. Simultaneously, it may

[28] Mabit, I, 22. See Caro, *Shulhan 'Arukh*, *Even ha-'Ezer*, *Gittin*, 154, 1 (in annotation).

[29] For example: Caro, Responsa *Beit Yosef*, 55 (=Divorce Laws, 3); Maharitatz, New Responsa, II, 210; Mabit, II, 47.

[30] See Rashba – Ramban, 139 ("In the final analysis, the issue is extremely complex and only the great decisors can resolve it. Therefore do not put yourself 'between the straits'"); Caro, *Shulhan 'Arukh*, *Even ha-'Ezer*, *Gittin*, 154, 7.

also use its right hand, the right-hand of God [mercy], to speak to her gently, and endear her husband to her so as to prevent her from destroying the family unit [...] The court may try to persuade her to the best of its ability [...] and dismiss her claim once, or twice, advising her to reconsider the matter. If despite the above, she persists in her rebellious and brazen intent, and insists that she still wants to divorce, he is urged to divorce her. Failure to comply is tantamount to disobedience of the sages. However, *he is not compelled to divorce.*[31]

A case that was debated by the sages of Egypt and Palestine in 1572-1573 is instructive of how such cases were resolved:

Reuben, who married the daughter of Simeon, has been married for three years without consummating the marriage. The wife claims that he has no sexual potency [*yisha'en ve-lo ya'amod*]. They argue every day. Finally, people came to make peace between them [...] and stipulated that each party [...] deposit 50 florins with [...] R. Solomon Mazuzi, a trustworthy person. The husband has been given a period of 29 days in which to consummate the marriage. If he succeeds [...] R. Solomon will return the 50 florins to the wife [...] If, God forbid, he is unable to consummate the marriage within the specified period, R. Solomon will investigate the matter further. He shall visit the couple each day, and if he concludes that the failure to consummate the marriage lies with the woman, he will return the 50 florins to the husband together with the "deed of rebellion" [deed declaring the wife rebellious]. In such a case, the husband cannot be compelled to grant a divorce [...] The husband also agrees [...] that neither he nor anyone else will lay a spell on the wife, and that he will treat her [...] with love, respect and affection.[32]

After the trial period elapsed, R. Solomon Mazuzi testified before the court that in his opinion the husband was to blame for failure to consummate the marriage. The husband, however, still refused to divorce his wife, insisting that he was not to blame. After due deliberation, the *dayyanim* of Egypt consulted the Mabit in Safed as to whether a compulsory divorce was indicated. The Mabit favored indirect rather than direct coercion. For example, the husband could be obliged to pay his wife the 50 florins deposited with the go-between, as well as her *ketubah* (with increments), and maintenance. He could be forbidden to take another wife. A communal regulation

[31] Ralbah, 33. See also Ralbah, 80.

[32] Mabit, II, 206. Cf. ruling of R. Barukh Barzilai, a Safed scholar of the first half of the 17th century, in connection with a husband who admitted to being impotent: "He is not compelled to grant her a *get*, but is forced to pay her maintenance until he consents to grant her a valid *get*" (Lieria, Responsa, 38). Suspicion of witchcraft in such matters was evidently very common. See also Mabit, I, 267.

(*haskamah*) could be issued forbidding any woman to marry him until he had divorced his first wife. The Mabit recommended that the rabbinical court of Egypt use these and any other measures it saw fit, to pressurize the husband into agreeing to a divorce. Such a divorce would not be considered a divorce obtained under duress.

Another case of an unconsummated marriage was brought before R. Yom Tov Zahalon and R. Bezalel Ashkenazi. The husband claimed that his wife was "impenetrable," while the woman claimed he was impotent. Various examinations conducted by female experts substantiated the husband's claim. However, the woman and her family refused to accept the court's decision and attempts to effect a reconciliation, and took the case to a gentile court instead. After serving a jail sentence for several months, and being subject to threats and harassment, the husband consented to grant a divorce and compensate the wife's family. However, he subsequently argued that the divorce had been granted under unlawful duress, and that his wife should not be allowed to remarry.

R. Bezalel Ashkenazi accepted the plea. Not only was the *get* obtained under duress, he said, in collusion between the mercenary Muslim court and the woman's wealthy relatives, but under no circumstances was a wife's testimony in cases of alleged impotence acceptable. He took the *dayyanim* in the case to task, and bemoaned the loose morals of his generation, where women could demand a divorce under trumped-up charges. The Maharitatz also invalidated the *get*, on the same grounds, and because the wife's accusations had not been substantiated. Even supposing her accusations had been substantiated, he argued, when a woman refuses to forego her *ketubah*, the husband cannot be compelled to grant a divorce.[33]

The Radbaz concurred with R. Bezalel Ashkenazi: "Moral standards are declining from generation to generation. This breach must be closed. Far better that one or two women go astray, than that the law allows all women to demand a compulsory divorce for such reasons [impotence]. Women will not hesitate to lie, in a bid for freedom."[34] The Radbaz feared that a precedent would trigger a spate of similar claims by other women.

[33] Ashkenazi, 15; Maharitatz, 40 [see also there responsum of R. Samuel Jaffe Ashkenazi, who was evidently the father of the husband in this case (see Maharitatz, New Responsa, II, 240).] The dispute took place in 1582/3 in Adrianople.

[34] Radbaz, IV, 1188. Ibid, I, 260.

The sages were sensitive to women's sexual needs. When a levir refused to cohabit with his wife on the pretext that she was no longer able to bear children, R. Eliezer Ibn Arha, the Mabit, and R. Abraham Gabriel promptly ordered the man to fulfill the commandment of cohabitation. Levirate marriage, they argued, was not contingent on the wife's ability to bear children, "For all decisors unanimously ruled that infertile women or women past childbearing age are still subject to the levirate marriage."[35] In the customs [*hanhagot*] of the Ari and the Safed Kabbalists, there is also a call for consideration of the wife's needs.[36] However, they were not prepared to compel a husband who was unable to satisfy his wife's sexual needs to divorce.

R. Josiah Pinto attached great importance to the fulfillment of the commandment of cohabitation. He was also probably the only sage of his generation who was prepared to mandate compulsory divorce on grounds of impotence: "In this particular case, it is obvious that the husband is suffering. Indeed, he has poured out his troubles to the physician, and admitted that his wife's claim is true. The consultant has pronounced the husband incurably impotent [...] thereby endorsing the wife's claim [...] Therefore, there is no reason to suspect the wife of setting her eyes on another and lying. This being so, she is entitled to her *ketubah* and increment [...] and the husband must [grant her a *get*]."[37]

As a rule, therefore, most 16th-century decisors adopted a strict approach toward divorce petitions submitted by women, although some showed understanding – even if only in theory – of their motives. In practice, the rabbis held that only a few grounds justified compulsory divorce. Had the broader view been accepted (namely, that the list of grounds for compulsory divorce was not a closed list), there would have been greater leeway for halakhic maneuver. But this was not the case. As things stood, the rabbis were sometimes willing to compel a husband to divorce only in cases of neglect of his marital obligations (food, raiment, and sometimes also cohabitation). They might have pressurized a husband to divorce on grounds of

[35] Arha, 10. Also Aptowitzer, p. 203.

[36] Vital, *She'arim, Sha'ar ha-Mitzvot, Parshat Bereshit*, Section 8, p. 7. For other versions, see Benayahu, *Ari*, p. 311. On the difference between the commandments of procreation and cohabitation, see Mabit, III, 131.

[37] Pinto, 45. See also ibid, 22.

'revulsion' or infertility, but would never have *compelled* him to do so in such cases.

The fact that in Judaism, the act of divorce is contingent on the husband's will, precluded equal consideration of both parties claims and a dispassionate examination of the wife's predicament. Under such circumstances, it is not surprising that the mere possibility that the wife might be unhappily married and wish to try again, was not given serious consideration.

In his comprehensive study on the law of the rebellious wife, Jacob Weinroth attempts to refute the 'myth' that in Judaism the woman is the husband's property, and to demonstrate that Jewish law "has never lost sight of the fact that a woman has feelings." The norms of Jewish Law, he argues, are "social and even psychological norms" which also have a rehabilitative function. The decisors' attitude toward women throughout the generations is described as "consideration of *a person in distress* [author's emphasis]."[38] Assuming this is so, the author fails to answer the following questions: Why was it necessary to relate to woman as to "a person in distress"? What was the cause of her distress? Why was a man in a similar plight not awarded similar consideration?

Indeed, a "paternalistic-conciliatory" approach runs through many of the 16th-century responsa, and proceedings were frequently adjourned in the hope that the situation would improve. This attitude, however, placed the onus on the woman: The expectation was that *she* would come to terms with the situation, or that *she* would think twice before renouncing her property.[39]

[38] Weinroth, pp. 3-4.

[39] On the paternalistic-conciliatory approach of the sages to divorce petitions by women, see Weinroth, pp. 203-208. According to Weinroth (p. 206), paternalism "destroys the immediate wish of *both parties* [author's emphasis] to dissolve the marriage." On the tendency toward greater conservatism in rulings, see below, Chapter 15, "Regulations concerning Women."

In this context, it is worth mentioning the progressive attitude of Rabbi Raphael Ben Shimon, rabbi of Cairo in the early 20th century, in his book on the laws of the rebellious woman (*Bat Na'avat ha-Mardut*, pp. 13-14). In it, he speaks of compassion and patience as qualities necessary for a *dayyan* in his dealings with women, and recommends the use of common sense, as well as justice. The following passage in particular is worth quoting: "Investigation into the case of a 'rebellious wife' requires patience, generosity, and gentleness, until the woman reveals the secrets of her heart. The *dayyan* must make it his business to unravel the truth, especially if the subject is a sensitive one, since Jewish women are modest and do not easily reveal their troubles to others, as experience has shown. Therefore, the *dayyan* must be compassionate and patient, and not rush to condemn women [...] who have fallen into the hands of

Acceptance of a woman's arguments was due more to 'paternalistic solicitude' than to a belief in the validity of her claims.

Even where the sages had considerable halakhic latitude – either through a more flexible interpretation of the grounds for compulsory divorce, or through adopting the Rambam's ruling that a husband could be forced to divorce his wife if she found him repulsive – an independent judgment was extremely rare. On the contrary, the tendency toward conformity and stringency, rather than innovation and flexibility, prevailed.

Options available to women seeking divorce

Financial pressure

In view of the above, women who were anxious to divorce often had to resort to financial means ('paying off' their husbands or renouncing their *ketubah* and other financial claims) in order to obtain their freedom. Obviously, such means were available only to women whose families were able to provide them with psychological and economic support. Without such support, the chances of obtaining a divorce from a recalcitrant husband were minimal. The above explains the following advice given by the sages of Jerusalem to the father of a woman whose recalcitrant husband was staying in Jerusalem.

> It is not within our power to coerce him [the husband] into granting her a divorce forthwith. Therefore we advise [...] with all due respect and in cognizance of your daughter's interests, [...] that you pay a certain sum of money to your son-in-law [...] We have further strictly forbidden your son-in-law, by all manner of oaths and vows,[40] to leave Jerusalem until we have your reply. If you remit us the above sum in the allotted time, we shall do our best to obtain a valid *get* for your daughter. If the above sum fails to arrive within the specified time, he [the husband] will

worthless men, to the fate of a 'rebellious wife' [...] Let the wise man hear and take counsel, and let the wise of heart take note [...] that the "rebellious wife's" claim that she is repelled by her husband is neither a serpent's venom nor a death potion. On the contrary, if her claim is substantiated, and her plight is revealed to the *dayyanim*, their compassion cannot fail to be aroused."

[40] A play on words, alluding to oaths [*shevu'ot*] and vows [*alot*] (cf. Numbers 5:21; Daniel 9:11, et. al.). Literally "by the gazelles [*tzeviot*], and by the hinds [*ayalot*] of the field" (Song of Songs 2:7).

have the right to go where he pleases. We hope, with the help of God, that our counsel is correct [...] and will speedily extricate your daughter from her predicament [...] Please also provide us with a notification absolving him [the husband] of all claims, petitions, arguments, liabilities and liens your daughter has against him.[41]

Conditional divorce

Another means of obtaining a divorce from a recalcitrant husband was through the *conditional divorce*. Such an expedient was most commonly used when husbands had to leave home for extended periods of time, or were about to undertake a dangerous journey. It was based on the understanding that if the husband returned within an agreed time – usually one to two years – the conditional divorce would be annulled. This method was unanimously considered to be in the woman's best interests, by precluding '*igun*' and forestalling the need for a levirate marriage, if her husband failed to return.[42] Although many husbands were quite willing to grant a conditional divorce to their wives prior to their departure,[43] some had to be 'persuaded' to do so. In some communities, conditional divorce was mandatory,[44] while in others, husbands had to be pressurized by the wife and her family, or by the local rabbis, into agreeing to grant a conditional divorce.[45]

As with the regular *get*, great care had to be taken to ensure that the wording, dispatch and delivery of the conditional *get* (irrespective of the condition) conformed to halakhic requirements and to the husband's stipulations.[46] The above notwithstanding, not all the

[41] MS Jerusalem, *Iggerot Shadarim*, Document 195, pp. 230-231. See also case described in Maharitatz, New Responsa, II, 192. For the background and sources of this custom, and also a comparison with the Islamic convention (*iftida*), see Friedman, "Ransom," and the works mentioned in note 3 above. See also: Warhaftig, "Compensation."

[42] Caro, *Shulhan 'Arukh, Even ha-'Ezer, Gittin*, 154, 8; Berkovitz.

[43] Arha, 6, 20; Caro, Responsa *Beit Yosef*, 62 (=Divorce Laws, 11); Mabit, I, 300; II, 10; Maharitatz, 175, 257.

[44] Maharit, I, 66; Arha, 6.

[45] Mabit, II, 82, 201; Maharit, I, 36, 66; Radbaz, I, 83; Caro, Responsa *Beit Yosef*, 56 (=Divorce Laws, 4).

[46] Rambam, *Divorce Laws*, VIII; Caro, *Shulhan 'Arukh, Even ha-'Ezer, Gittin*, 143; See also: "*Get*" in Talmudic Encyclopedia, Vol. 5 (1963), p. 671 ff. Examples of bills of divorce which contained limiting clauses can be found in: Caro, Responsa *Beit Yosef*, 56 (=Divorce Laws, 4), 57 (=*Divorce Laws*, 5); Pinto, 38; Radbaz, I, 83; IV, 156, 1357-1358; Maharit, I, 49-51; Mabit, I, 332; II, 1.

clerks or agents were familiar with *halakha*, and clerical or technical errors sometimes occurred. In such cases, the rabbis often had to decide between stringency (invalidating the divorce) to preclude polyandry, or leniency (validating the divorce) to preclude *igun*. Sometimes these deliberations continued for months or even years.[47] In general, however, the rabbis bent over backwards to validate a conditional divorce when a husband failed to return for whatever reason.[48]

During the 16th century, the conditional divorce was frequently used, both by Iberian refugees roaming the Levant in search of a place to settle, and by merchants who were absent for months or years on end. As well as these bona fide cases, the conditional divorce sometimes served as a stepping stone to a permanent divorce. All a woman had to do was to lie low until the period stipulated in the conditional divorce had elapsed. That abuse of the conditional divorce as a stepping-stone to a permanent divorce was commonplace is attested to by the frequency of such cases in the Responsa literature.

An interesting example of abuse of the conditional divorce is provided by the following case brought before the Radbaz, in which a woman claimed her *ketubah* after the statutory period had elapsed and her husband had not returned. The husband, however, pleaded 'duress,' stating that he had returned on time but that his wife had disappeared. The Radbaz, against the opinion of a local rabbi, ruled:

> He [the husband] should have introduced a clause into the conditional divorce, stipulating that if the wife refuses to be placated [...] there will be no *get*. [Or] if she hides from him so that he does not even have the chance of placating her – there will be no *get*. Since he made no such condition, he has actually left the decision in her hands, and therefore the divorce *is* valid [...] We have already shown above that the husband should have thought of the possibility that his wife might disappear, especially since they had quarreled [before he left] and he had continued to provoke her [...] *For it has become common practice for women who are granted a conditional divorce to disappear until the stipulated period is over, in order*

[47] Arha, 6; Mabit, II, 131; Castro, *Ohalei Ya'aqov*, 120 (this case is discussed in detail in the introduction to the Responsa of R. Meir Gavizon, pp. 50-51, and in the editor's notes to responsum 26. The notes there also contain source references to the responsa of the decisors who were involved in the case).

[48] For example: Maharit, I, 66; Arha, 6, 20; Gavizon, I, 26; Maharitatz, 183; Mabit, II, 131, et al. See also: Caro, *Beit Yosef* on the *Tur Even ha-'Ezer*, Divorce Laws, 144, 65b; 147, 68b; Benveniste, 147, *Hagahot ha-Tur*, 5.

to obtain a valid divorce [...] and there are quite a number of cases where this is justified.[49]

Since the husband had failed to take into account the probability of his wife's disappearance, he could no longer claim 'duress.' The woman was therefore legally divorced, and entitled to remarry. Furthermore, the Radbaz stated, if the local rabbis refused to officiate at her marriage, the woman should make her way to Safed or Jerusalem, where he himself would perform the marriage ceremony, with the consent of his colleagues.

In a similar case, a man from Cairo, fleeing to Sa'id to escape his creditors, granted his wife a conditional divorce for a year, only to find, upon his return, that his wife had disappeared:

> He stalked the area like a man berserk, bringing a never-ending array of lawsuits against his father-in-law [...] The rabbinical court, meanwhile, sent an envoy to track the woman down – in vain. The husband, too, looked for her high and low, climbing over rooftops and through windows, but all to no avail [...] As time went on, he became increasingly distraught [...] When the year was up, and he had returned to Sa'id [...] she suddenly turned up, requesting that the divorce be honored, since the mandatory period of a year had elapsed.[50]

Despite the husband's moving efforts to trace his wife, R. Jacob Berab pronounced the woman legally divorced. The ruling was strongly opposed by R. Moses Alashqar.

A rather different condition was stipulated in a conditional divorce that was granted in Damascus, whereby a husband was given thirty days' grace to appease his wife and associate with her, failing which the divorce would become effective. Although the husband turned up within the specified time, there was no wife to appease!! He searched for her high and low, but to no avail. When the thirty days were up, the woman turned up and declared: "The divorce is valid. It was conditional on appeasing me and associating with me [...] However, I did not want a reconciliation, so I kept away. Therefore you did not fulfill the condition of associating with me. Therefore, the *get* is valid, and I am entitled to my *ketubah*!"[51]

In another similar case which took place in Jerusalem, the local

[49] Radbaz, VI, 2220 (and also 2219 on the same topic). See also Maharitatz, 227.

[50] Alashqar, 31.

[51] Caro, Responsa *Beit Yosef*, 61-64 (=Divorce Laws, 10-12); Mabit, I, 192. Also ibid, I, 166; II, 177.

rabbis sided with the woman in order to deliver her from the hands of her reprobate husband.[52]

From the above, it is clear that women knew how to exploit the possibilities of the conditional divorce, even where there was no previous history of marital discord.[53]

Recourse to gentile litigation

Where *halakha* was unable to provide a satisfactory solution, women in the Levant often resorted to Muslim litigation. This option was used not only as a means of exerting pressure on the husband to provide a *get* and meet his financial obligations, but also because Muslim law was more favorable to women than Jewish law, particularly in matters of divorce. Members of the wife's family could threaten "to claim all objects that Reuben had made over to his wife, as was the practice for women who divorce in Muslim courts."[54]

As a rule, a divorcee was not considered a "blot on the family name."[55] On the contrary, the wife's family supported her, and encouraged her not to relinquish her rights. As stated above, without the family's financial and psychological support, divorce would have remained an unfulfilled aspiration for many women.

Divorce without the wife's consent

Like the *takkanah* against polygamy, there was much controversy concerning the scope and expiry date of the *takkanah* against divorcing a

[52] Arha, 19; Pinto, 43; Lieria, Responsa, 7*.

[53] See: Berab, 21; Radbaz, IV, 1113. On the fear of the abuse of the conditional *get*, see: Radbaz, I, 310.

[54] Ashkenazi, 15.
According to Muslim law, there is no obstacle to a couple separating out of mutual consent and at the woman's initiative: "If a woman fear ill-treatment or desertion on the part of her husband, it shall be no offence for them to seek a mutual agreement, for agreement is best [...] If they separate, God will compensate both out of His own abundance" (Quran 4: 127-129, trans. N.J. Dawood, Penguin Classics, 1956). See also: Cohen, *Jerusalem*, pp. 144, 239; Cohen-Pikali, pp. 345-346; Ibid, Documents 396-398, pp. 351-352; Goitein, *Introduction*, pp. 126, 138-139; Jennings, "Kayseri," pp. 82-84, 87. On divorce in Turky in the mid-16th century, see Busbecq, p.119.

[55] Jacob Katz reached a different conclusion in his study of Ashkenazi society, in which the chances of a divorcee remarrying were slim. In his opinion, this was one of the reasons for the rejection of divorce as a solution to marital problems (Katz, *Tradition*, pp. 173-174).

wife against her will, also attributed to Rabenu Gershom Me'or ha-Golah. It was generally agreed that the *takkanah* did not apply when there was a rabbinical court order to divorce the woman, or when a commandment was at stake. Moreover, even if a woman was divorced against her will for no good reason, most decisors held that the divorce was valid.[56] Thus, despite the *takkanah*, there were still several expedients for divorcing a wife without her consent.

Frequent grounds cited in divorce petitions of this kind were defects that were discovered after the marriage, or others which were known of beforehand, but which only later proved problematic. According to the Radbaz, a woman's consent to divorce is not needed if unforeseeable defects are discovered in her. Among such defects, epilepsy was particularly serious, "since epilepsy is considered a defect in a woman."[57] Even if the husband cannot afford to pay his wife's *ketubah*, he may still divorce, and simply "owe" her the sum of her *ketubah*. The Maharitatz ruled likewise in the case of a man who sought to divorce his sick wife, claiming "that his life was no life, due to all the trials and hardships he had experienced in trying to find someone to look after him and their children."[58]

Even when all rabbis agreed that a divorce was mandatory, as when the wife transgressed the Mosaic Code, there was still controversy concerning entitlement to her *ketubah*.[59] According to the Radbaz, "The fact that she has eaten forbidden fruit does not invalidate her entitlement to her *ketubah* [...] I do not believe that the early sages had this in mind when they introduced the regulation. The husband should give her a divorce and her *ketubah* should be carried over as a debt."[60]

[56] Caro, *Shulhan 'Arukh, Even ha-'Ezer*, Laws of Procreation, 1, 10; 117, 11; 154, 1-2; Rosh, 42, 1. On the evolution of the regulation not to divorce a woman against her will in the Rhineland, see: Falk, *Marriage*, pp. 98-101. For a general overview and references to other sources, see Silberg, pp. 105-194; Schereschewsky, pp. 353-354, 420-427; Havlin, "*Takkanot*", pp. 213-215.

[57] Radbaz, I, 53; VII, 46.

[58] Maharitatz, 3. See also: Gavizon, I, 10.

[59] Mishnah *Ketubot*, VII, 6; Rambam, *Marital Laws*, XXIV, 16; Caro, *Shulhan 'Arukh, Even ha-'Ezer, Ketubot*, 115, 1-4. On the decisors' opinions regarding the rights of a woman of unbecoming conduct, see Schereschewsky, pp. 397-411; Epstein, *Marriage Contract*, pp. 136-137.

[60] Radbaz, I, 445. On the Gaonic regulation that a man should not divorce his wife unless he gives her her *ketubah*, see also ibid, 458; ibid, III, 566; VI, 2115. See also: Schipansky, *Takkanot*, III, pp. 391-392.

In communities where Rabenu Gershom's *takkanah* was not ob-
served, a clause was generally introduced into the *ketubah* (similar to
the monogamy clause) whereby the husband undertook not to di-
vorce his wife without her consent.[61] Be this as it may, in all the cases
I came across where a husband wished to divorce his wife against her
will – the sages ruled in favor of the man! Evidently, the husband's
wellbeing came before any other consideration. Indeed, as we can see
from the above examples, in certain cases the husband was allowed
to divorce his wife even when he was unable to pay her *ketubah*.

Divorce from apostates

Since many Iberian refugees had left behind families who had con-
verted, divorce from a converted Jew was a topical issue in the 16th-
century Levant. Moreover, the splitting up of families and couples
intensified the problem of *agunot*. In principle, the wife of a convert
was unable to remarry until she received a valid divorce from her
husband, since marriage to a convert has full validity in Jewish law.[62]
It was no easy matter, however, to persuade the converts to grant a
divorce, and sometimes only financial incentives worked. Many con-
verts were difficult to trace, having moved away from their former
domicile. If any doubt was cast on the validity of the *get* they sent –
their wives remained *agunot*. In places with a particularly large influx
of refugees, such as Salonika, the sages faced a serious dilemma.
Some rabbis, unwilling to bring about a total rupture with their
convert brethren who had stayed behind in Spain or Portugal, re-
jected a blanket ruling permitting the wives or *yevamot* of converts to
remarry, but tended to favor a stringent approach. Others favored
leniency, seeking to relieve the plight of these women through techni-
cal loopholes that invalidated the marriage (such as claiming that the
witnesses to the marriage were unreliable, since in countries where
forcible conversion was practiced, reliable Jewish witnesses did not
exist). But this solution was not accepted by all.[63]

[61] Radbaz, VI, 2115.
[62] Rambam, *Marital Laws*, IV, 15; Caro, *Shulhan 'Arukh, Even ha-'Ezer, Gittin*, 129,
5;140, 11; See also Rama's annotations to *Shulhan 'Arukh, gittin*, 154, 1, 23. For the
halakhic and historical background, see Katz, "Though he Sinned."
[63] Rashdam, *Even ha-'Ezer*, 10; Binyamin Zeev, 76.

This issue, so controversial in Salonika, was far less so in Palestine and Egypt where the sages – most of whom were Sefardi – nevertheless tended toward leniency in divorces from converts, whether these were converts to Christianity or Islam. They disregarded errors of a clerical nature in the *get*, and pronounced it "valid, due to the exigency of the times!"[64] They were also lenient regarding anomalies in the delivery of the *get*. Although on the one hand, this approach signified a total break with the conversos, on the other, it also made it possible for their wives to start a new life and family.

Appeals

It sometimes happened that even after a woman received a divorce, its validity was subsequently appealed on 'technical grounds.' As stated above, the wording, dispatch and delivery of the *get* had to be flawless. A slight change in the formula or even a slight problem with the rabbinical terminology (literally: rabbinical coinage) were sufficient to place the wife's fate once again in the balance. As soon as any doubt was cast on the wording of the *get*, the woman was prohibited from remarrying (a valid bill of divorce was a prerequisite for remarrying). If the woman had already remarried before the error was detected, she was forbidden to both her current husband, and to her former one. She not only had to obtain a valid *get* from her first husband, but from her second husband too, if she did not wish to remain an *aguna* for the rest of her life. The court, the scribe, or the courier, any of whom may have been responsible for the error, were not taken to task. It was the woman who was left to suffer the personal, social and economic consequences of the error.[65] Below, we shall review the different types of error and how the 16th-century sages related to them:

Faulty dispatch and delivery: Usually leniency was advised, particularly when the *get* had been sent from afar or had been obtained under great difficulty. However, the sages tended to be less lenient if the

[64] Pinto, 40. Concerning a convert who was about to leave for Ethiopia after joining the Ottoman army as a janissary, see: Caro, Responsa *Beit Yosef*, 69 (=Divorce Laws, 4). Also: Radbaz, III, 900; VI, 2311; Castro, *Ohalei Ya'aqov*, 84; Gavizon, II, 69(75); Maharitatz, New Responsa, II, 188.

[65] See Dikstein, "Mysteries," p. 209.

husband and wife did not live far apart, or if there was regular traffic between the two places of residence.[66]

Clerical errors: Usually such problems resulted from different traditions regarding the wording of the *get*, such as the use of 'plene' [*malé*] or 'defective' [*haser*] spelling, or in the way names were spelt. Again, the tendency was to be lenient if the couple lived far apart. If the couple lived near each other or there was regular traffic between the two localities, it was customary to draw up a new *get*. In general, if there was reasonable concern that the woman might remain an *aguna*, the *get* was approved. However, even in such cases, some rabbis inclined toward stringency, thereby forcing the wife to consult other authorities who could perhaps find reasons for upholding the *get*. As a rule, however, leniency was preferred. As R. Meir Gavizon put it, anyone with a heart should not probe too deeply.[67]

Loss of get: Another pretext for appeal arose when a woman for whatever reason was unable to present a valid *get* or affidavit testifying to her divorce. Even in such cases, the tendency was toward leniency, in particular if the woman was of good character, and had been considered divorced for some time: "If she has been considered divorced – obviously she does not require proof."[68]

Duress or unfulfilled conditions: Some husbands, wishing to harm their wives or take revenge on them, later claimed that the *get* was invalid,

[66] Mabit, I, 24, 107 (on the same subject), 221, 231; II, 155 (a question put to the Safed sages by the community of Isfahan); Garmizan, 112, 113; Maharitatz, 256, 265; Caro, Responsa *Beit Yosef*, 58 (=Divorce Laws, 7); MS Jerusalem, Tzayyah, 306, pp. 11b-12a; 308, pp. 12b-13a; 380, pp. 71b-75b; 420, pp. 94b-97a; 496-497, pp. 229a-230a; 529, pp. 254a-257b.

[67] Gavizon, II, 69(75); The subject is discussed in the Maharitatz, New Responsa, 188, but from another angle. See editor's notes in Gavizon. See also: Radbaz, I, *Even ha-'Ezer*, 182, 185, 469; Garmizan, 115, 119; Maharit, New Responsa, 14; Maharitatz, New Responsa, I, 89; Alashqar, 68; Mabit, II, 52 (validation of a *get* granted by a North African man, who had married three time in three different places, each time under an assumed name and patronymic. Possibly R. Joseph Caro's responsum in Responsa *Beit Yosef*, 67 (=*Divorce Laws*, 13) is referring to the same case: R. Joseph Caro ruled that the man has to grant a new *get* with his father's real name). See: Caro, Responsa *Beit Yosef*, 70 (=Divorce Laws, 15); Pinto, 39, 40; Ralbah, 129-133 (pp. 81b-85a); Ashkenazi, 21, 23; Castro, *Ohalei Ya'aqov*, 20; Galante, Responsa, 6, 19; Ben Haviv Moses, *Divorce Laws*, 126, subsection 48; De Buton, 28-29; Ha-Cohen Solomon, II, 5; Ben Lev, I, 59; MS Jerusalem, Tzayyah, 423, pp. 99b-100b.

[68] Radbaz, IV, 1316. See also: ibid, I, 398; Castro, *Ohalei Ya'aqov*, 8; Maharitatz, New Responsa, II, 198, 221, 222.

either because it had been granted under duress,[69] or because certain conditions included by the husband in the *get* had not been fulfilled.[70]

In order to prevent fraudulent appeals, it was customary to tear up the bill of divorce crosswise after it had been delivered to the woman, in the presence of witnesses. Usually, the torn segments were deposited with the scribe or court for safekeeping, and the woman was presented with an 'affidavit' – testifying to her divorce. Although this custom was widespread both in the Rhineland and in the Levant, it was by no means universal.[71] The Radbaz explains the source of the custom:

> What lies behind the custom of tearing up the *get* after it is delivered? [...] First, so that the woman will not abuse the *get* to demand her dues a second time [...] Second, during times of forced conversion, there was no choice but to tear it up [...] and even though times have changed, the custom has been retained [...] I have found a third reason, namely [...] *that the husband should not get hold of the get and quibble over its validity* [...] thereby preventing her from remarrying [...] Therefore it is torn up. *In this way, the husband himself knows that once the get is delivered, he will never be able to invalidate it,* and that once he goes through with the divorce, there is no going back [...] This salutary practice is widespread in Egypt.[72]

Despite the Radbaz's enthusiastic approval of this custom, it was not entirely without problems. For example, what happened if for some reason the *get* had not been torn up in the rabbinical court? Or, conversely, what if only the *get* fragments were found in the court archives, with no accompanying 'affidavit?' Such problems, in the event, proved insignificant, since all appeals based on such arguments were summarily rejected.[73]

[69] Ralbah, 124; Mabit, I, 22, 76; Ashkenazi, 15; Caro, Responsa *Beit Yosef*, 55.

[70] Caro, Responsa *Beit Yosef*, 56 (namely, the condition that the wife refrain from marrying any one of five men whose names he specified); Radbaz, IV, 1156, 1357, 1358; Pinto, 38; Mabit, I, 332-333.

[71] Radbaz, II, 602, 795; IV, 1185. For an example of the delivery and tearing up of the *get*, as well as a copy of the court's decision delivered to the divorcee, see: MS Jerusalem, *Sefer Tikkun Soferim*, pp. 30b-31b, 136a. See also Gelis, *Customs*, p. 376 (94).

[72] Radbaz, III, 881; Also ibid, I, 398 (67a). The custom had been practiced in Egypt "from the days of the Neggidim." (ibid, IV, 1316).

[73] Radbaz, I, 398; II, 795; Castro, *Ohalei Ya'aqov*, 8; Mabit, I, 24 (107 on the same topic); Caro, Responsa *Beit Yosef*, 57 (=Divorce Laws, 5). Apparently the Mabit and R. Joseph Caro were referring to the same case, since the details are almost identical. The case involved a woman from Safed who had been an *aguna* for several years, and whose husband finally agreed to send her a *get* from afar, after considerable effort to get him to agree. The Mabit even mentions the name of the husband: Isaac Mas'ud (Mabit, 107).

WIDOWHOOD

In the 16th-century Levant, widowhood was effectively a passport to freedom. Widowhood freed a woman from the tutelage of father, brother or husband, and conferred on her the right to make her own decisions, manage her property, and even choose a husband. If the widow was also wealthy, she enjoyed a high social status, as well as independence. Widowhood turned a woman into a legal entity in her own right, empowered to invest, bequeath, or donate money. Even if she remarried, she had the right to add a clause to the *ketubah* allowing her to retain some of her property, rather than transferring all of it to her new husband.

Obviously this freedom was anathema to potential heirs or their guardians, and every so often attempts were made to discredit the widows, sometimes years after the husband's death. Many family disputes stemmed from efforts by heirs to dispossess widows of their property or curtail their rights. Indeed, most of what we know about widows and the freedom to dispose of their property as they pleased is based on legal deliberations on the subject in the Responsa literature.

Take the case of the widow of Abraham Hadidah of Safed, an independent woman, renowned for her ability to manage the various estates left by her husband. She not only brought up and married off her daughter single-handedly, but found a good match for herself (a Torah scholar, lured by her wealth). After some years, her daughter died, whereupon her heirs staked a claim in her property, arguing that it was dishonestly gained and that the widow had abused her capacity as trustee of her late daughter. Resting their case on the testimony of relatives and neighbors, they claimed their entitlement to various objects and items of jewelry. The woman's objection that these were part of her own estate, and not her daughter's, was not accepted by the judges.[1]

In a similar case, the legality of a widow's property transactions, including a mortgage on a house in her name, was contested by her husband's heirs after the widow's death. It transpired, in the course

[1] Galante, 97; Maharit, I, 33.

of the hearing, that the widow had been carrying out property trans-
actions in her name for many years, and had sold off some of her
dowry in order to purchase the house. This time, however, the onus
of proof was on the heirs, who had to prove that the said property
was originally the husband's.[2]

The difference between this case and the previous one is that
during her lifetime, the burden of proof (that she received property
from her husband) lies on the woman, while after her death, the
burden of proof lies on the heirs.[3]

Some wealthy widows bequeathed or endowed Torah scrolls and
finials to the synagogue, while others donated sums of money or
income from property to charity or to a house of learning. Even such
altruistic actions were frequently contested by heirs, who felt they had
been robbed of their dues, or by institutions who claimed they had
been discriminated against.[4]

It was not uncommon for husbands to appoint their wives trustees
of their property before their death – an indication that many men
trusted their wives' ability to manage their affairs. This confidence
was well-placed, as borne out by the fact that the rabbis themselves
usually upheld the widows' claims in contested inheritance suits.[5]
Also, both Jewish and Muslim courts awarded widows custody of
their children and trusteeship of their husbands' property.[6]

Widows with a regular income lived in relative comfort. Some
widows derived a regular income from money-lending. In Jerusalem,
for example, it was fairly common for widows to lend money at
interest to priests and monks.[7] Others invested their money and lived
off the income.[8]

[2] Alshekh, 83 (quotation from his ruling in Vital Samuel, 62).

[3] See: *Bava Batra*: 52a-b.

[4] Galante, Responsa, 97; Maharitatz, 28, 276; Gavizon, II, 40, 55(61); Radbaz, I,
501; II, 677, 678; III, 995; IV, 1372; Alshekh, 87,89; Pinto, 75, 123; Mabit, I, 270;
II, 147, 150, 153, 202; Caro, *Avkat Rokhel*, 101; Maharit, *Hoshen Misphat*, 64, 66, 68;
Ashkenazi, 14 (see also Arha, 23-24); MS New York, Capusi, 75, 122; Cohen, *Jeru-
salem*, p. 99.

[5] Radbaz, I, 279; Pinto, 71; Mabit, II, 193; Caro, *Avqat Rokhel*, 74; Alshekh, 128;
Maharit, I, 67; Assaf, "Appointment." See also Chapter 4, "Married Life."

[6] For example: Galante, Responsa, 121; Gavizon, I, 15; Mabit, II, 29; Cohen-
Pikali, documents 411-414, pp. 363-364.

[7] Mabit, I, 298; III, 82; Arha, 13(b); "Travels of R. Moses Basola," in Yaari,
Travels, p. 149.

[8] Radbaz, I, 84; Caro, *Avkat Rokhel*, 165 (on the same subject: Mabit, II, 34);
Maharitatz, 9; Danon, "Letters," letter 2, pp. 115-116.

Not all widows, however, were wealthy. Many had to work in order to supplement their incomes. The range of professions open to women was very limited. A rather exceptional woman was a steel-welder from Aleppo, whose case was deliberated by the Safed sages, after she, and her partner Reuben, fell out. From the description of the case, a picture emerges of a fiercely independent woman. The fact that she asserted her right to practice a trade and take on a new partner shows that she was a woman who knew how to make her way in a man's world. In the event, a technical error in the wording of the contract tipped the balance in her favor, and she won the case.[9]

In actual fact, the majority of widows were hard up, so much so that some were forced to rely on public assistance. The widows of Palestine in general, and of Jerusalem in particular, were particularly poor. Already at the end of the 15th century, R. Obadiah of Bertinoro remarked on the plethora of widows in Jerusalem: "And many elderly and impoverished widows of Ashkenazi, Sefardi, or other extraction, can be found there: There are seven women for every man."[10]

In the 16th century, major demographic and political changes, as well as improved routes to Palestine, rendered the problem even more acute. Not only did many widows emigrate to Palestine, a significant proportion of women were widowed there, after having moved there with their husbands to spend their last years in the Holy Land. R. Moses Basola, who visited Jerusalem in the early 1520s, informed that the five apartments in his own courtyard were "all tenanted by women," and houses belonging to the Ashkenazi charitable trust were rented by widows. He spoke of 300 Jewish householders, "not including widows, of whom there are over five hundred [Tav-Kof]!"[11] However, this figure was recently refuted by Abraham David, who suggests that the barely decipherable figure in the original manuscript is eighty-eight [Peh-Het].[12]

Letters from Jerusalem describe the sorry plight of the "orphans and widows of great scholars [...] who have been left totally desti-

[9] Mabit, II, 27 (R. Joseph Caro also agreed with the ruling); Alshekh, 57. See also above, Chapter 7.

[10] "Letters of R. Obadiah of Bertinoro," in Yaari, *Letters*, p. 127. Ibid, pp. 129, 137.

[11] "Travels of R. Moses Basola," in Yaari, *Travels*, pp. 129, 137, 149.

[12] David, *To Come to the Land*, p. 193, note 50.

tute." A particularly moving letter describes the predicament of a
wealthy woman who was reduced to begging in the streets after being
widowed: "Alack and alas, it has come to our notice that this woman
of fine breeding, who has never known poverty or disgrace, now
spends her days bemoaning her lot [...] After she was widowed, she
was forced to leave home and country, journeying far and wide with
her orphaned children until they came to this city. Bitter of heart and
wretched of soul, they roam the streets all day long, crying for
help."[13]

R. Eliezer Tzarit's widow provides an even more graphic descrip-
tion of her poverty and dependence on public assistance: "I have no
choice but to rely on the public coffers, for my sins, and even that is
not enough. Since the beginning of [the month of] Kislev, they have
been giving me fourteen *muayydi*[14] a month, and I have not had a
decent meal since [...] For two years I have been sleeping under the
same, grimy coverlet, which I cannot afford to wash [...] I am con-
stantly unwell [...], perspire a lot [and do not even have] a sheet to lie
on." In a letter she sent to Venice, she pleaded for repayment of
money that was owed her, in order to ease her terrible plight.[15]

The tough economic situation in Jerusalem continued, as testified
by a joint letter sent to the Diaspora in the middle of the 17th century
by a group of 28 lonely Ashkenazi women, in an attempt to raise
separate funds for themselves. A special missionary, Samuel Levi of
Frankfurt, acted on their behalf.[16]

The leaders of the Jerusalem community tried to ease the burden
of widows by introducing a regulation exempting them from pay-
ment of various taxes.[17] Since a widow was a burden on the commu-
nity, the community had an interest in alleviating her economic
plight. Moreover, a widow who was financially secure was more
likely to remarry sooner. This was clearly in society's interest, since
the presence of unmarried women in its midst threatened the existing
social order.

[13] MS Jerusalem, *Iggerot Shadarim*, letter 75, p. 117; letter 122, pp. 154-155; Ibid,
letters 100-101 (published by Rozen, *Community*, pp. 501-504), and letter 123, p. 155.

[14] The *muayydi* (after the Mamluk Sultan al-Muayyd), was a very small silver coin,
also known as '*hatikha*' (piece).

[15] Turniansky, letter 4, p. 195; letter 7, p. 207.

[16] Yaari, "Women." Yaari dated this letter to the years 1650-1655. Benayahu,
however, dated it a little later, around 1690 (Benayahu, "Community", p.185).

[17] "Travels of R. Moses Basola," in Yaari, *Travels*, pp. 149, 158 (cf. Finkelstein,
pp. 348-375).

There was a positive side too to the profusion of widows in Jerusalem. The assets of a widow who died heirless swelled the public coffers. This, according to R. Moses Basola, was the community's main source of revenue.[18] This fact was also alluded to in a letter sent by community leaders to an affluent man whose assistance was sought in settling the financial affairs of a Jerusalem widow. The community leaders, aware that the widow's in-laws were trying to stake a claim in her late husband's estate, urged the benefactor to: "make sure [...] she gets her dues, *for the well-being of our holy city, whose fortunes have rapidly declined, depend on her well-being,* as we are sure you will appreciate [...]."[19]

The fact that widows were not subject to the tutelage of a male relative made them largely dependent on the local rabbis for support. The rabbis, for their part, were sensitive and sympathetic towards them, and their interest in the legal and family affairs of widows was often based on personal acquaintance.[20]

R. Joseph Trani remarked that "most widows do not remarry" but prefer to live with their grown-up children.[21] This strongly contradicts the sources, which show that many widows (and divorcees) were anxious to remarry as soon as possible.[22] The responsa dealing with "the killer wife" ('*isha katlanit*')[23] also indicate that several marriage cycles was commonplace. Although some arbiters forbade "a killer

[18] Ibid, p. 149 (cf. "Letters of R. Obadiah of Bertinoro," in Yaari, *Letters*, pp.128-129).

[19] Rozen, *Community*, p. 135; Ibid, letter 101, p. 504 (and letter 100 on the same subject).

[20] Gavizon, 49(55); Maharitatz, 4; Mabit, III, 213; Radbaz, IV, 1088; Radbaz, end of III, Responsum of R. Hayyim Capusi; Assaf, "Maran"; David, "Genizah," document 15, p. 51, and cf. the rabbinical court decision in Egypt concerning the payment of the *ketubah* to R. Moses Castro's widow (David, "Castro,"); MS Manchester (courtesy Dr. A David.)

[21] Maharit, II, *Hoshen Mishpat*, 61.

[22] Mabit, I, 42; II, 45, 209; III, 135, 210; Galante, Responsa, 97 (Maharit, I, 33), 104; Alshekh, 70; Maharitatz, 26, 151, 152; Berab, 4; Radbaz, I, 451, 569; VI, 2288; Radbaz, end of III, Responsum of R. Hayyim Capusi; Maharit, II, *Hoshen Mishpat*, 35; Lieria, Responsa, 17; Maharitatz, New Responsa, II, 193; Beer , 28; Gavizon, II, 48(54); MS Jerusalem, Tzayyah, 321, p. 235; Benayahu, *Ari*, p. 216; Ashtor, III, pp. 119-120; Gottheil-Worrell, document L, p. 260, lines 142-145 (in line 143, 'and he kissed her' [u-*neshaka*] should read 'and he married her' [u-n*esa-ah*]); On second marriages in the classical Genizah society, see Goitein, *Society*, III, pp. 260-277; In Christian society, see Shahar, *Fourth Estate*, pp. 89-90, 211-213. On the low social status of single women in Ottoman society, see Dengler, pp. 229-231.

[23] See Chapter 1, 'Women through the Eyes of the Sages', Footnotes 26-27.

wife" to marry a third time, even if her husbands died of old age rather than from a disease or accident,[24] others disregarded the rule, and retroactively ratified such marriages in certain cases (for example, levirate marriages, or if the widow was young and it was feared she might go astray if forbidden to remarry).[25]

The fact that widows were so desperate to remarry, even at the cost of their freedom, indicates that the position of single women in the 16th-century Levant was extremely precarious. Not only were they fair targets for malicious gossip, they were constantly being harassed by in-laws with a stake in their property. Their single status rendered them vulnerable, and diffident in their dealings with the public. Therefore, even the more affluent widows who were economically self-sufficient, preferred to remarry than to contend with social and economic problems on their own, especially since as property-owners they could set their own conditions.

[24] Garmizan, 97. See also: Radbaz, II, 668, 682.

[25] Ralbah, 36; Lieria, Responsa, 17; Alashqar, 79 (according to the Rambam, who quoted the Spanish and Egyptian custom on this issue. See Rambam, I, 15; II, 218; Also, Rambam, *Prohibition of Cohabitation*, XXI, 31.)

CHAPTER THIRTEEN

DESERTED WIVES (*AGUNOT*)

The problem of *agunot* – women whose husbands had disappeared or absconded – is a thorny issue that has preoccupied the sages through-out the centuries. According to *halakha*, *agunot* may not remarry until there is conclusive proof that the husband is dead, or until they receive a divorce.[1]

The plight of the *agunah* was compounded by her indeterminate status: She was neither a widow, nor a divorcee, nor a single woman. She was not entitled to collect her *ketubah*, or remarry. She lost out on both counts: She was deprived of the protection of her family, but had neither independence nor responsibility to compensate for this loss. Frequently, she was reduced to relying on public alms. Despair caused these women to challenge conventional morality and rabbini-cal rulings, and form illicit relationships with members of the oppo-site sex, to the chagrin of the community's leaders and rabbis.

The tradition of leniency in rabbinical arbitration in connection with *agunot* dates back to ancient times, when the sages tried to help women whose husbands had disappeared due to misadventure. In-deed, the issue of "freeing" an *agunah* is one of the only issues where the rabbis tended toward leniency on principle. They left no stone unturned in their attempt to deliver women from the predicament of *igun*.[2] This leniency is all the more remarkable in view of the decisors' uncompromising stance towards women's requests for divorce, or compulsory divorces. Freeing *agunot* was perceived as a moral impera-tive, and undue stringency in such cases was frowned upon. Gener-ally, this leniency took the form of accepting evidence in connection with *igun* at face value. The Rambam himself said: "Too close a scrutiny of the evidence in such cases is wrongful, and condemned by

[1] For a review of the subject and listing of sources and bibliography see: Kahane, *Agunot*. Note in particular R. Hayyim Shabtai's booklet, *Kunteres 'Iguna di-Ittata*, which was printed in conjunction with his responsa on *Even ha-'Ezer* (Shabtai, I, pp.1-81). In recent times, several proposals have been raised for easing the plight of *agunot*. See for example, Freimann, *Betrothal*, Appendix, pp. 385-397.

[2] *Yevamot*, 88a.

the sages."[3] Thus, not only is the evidence of the *agunah* herself believed if she says "my husband has died," but she may, in certain cases be freed on the basis of the testimony of a single witness, instead of two as is usually the case (for example, if her husband died in some remote country, making it hard to find witnesses).[4] On the other hand, excessive leniency was discouraged, since the issues at stake were serious ones in which a mistake might have dire consequences such as adultery, illegitimacy, inheritance disputes, etc. Therefore, although excessive scrutiny was discouraged, evidence had to be subjected to a thorough examination. The wish to safeguard the sanctity of marriage and preserve the purity of the family sealed the fate of many unfortunate women.[5]

The expulsion of the Jews from Spain rendered the problem of *agunot* even more acute. Apostasy, migration, and economic hardship had eroded the institution of marriage for the Iberian refugees. "Men arrived without women, and women without men" as R. Abraham Shamsolo, a preacher of Spanish origin, said. "Since many of the men were single, they were eager to find a wife among all the available women [...] without being too scrupulous about family background or lineage. The greater their suffering, the greater their desire to get married."[6]

[3] Rambam, Responsa, 350 (and quotation in R. Joseph Caro's *Shulhan 'Arukh, Even ha-'Ezer*, 17).

[4] Mishnah, *Yevamot*, XVI, 7; (Babylonian Talmud) *Yevamot*, 116b; Ibid, 122a (see Rashi there: "This may be considered an emergency situation, for if you do not believe the witness, you will not find another, and she will remain an *agunah*"). Rabenu Asher wrote: "The sages were very concerned over the issue of *agunot* and were prepared to lift the *agunah* status on the basis of hearsay evidence, a woman's evidence, a woman's hearsay evidence, a servant's evidence, a maidservant's evidence, or her own evidence. All witnesses normally barred by the rabbis, and the 'unwitting testimony' of witnesses normally barred by the Torah, are permitted in this case provided it is given in ignorance of its implications [...] Each rabbi should do his utmost to find a loophole for lifting her *agunah* status" (Rosh, Rule 51, b). Similarly the Rambam states that in all cases where a single witness is allowed, the testimony of a woman and of others normally disqualified from testifying, is also allowed (*Laws of Evidence*, V, 1-3). See also: Rambam, *Divorce Laws*, XIII, 27-29; Caro, *Shulhan 'Arukh, Even ha-'Ezer*, Marital Laws, 17, in particular paragraphs 3-19. On the background and legal arguments for leniency in cases of *igun*, see Elon, *Jewish Law*, pp. 428-434.

[5] Mishnah *Yevamot*, X, 1; (Babylonian Talmud) *Yevamot*, 91a-b; *Bekhorot*, 46b. See discussion in Dikstein, "Mystery", esp. p. 210.

[6] Benayahu, "Sermons," p. 203. The signs in the original source above the word *yahas* (pedigree) alludes to the lack of concern over family pedigree in these hasty marriages.

Letters preserved in manuscript form testify to the gravity of the problem of *agunot* in Jerusalem and to the great efforts made by the community and the wife's relatives to trace absentee husbands. One such letter, sent to a community in the Diaspora, reads:

> It is now almost a year that a certain man left Jerusalem and went to live in your community, leaving his wife and son destitute. They have no clothes or food, and are suffering from hunger and thirst [...] The wife, seeing that time is passing, and having received no reply to the letters she sent her husband, appeared before us weeping tears of bitterness [...] We therefore appeal to you to pursue this man, and force him either to return home and care for his wife and son, or to send a sum for maintenance, as determined by your good selves [...] It is an act of kindness to resolve the poor woman's situation as soon as possible in one of the two aforementioned ways, for matters have come to a head [...] We therefore turn to you, trusting that you will be able to ease the plight of this poor woman. If he refuses to come home or provide for her, then let him divorce her forthwith. For it is not right that a Jewish woman be consigned to the fate of a "grass widow." Therefore, we beseech you not to rest until you have achieved one of the three aforementioned objectives.[7]

In another letter, the heads of a community (unspecified) are beseeched to come to the aid of an *agunah* and her daughter:

> May our entreaties find favor in your eyes [...] May you succeed in persuading him [the husband] to return to his wife forthwith and live with her as man and wife, as is the custom of Jewish men. Do not rest until you see him setting out on his way [...] Make him vow not to stray from the path, but to make his way directly home [...] Make him promise by all manner of oaths that he will not delay or postpone his return.[8]

In some cases, when letters failed, or when the husband could not be traced, the father of the *agunah* would himself attempt to track down the elusive husband, and free the daughter from her state of *igun*. In one extreme case, an indigent father even sold himself to gentiles in order to support his *agunah* daughter. In the end, unable to stand the strain, "he decided to go from town to town and seek out the errant husband, in the hope of finding a balm for his troubled soul, by forcing his son-in-law either to return to his wife or divorce her."[9]

 [7] MS Jerusalem, *Iggerot Shadarim*, letter 185; Ibid, letters 91, 171, 172, 177, 184, 186, 188, 206 (letter 91 is published in Rozen, *Community*, pp. 490-492).
 [8] Ibid, letter 151.
 [9] Ibid, letter 187.

At the turn of the century, the economic recession that hit Safed forced many men to leave their families in search of greener pastures. The result was a sharp rise in the number of *agunot*. "Alas and alack, the marketplace and streets are full of wailing women [...] From one end of the city to the other, women who have been abandoned by their husbands are bemoaning their fate. Anyone who sees them cannot help but weep at the sorry sight. While one woman laments the fact that her husband and provider has left her and her children bereft, another bewails her divorce, while a third [*agunah*] [...] weeps over her [lost] *ketubah* [money]."[10]

As stated, the contemporary sages could not fail to notice the plight of *agunot* and many were extremely sensitive to their predicament, and flexible in their rulings. For example, R. Abraham Treves Ashkenazi, a Jerusalem sage, tried to find a way of freeing some *agunot*. Their husbands, textile merchants, had disappeared three years earlier, one-and-a-half-day's walk away from Jerusalem, allegedly murdered. He wrote to R. Elijah Mizrahi, one of the most outstanding rabbis of Istanbul in the early 16th century, saying: "I have heard how his honor has previously freed *agunot* whose husbands drowned in the Mediterranean Sea," and asked for a copy of the ruling. He asked his support for a similarly lenient ruling toward the *agunot* of Jerusalem.[11]

Of course, where warranted, investigations were carried out. The fear of making a mistake with disastrous implications was real enough. Indeed, sometimes husbands who had been missing for several years suddenly turned up!![12] Therefore, in cases of missing per-

[10] Pachter, "*Hazut Kasha,*" pp. 183-184.

[11] Mizrahi Elijah, 74. For further examples of rabbinical leniency in this matter, see: Radbaz, I, 398; VII, 25; Pinto, 63; Mabit, I, 24; Ashkenazi, 30 (for a similar debate, see Maharitatz, 36; Maharitatz, New Responsa, II, 120; Galante, Responsa, 12; Gavizon, I, 14, and ibid, note 23, for source references and rabbinical opinions on this matter); Shabtai, pages 12b; 14a; Gavizon, II, Letters, letter 10.

[12] Alashqar, 67 (this case of false testimony concerning the death of Isaac Alfandri is also alluded to by R. Moses Alashkar in No. 16, page 8a. Alashqar also condemns R. Jacob Berab's decision concerning Yakuta [see below]); MS Jerusalem, Tzayyah, 332, p. 20b. On the importance of investigating the circumstances surrounding the husband's disappearance, see: Caro, Responsa *Beit Yosef*, 83 (= Laws of unlimited expanse of water), p. 322. See also R. Abraham Halevi's memorandum regarding freeing the *agunah* of R. Abraham Hever of Jerusalem: "Even though testimony on such matters should not be subjected to too close a scrutiny [...] if it is clear that some other factor caused the witnesses to testify the way they did, that factor must be thoroughly investigated [...] The fact that an erroneous verdict was delivered is no excuse for us to go along with it blindly" (*Ginnat Veradim*, II, *Even ha-'Ezer*, Rule 3, 17).

sons, the rabbis were far stricter with the *agunot* than with potential heirs. Heirs were allowed to inherit even on flimsy evidence, while a woman was forbidden to remarry, or to receive her *ketubah* money, until she brought conclusive proof that her husband had died.[13]

Since leniency was not always an option, serious polemics occasionally erupted between the decisors. In the late 1540s, for example, R. Joseph Caro and R. Moses Trani of Safed argued the case of an *agunah*, whose husband was one of twenty men who had drowned at sea. While R. Joseph Caro and others (R. Isaac Mas'ud, R. Abraham Yerushalmi, R. Abraham Zarfati, R. Isaac Hacohen, R. Yom Tov Bibas, R. Shem Tov Alfaraji and R. Jacob Alhami) ruled that the woman could not remarry, the Mabit, supported by R. Abraham Shalom, argued that stringency was unnecessary in the case of *agunot*, and that an *agunah*, once married, was not required to divorce. Even the Radbaz, who agreed with R. Joseph Caro in principle, argued that if an *agunah* had remarried she need not divorce. In this case, the woman subsequently remarried, but her new husband was pressurized by R. Joseph Caro to grant her a divorce. The polemic, which lasted for over three years, had huge repercussions, since the fate of another twenty (!) or so women hung in the balance. Caro, whose ruling was influenced by his fear of setting a precedent, accused the Mabit of encroaching on the affairs of people outside his community. However, judging by the names of the sages involved in the case, the polemic clearly had no ethnic bias. Rather, it reflected a personal power struggle between the two veteran sparring partners, R. Joseph Caro and the Mabit. In this power struggle, women were once again reduced to mere pawns in a game of rabbinical dialectic, in which personal suffering was a secondary issue.[14]

[13] Mabit, II, 154. According to the Rambam: "The evidence of witnesses who testify that they saw someone drown in an unlimited expanse of water and disappear without a trace, is admissible in inheritance cases but not, a priori, in *agunah* cases." (*Inheritance Laws*, VII, 3). For an explanation of the apparent contradiction in the Rambam, see R. Hayyim Shabtai, p. 3, end of a-b.

[14] For an account of the debate, see Dimitrovsky, pp. 94-101. For responsa of the decisors, see: Caro, Responsa *Beit Yosef*, 82-88; Mabit, I, 186-189; Radbaz, I, 258. For more information on the complex relationship between R. Joseph Caro and R. Moses Trani, see: Dimitrovsky; Benayahu, "Controversy"; Benayahu, "Mabit". On the conflict between R. Jacob Berab and R. Moses Alashqar, see: Alashqar, 114 and Berab, 14; Alashqar, 60 and Berab, 42. On the conflict between the Ralbah and R. Jacob Berab, see: Ralbah, 129-133 and Ashkenazi, 23.

In another case that caused a furor in Egypt and Jerusalem, R. Moses Alashqar – generally extremely strict regarding evidence in cases of drowning[15] – turned out to be one of the more lenient decisors.

The case involved Yakuta, a girl from Tripoli, North Africa, who was betrothed [*mekudeshet*] at the age of nine. Shortly after her betrothal, she became an *agunah*, a status which she held for fifteen years. After moving to Egypt, the family, at the sages' instigation – petitioned the court to free the woman. Testimony was brought to the effect that the betrothal had been conducted against the father's will. After a two-year investigation, the court, headed by R. Moses Alashqar and R. Samuel Halevi, ruled that since the woman had been betrothed as a minor without her father's consent, the betrothal was invalid and she was allowed to remarry. This ruling was contested by R. Samuel Ibn Sid. In the event, Yakuta remarried and had children. Some nine years later, R. Jacob Berab heard the story from R. Samuel Ibn Sid, and being, according to the Ralbah, "of argumentative disposition," he decided to reopen the case although the woman already had children and had been permitted to remarry by all the sages of Egypt (Cairo). R. Jacob Berab accepted the evidence of some Tripolitans living in Jerusalem to the effect that Yakuta's father had, in fact, agreed to the betrothal. Therefore, he ruled, she was still considered married to her first husband, her offspring were bastards [*mamzerim*], and she was required to divorce forthwith. R. Moses Alashqar accused R. Berab of trying to stir up trouble. Even when the evidence turned out to be false, R. Berab refused to admit his error. He even resorted to hiding the evidence, so that envoys had to be sent to Jerusalem to obtain a copy of the statements. In the end, it was patently clear that R. Berab was wrong:

> In the end, let the Lord be praised, the light of true justice shone forth like the sun, and a true verdict was delivered. The one who challenged it was seen to be false, while the testimony of the two remaining witnesses was once again corroborated in the presence of the sages of Jerusalem, may it speedily be rebuilt, and in the presence of the representatives of the husband and wife, under oath. They testified that the evidence R. Jacob [Berab] allegedly took from them regarding the said Yakuta was not first-hand evidence, but rather based on hearsay. They themselves never claimed to have witnessed the events described. For

[15] Alashqar, 25-26.

this [acceptance of hearsay evidence] our Torah grows faint, for we
have become as Gomorra![16]

In another case, which became a *cause célèbre* in Palestine and the
Diaspora in the 1530s, R. Moses Alashqar upbraided the sages for
refusing to free an *agunah* from Corfu: "Generally, stringency with the
testimony of an *agunah* [...] is not recommended. He who sentences a
woman to *igun* by being too strict [*hamur*], of him it is said 'and his ass
[*hamor*] declareth unto him' [indicating undue stringency, cf. Hosea
4:12]." R. Moses Alashqar's position (to free the *agunah*) was sup-
ported by "the Rabbis of Jerusalem, Safed in Upper Galilee, and
Egypt, which sits first in majesty" as well as sages from Candia,
Istanbul, and Venice.[17]

Compassion was not the only factor that drove the rabbis to adopt
a lenient stance. Even more important was their fear that *agunot*
might decide to remarry anyway, in defiance of *halakha*. This fear was
compounded by the additional concern that precedents might be set.
This concern was especially acute in the post-Expulsion era with its
sociocultural and demographic upheavals. Many women who were
uprooted from their families and natural environments, were forced
to become independent and fend for themselves. The Mabit argued
that if *agunot* were anyway going to remarry, they might as well do so
lawfully.[18]

The case of the twenty *agunot* whose husbands drowned at sea
illustrates the extent of this rabbinical concern. The following
responsum by R. Jacob Alhami, one of R. Joseph Caro's followers in
this matter, is representative:

> In this case, which involves almost twenty women [...] the other women
> will doubtless come with similar claims. If they do not get their way,
> they will almost certainly bear a grievance towards the courts, and
> possibly also the Torah, saying: 'After all, we are all in the same boat

[16] Alashqar, 16, and 14 (Alashqar's first ruling). See also: Berab, 56-57; Radbaz,
IV, 1129; Ralbah, pp. 37-38, 43-44 (*kunteres ha-semikha*). R. Zedaka Hotzin (first half
of the 18th century) disagreed with R. Moses Alashqar concerning hearsay evidence,
and agreed with R. Adrabi, the Radbaz, R. Bezalel Ashkenazi and others who
argued that in the case of *agunot*, such evidence was admissible (Hotzin, 223-224).

[17] Alashqar, 111-113, and the second half of 114. Also ibid, 99, where he discusses
the same issue. The above excerpt is taken from his responsum no. 112. For a
description and dating of the polemic, and references to other decisors, see
Benayahu, *Beauty*, pp. 19-25. Benayahu contests several of Dimitrovsky's conclusions
(Dimitrovsky, p. 119 ff.)

[18] Mabit, III, 54.

[...] why should her *agunah* status be lifted, and ours not?' [...] Moreover, since women are fickle, they will use every available ploy to remarry, even moving to a place where they are incognito. And since they are liable to consider themselves single rather than married, they may become promiscuous, causing havoc and destruction. Even if we forbid them to remarry, they will ridicule our decision, saying: 'Why are we different from that woman who was allowed to remarry?'[19]

As we see from the above, the sages were concerned that *agunot* might become promiscuous and have a destructive effect on society. If they were not allowed to marry, they would be unable to curb their instincts, and would therefore be easy to seduce "*becoming sinners and causing others to sin!*"[20] As stated, this concern grew in the post-Expulsion period, when some single women began to flout moral and religious norms. Jewish society tried to cope with this moral decline by introducing rules and control mechanisms. The rabbinical emphasis on leniency in the case of *agunot* was actually an attempt to forestall immorality. The Radbaz emphasized that "in these times, stringency is not politic!" and that "leniency in matters of *aginut* has been universally adopted in these generations, as the better of two evils."[21] R. Meir Gavizon even saw the fear of promiscuity as the *main* reason for leniency in cases of *igun*. "Besides this, there is no other!"[22]

The rabbis were anxious to prevent another phenomenon: *agunot* who chose to apostatize as a way out of their predicament. The *agunah* from Corfu, for example, whom R. Moses Alashqar refused to free, later apostatized, to his lasting regret.[23]

As well as the above reasons, the decisors were also presumably aware of the fact that *agunot* not only could not contribute to society by bearing children, but actually became a burden on the community which had to support them. Therefore, a solution which allowed them to remarry, and fulfill their function as women, was preferred.

As shown, the bias toward leniency did not rule out controversy in some cases. Differences of opinion frequently arose between the sages

[19] The Mabit's responsum in Caro's Responsa *Beit Yosef*, 125b; R. Jacob Hami's responsum: ibid, on page 358. R. Shem Tov Alfaranji's responsum: ibid, on page 355. There are other examples of women from Palestine and Egypt who defied the sages' rulings: Radbaz, IV, 1342; VII, 20; Gavizon, II, 46.

[20] Gavizon, I, 18. See also: ibid, 14; II, 82.

[21] Radbaz, I, 469. See also: ibid, VII, 26; Mizrahi Elijah, 36.

[22] Gavizon, I, 14; ibid, 3 (p. 27). In this context, see editor's notes in introduction, p. 50.

[23] Alashqar, 114 (54a).

of Egypt and of Palestine.[24] And yet, the 16th-century decisors showed
special consideration towards *agunot*, and did all they could in order
to free them. Some were motivated by compassion, others by fear of
potential promiscuity and its social consequences. Whatever the mo-
tive, in most cases the end result was the same: The woman was
released from her *igun* status by a majority decision. As R. Joseph
Caro put it, if testimony in connection with *igun* cases were subjected
to rigorous investigation, *"no agunah would ever be freed, not even one in a
thousand!"*[25]

All in all, the facts speak for themselves: Of 148 halakhic opinions
examined, 116 favored lifting the woman's *agunah* status. That is to
say, over 78% of cases were satisfactorily resolved.

[24] Castro, *Ohalei Yaʻaqov*, 52, end of 88, 122; Maharitatz, New Responsa, II, 120,
191; Pinto, 52-56; Caro, Responsa *Beit Yosef*, 80, 81 (= Laws of a Gentile who makes
a statement in ignorance of its legal implications, 11, 12); Alshekh, 44; Mabit, I, 135,
326; Radbaz, III, 876 (=VII, 19); VII, 20-26; Galante, Responsa, 52 (on the same
subject: Maharitatz, 144); Gavizon, I, 18; II, 67(73). On Gavizon's unconventional
rulings in cases of *aginut*, see editor's notes in the introduction to Gavizon's Responsa,
p. 55, and note 23 on section 18.
[25] Caro, Responsa *Beit Yosef*, 75 (=Laws of a Gentile who makes a statement in
ignorance of its legal implications, 2).

LEVIRATE MARRIAGES

Yibum *versus* Halitzah

One of the issues that was never resolved in Jewish law was that of *yibum* (levirate marriage) versus *halitzah* (waiver of levirate marriage). Usually the sages of Ashkenaz (Germany and France) ruled that *halitzah* took precedence over *yibum* – whereby the deceased's brother is obliged to marry his widowed sister-in-law if she is childless – while the sages of Spain ruled that *yibum* took precedence over *halitzah*. The difference in approach had significant bearing on issues such as a woman's right to demand *halitzah*, the possibility of enforcing *halitzah*, and the financial rights of a woman refusing to enter into a levirate marriage.[1] The influx of Jews from Germany and Spain in the 15th and 16th centuries, and the resultant clash of cultures and traditions, added fuel to the halakhic polemic. In the cross-fertilization of ideas, many controversial issues were re-opened for debate, including that of '*yibum* versus *halitzah*'. Agreement on this issue was extremely rare. The plethora of cases discussed in the Responsa literature indicates that the issue, far from being simply academic, had a practical bearing on the lives of many women.

The Ashkenazi halakhic tradition on *yibum* was particularly strong in Italy and Greece, but also, to a lesser extent, in other places. "Evidently, following the assimilation of both traditions in Greece, ethnic affiliation ceased being the sole consideration of the parties, or

[1] Katz's article "Levirate Marriage," provides a thorough description of the subject from all angles, supplies a comprehensive list of references, and follows the evolution of *halakha* and customs in various Jewish communities. According to Katz, the status of the Ashkenazi woman was better than that of her Sefardi counterpart. This explains the tendency of the Ashkenazi sages to prefer *halitzah* to *yibum* (ibid, p. 69). Sources from the Genizah period are published in Goitein, *Society*, III, pp. 210-211, and Friedman, *Polygyny*, pp. 129-151. On *yibum* when the levir is already married, see above, Chapter 9, "Polygamy." For a general survey, see '*yibum*,' Talmudic Encyclopedia, Vol. 21 (1993), pp. 280-306; 'Yavam, yevamah,' ibid, pp. 385 ff; 'Yibum ve-halitzah,' Hebrew Encyclopedia, Vol. 19 (1968), pp. 120-122; Schereschewsky, pp. 295-307.

of the rabbis instructing them,"[2] writes Jacob Katz. From the begin-
ning of the 16th century, however, the positions once again became
polarized, with the Ashkenazim vehemently opposing *yibum*, and
other ethnic groups adamantly upholding it (with the consent of the
parties concerned).

In practice, however, the positions were not so clear-cut. If both
parties consented to *yibum*, there was no problem. Problems occurred
when the parties disagreed. Then, even within the Sefardi commu-
nity, the issue became controversial. In 1565, for example, the sages
of Palestine debated the case of a married man who refused to per-
form *halitzah*. The issue was compounded by the fact that there were
several reasons against the levirate marriage: The woman was of
Ashkenazi extraction, while the brother-in-law was of Maghrebi
(North African) extraction; the brother-in-law was extremely hard-
up, barely being able to support his first wife and children; the
woman was allegedly infertile; the brother-in-law had told his rela-
tives that he himself was reluctant to go ahead with the marriage, but
was being pressurized into it by his mother; and, most important, the
brother-in-law had apparently tried to extract an exorbitant sum of
money from the widow which she had been unable to pay, and was
insisting on marrying her 'out of spite'. Therefore, his motives were
suspect. In any case it was clear that he was not marrying her in
order to fulfill the commandment of *yibum*.

Three Ashkenazi rabbis and one Sefardi rabbi involved in the case
ruled unanimously that the levir (the brother of the deceased) should
be excommunicated until he agreed to perform *halitzah*. The decision
was sanctioned by R. Joseph Caro.[3] The Radbaz initially also en-
dorsed this opinion, and even tried to bribe the levir into agreeing to

[2] Katz, "Levirate Marriage," p. 96. See, for example, Berab, 59-60 (60 is printed
as a continuation of 59, unnumbered). For further sources see: Ha-Cohen David,
Bait 2; Ralbah, 36; Caro, Responsa *Beit Yosef*, responsum of R. Isaac Caro on
pp. 384-387; In the 1560s, R. Moses Trani, who was involved in another *yibum* case,
quoted the rulings of R. Joseph Fasi and his colleagues, which he apparently had in
manuscript (Mabit, II, 41). On the attitude of the Salonika rabbis and others to the
question of *yibum*, see: Goodblatt, pp. 98-99.
[3] Caro, Responsa *Beit Yosef*, p. 90 (= Laws of *Yibum* and *Halitzah*, 2). Signatories of
the decision were: Zechariah bar Solomon Zaksel Ashkenazi, David Frank bar
Zechariah Ashkenazi, Joseph Lombroso, and Yudah bar Uri Halevi Ashkenazi. The
Mabit (II, 41), states: "The Ashkenazi sages there wrote that they would force him to
perform *halitzah*, and this decision was upheld by one Sefardi rabbi." His own deci-
sion is brought after the aforementioned ruling.

halitzah. Some days later, however, he had a change of heart, and refused to be party to the rabbinical decision to excommunicate the recalcitrant levir.[4]

Although the rabbis of Safed were consulted on this issue, they hesitated to challenge the Radbaz. The Mabit, speaking for them all, replied that if neither the early sages nor the Gaonim had reached a decision on this thorny issue, how could they presume to do so? The genius of the Radbaz, he claimed, equaled that of all the other rabbis put together. He himself was not prepared to uphold the decision to excommunicate the levir, unless the Radbaz agreed.[5]

In his answer, the Mabit referred also to a responsum by R. Levi Ibn Habib, in which he stipulated that even if the levir was a married man, and even if the widow was no longer capable of bearing children, the levir could not be compelled to perform *halitzah.*[6] The Mabit, therefore, proposed an alternative solution: "The rabbis should lift their excommunication ban, and try to 'pay off' the levir according to the widow's means. If his main interest was mercenary, as they claimed, he would probably agree [to grant her *halitzah*] when he realized that she had no money left. She, for her part, would not remain an *agunah* all her life." He ended his responsum with the somewhat dubious wish: "May the Lord protect *agunot,* and open for them the gates of light, Amen."

One wonders how the Mabit, no doubt aware that the woman had no chance of remarrying without a dowry to her name, could in the same breath advise the widow to pay off the levir, and pray for an alleviation of her plight....

In 1580, a furor erupted in Safed in connection with R. Joseph Caro's daughter-in-law, who refused to marry her levir, but at-

[4] The Radbaz's decision is brought in Berab, 61. The Radbaz did not even relate to the fact that the woman was Ashkenazi. This is not surprising when we take into consideration the fact that Rabenu Gershom's ban applies to men, not women. When R. Jacob Hagiz, head of the 'Beit Ya'aqov' house of study set up in Jerusalem in 1658, was asked if two Ashkenazi women were permitted to marry a Sefardi, he assented. He based his opinion on Jerusalem custom and on the ruling of R. Or Shraga Feivish, head of the Ashkenazi community of Jerusalem in the middle of the century: "Rabenu Gershom's ban applies to men only [...] not to women [...] R. Or Shraga's ruling has never been contested, although there is room for questioning it." (Hagiz Jacob, II, *Even ha-'Ezer,* 38; See also Rozen, *Community,* pp. 108-109).
[5] Caro, Responsa *Beit Yosef,* 91 (=Laws of *Yibum* and *Halitzah,* end of 2); Mabit, II, 41 (although the rabbis are not mentioned by name, it is clear from the text that he is referring to the same case). See also Sithon, p. 10a (*Kunteres ha-Kelalim).*
[6] Ralbah, 36.

tempted to perform her own makeshift *halitzah* ceremony by spitting in front of him in the presence of witnesses (spitting is part of the *halitzah* ceremony). The majority were of the opinion that the levir should release her, since she had anyway disqualified herself from marrying him. Others challenged this ruling, saying that the impromptu *halitzah* ceremony was not valid since it had been performed without the levir's consent. Furthermore, the brother-in-law insisted that his sole motive in wishing to marry her was to perpetuate the name of his deceased brother. Therefore, they stated, "she clearly has only herself to blame, and the levir cannot be compelled to release her. She must therefore remain [an *agunah*] until her hair grows white, since she has acted improperly."[7] According to R. Yom Tov Zahalon, *all the Ashkenazi sages* of Safed refused to compel the levir to release her, indicating that they did not totally rule out *yibum* as an option. In the event, however, the opinion favoring *halitzah* prevailed.[8]

This and similar cases[9] indicate that the Ashkenazi sages, like their Sefardi counterparts, had no clear-cut stand with respect to *yibum* and *halitzah*. At the very most, the ban on bigamy reduced the incidence

[7] Maharitatz, I, 31. See also Alshekh, 92 (=Ashkenazi, 34); Ashkenazi, 26. This episode is referred to briefly by Katz in "Levirate Marriage," p. 103 (although there are several inaccuracies both in respect of chronology and the identity of the sages who were involved in the case). For the bride's identity, and information about R. Joseph Caro's children, see in the introduction to the Alshekh's Responsa, p. 26. Concerning the spitting ritual, see Katz, "Levirate Marriage," pp. 73-74.

[8] The *halitzah* deed of the "daughter-in-law of our great Rabbi, our honored Master and Teacher R. Joseph Caro, may he rest in peace" has been preserved in manuscript, in the collection of deeds from Jerusalem. See MS Jerusalem, *Sefer Tikkun Soferim*, p. 112b (photocopied in the introduction to the Alshekh's Responsa, pp. 25-26).

[9] See, for example, the question put by R. Judah Hen of Candia to the sages of Palestine: Mabit, I, 80; Alshekh, 11; Caro, Responsa *Beit Yosef*, 92 (= Laws of *Yibum* and *Halitzah*, 3); Radbaz, IV, 1180 (See also Katz, ["Levirate Marriage," pp. 100-102], on the subject of this "unsatisfactory and even bizarre" responsum). On the *Takkanot Shum* (regulations of the synod of the communities of Speyer, Worms and Mainz, which were binding on all German Jews) regarding levirate marriages, see ibid, pp. 83-85. The rumor mentioned by the Radbaz that *halitzah* was condemned in Candia is refuted by the testimony of R. Judah Hen's grandson, who wrote the following to R. Jacob Castro: "There was a case here in Candia in which a certain levir deferred *halitzah* in order to extort money from his sister-in-law. Whereupon the great rabbi and *Gaon*, our Master and Teacher, luminary of the generation, R. Judah Hen, may he rest in peace, forced him [...] to perform *halitzah*. For the custom in Candia, according to ancient rabbinical tradition, is to perform *halitzah*, not *yibum*." (Castro, *Ohalei Ya'aqov*, 91). See also Mabit, II, 133-136; Lamdan, *Status*, pp. 547-549.

of *yibum*, but did not rule it out completely. In the Sefardi community, too, *yibum* was on the decline, no doubt due to the influence of the Ashkenazi tradition. Just as the Ashkenazi sages were prepared to condone *yibum* on occasion, the Sefardi sages were prepared to condone *halitzah* too, where appropriate.[10]

The above notwithstanding, most decisors in Palestine and Egypt favored *yibum* and opposed compulsory *halitzah*. The Radbaz advocated *yibum*, even when the levir was married and had mercenary – as opposed to *halakhic* – motives. Inter alia, the Radbaz based his view on R. Obadiah of Bertinoro's commentary (Mishnah *Bekhorot*, I, 7) which stated that according to Jewish law, *yibum* took precedence over *halitzah*, even in his times. "He was the last great authority," wrote the Radbaz, "and all the French, Spanish, and Askhenazi sages of Jerusalem, as his disciples, abide by this ruling."[11] R. Jacob Berab likewise claimed: "My mentors uphold the view that *yibum* takes precedence over *halitzah*, and this is the principle we too follow here." Similarly R. Jacob Castro declared that "all the leading sages of our countries" believe that the *mitzvah* of *yibum* takes precedence. Many others concurred.[12]

Despite this general trend, some sages – notably the Mabit – tended toward leniency. The Mabit was noted for his sensitivity toward women, as the following story, involving a Musta'rab widow and a child levir, illustrates:

> Obviously the levir cannot be expected to marry her, since he is only four years old, and when he will be 13 she will be 40 or over. Surely, [when the time comes] the court will advise him to release her[13] [...] And in order that this woman will not [in the meantime] be put to shame by asking for her maintenance, and in order to prevent a situation whereby formerly wealthy wives who have never had to work have

[10] Katz, "Levirate Marriage," esp. p. 82 ff. See also responsum of R. Isaac Gershon (Safed-Italy) concerning an apostate levir: "In the year 1605 [...] the Ashkenazi *Gaonim* here supported by five Sefardi sages [...] ruled unanimously that an apostate who wished to marry his sister-in-law should not be allowed to marry under any circumstances, even though he had reverted back to Judaism and had undergone circumcision, but should grant her *halitzah*" (Maharitatz, 148).

[11] Radbaz, IV, 1180. See also: Radbaz, I, 457; Idem, *Metzudat David*, commandment 129. On the Italian tradition, see Katz, "Levirate Marriage," pp. 93-94; Adelman, "Custom."

[12] Berab, 41; Castro, *Ohalei Ya'aqov*, 21; Beer, 78; Alashqar, 79; Responsum by R. Isaac Caro at the end of Caro's Responsa *Beit Yosef*; Maharitatz, 290.

[13] According to *Yevamot*, 101b.

to go begging [...] I have searched for a remedy [...] and found a precedent which says that when the levir is a minor and she is much older, he is compelled to release her. And since *halitzah* is compulsory [when the levir is 13 years old], she is entitled to her *ketubah* now.[14]

In another case, in which the widow was prepared to marry her brother-in-law, but he refused to accept responsibility for providing her *ketubah*, the Mabit ordered him to release her forthwith, without demanding financial compensation.[15] The Mabit also ruled in favor of a woman who was being threatened by her levir. The man in question made no secret of the fact that he was not attracted to her. Even during his brother's lifetime, "he used to pick arguments with her, insult her, and call her all manner of names, saying: 'When that whore comes to my house I shall wreak my revenge!' Naturally, she refuses to marry him, for she is afraid that he will make her life a misery. Moreover, he already has a wife to support and is not well-off, and if he gets his hands on her *ketubah* that's the last she'll ever see of it [...] Therefore, she found someone who arranged a compromise solution [...] Now, however, the levir has changed his mind and says he wants to marry her." The Mabit concluded that when it is public knowledge that the levir has ulterior motives, and is liable to carry out his threats, he is compelled to release her.[16]

Opinions were divided in the case of a married levir who had vowed not to take another wife: Some believed that Rabenu Gershom's ban on bigamy did not apply to *yibum*,[17] while others (the Mabit, R. Jacob Castro, R. Joseph Caro and even the Radbaz) held that since *halitzah* was also a commandment, a married levir who wished to perform *halitzah* was entitled to do so.[18]

The school of thought that gave priority to *yibum* over *halitzah* found confirmation in the *kabbalah*, as the following ruling by R. Isaac Caro illustrates:

> The Kabbalists believe that the commandment of *yibum* takes precedence over that of *halitzah*. This is because the commandment of *yibum* greatly benefits the soul of the deceased. For the soul derives pleasure from being reincarnated in the closest relative [...] A levir who fails to

[14] Mabit, I, 133.

[15] Ibid, II, 53.

[16] Ibid, 158.

[17] MS Jerusalem, Tzayyah, 524, p. 247b; Maharit, I, 118.

[18] Mabit, III, 172; Castro, *Ohalei Ya'aqov*, 117; Caro, Responsa *Beit Yosef*, 94 (=Laws of *Yibum* and *Halitzah*, 4); Radbaz, I, 114.

marry his sister-in-law therefore shows a cruel lack of concern for his brother's soul [...] He is effectively barring the transmigration of his dead brother's soul [...] Because the levir is cruel and despicable for refusing to marry her [...] she spits before him as a sign of contempt.[19]

The true reason behind the 'secret of *yibum*,' however, is provided by the Radbaz, in his book on the reasons for the commandments. On the question of why the commandment of *yibum* is incumbent only on a brother on the father's side, and not on the mother's side, he answered: "The souls descend from heaven in families. *The mother's family, however, is not considered family in respect of inheritance.*[20] For this reason, the soul forms a bond with the father's family only. This explains why *yibum* is not incumbent on brothers on the mother's side. The soul of the deceased does not seek out brothers on the mother's side, but seeks out brothers on the father's side."[21]

It is thus clear that the original reason for *yibum* was to preserve property within the family and prevent it passing into alien hands. One of the ways in which the levir perpetuated the name of the deceased, as prescribed by the Torah, was by inheriting his property.[22] Therefore, the levir had an economic interest in fulfilling the commandment, and if he waived his right, he felt entitled to demand suitable monetary compensation. Naturally, this situation lent itself to abuse.

[19] His responsum at the end of Caro, Responsa *Beit Yosef.* See also Katz, "Levirate Marriage," p. 99 ff., and his article "Relationship."

[20] Brothers on the maternal side are considered brothers only in respect of mourning and testimony, but not in respect of inheritance or *yibum* and *halitzah*. See Rambam, *Laws of Yibum and Halitzah*, I, 7.

[21] Radbaz, *Metzudat David*, commandment 129. Ibid, commandment 130; Radbaz, IV, 1180; Responsum of the Radbaz in Berab, 61. Other rabbis who speak of the 'secret meaning of *yibum*' are R. Shabtai Beer, R. Moses Galante, R. Abraham Gabriel, R. Hayyim Vital, among others. See: Beer, 78; Arha, 10; Vital, *She'arim, Sha'ar ha-Gilgulim*, Introduction 2, p. 16; Introduction 29, p. 81; Idem, *Sefer ha-Hezyonot*, II, 10 (pp. 53-54). In Islam too, after the husband's death, it is customary for one of his relatives to marry the widow, and inherit her property. Goitein (*Introduction*, pp. 125-126) believes that there is a fundamental difference between this custom and that of *yibum*. In his opinion, the former is a mere property transaction (the relative inherits the wife along with the deceased's property) while the latter is based on a religious perception of marriage. Although this is not the place to discuss the origins of *yibum*, there is no doubt that this custom also has a property basis. The Radbaz's comment above corroborates this.

[22] Deuteronomy 25: 5-10; *Yevamot*, 17b; 24a, et al.

The apostate levir

A phenomenon which had a direct impact on the issue of *yibum* and *halitzah* in the 16th century was that of the apostate levir. Some argued that *yibum* or *halitzah* did not apply if the levir was a convert. Others argued that it did.[23] Obviously, apostate levirs were no novelty. The Responsa speak of converts in Muslim countries who left home, leaving behind *agunot* or *yevamot* (women awaiting *yibum*). With the fragmentation of families after the Expulsion from Spain, the problem not only intensified, but acquired an added significance.

On an individual scale, there was concern for the fate of a woman whose future depended on an apostate levir. On a national scale, there was a psychological need to retain some sort of tie with family members who had apostatized, however alien their way of life. Through preserving the widow's dependency on her apostate brother-in-law, the reasoning went, some sort of link would still be maintained with the community that had been left behind. By dispensing with the need for *halitzah*, on the other hand, all ties with the Iberian community would be severed. The tacit hope was that one day the *conversos* might decide to return to Judaism, and join their brethren in the Levant. No doubt many women paid the price for this aspiration, however understandable it was.

The rabbis of Salonika, with its large contingent of Spanish refugees, were particularly sensitive to this issue. This explains why most decisors of the post-Expulsion generation tended toward stringency. They feared that a ruling automatically lifting the *agunah* status of all women married to apostates, or the *yevamah* status of all women awaiting *yibum* or *halitzah* from an apostate, would totally sever the halakhic and emotional ties between the Iberian refugees and their families. They truly hoped that some day the converts might revert to the Jewish faith and join their families abroad. The stringency was almost certainly an expression of the hope that the separation between them was temporary.[24]

[23] Caro, *Shulhan 'Arukh*, *Even ha-'Ezer*, Laws of *Yibum*, 157, 4; Idem, *Beit Yosef* on *Tur Even ha-'Ezer*, 159. See also "*yavam*," Talmudic Encyclopedia, Vol. 21 (1993), pp. 389-395, 423.

[24] See for example Radbaz, I, 69. On the halakhic and historical background, see Katz, "Though He Sinned."

In Istanbul, on the other hand, with its Romaniot leadership,[25] sages such as R. Moses Capsali and R. Elijah Mizrahi permitted *agunot* and *yevamot* of converts to marry, probably because they had no emotional ax to grind, and were therefore able to consider the woman's good per se. They were also concerned that women who were not allowed to remarry might themselves convert, as a way out of their predicament.[26]

In Palestine and Egypt, the rabbis – most of whom were of Spanish origin – unanimously favored leniency. The words of R. Jacob Berab acted as their guiding principle: "The sages of Egypt consulted me on this issue. My answer to them was that *halitzah* and *yibum* are not incumbent on their brethren who have become assimilated among the gentiles. In the West, I myself have seen women [childless widows whose brothers-in-law had converted] who married without *halitzah* or *yibum*. All, or most, of the Castilian sages rule likewise."[27] In any case, if these women had already remarried, they were not required to divorce their husbands. This attitude is reflected in legal decisions: While the vast majority of sages in Palestine and Egypt usually tended toward stringency in the case of *yevamot*, they were far more flexible if the levir was an apostate.[28]

No doubt, many women were aware of the decisors' leaning toward flexibility in the case of an apostate levir, and had no scruples about exploiting it, as the following story illustrates: "A *yevamah* had an apostate brother-in-law in Portugal who had no intention of reverting to Judaism during the period of amnesty granted by the King of Spain [...] and no intention of leaving the country, which he could easily have done, since he was a wealthy man. When the sister-in-law saw that he had no intention of reverting to the Jewish faith, she took the law into her own hand and remarried, despite the fact that she had been warned not to, *because she had heard that once she remarried, she would not be required to divorce!*[29]

[25] Romaniots was the name given to Jews who came from the former Byzantine Empire.

[26] Mizrahi Elijah, 47 (ibid, also responsum of R. Isaac Ibn Habib); Binyamin Zeev, 75 (Responsum of R. Moses Capsali). See also Assaf, "Marranos," pp. 56-58; R. Cohen, esp. pp. 17-22.

[27] Berab, 39.

[28] Maharitatz, 13; Galante, Responsa, 95; Radbaz, I, 175, 1162; IV, 1164; Mabit, II, 83; Beer, 76. R. Jacob Castro was particularly stringent (Castro, *Ohalei Ya'aqov*, 48).

[29] Maharitatz, 201.

We see, therefore, that the same concerns that moved the rabbis to display leniency toward *agunot*, in particular fear of immorality, applied in the case of *yevamot* with apostate levirs. In many cases, the rabbis permitted these widows to remarry, for fear that unless they did so, these women would remarry in any case, or at the very least, sanctioned their marriages retroactively.

As the emotional ties between the Sefardi rabbis and their brothers in Spain and Portugal weakened, they no longer felt the need to be as stringent in cases of apostate levirs. A similar change in attitude occurred among the rabbis of Salonika and Istanbul over the 16th century. Just as there was no consensus on the question of the *conversos* in general, the attitude toward *yevamot* of *converso* levirs underwent several transitions in the course of the century.[30]

Circumventing yibum

A woman who eschewed *yibum* in favor of *halitzah*, had to contend with an assortment of 'technical' and economic problems. Sometimes, long journeys were necessary before she could be 'released'. Often protracted financial claims were involved. It frequently took years to determine if the deceased husband had any brothers in his country of origin. The situation of a widow awaiting *halitzah* was akin to that of an *agunah* in this respect. In both cases, the woman was dependent on the man's decision, and compulsory *halitzah*, like a compulsory *get*, was extremely rare.[31]

In view of the above, several measures were adopted to spare the woman unnecessary suffering. In some places, a condition was added to the *ketubah* stipulating that if the husband died childless, the husband's brothers undertook to grant the wife *halitzah*.[32] Another way

[30] Rozen, *Routes*, pp. 5-23; R. Cohen.

[31] Mabit, II, 166 (a woman who waited for twelve years!); III, 189; Maharitatz, 27, 277; Maharitatz, New Responsa, II, 220; Radbaz, I, 114, 269; VI, 2087, 2234; Galante, Responsa, 39; Castro, *Ohalei Ya'aqov*, 21; Berab, 41. See also the complicated case of the levir Baruch Samuel Benedit of Provence: Mabit, III, 131-132; Galante, Responsa, 67; Alshekh, 50 (see also introduction, pp. 23-24).

[32] For example: Radbaz, I, 309; Mabit, III, 172; Berab, 12; Maharitatz, 277. On the possibility of a conditional marriage (the condition being that if the levir turned out to be an apostate, the widow's marriage would be retroactively annulled), see Freimann, *Betrothal*, pp. 386-388, which brings cases from various communities, including Sefardi ones.

out was for childless husbands to grant their wives a "deathbed di-vorce" that became valid retroactively only after their demise. In this way, the woman would be a divorcee, not a widow, and would not require *yibum*. In some places, it was even customary to introduce a condition into the *ketubah* in which the husband undertook to grant his wife a deathbed divorce.[33] However, there were certain problems attendant upon such a condition. For example, was the woman enti-tled to her *ketubah* as a widow or divorcee? What if her husband recovered and died at a later date? [34]

Merchants who had to travel far from home often left their wives a conditional *get* which became valid only if the husband did not return within a specified period of time. Such a *get* was designed to prevent a situation whereby women remained *agunot* or subject to the mercy of a levir. As the Maharit put it: "Most women who demand a [conditional] get do so only to avoid a levirate marriage!"[35]

Another way of circumventing *yibum* or *halitzah* was by cross-ex-amination of the groom prior to the wedding. The custom of cross-examining the groom, or obtaining a sworn statement from him that he had no brothers abroad, existed in several places.[36] As stated, the main reason behind these customs was to spare women unnecessary hardship. They also had a social component. A family about to ac-quire an extra member who came from far away, had an interest in checking out his origins, genealogy, prospects, and the like. This custom was particularly prevalent in Palestine, with its high percent-age of bachelors from remote places who came to study Torah and find a wife. Obviously, such investigations were not always successful, since it was often hard to establish communication with the place of origin. In such cases, the family had no option but to trust the man's word. This is what happened to Ordoña bat Samuel Cohen, of Safed. Her intended, R. David of Arbel (Irbil, a city in Kurdistan), was cross-examined by the Safed court, since "in this city, a woman is not given away in marriage to men who have brothers in distant places." Since the said David swore that he had no brothers, he was

[33] Maharitatz, New Responsa, I, 68; II, 198, 221-222; Galante, Responsa, 17; Ralbah, 52, 80-81; Radbaz, I, 75; VI, 2259; Mabit, I, 55.
[34] Mabit, I, 55(a), 55(b), 56, 62, 65; Ralbah, 52, 80-81; Caro, Responsa *Beit Yosef*, 95 (= *Laws of Yibum and Halitzah*, 5).
[35] Maharit, I, 66; See also MS Jerusalem, Tzayyah, p. 3b.
[36] See for example Rambam, Responsa, 347; Ha-Cohen Shlomo, II, 97; Freimann, *Betrothal*, pp. 97, 102.

not required to add a condition to the *ketubah* granting a deathbed divorce. Several years later, a man from Kurdistan arrived in Safed saying that David had a brother in Kurdistan. When David wished to undertake a business trip, he himself suggested leaving his wife a conditional *get*. She, however, dilly-dallied, fearing that he would take the opportunity to desert her and marry someone else abroad. Later, he was reported to have drowned off the coast of Venice. After five years of *igun*, the widow approached the rabbis of Safed. The latter had to decide whether to give credence to the fragmentary hearsay evidence that David had a brother back in Kurdistan, and to decide the widow's fate accordingly. R. Yom Tov Zahalon and the Maharit ruled that she was a *yevamah* and as such could not remarry. R. Moses Galante and R. Moses Berab ruled that she could. Hearsay evidence, they argued, was admissible for the purpose of disproving *igun*, not proving it. In the latter case, the testimony of a single witness – even if his evidence was substantiated – was insufficient. To the halakhic arguments, R. Moses Berab added another: If for five years there has been no sign of life from any of David's brothers, one could assume there were no brothers left.[37]

Relying on the opinion of the lenient rabbis, Ordoña got married. But that was not the end of the matter. No less than twenty Safed sages convened to deliberate her case, and in the month of Av 1605 published their decision in the Galilee village of Peki'in, whither they had fled apparently to avoid the plague: "The woman is absolutely forbidden [to remarry] [...] The rabbinical decision that previously permitted her to remarry was erroneous [...] We, the undersigned, all agree that this woman is forbidden and is living in a state of sin. Therefore, she must divorce her husband and be absolved by her levir, according to *halakha* on the subject of a *yevamah* who remarries."[38]

The measures designed to spare the woman needless suffering were not always adequate. In many cases, *halakha* could not provide a

[37] Maharit, I, 82; Maharitatz, 27; Galante, Responsa, 17 (= Maharit, I, 81); MS Cambridge, TS Glass 16, p. 348.

[38] Maharit, I, end of 82. The name of the signatories as they appear are: Shem-Tov Attia, Moses Ibn Makhir, Samuel de Uçeda, Yom Tov Zahalon, Jacob Sasson, Joseph Ibn Teboul, Hiyya Rofeh, Gedalya Halevi, Abraham Shalom, Suliman ibn Ohana, Mas'ud Azulai, Joseph ben R. Moses Trani, Tuvyah Halevi, Abraham di Buton, Solomon Hacohen, Isaac di Buton, Judah Barzilai, David De Castres (Castro?), Joseph Calderon, Jacob Falcon. On the injustice of such a ruling, see: Dikstein, "Mysteries."

solution, and women were subjected to extortion or long periods of *igun*. If a woman's marriage subsequently turned out to be based on a legal error, as in the aforementioned case, it was she who had to bear the full socioeconomic consequences. From the abundance of questions and polemics on this issue, we may conclude that extortion was fairly widely practiced when a widow refused *yibum*.

In conclusion, the age-old controversy of "*yibum* versus *halitzah*" continued into the 16th century. As stated, the rabbis were less flexible on this issue than in the case of *agunot*. Most of the rabbis of Palestine and Egypt, including also Ashkenazi ones, favored *yibum* over *halitzah*, and opposed compulsory *halitzah*. (In the responsa I studied, 32 decisors favored *yibum*, while 12 favored *halitzah*. Three were undecided.)

Only in the case of an apostate levir did they display a definite bias toward *halitzah*, with the exception of the rabbis of Salonika in the first generation after the Expulsion from Spain. But even in Salonika, as time went by the rabbis tended increasingly toward leniency in the case of apostate levirs, as the hope of reunification with *converso* relatives faded.

CHAPTER FIFTEEN

REGULATIONS CONCERNING WOMEN

Regulations were promulgated by congregations or groups within the Jewish community in order to resolve problems relating to a specific (usually socioeconomic) reality which were not answered by *halakha*. Therefore, the regulations also serve as a mirror of this reality, and afford us a glimpse into the daily lives of the congregations which enacted them.[1]

A number of 16th-century regulations from Jerusalem, Safed, Egypt, Damascus, Aleppo and other places have been preserved, together with customs of the kabbalists of Safed and its environs.[2] Some of these regulations deal with marital issues, especially the financial arrangements attendant upon marriage. Others are guiding principles attempting to regulate women's behavior in public, and reflect society's expectations of women (see chapter 8 above: "Social Norms versus Reality.")

Both kinds of regulations were 'paternalistic,' enacted by men from a position of superiority. Even regulations which seem to express concern for women, are usually inspired by an attitude of solicitous condescension rather than true respect.[3]

[1] Elon, "Nature"; Idem, *Jewish Law*, pp. 558-712 (and other chapters); Barnai, pp. 271-275; Y. Cohen; Katz, *Halakhah*, pp. 242-246; Schipansky, *Takkanot*, I, "Introduction to Talmudic Regulations"; IV, "Introduction to Communal Regulations".

[2] *Jerusalem*: Benayahu, "Collections"; Freimann, "Regulations"; Lavsky; *Safed*: Radbaz, I, 644; De Vidas, *Totzeot Hayyim*, pp. 5a-b, 13b, 15a; Toledano, pp. 48-51; Meroz; Schechter, pp. 294-301; Hallamish; Benayahu, *Ari*, pp. 309-314; *Egypt*: Radbaz, I, 382, 397, 515; III, 960, 972. *Damascus*: Pinto, 26. *Aleppo*: Mabit, I, 206.

[3] The extent to which the condescending attitude of the male legislator has persisted to this day is striking. "Although the aim of the Jewish law courts and legislators" writes a contemporary researcher "is to maintain public order and safeguard the institution of marriage, their primary concern is the well-being of woman in the long term, in contrast to her short-term view of events which is by nature [!] limited and bound up in, if not ruled by, strong emotions that interfere with logical thought" (Weinroth, p. 206).

Marriage Regulations

Several marriage regulations that were adopted by the Jewish communities were an attempt to restrict the number of 'dubious' marriages (*kidushei safek*), and to ease the plight of women seeking a divorce from recalcitrant husbands.

According to Jewish law, a woman is 'consecrated,' that is, she is assigned to her husband for a special purpose, and is therefore forbidden to anyone else. She may be 'consecrated' in one of three ways: Through payment of money [*kesef*], through a marriage contract [*shtar*], or through cohabitation [*bi-ah*]. Certain conditions are attached to each of these methods, but these are relatively straightforward. Although on the face of it, a woman cannot be betrothed without her consent, in practice if she does not object immediately, or if she is silent, the betrothal is valid.[4] (Note the low age of legal consent: thirteen for a boy, twelve-and-a-half for the girl.)

The simplicity of the marriage rite and the father's prerogative to marry off his daughter while still a minor, led to a plethora of 'questionable betrothals' or marriages under false pretenses both of which, according to the strict interpretation of the law, necessitated divorce. The fact that divorce was contingent solely on the husband's will opened the way to extortion and abuse. The situation was exacerbated by the hybridization of cultures in the wake of the Spanish Expulsion. The resultant social and legal problems forced communities to seek ways of preventing abuse, such as inspecting the personal and economic status of the groom to ascertain if he had a wife or brothers back home. In several communities, marriage ceremonies were subjected to public supervision.[5] In Palestine and Egypt, for

[4] Mishnah *Kiddushin* I, 1; (Babilonian Talmud) *Kiddushin* 2b, 7b, and *Tosafot* there; *Kiddushin*, 12b-13a; Freimann, *Betrothal*, p. 4. As far as cohabitation is concerned, the *Shulhan 'Arukh* writes (*Even ha-'Ezer*, Laws of Betrothal, 33, 1): "If he pronounces the words 'behold you are consecrated to me by this act of cohabitation' before two witnesses, and secludes himself with her before the witnesses, she is betrothed." A later addendum, that is missing in the 1567 edition of Caro's *Shulhan 'Arukh*, states: "Even though this is effrontery" (see Sithon, *Even ha-'Ezer*, on the above law). On age of marriage, see: Rambam, *Marital Laws*, II, 2-3; Caro, *Shulhan 'Arukh*, Laws of *Mi-un*, 155, 12 ff. For further references see: Schereschewsky, pp. 33-42, 47-50; Katz, "Levirate Marriage," p. 104.

[5] Freimann, *Betrothal*, discusses this at length in his introduction, inter alia. See also Elon, *Jewish Law*, pp. 518-527 (Legislation in the Age of the Amoraim), pp. 539-540 (Legislation in the Age of the Gaonim), pp. 687-707 (Legislation from the 10th Century on), and other chapters. Schipansky, *Takkanot*, III, pp. 368-370. A regula-

example, a regulation dating back to the Mamluk period stipulated that: *Weddings had to take place before a rabbinical court and in the presence of ten men.*[6] R. Joseph Caro ruled that anyone who contracted a betrothal in secret must be excommunicated "lest the daughters of Israel become worthless in the eyes of the grooms" and R. Yom Tov Zahalon went even further: "They and their associates deserve to be stretched on the rack!"[7] A similar regulation was adopted also in Damascus, Tsobah (Aleppo), Hamat (Homs) and Sidon.[8]

The avowed purpose of these regulations was to protect women from maltreatment by abusive and exploitative husbands, and to spare them the fate of *igun* due to the existence of a distant levir. Underlying these regulations was another, no less important concern – that hasty marriages might be contracted without the knowledge of the families concerned and without suitable economic arrangements between the parties. Thus, the regulations expressed society's wish to

tion concerning preliminary investigations into the personal status of the groom was introduced by the Rambam in Egypt (Rambam, Responsa, II, 347). A Genizah document shows that in 12th-century Egypt, marriages were supervised, and the groom fined if any impediment was discovered (Baneth, Document 1). See also Goitein, *Society*, II, pp. 16-17, 29-30. In the 17th century, R. Mordecai Halevi of Egypt introduced a regulation that the consent of the bride's father was necessary, to ensure the girl had not already been betrothed while still a minor (*Darkhei No'am, Even ha-'Ezer*, 1). A similar regulation was still in force in the early 20th century (Ben Shimon, *Nahar*, pp. 165b-166a). In 14th-century Ashkenaz too, it was customary to investigate the personal status of the groom (Freimann, *Betrothal*, pp. 45-46). In Safed it was customary to investigate the family background of a 'foreign' groom (see Lamdan, *Status*, p. 566). See also Ben Shalom, pp. 22-23; Rozen, *Routes*, pp. 151-152; Biale, pp. 84-88.

[6] Berab, 42. In other versions: "[...] only with the permission of the Jewish court and in the presence of the city scribes" (Radbaz, III, 972); "[...] only with the permission of the congregation" (ibid, I, 515; II, 707); Castro, *Ohalei Ya'aqov*, 62; Gottheil-Worrell, XL (third document), pp. 184-186-188. For the Safed regulation, see Lamdan, *Status*, pp. 24-25. Already in the Rambam's time, a regulation was introduced in Egypt "that a local rabbi must be present for a marriage to be valid" (Rambam, Responsa, 348; Sambari, 66, p. 118 in photocopied edition). In the Rambam's regulation, there is no mention of the presence of a quorum of ten at the ceremony. Evidently, this condition was added later (Schipansky, "Ordinances," pp. 156-158, and note 13 there). On supervision of marriages during the Age of the Gaonim, see Friedman, *Polygyny*, p. 2; On the regulations of the exiles in Fez, see: Ankawa, Regulations 1, 34; On the Salonika regulation, see Rashdam, *Even ha-'Ezer*, 12; On the Arta regulation, see Bornstein-Makovetzky, "Arta," p. 146. See also Goodblatt, pp. 97-98, pp. 209-210, note 32.

[7] Caro, Responsa *Beit Yosef*, 16 [= Laws of *Kiddushin*, 11]; Maharitatz, 29.

[8] Pinto, 26-30; Maharitatz, New Responsa, II, 205-206; Maharitatz, 54; Mabit, I, 206; Caro, Responsa *Beit Yosef*, Laws of *Kiddushin*, 4, 6; Hotzin, *Even ha-'Ezer*, 24.

protect its institutional basis. Class differences and socioeconomic alliances between families were not matters to be trifled with. The regulations therefore served to safeguard the dominant role of the family, particularly of the father, in choosing a suitable partner for his daughter.

Another regulation was introduced in order to solve problems occasioned by the time interval between betrothal (*kiddushin* or *erusin*) – by which a woman is consecrated to her husband – and marriage (*nisuin*). One such problem was sexual tension, which frequently led to precipitous marriage ceremonies conducted clandestinely. Alternatively, one of the parties might have a change of heart, or renege on the conditions that had been drawn up, sometimes years earlier, between the parties. Toward the beginning of the 16th century, most communities adopted the custom of combining the betrothal (*kiddushin* or *erusin*) and marriage rites, as is the custom today.[9] In Palestine and Egypt, similar regulations were adopted even before the 16th century: The Radbaz spoke of "*an ancient Jerusalem regulation to conduct the betrothal ceremony together with the marriage ceremony*," and of an Egyptian regulation, "adopted by the early *Neggidim* of *conducting the betrothal ceremony shortly before the sheva' berakhot*."[10] The Radbaz qualified this by saying that although the regulation had more or less become law, betrothals that took place before the marriage ceremony were allowed in exceptional cases. Nevertheless, "This regulation has taken root, and even though we may occasionally permit a betrothal

[9] Freimann, *Betrothal*, pp. 25-26, 31-32, 62, 98-100, 105-106. Tykocinski, p. 126. The Romaniot communities throughout the Ottoman Empire observed an interval between betrothal and wedding for a longer period. On problems this occasioned, see Freimann, ibid, pp. 150-153, 190-192, 240 and *passim*. Rashi, interestingly, attributed the merger of the ceremonies to the need to economize (*Mahzor* Vitri, 469; Freimann, *supra*, p. 29; Schipansky, "Ordinances," p. 148). See also: Schipansky, *Takkanot*, III, pp. 368-371; Schereschewsky, pp. 42-43; Assaf, "Family"; Zohar, p. 70, note 18; Friedman, *Jewish Marriage*, pp. 192-194, and notes there; Gulack, *Origins*, pp. 13-14.

[10] Radbaz, II, 664. Ibid, I, 382 (=VII, 55); III, 960, 972; See also R. Jacob Castro: "It is customary in this city [Cairo] for the betrothal to take place shortly before the wedding ceremony" (Castro, *Ohalei Ya'aqov*, 71, and ibid, 11). R. Moses Mizrahi (Responsa *Admat Kodesh*, *Even ha-'Ezer*, 39), relates: "We have heard from our fathers that there is an ancient custom in this holy city of Jerusalem, enacted by the great sages and Gaonim of yore [...] under penalty of excommunication, that no betrothals shall be conducted prior to the wedding ceremony in Jerusalem." For further, and later references, see Sithon, *Even ha-'Ezer*, 34, 3; Ben Shimon, *Nahar*, p. 170b; Littman, "Family," pp. 220-222.

[before marriage] if there is a very good reason to do so, this is no excuse for changing the custom!"[11]

Before the integration of betrothal and marriage ceremonies (a process which was not yet completed in the 16th century), the terms 'betrothal' [*kiddushin, erusin*] and 'engagement' [*shiddukhin*] were often used interchangeably. Perhaps because of this, a regulation was introduced in Jerusalem, that *even engagement ceremonies had to take place under the supervision of the rabbinical court.*[12] R. Bezalel Ashkenazi stressed that a betrothal "without an engagement [*shiddukhin*], without the presence of her [the woman's] relatives, without the blessing of *erusin*, without a quorum of ten men" was an act of duplicity.[13]

The efficacy of regulations relating to betrothal and marriage was frequently put to the test. The dozens of questionable betrothals that are discussed in the Responsa literature of the period indicate a social problem of substantial proportions. Some of these cases reek of injustice and treachery. There were cases of fraud and extortion, cases of marriages contracted in jest or in a state of inebriation. Other marriages were undertaken frivolously, for an object worth a penny or less: a chunk of cheese, a bunch of grapes, a sugar cane, a bunch of Jasmine, a slice of bread, and the like.[14] The above notwithstanding, even if the betrothal or marriage had been performed *against the regulation* or against the will of the bride and her parents, some decisors took the strict view that the bond was valid, and could only be dissolved by divorce.[15] This naturally provided a golden opportunity

[11] Radbaz, I, 382. Elsewhere: "Even if there are two or three exceptions, the rule still stands" (ibid, 367). Likewise: "Sometimes there are men who are in a hurry to perform the betrothal ceremony immediately, lest the bride change her mind" (ibid, III, 972). See also: ibid, IV, 1077; Radbaz, New Responsa, 199; Mabit, I, 41, 78; III, 14; Maharitatz, New Responsa, I, 37; Ralbah, 134; Alashqar, 32; Caro, *Avkat Rokhel*, 85; Maharitatz, 29.

[12] Freimann, "Regulations," Regulation 5 (p. 208). As to the confusion of terms, see for example the responsum of R. Solomon Ashkenazi (Arha, 31), in which the agreement drawn up between the parents is referred to both as a betrothal deed, and as an engagement deed. See also Freimann, *Betrothal*, p. 218; Lamdan, *Status*, pp. 17-19, 34-35; see also the regulation forbidding a fiancé to enter his fiancée's house, *supra*, in Chapter Two 'From Childhood to Marriage -The Burden of a Daughter.'

[13] Ashkenazi, 4.

[14] Radbaz, I, 312; III, 942, 982; VI, 2151 (=VII, 49); VII, 36; Ashkenazi, 4 (on the same issue: Maharitatz, 54; Alshekh, 104); Maharit, II, *Even ha-'Ezer*, 42; Maharitatz, 29, 236; Maharitatz, New Responsa, I, 41, 52, 74; Caro, Responsa *Beit Yosef*, 16; Castro, *Ohalei Ya'aqov*, 92, 107; Berab, 17, 20; Pinto, 33; Mabit, I, 14.

[15] The debate concerning the authority to dissolve a marriage dated back to previous generations. See Freimann, *Betrothal*, p. 38 (12th century), p. 71 (the Rosh's support for the dissolution of a marriage performed in contravention of a regulation),

for rogues and recalcitrant husbands to extort large sums of money from the bride's family, in return for granting her freedom.

In one controversial case, which took place in 1527, a man named Samuel Okania betrothed Ordoña bat R. Meir Zarfati, in the Alley of the Karaites in Cairo, with one gold dinar. After the bystanders' testimony turned out to be false and inconsistent, the leading decisors of Palestine and Egypt were consulted concerning the validity of the betrothal. Although they invoked the regulation that betrothals must be performed before a rabbinical court and in the presence of ten men, they disagreed about what steps to take, after the event. The Radbaz, R. Levi ben Habib (the Ralbah) and R. Moses Alashqar pronounced the betrothal valid according to Jewish law, since the ancient regulation did not explicitly state that failure to comply with it invalidated the betrothal. Therefore, they declared, a *get* was required. This view was challenged by R. Jacob Berab, R. Moses Trani (the Mabit) and R. Joseph Gabbai from Damascus, who argued that "the intention of the sages in enacting this regulation was surely to invalidate a betrothal that contravened the regulation, since otherwise, why introduce the regulation in the first place?"[16]

Another frivolously contracted marriage took place in Damascus in 1617, when Muença bat Rashid Nehmad was betrothed to her cousin without her father's consent, during a circumcision ceremony on Purim, when everyone was drunk. In this case, R. Josiah Pinto pronounced the betrothal invalid, because the culprit had infringed the regulation by betrothing the woman in a private ceremony and not before the court, 'as was the custom.' His ruling was endorsed by R. Yom Tov Zahalon (the Maharitatz) and R. Hiyya Rofeh. R. Suleiman ibn Ohana, on the other hand, was of the opinion that the betrothal was valid, and that the girl required a *get*.[17]

p. 80 (15th-century Spain), p. 103 (North Africa in the late 15th century), and his conclusion on pages 98-100. See also Schipansky, "Ordinances," III, pp. 371-372; IV, pp. 549-554; Zohar, especially pp. 73-75. On the dissolution of a marriage performed under duress, see: Shohetmann, "Marriage"; Elon, *Jewish Law*, I, pp. 427-428, 518-527.

[16] Radbaz, IV, 1128 (=VII, 51); Ralbah, 138; Alashqar, 60; Berab, 42 (=Ralbah, 136); Mabit, I, 49. The case of Ordoña's betrothal, and the polemic between the decisors, continued to have repercussions throughout the first half of the 17th century (in connection with the marriage between R. Samuel Ibn Zawig from Istanbul and R. Yom Tov Zarfati's daughter from Adrianople). See Maharit, II, *Even ha-'Ezer*, 39 (pp. 151-154); ibid, 40: 2, p. 195, and in the summary of the responsum, p. 160. See also Freimann, *Betrothal*, pp. 182-184.

[17] Pinto, 30.

The controversial nature of this issue, and the wariness displayed by the sages regarding the authority to dissolve a questionable betrothal, often led to seemingly contradictory rulings, even by the same rabbi. For example, R. Moses Alashqar ruled that Ordoña bat Meir Zarfati did require a *get*, while in a responsum on a similar case sent to Salonika, he wrote: "In every generation, the local townspeople and their court can introduce regulations and strictures that may even contravene biblical law [...] If the local townspeople agree that a betrothal that contravenes the local regulation is not valid, and that any money given by [the groom] is not his [...], *their regulation is upheld and the betrothal is not valid.*" This was the ruling, in theory anyway. In practice, even in this case, Alashqar ruled that a *get* was necessary, on the grounds that the regulation was adopted only by one of the local congregations, not by all.[18] The Radbaz also ruled that Ordoña's betrothal was valid even though it contravened the regulation. However, in a similar case, he ruled that the woman did not require a *get*.[19] The ambivalence indicates the tremendous importance attached to the act of betrothal *per se*, as a sacrosanct act which transcended local regulations or socioeconomic concerns. Despite the regulations, if no *halakhic* fault was found with the betrothal procedure, the betrothal was considered valid according to the strict letter of the law and the woman was required to obtain a divorce. As R. Jacob Castro of Cairo explicitly stated: "The community regulation concerning the annulment of a betrothal was never put into practice!"[20]

Despite the above, great efforts were made to find a way of dissolving questionable betrothals, not only to prevent extortion and safeguard financial settlements between the parties, but also possibly to prevent a marriage (sometimes even with the girl's collusion) that would be hard to revoke.[21] Usually, however, *this was not done by*

[18] Alashqar, 48.

[19] Radbaz, I, 382 [=VII, 55]. See also Ben Shimon, *Nahar*, p. 170b; Freimann, *Betrothal*, p. 219, and *passim*.

[20] Castro, *'Erekh ha-Lehem, Even ha-'Ezer*, Section 28, para. 23.

[21] In several discussions of questionable betrothals, the groom argued that the bride had known him beforehand, and had agreed to the betrothal. Presumably, in some cases at least, the groom was telling the truth. See for example, R. Jacob Castro's responsum concerning a minor, where an attempt was made to validate her marriage: "I have heard from reliable sources that the minor wanted, and still wants, him but is simply afraid of her father" (Castro, *Ohalei Ya'aqov*, 84). See also Mabit, I, 14, 226, 227, 331; Radbaz, VII, 34, 43; Sometimes the girl expressed no opposition to the questionable betrothal: Castro, *Ohalei Ya'aqov*, 38; Berab, 17; Mabit, I, 299; Radbaz, I, 312; III, 937, 942; IV, 1227.

invoking a local regulation, but through finding some flaw in *the act of betrothal itself* (for example, the betrothal formula was not properly recited, the object handed over to the woman was borrowed or stolen, the witnesses were not acceptable, etc.).[22] This explains why 83 out of the 114 questionable betrothals I examined (betrothals which contravened the regulations) were dissolved by the decisors. In other words, a solution was found for 73% of the dubious marriages, while only 27% required a bill of divorce.[23]

This tendency of invoking technical flaws rather than a contravention of local regulations as a means for invalidating a betrothal, corroborates a phenomenon described by Menahem Elon. In recent generations, he states, most decisors have been reluctant to dissolve marriages, even when community regulations mandate otherwise. The decisors and legislators of the regulations had no hesitation about using their legal authority when it came to financial and property transactions, or inheritance laws, "even if a regulation contravened *halakha*." They were far more hesitant when it came to marriage and divorce laws, and were wary of using their authority in such cases, even when this was 'technically' possible. Although regulations were passed well into the 18th and 19th centuries, in practice, the rabbis were reluctant to invoke them as a basis for their legal decisions. The dissolution of a questionable or fraudulent betrothal on the grounds of violation of a community regulation was a rare occurrence.[24]

Although the testimony of the woman herself was usually not admissible for halakhic purposes, the rabbis were generally very painstaking when it came to taking testimony from others.[25] However, in the case of a questionable marriage that was performed with a sugar cane, the Maharitatz testified that he sent someone after the woman to inquire what had happened, and she explicitly claimed that it was

[22] Maharitatz, 91, 191; Castro, *Ohalei Ya'aqov*, 38; Mabit, I, 66, 328; III, 148; See the case of Ordoña mentioned above (Alashqar, 48) and also: Alashqar, 83, 99, 114.

[23] It is interesting to note the ratios for individual decisors: The Mabit, 15:2 (15 cases required a *get*, 2 did not); the Maharitatz 14:1; the Radbaz 13:15; and R. Joseph Caro, 5:2.

[24] Elon, *Jewish Law*, pp. 676-712. For other examples, see: Freimann, *Betrothal*, pp. 277 ff. Although, in his opinion, the regulations had almost become obsolete in 17th-century Egypt, a similar regulation was resurrected in 1901: "A regulation to dissolve betrothals *and revoke financial agreements* which is binding on all communities within the Kingdom of Egypt" (Ben Shimon, *Nahar*, 171b-174b). On the background to this regulation, and the efforts of the Egyptian sages to promulgate it, see Zohar, especially pp. 68-78.

[25] For example, Maharit, I, 92; II, *Even ha-'Ezer*, 37, 38.

all a pack of lies, and that she had thrown away the sugar cane as soon as it had been handed to her.[26] As a precautionary measure, the sages advised Jewish girls not to accept any object from a man that might be construed as legally valid for betrothal purposes.[27] In a questionable marriage discussed by R. Jacob Castro, no less than twelve (!) depositions were submitted from the Alexandria and Cairo courts. It transpired, following this incident, that although the rabbis had advised the father – Abraham Raqat – to make his daughter swear "not to accept any object as an act of betrothal other than in his [=her father's] presence," she had done so.[28] In his annotations to the *Shulhan 'Arukh*, Castro admonished: "A father should always teach his daughter to reject [by an oath] before God and before the community, any money or monetary equivalent given to her as an act of betrothal, even with her consent, unless this is done in the presence of [...] the city's scribes, and with the permission of the girl's father, or guardian."[29] A similar oath was introduced in Jerusalem. In the year 1527, Qamar, the divorcee of Suleiman Ibn Danon, swore in Jerusalem "that she would never marry anyone without the consent of her father, R. Abraham ben Hayyim, her uncle, and her orphaned son's guardian."[30]

Inheritance Regulations

In Jewish law, the nuclear family is perceived as an economic unit. As such, it invests considerable effort in keeping its property within the family (blood relatives). The status and rights of a family member vis-à-vis the deceased are determined not only by the degree of relationship, but also by gender.[31] Mothers, wives and daughters do not

[26] Maharitatz, New Responsa, I, 74.

[27] Mabit, II, 104-105, following a custom attributed to R. Sherira Gaon.

[28] Castro, *Ohalei Ya'aqov*, 92.

[29] Castro, *'Erekh ha-Lehem, Even ha-'Ezer*, 28:23.

[30] Berab, 4. The exact text of the oath is brought in R. Isaac Tzabah's Book of Deeds (MS Jerusalem, *Sefer Tikkun Soferim*, p. 107b. See also ibid, 83-84, pp. 91b-92b).

[31] On the law of succession, see Deuteronomy 27:8-11; Mishnah, *Bava Batra*, VIII, 1-2; Rambam, *Inheritance Laws*, first chapter; Gulack, *Origins*, III, pp. 81-83. The mother's family is not considered family in respect of inheritance. Inheritance laws also have repercussions on the custom of *yibum*, since only the deceased's brother on the *father's side* can perform *yibum* and inherit his estate. See *Yevamot*, 54b; *Bava Batra*, 109b, and others. See also above, Chapter 14, "Levirate Marriage," notes 20-21.

inherit in the first instance, for fear that through them family property would leave the family and pass into alien hands. These concerns effectively meant that women were totally dependent on the mercy and good will of the male members of their family, thereby effectively perpetuating their economic inferiority. It was only natural that the sages, aware of the social injustice inherent in such a situation, introduced regulations to provide for women, and prevent family disputes. Such considerations figure prominently in the Talmudic and post-Talmudic literature, although the ruling is not always clear-cut. The inheritance regulations and customs that were introduced over the generations provide an interesting insight into the way social reality affected the status of women within the family and society.

The inheritance regulations introduced in Palestine and Egypt in the 16th century, in particular those relating to a husband's right to inherit his wife's estate, are a remarkable patchwork of eastern and western traditions, and mirror the geographical and demographic vicissitudes that befell the Jewish people in that century. Although not all these regulations were introduced in the 16th century, the degree to which they were invoked is indicative of the attitude toward the parties in marriage settlements, and of the importance of the family as an economic institution.

Regulations concerning the husband's right to inherit his wife's estate

In Jewish law, a husband inherits his wife's estate unconditionally, even if she dies shortly after the wedding.[32] This situation bred economic injustice, and led to financial and emotional disputes between families, especially if the woman died childless, or if the husband had children from other wives. Thus, the rabbis, already in the early generations, saw fit to introduce regulations that in certain cases restricted the husband's inheritance rights, and safeguarded the rights of the woman's heirs.[33] The main reason for these regulations (all of

[32] Mishnah, *Bava Batra*, VIII, 1; Mishnah, *Ketubot*, IX, 1; Caro, *Shulhan 'Arukh, Even ha-'Ezer, Ketubot*, 90:1. For a discussion of halakhic and other sources, see Friedman, *Jewish Marriage*, p. 391, note 2.

[33] The various regulations and norms concerning a husband's entitlement to his deceased wife's estate, have been discussed and summarized in a comprehensive article by Simha Assaf (Assaf, "Regulations"). This has been complemented by Yedidiah Cohen in his article "The husband's entitlement to his deceased wife's estate in the communal enactments," and by Menahem Elon's monumental work, *Jewish Law*. See also Schipansky, *Takkanot*, IV, pp. 133-149. For references and a

which to some extent restricted the husband's biblical entitlement to
his wife's estate) was to persuade fathers to be more generous with
the dowries they gave their daughters. Hitherto, fathers had been
reluctant to provide their daughters with large dowries, lest "Thine
ox shall be slain before thine eyes, and thou shalt not eat thereof."[34]
The main concern, thus, was to protect family property, not the
daughter. Fathers feared that any money or property they gave their
daughters when they married would pass into alien hands.

The details of the regulations affecting the husband's right to in-
herit his wife's estate introduced in the Diaspora over the years var-
ied from place to place, depending on the particular social context.
The sheer volume of questions addressed to the sages in the 16th
century would seem to indicate that some confusion surrounded the
issue, no doubt due to the clash of different customs in the wake of
wide-scale immigration and cross-cultural marriages. The most fre-
quently invoked customs in the Levant were the local 'Damascus cus-
tom,' and the imported 'Toledo [Tolitola] custom' brought with by the
Iberian exiles. In both cases, the right of the husband to inherit from
his wife was determined by whether he had children from the de-
ceased or not.

*The Damascus regulation stipulated that if the deceased had children, her
husband was sole beneficiary, as prescribed by biblical law.* If she died child-
less, what remained of the wife's dowry, including bridal and other
gifts, was shared between the husband and the deceased's relatives on
her father's side. The regulation's silence on the subject of *nikhsei
melog* (wife's estate of which the husband has usufruct, without re-
sponsibility for loss or deterioration), implies that the husband was
sole beneficiary thereof.[35] *The Toledo custom*, on the other hand, *stipu-*

survey of inheritance norms in the post-16th-century era, see Gelis, *Customs*, pp. 348-
354, notes 23-25. See also Gulack, *Origins*, III, pp. 91-96; Idem, *Treasury*, p. 22. On
the community's authority to legislate regulations that contravened halakha, see
Elon, "Nature," pp. 5-9, 22-31; Idem, *Jewish Law*, pp. 522-523, and *passim*. See also
the debate on the Algiers regulations, Tashbetz, II, 292, Regulation 3.

[34] Deuteronomy 28:31. This explanation is given by all the decisors throughout
the generations. Many based themselves on Rabenu Asher (Rosh, Rule 55, section
1). See, for example, Radbaz, I, 397; Vital Samuel, 43; Ashkenazi, 12; David,
"Responsum."

[35] The Damascus regulation is brought in full in Vital Samuel, 43 (see also ibid, p.
106, the quotation from Berab, nos. 41, 46). On its historical background see Assaf,
"Regulations," pp. 81-82, 88-89; Ashtor, II, pp. 346-347; See also the Palestine
custom in the Gaonic period: when a woman dies her husband inherits her estate,
unless the *ketubah* contains a clause specifying her fathers' family as heirs (Friedman,

lated that irrespective of whether the wife died childless or not, the husband had to share her inheritance: If she had children, the husband shared with the offspring, if she died childless, the husband shared all her estate – including *nikhsei melog* – with her relatives.[36]

The Damascus regulation, by favoring the husband, is closer to the true spirit of the biblical law. The husband/father is awarded control of the family property, and thus also of his children's fate. The Toledo custom, on the other hand, favors the wife's relatives: Not only does it fail to grant the husband exclusive control of the wife inheritance, but orders him to share his wife's *entire estate* – not only those items specified in the *ketubah* and increments – with her relatives.[37]

The Toledo regulation, with its concern for keeping landed property within the woman's family (a relic of Spanish feudal law) swiftly gained currency among the Jews of Spain.[38] In Palestine and Syria, on the other hand, there is scarcely any reference to landed property, probably because most women there had none.

According to the Mabit, the Damascus regulation gradually came to replace the Toledo one, even among the Spanish immigrants in Palestine. "This local custom, which is based on the Gaonim, has

"Marriage Laws" pp. 218-219; Idem, *Jewish Marriage*, p. 414, note 75). See also Rambam, Responsa, II, 374, and note 1 there. On the use of the term 'custom' in the sense of 'regulation,' see Elon, *Jewish Law*, pp. 717-718.

[36] The regulations are brought in the Rosh, Rule 55. See also: Tur *Even ha-'Ezer*, 118.

[37] The property a woman brings with her when she marries may be divided into two kinds: (1) *nikhsei tzon barzel – inalienable goods*: Property specified in the *ketubah* as part of the dowry over which the husband has almost exclusive control. Although he may do with it as he wishes, he is also responsible for loss or deterioration thereof, and must return it upon her divorce or death: "This property is held for her like 'iron' since he has accepted responsibility for it." (2) *Nikhsei melog – usufruct*: Property not specified in the *ketubah*, wholly owned by the wife, of which the husband has usufruct without responsibility for loss or deterioration. "The principal is hers while the usufruct belongs to her husband." In practice, there was no difference between the two types of property in terms of the benefit the husband derived therefrom. As long as she was married, the wife could not do as she pleased with her property. See: *Ketubot*, 101a; *Yevamot*, 66a; *Bava Kama*, 89a; Rambam, *Marital Laws*, XVI, 1-2; Caro, *Shulhan 'Arukh, Even ha-'Ezer*, 85, 2, 7; Radbaz, I, 383 (on four kinds of women's property). For a discussion on the evolution of legislation on this matter, see: Y. Cohen, pp. 150-153; Elon, *Jewish Law*, pp. 466-470 and note 117 there; Rozen-Zvi, pp. 129-131.

[38] See Y. Cohen, pp. 140-141; Assaf, "Regulations," p. 84; Cf: Shahar, *Fourth Estate*, p. 91 (second marriages), p. 131 (noblewomen), p. 163 (townswomen), p. 211 (peasant women).

spread among the inhabitants of the country. Even we who have
come from other countries have adopted this custom [...] The law of
the land, based on the Damascus custom, and on conditions written
into the *ketubah* [...] is acceptable to us also [...] especially since this
custom conforms with the custom of the Rambam."[39]

The above is all the more unusual in view of the unchallenged
supremacy of the Spanish community in Palestine in the 16th century.
Indeed, by the end of the century, their numerical, economic and
cultural ascendancy over the other communities was undisputed. Not
only was the indigenous Musta'rab community of Palestine assimi-
lated into the Spanish community, the Spanish leadership repre-
sented the entire Jewish population before the Ottoman authorities.[40]
Therefore, it is all the more surprising that the Spanish Jews were
inclined to accept the local custom in matters of economic import,
such as inheritance and succession!

The above notwithstanding, the transition from the Toledo to the
Damascus regulation was not smooth. Spearheading opposition to
the changeover was a group of Spanish sages in Safed. R. Joseph
Caro wrote: "The rule is that the Spanish Jews of Galilee are bound
by the customs they followed in Spain [...] until such time as another
custom, laid down by the Gaonim, has taken root *among them all* [...]
in which case, from that time on, they follow that custom in respect
of inheritance. However, those who married before the new custom
was accepted are subject to the provisions of the first [Toledo] cus-
tom."[41]

For years the two regulations co-existed. This situation of indeci-
sion was brought to an end by an epidemic that swept through the
city in the middle of the century. The plethora of inheritance prob-
lems it occasioned forced the rabbis to lay down a clear and uniform
ruling. The result was the *"Safed Custom"* or *"Palestine Custom"* – a
hybrid of the Damascus and Toledo regulations. It stated that if a
woman died childless, one third of her dowry would go to her rela-
tives and two-thirds to her husband. *Nikhsei melog* would be divided

[39] Mabit, I, 28 (his responsum is quoted in Caro's Responsa *Beit Yosef*, 20 [= Laws
of *Ketubot*, 2]); See also: Mabit, III, 56; Ashkenazi, 16; Assaf, "Regulations," p. 90;
Idem, "Family," p. 174. On the Rambam's opinion concerning inheritance condi-
tions, see: *Marital Laws*, XXIII, 5.

[40] Rozen, "Musta'rabs"; David, "Ashkenazic Community," p. 334.

[41] Caro, Responsa *Beit Yosef*, 20 [=Laws of *Ketubot*, 2]. This responsum was en-
dorsed by five rabbis.

equally between them, while all bridal and other gifts not included in the *ketubah* would be inherited by the husband. If the woman had children, the husband would inherit everything, according to biblical law, and as laid down by the Damascus regulation.[42]

The new "*Safed Custom*" did not entirely usurp the Damascus regulation, but existed alongside it.[43] In fact, it was not popular among certain sectors of the community, which claimed that it was less favorable to the husband than the local Damascus regulation. This led to the enactment in 1569 of "*the amended Palestine custom*" by the Spanish sages of Safed. The new regulation stipulated that if a woman died childless, her relatives would inherit two fifths, and her husband three-fifths, of her dowry as well as all the bridal gifts he had given his wife. The new regulation made no reference to *nikhsei melog*, indicating that the husband was probably the sole beneficiary, as specified in biblical law, and in the spirit of the Damascus regulation.[44] As the years went by, these regulations supplanted the original Damascus regulation, so much so that by 1595, the latter was already referred to in Safed as obsolete.[45]

Far from simplifying matters, the amended Safed regulation actually complicated matters, and made the rabbis' work harder. In particular, doubts arose as to whether the Damascus custom assumed that the husband was the sole beneficiary of *nikhsei melog* or not. In order to clarify the matter, R. Samuel Vital, R. Hayyim Vital's son, decided – in the middle of the 17th century – to conduct his own research into the issue. After summarizing all the written and oral information he had gathered concerning the Damascus custom, he confirmed that according to the Damascus regulation, the woman's relatives were co-beneficiaries with the husband of her dowry, that is clothes, gifts, and *nikhsei tzon barzel* (wife's estate held by husband which he must restore if she dies or he divorce her). All *nikhsei melog*, and all property not included in the *ketubah*, were inherited by the

[42] Mabit, I, 27; Alshekh, between 27 and 28 (not specified). A similar, though not identical version can be found in the collection of deeds recorded by R. Isaac Tzabah in Jerusalem in the second half of the 16th century, and which were copied by his disciple Judah Mor'ali in 1635. There it states that according to the 'Spanish *ketubah*' – the heirs receive one third and the husband two thirds of the wife's estate, including *nikhsei melog* (MS Jerusalem, *Sefer Tikkun Soferim*, p. 2b).

[43] Mabit, II, 128. See also Maharitatz, 173.

[44] Alshekh, end of additions to 27; Vital Samuel, end of 43.

[45] Vital Samuel, 43.

husband according to biblical law, and did not belong to the category of "thine ox shall be slain before thine eyes."[46]

Some objected that this interpretation of the Damascus regulation was over-generous to the husband. Therefore – as borne out by R. Isaac Tzabah's *Sefer ha-Shetarot* [Book of Deeds] – the Musta'rabs of Jerusalem ruled that if a woman died without issue, her relatives would inherit her estate along with the husband, including *nikhsei melog*.[47] At some point the Radbaz introduced a similar amendment into the *ketubot* of Egypt.[48] However, from his and other responsa, it is clear that in most cases the *ketubot* contained the phrase 'according to the Damascus custom' without further specification.[49]

Thus, as well as the original Damascus and Toledo regulations and the 'amended Palestine custom' adopted in Safed, an amended regulation was also adopted in Jerusalem and Egypt, at least in the times of the Radbaz. This proliferation of customs only confused matters further in the generations following the Radbaz. Some decisors argued 'that the Damascus and Toledo customs were identical, or differed only in detail."[50] The Radbaz, too, in one of his responsa, used the two terms interchangeably: "The husband is the woman's heir, by [biblical] law whereas her relatives inherit by virtue of the *Damascus regulation, that is, the Toledo regulation*. The main purport of the regulation is [...] that what remains of the *dowry* shall be divided between the father's heirs and the husband."[51] In the same vein, Ashtor wrote that on an issue as important as inheritance law, the Musta'rabs bowed to the Spanish custom, and that the amended version of the regulation introduced by the Radbaz "was none other than the famous Toledo regulation of the Spanish communities."[52]

However, as already stated, it was local custom that prevailed in this particular area, and misunderstandings were usually due to subsequent amendments introduced in an attempt to find a compromise

[46] Ibid, excerpts from the responsa of the Safed sages through the generations. Ibid, 74.

[47] MS Jerusalem, *Sefer Tikkun Soferim*, p. 2b. See also ibid, no.1, form for *ketubah* deed which states: "The succession shall conform to the Jerusalem regulations."

[48] Radbaz, II, 605.

[49] Ibid, 597. See also: ibid, IV, 1280, 1336; Ashkenazi, 10 (=16), 12; Castro, *Ohalei Ya'aqov*, 110; Castro, *'Erekh ha-Lehem, Even ha-'Ezer*, 91, p. 66b ff.

[50] Mabit, I, 89; David, "Responsum," p. 582.

[51] Radbaz, III, 955.

[52] Ashtor, II, pp. 498-499.

formula. Therefore, when differences arose between heirs, it was necessary to examine the specific wording of the *ketubah* and to interpret what was meant by the vague term 'according to the Damascus custom.'

In practice, there was a fundamental difference between the two customs, as the chief rabbi of Cairo, R. Raphael Aaron Ben Shimon pointed out at the beginning of this century. "According to the Toledo custom, the husband is never sole beneficiary, but always shares his wife's estate, either with their children, or with her relatives. According to the Damascus custom, however, if there are children, we invoke the Mosaic code, and the husband is sole beneficiary, and his children and her relatives have no claim. This too is the custom of the holy city of Jerusalem [...] Egypt too, follows the Damascus custom."[53]

The way the dowry was evaluated also depended on the type of custom followed. Again, the Musta'rab custom differed from the Spanish custom. The Musta'rab custom was to specify all items, whether 'immediate' [*muqdam*] or 'deferred' [*me'uhar*], in the *ketubah*.[54] Since the Spanish custom, on the other hand, was to apportion the *entire* estate between the various heirs, there was no need to specify every object in the *ketubah*.[55]

A case brought before R. Yom Tov Zahalon sheds light on problems that arose as a result of cross-cultural marriages: Reuben, a Musta'rab, married a woman in a place which observed the Spanish custom. After she died childless, her relatives argued that they had a share in the '*joyas*' (jewels in Spanish) given to her as a bridal gift ['*muqdam*'], since according to the Musta'rab custom, bridal gifts were part of the dowry, even if not explicitly stated. Reuben for his part argued that despite the fact that he was a Musta'rab, "he had mar-

[53] Ben Shimon, *Nahar*, p. 207a-b. Although at the start of his discussion on the inheritance customs, Rabbi Ben Shimon writes "the source of these inheritance customs is the Toledo regulation, alias the Damascus custom," (ibid, 202b), he himself later clarifies the differences between the two.

[54] The "immediate" part of the *ketubah* increment was handed to the wife during the wedding ceremony, while the "deferred" part was paid only in cases of widowhood or divorce. See Friedman, "Division"; idem, *Jewish Marriage*, pp. 269-272, 278-279. On the possibility of a Muslim influence on this custom see ibid, pp. 283-284.

[55] See *ketubah* texts in R. Isaac Tzabah's Book of Deeds (MS Jerusalem, *Sefer Tikkun Soferim*, p. 2b)

ried according to local [Spanish] custom, and that therefore the '*joyas*' had not been included in the inventory [*shumah*] of her dowry." R. Yom Tov Zahalon ruled in Reuben's favor: Unless otherwise stated in the *ketubah*, the local custom took precedence. "[...] Since he married without specifying [any particular custom or condition], one must follow the local custom. And since according to the local custom *joyas* are not included in the dowry, it is to be assumed he accepted this custom. If one argues there are two local customs in this town – the Spanish and Musta'rab customs – as in my town Safed [...], those who follow the Musta'rab custom must specify this in the *ketubah*."[56] R. Joseph Caro gave a similar ruling for Syria and Palestine, where the Damascus custom prevailed. "Since the Musta'rabs have adopted the Damascus custom, any marriage is automatically bound by the Damascus custom, even if not explicitly stated in the *ketubah*."[57] In order to prevent confusion, however, R. Yom Tov Zahalon ordained that the phrase "according to the Damascus custom" be included in the *ketubah*. Failing this, biblical law, whereby the husband inherited everything, obtained.[58] The Radbaz ruled similarly for Egypt.[59]

Another problem was that of missing items. Were the heirs entitled to demand that the husband reimburse them for objects specified in the *ketubah* that had since disappeared, or were destroyed? On this issue, the sages were unanimous: Both according to the Toledo and Damascus customs, if the husband sold or pawned dowry items for his own personal needs or for business purposes, he had to reimburse the heirs. If, on the other hand, an item had simply got lost or destroyed in the natural way of things, he was not required to reimburse them.[60] As to the husband's responsibility for loss or destruction of *nikhsei tzon barzel*, this was vis-à-vis his wife, not her heirs, since the woman's claim was based on biblical law, while the heirs' claim was based on a mere regulation. Therefore, the heirs could not claim missing items.[61]

[56] Maharitatz, 173.
[57] Caro, Responsa *Beit Yosef*, 31 (=Laws of *Ketubot*, 7).
[58] Maharitatz, II, 273.
[59] Radbaz, II, 605; III, 932. Nevertheless, the Radbaz admits that had the incident under discussion taken place in Damascus instead of Egypt, local custom (the Damascus custom), would have applied.
[60] Radbaz, I, 397; IV, 1336.
[61] David, "Responsum"; Alshekh, 28; Castro, *Ohalei Ya'aqov*, 110; Mabit, I, 89.

The Damascus and Toledo regulations and other similar regulations testify to the fact that marriage in the 16th-century Levant was primarily an economic institution. Within this institution, the wife was expected to bear children, and if she succeeded in doing so, it was to her husband's advantage. Usually, the marriage agreement was drawn up between the families, not the couple. Naturally, each family was anxious to safeguard its own economic interests. In Palestine, where the Jewish population was poor and had a lower standard of living than in Spain, it was easier to preserve the spirit of the original *halakha*. Poverty precluded claims by the woman's family. Since most women did not own property, the Damascus regulation referred to the division of *nikhsei tzon barzel* only. In the rare cases where women did own property – the regulations were based on biblical law.[62] In Spain, as stated above, Jewish society was influenced by the ambient Christian society, which stipulated that the husband was not the sole heir, and that the real estate left by the deceased was inherited by her relatives.

The Spanish refugees, brought up on the Toledo custom which favored the woman's family, gradually switched to the Damascus (Palestine) regulation, or else adapted the Toledo regulation, as the Spanish Jews had done in Safed. This may have been because the Damascus custom fulfilled a social need. At a time of migration and expulsion, when families were disintegrating, and societal frameworks were collapsing, the Damascus regulation helped reassert paternal authority. Control of his wife's inheritance, or at least of the major part of her inheritance, gave the paterfamilias control over his children, not only as the one in whom moral and traditional authority was vested, but also as the one who held the purse strings.[63]

Just as the bride had no part in the marriage settlement, she often had little say in how to spend her dowry. A woman's right to donate, bequeath, renounce, or sell an asset from her estate is discussed in the literature, alongside the husband's right to inherit. Sometimes, potential heirs argued that she was not entitled to expropriate the inheritance which, according to the regulations, would one day be theirs. An explicit condition was even introduced into the Toledo regulation *forbidding a woman to give her relatives' share to her husband in her lifetime.*

[62] Vital Samuel, 43, p. 106; Radbaz, I, 316 (= Ashkenazi, 11); Ashkenazi, 12.

[63] On the willingness of the Spanish refugees to adopt Palestinian customs they approved of, see: Rozen, "Musta'rabs," pp. 92-93.

Such a gift would be legally invalid "for the legislators were anxious to spare the father the pain of 'Thine ox shall be slain before thine eyes, and thou shalt not eat thereof.'"[64] They also stipulated that the condition applied even if not specified in the *ketubah*, or even if the woman wished to give or sell her share to someone other than her husband.

Paradoxically it was the more 'conservative' Palestine regulation favoring the husband that allowed women more independence in decisions affecting their dowries. The Mabit testifies with respect to the Safed custom: "According to our regulations, such as the *Damascus and Palestine [Eretz Israel] customs, a woman is permitted to donate her relatives' share to her husband.*"[65] Elsewhere, he stated: "Our regulations do not carry the power of excommunication [as the Toledo regulation does] [...] and anyone is entitled to make a condition [in the *ketubah*] that contravenes the regulation [...] A woman can draw up a will that contravenes the regulation, just as they [the parties], at the time of the wedding, can make a condition that contravenes the regulation."[66]

Indeed, a Jerusalem *ketubah* stipulating "that he [the husband] will not try to persuade or force her to waive her *ketubah* either wholly or in part, nor any of the conditions thereof" (based on the Toledo regulation) also states that: "the inheritance shall conform to the Jerusalem regulation *or as stipulated between the parties.*"[67]

In a similar vein, a Jerusalem regulation dating back to 1509 specifies various options: "The condition introduced into [*ketubot*] in this country [...] is a function of *whether* [it was stated that] the inheritance is based on biblical law, namely: the husband inherits from the wife,

[64] Radbaz, I, 397. See also ibid, IV, 1336; Maharit, II, *Hoshen Mishpat*, 56; Ibid, *Even ha-'Ezer*, 44; Caro, Responsa *Beit Yosef*, 27 (= Laws of *Ketubot*, 4); Galante, Responsa, 49; Alshekh, 15; Vital Samuel, 73; Ashkenazi, 10 (= 16). For a comprehensive discussion of a woman's right to waive her rights according to ancient Spanish and North African regulations, see Amar, "Waiver"; On the Toledo regulation, see ibid, pp. 24-26; On Greek communities, see: Bornstein-Makovetzky, "Arta," pp. 147-149. Cf. Shahar, *Fourth Estate*, pp. 87-88.

[65] Mabit, III, 2. The term 'Palestinian custom' refers to the original Safed regulation.

[66] Ibid, II, 128 (R. Isaac Arha and R. Jacob Berab the Second agreed with this ruling). See also ibid, I, 334.

[67] MS Jerusalem, *Sefer Tikkun Soferim*, I, pp. 14b-16a. 'Jerusalem custom' refers to the Damascus custom. The Ralbah, in deference to Jerusalem, renamed the 'Damascus custom' the 'Jerusalem custom' (Mizrahi Moses, I, 33; MS Jerusalem, *Zera' Anashim*, p. 349a). See also MS Jerusalem, *Sefer Tikkun Soferim*, p. 2b.

or on local custom, *or on an agreement between the two parties.*[68] Obviously the customs of Safed and Jerusalem differed on this issue. In any case, in Jerusalem it was possible to add or omit the condition at will.

The conclusion is clear: The *ketubot* based on the Damascus or Palestine custom were more flexible than those based on the Toledo custom, and allowed women some control over how they disposed of their dowries. The condition concerning the woman's right to waive her *ketubah* was optional. Some included it in the *ketubah*, while others did not. On the other hand, according to the Toledo custom, a woman had no right to dispose of her dowry and property as she saw fit. Therefore, a condition restricting this right, under penalty of excommunication, was an integral part of all *ketubot* based on the Toledo custom.

Widow's maintenance rights and payment of the ketubah

The financial arrangements preceding the wedding, including the transfer of the bride's property to her husband's control, were designed to maintain marital harmony and preserve the family unit. A married woman's rights over her property were so restricted that in practice "marriage rendered even the richest woman poor, restricted her rights to ownership, and made her totally dependent on her husband economically."[69] Since in Jewish law a woman does not automatically inherit her husband's estate, the *ketubah* ensured that she was provided for in the case of widowhood (or divorce).[70] In addition, the sages introduced a maintenance clause in the *ketubah*: "You will live off my estate as long as you remain a widow in my house."[71] This effectively allowed a widow a choice: (a) She could live off her deceased husband's estate, and be supported by his heirs; or (b) she could claim her *ketubah* from the heirs, thereby forfeiting her right to maintenance.

[68] Badhab, 96. See also Radbaz, I, 474; II, 604, 605, 612; Caro, *Avkat Rokhel*, 91; Ashkenazi, 10; Assaf, "Regulations," pp. 89-90.

[69] Rosen-Zvi, p. 131. See also ibid, pp. 121-124, and *passim*.

[70] Epstein, *Marriage Contract*; Friedman, *Jewish Marriage*, pp. 1-48; Schereschewsky, pp. 96-104; Rozen-Zvi, pp. 320-324; Schipansky, *Takkanot*, I, pp. 290-295. For general background and references to widows' rights, see 'widow,' Talmudic Encyclopedia, II (1976), pp. 16-20; Falk, "Inheritance".

[71] Mishnah, *Ketubot*, IV, 12; Caro, *Shulhan 'Arukh, Even ha-'Ezer, Ketubot*, 93: 3, 5.

The first option, designed to ensure that the widow was suitably provided for, was not very popular with the heirs. It represented a financial burden that sometimes lasted for years and in some cases the heirs ended up paying even more than the amount stipulated in the *ketubah.*

The *Mishnah* already brings a dispute as to whether the heirs may pay the widow her *ketubah* so as to escape the burden of maintaining her for an unspecified number of years. Whereas maintenance was the rule in Jerusalem and the Galilee, in Judea a condition was introduced into the *ketubah*, granting the heirs discretion as to how long they would support the widow. This effectively meant that in Judea, the option of *ketubah* or maintenance was the prerogative of the heirs, not the widow. Although the decisors came down in favor of the Jerusalem and Galilee custom, in many places the Judean custom was followed.[72]

Even the *Shulhan 'Arukh* is not unequivocal on this issue. On the one hand, it states: "A widow lives off her late husband's estate as long as she remains a widow, even if the *ketubah* failed to specify this, or even if [her late husband] forbade this prior to his death. The heirs cannot pay her *ketubah* [money] and thereby shake off their responsibility to provide for her, but must provide for her whether they want to or not, as long as she does not claim her *ketubah*." However, the *Shulhan 'Arukh* then goes on to qualify this by saying: "Unless there is an express condition to the contrary, or local custom mandates otherwise."[73]

The clause 'unless local custom mandates otherwise' provided an opening for abuse, and weakened the widow's position to the point where she sometimes had to resort to litigation in order to protect her rights. Moreover, a widow who chose to collect her *ketubah* had to testify under oath that she had not previously taken or received objects or money against payment of the *ketubah* from her husband.[74]

[72] Mishnah, ibid; *Ketubot*, 52b, 54a; 103a; Rambam, *Marital Laws*, XVIII, 1; Caro, *Shulhan 'Arukh, Even ha-'Ezer, Ketubot*, 93: 3. Ribash, 117; See 13th-century Toledo and Molina Regulations concerning the division of the deceased's estate (Rosh, Rule 55; see also Rule 50: 9-10); the 14th-century Algiers regulation (Tashbetz, II, 292, Regulation 7); See also Assaf, "Regulations," p. 86, note 7; Elon, *Jewish Law*, pp. 470-471; Friedman, *Jewish Marriage*, pp. 427-434.

[73] Caro, *Shulhan 'Arukh, Even ha-'Ezer, Ketubot*, 93: 3.

[74] *Ketubot*, 87a.

The burden of proof was on the widow, and she had to testify to her innocence before the court in a public appearance that was often humiliating. No wonder, then, that some women preferred to renounce their rights than to suffer such embarrassment.

There were exceptions to the rule. In some communities, widows were not required to testify under oath. In others, the husband (in his lifetime) or heirs waived the requirement. Sometimes, a condition in the *ketubah* exempted the widow from having to take such an oath.[75] On the other hand, an oath was sometimes considered inadequate by potential heirs, and widows were required to bring proof that any money or property they owned belonged to them and not to their husbands. For example, the heirs of Rabbi Yehiel Hazan accused his widow, Dulce, of using her late husband's property to earn a tidy profit that was not rightfully hers. R. Joseph Ibn Tzayyah found her guilty, stating in his summing up that the woman was not to be trusted since her evidence cannot be relied on ("we do not live off her mouth").[76]

If a woman chose not to testify under oath, but opted for maintenance instead, her relatives or any children of hers from another husband could lose their entitlement to her *ketubah*. The same was true if she died before she had a chance to testify under oath. The complexity of this issue is apparent in a question put to R. Yom Tov Zahalon: "Reuben's widow, fearing that she might die unexpectedly before she had a chance to take the widow's oath, wished to take the oath without further delay. It was not that she wished to claim her *ketubah*, she said. She simply wished to take the oath before she died, and thereby to ensure that her heirs would not lose their entitlement to her *ketubah*. She also wanted the oath to be kept secret from her husband's heirs [...] She therefore asked if it were possible for her to take the oath without her husbands' heirs being present, and whether such an oath would involve forfeiture of her [right to] mainte-

[75] "No man wishes his wife to be humiliated in court" – *Gittin*, 46a. Rambam, *Marital Laws*, XVI, 4; XVI, 20; Caro, *Shulhan 'Arukh, Even ha-'Ezer, Ketubot*, 98; See also Pinto, 67; Radbaz, VI, 2059; Mabit, II, 89, 176; MS Jerusalem, Tzayyah, 379, p. 70a; 536, p. 266b-267a. See also Friedman, *Jewish Marriage*, pp. 262-267. For a condition in an Egyptian *ketubah* dating back to 1492, see Ashtor, III, Document 66, pp. 119-120. For a photocopy of a document from Jerusalem signed by members of the court, confirming that the widow Estrella had testified before them under oath, see Benayahu, "Sources," p. 377.

[76] MS Jerusalem, Tzayyah, 469, p. 150b.

nance."[77] The Maharitatz ruled that the husband's heirs need not be present, and that the widow did not forfeit her right to maintenance.

As a rule, a widow who claimed her *ketubah* forfeited her right to maintenance.[78] This was not the case, however, if she claimed only 'part of her *ketubah*,' i.e., her dowry only, and not the increments: "If she claims payment of her dowry, she does not lose her maintenance, since the main part ['*iqar*] of the *ketubah* and the increments are intact. If she claims the main part and the increments, she forfeits her right to maintenance, even if her dowry is one hundred coins [*maneh*]."[79] In Egypt, the law was revised in the course of time in favor of the heirs. Most decisors in Egypt claimed that as far as maintenance was concerned, the dowry was considered part of the *ketubah*. The Radbaz also stated that according to the prevailing custom, the orphans had a prior claim, and the widow lost her right to maintenance, even if she claimed her dowry only, without the increments. "I am almost certain this custom originated in Spain," he added.[80] In this respect, the Egyptian sages disagreed with the Rambam, who ruled that if the heirs had reached their majority, "the dowry was not considered part of the *ketubah*" and the woman could collect "part of her *ketubah*" without forfeiting her maintenance. However if the orphans were still minors, the rule that "the property of orphans is left intact" applied, and the widow could not claim even part of her *ketubah*, unless it was proved that the property was liable to depreciate in value, or in case she wished to remarry ('*mishum hinna*').[81] The Radbaz himself retracted his ruling and endorsed a woman's

[77] Maharitatz, New Responsa, 55. See Rambam, *Marital Laws*, XVI, 4, 12; Caro, *Shulhan 'Arukh, Even ha-'Ezer, Ketubot*, 96:1-2; 98:3. The following are examples of rabbinical rulings in the 16th century: Radbaz, I, 501, 523; III, 896, 920, 935; IV, 1260, 1294; Maharitatz, 26, 61; Maharitatz, New Responsa, II, 105, 164, 165; Caro, *Avkat Rokhel*, 103; Gavizon, II, 40; Vital Samuel, 25; Mabit, I, 69; II, 143; Alashqar, 33, 43; Ralbah, 59. An oath was required only in respect of the *ketubah*, and not other property items belonging to the woman which were hers by right. See: Radbaz, IV, 1294; VI, 2242; Pinto, 105.

[78] There were exceptions: If a woman claimed her *ketubah* under duress, or because she had been deceived, or not been paid maintenance, etc. See Caro, *Shulhan 'Arukh, Even ha-'Ezer, Ketubot*, 93:5.

[79] Caro, *Shulhan 'Arukh, Even ha-'Ezer, Ketubot*, 93 (see also Kerlin, pp. 135-136, and ibid, notes 12, 18-19); Rambam, *Marital Laws*, XVIII, 1.

[80] Radbaz, I, 92.

[81] *Ketubot*, 84a (see Rashi and *Tosafot* there); 87a; *Gittin*, 34b; Rambam, *Marital Laws*, 16a; Ashkenazi, 7-9; Castro, *Ohalei Ya'aqov*, 25. On the "*mishum hinna*" regulation and its various interpretations, see Schipansky, *Takkanot*, II, pp. 231-235.

claim to her *ketubah* in order to facilitate her remarriage. In the final analysis, the heirs stood to gain if a widow opted for immediate payment of the *ketubah*. The Radbaz also favored this option: Far better that the heirs pay the widow her *ketubah*, especially when this is not excessive, than be responsible for her maintenance indefinitely. For unless she has some money to her name, she will never be able to remarry, and will be an everlasting burden on them.[82]

In Safed, when R. Moses Berab's widow renounced her dowry and increment, but not the main portion of her *ketubah*, the heir tried – unsuccessfully – to evade paying maintenance on the grounds that she had renounced all her entitlement. As R. Yom Tov Zahalon stated: "Since she is still in possession of her *ketubah* deed, which is her main *ketubah*, he is obliged to pay her maintenance. The widow's claim is upheld: For she renounced [at her husband's insistence] only the dowry and increment he had promised her, but not the main part of the *ketubah*. The proof is that she is still in possession of the *ketubah* deed."[83]

We see that the Egyptian custom of trying to evade payment of maintenance was not accepted in Safed, where the dowry and increment were not considered an integral part of the *ketubah*, for the purposes of payment of maintenance (forfeiture of dowry or increment did not imply forfeiture of the main *ketubah*). We may conclude, therefore, that in Safed, the sages were more concerned for the widow, while in Egypt, the sages were more concerned for the heirs.[84]

A widow had a lifelong entitlement to her *ketubah*, even if she remarried. However, a widow who had lost the *ketubah* deed could not claim her *ketubah* money, or even maintenance. In such cases, only circuitous methods could alleviate her plight.[85]

In the interests of expedience [*tikkun 'olam*], maintenance and in-

[82] Radbaz, IV, 1142. See also: I, 92; II, 630.

[83] Maharitatz, 172.

[84] The sages of Safed protected widows against exploitation in other cases too. See Mabit, I, 312; III, 134; Galante, Responsa, 121.

[85] Rambam, *Marital Laws*, XVI, 21-24, where he writes: "Where the custom is not to specify in the *ketubah* but to rely on a *tenai bet din* [*takkanah* of the early sages] – she may collect her main *ketubah*, even if the *ketubah* deed is not in her possession [...] Payment of the increment, however, is contingent on clear-cut evidence [production of the *ketubah* deed]." Caro, *Shulhan 'Arukh, Even ha-'Ezer, Ketubot*, 100, 101; Radbaz, VI, 2288; Maharitatz, 278.

heritance laws applied only after all other debts had been defrayed, especially since the obligation to support a widow was not clear-cut, but depended on a number of variables (her life span, whether she remarried or not). As a result, widows frequently decided to 'stake a prior claim' in their husband's estate, in order to ensure that the property would not be carved up between the various creditors and heirs, reducing them "to chasing after the heirs whenever they needed money."[86] Long deliberations were held concerning the validity of such a procedure and concerning the widow's priority over other creditors. Rulings were by no means consistent.[87] In once case, for example, R. Josiah Pinto ruled that even if the widow's 'staking of a claim' [tfisah] was performed in accordance with halakha, the creditors still had to be paid off first, and only then could the remainder be used to pay her maintenance. In another case, however, fearing that the widow might resort to a Muslim court – which would have upheld her claim – he ruled that the widow's claim took precedence.[88]

Note that any clothes or jewelry the husband bought his wife after their marriage "were listed in the ketubah and her entitlement to them

[86] Maharitatz, New Responsa, I, 95. 'Staking a claim' [tfisah] is a legal act equivalent to the right of possession. It must be performed in accordance with the laws of acquisition (acquisition by deed, money, pulling, fencing, barter, etc.) It is valid only in respect of chattels that have been freed from lien or debt (Caro, Shulhan 'Arukh, Hoshen Mishpat, Laws of Buying and Selling; Gulack, Origins, I, pp. 102 ff; III, pp. 126-127). The fear that the heirs might indulge in dilatory tactics is discussed in Radbaz, VI, 2059. See also: Pinto, 65; Castro, Ohalei Ya'aqov, 76; Mabit, III, 184, 202.

[87] Ketubot, 86a and Tosafot there; Rambam, Marital Laws, XVII; Caro, Shulhan 'Arukh, Even ha-'Ezer, Ketubot, 102; Kerlin, pp. 143-144; Caro, Responsa Beit Yosef, 29 (=Laws of Ketubot, continuation of 5); Mabit, I, 149, 265, 295; II, 34; III, 55, 184, 185; Radbaz, I, 504; II, 601, 664, 758; III, 1053; IV, 1143; Pinto, 64; Maharitatz, 30, 213, 266; Maharitatz, New Responsa, I, 11; Maharit, I, 101; Castro, Ohalei Ya'aqov, 75 (the same subject is discussed in R. Abraham Monzon's responsa, MS London, Montefiore, pp. 53a-70b). A regulation, apparently introduced during the Gaonic period, was designed to protect the rights of creditors to collect certain debts, and determined that these debts could be collected not only from the deceased's landed estate, but also from movable chattels held by the heirs. Since the ketubah was also considered a debt, this regulation worked in the woman's favor when the time came for her to redeem her ketubah money. Indeed, the decisors had this in mind when they introduced the regulation, its purpose being "not to leave the creditor defenseless, and to give legal validity to the ketubah" (Hemdah Genuzah, 65). See also: Rambam, Marital Laws, XVII, 5; Caro, Shulhan 'Arukh, Even ha-'Ezer, Ketubot, 93; 100: 1); Tykocinski, Chapter 2; Elon, Jewish Law, pp. 531-533. For heirs' claims, see MS Jerusalem, Tzayyah, 329, p. 19.

[88] Pinto, 73, 65. See also Castro, Ohalei Ya'aqov, 76.

took precedence over other claims [...] Indeed, the law regarding such property is akin to the law regarding mortmain [*nikhsei tzon barzel*] [...] This is a sound custom, since it encourages a man to give freely to his wife, and buy her expensive clothes and jewelry, knowing that when she comes to claim her *ketubah*, she takes precedence over other creditors in respect of these gifts [...] The law of country similarly states that even if a man owes the government money, the debt cannot be collected from the woman's [widow's] clothes or jewelry."[89]

It was not uncommon for widows to conceal objects – rather than 'stake a claim' in them – over and above what was owed them in the *ketubah*. In order to prevent this, it was customary for the court representatives to draw up a detailed inventory of the deceased's estate as soon as possible after his demise. For example, in a *ketubah* bill of payment from Jerusalem, a widow declared that she had not taken possession of anything other than "items inventoried by the court assessors, in the amount of so and so many *groshos* (silver coins)."[90] Despite these legal measures, cases of fraud were not unknown.[91]

During the first half of the 17th century, the Safed sages realized that often, after the *ketubah* had been paid in full, not much remained for the rightful heirs according to the biblical law of inheritance. To rectify this situation, the following regulation was passed in 1637:

> Henceforth, whenever a widow who has sons from her husband wishes to claim her *ketubah* […] the deceased's estate, irrespective of size, shall be shared between the widow and the children, until the woman is paid the sum of her *ketubah* in full. If, by this method, the widow's share exceeds the amount specified in the *ketubah*, she shall receive only the amount specified in the *ketubah*, and the remainder, however big or small, shall be divided among the heirs, her sons.[92]

This regulation, which incidentally overrides *halakha*,[93] shows a clear bias toward the heirs. The widow loses out on both counts: If her

[89] Radbaz, I, 383. See also Galante, Responsa, 42. According to Muslim law, the woman's private property belonged to her and could not be confiscated to pay her husband's debts; see Jennings, "Kayseri," p. 66, and note 14 there.

[90] See MS Jerusalem, *Sefer Tikkun Soferim*, 7, p. 19b.

[91] Alshekh, 99, 135; Mabit, III, 55, 135; Radbaz, III, 921.

[92] Diwan Yehudah, 22. See also Molina regulation (Assaf, "Regulations," p. 84).

[93] According to Jewish law, a widow collects her *ketubah* from her husband's estate, even if the amount of the *ketubah* equals the entire estate (see Rosh, Rule 55:7; Elon, *Jewish Law*, p. 682).

husband is poor, she receives *less* than her *ketubah*. But if he is rich, she is not entitled to receive more than her *ketubah*.

Men who loved their wives and wished to leave them more than the amount specified in the *ketubah* were forced to resort to legal subterfuges, such as gifts, wills, or *ketubah* conditions.[94] If the will or *ketubah* was not particularly favorable to the widow, she would sometimes try to circumvent the law by resorting to a Muslim court. According to Muslim law, a widow with children was entitled to one eighth of her husband's estate. A childless widow, on the other hand, was entitled to one quarter of her husband's estate, while the remaining three-quarters went to the public coffers.[95]

Assessment of the Ketubah

Another issue raised in the debates concerning a woman's 'inheritance' is the assessment of the *ketubah*. Here again, the customs varied between the various countries (Palestine, Egypt, and Syria) and communities (Spanish versus Musta'rab). This issue was particularly important in times of inflation, when there was a large discrepancy between the value of the *ketubah* at the time of the marriage, and its value on the date of payment.

1. *Assessment of objects*

The Musta'rabs in Syria and Palestine specified the value of each object in the *ketubah* deed, so that when the time came to pay up, the value of still usable objects could be deducted from the total sum of the *ketubah*. The Spanish Jews, on the other hand, did not specify the value of every object in the *ketubah*, but rather recorded an overall sum. On the rare occasions when they did specify the value of specific items, this was recorded in a separate ledger.[96]

[94] On ways husbands circumvented *halakha* in order to provide for their wives, see Chapter 4, "Married Life."

[95] Goitein, I*ntroduction*, p. 148; Pearl, p. 150. See: Cohen, *Jerusalem*, pp. 146, 148; Cohen-Pikali, Documents 62-63, pp. 63-64; Document 418, pp.366-367; Document 430, pp. 375-376.

[96] Mabit, I, 28; III, 184; Maharit, I, 75; II, *Hoshen Mishpat*, 8; Caro, Responsa *Beit Yosef*, 18 (= Laws of *Ketubot*, 2); Pinto, 104; Maharitatz, 173; Friedman, *Jewish Marriage*, pp. 294-295.

Two basic problems arose in connection with the assessment of objects. First, how to assess items that had deteriorated or depreciated over the years and second, how to assess items whose value had been artificially inflated at the time of the marriage in order to enhance the prestige of the parties involved and "to impress the public."[97]

The Musta'rab custom was to the woman's detriment in both cases. Usable objects were assessed at their value at the time of the marriage, not at their real value, and took no account of deterioration or depreciation. For example, the Mabit, dealing with what he considered the 'excessive' claims of R. Abraham Hamon's widow,[98] ruled that as long as the objects 'still fulfilled their purpose' they were to be assessed according to their original value "even if they are not worth half as much now."[99] The Mabit claimed that this custom had also been adopted by the Spanish Jews in the Galilee,[100] but this claim was sharply contested by sages in Safed and Damascus, headed by R. Joseph Caro:

> Our *ketubot* are promissory notes specifying *amounts* that the wife is entitled to when she is widowed or divorced. This is the reason why we [Spanish Jews], unlike the indigenous population, do not specify the value of each and every object [...] True, the ledger given to the groom specifies individual items, but this is only to ensure that the groom receives every item due him [...] It is not meant to be used at some future date to calculate the woman's dowry if she is widowed. For if this were the case, the inventory should have been included in the *ketubah*, according to the local custom. Moreover, whereas the *ketubah* is held until such time as she is widowed, the ledger is discarded once the objects are delivered to his [the husband's] house. It would be hard to find even one in a thousand who keeps the ledger, unless by accident.

[97] Rambam, *Marital Laws*, XXIII, 11. According to the Mabit, it was the Palestine custom "when assessing the *ketubah* items, to add on about a quarter of their worth" (Mabit, I, 28; See also there, 119). In Egypt (Radbaz, I, 383), Damascus (Mabit, I, 267) and Fez (Ankawa, 23-24) it was the custom to add on another third. In Rhodes, it was the custom to double their worth (Berab, 45). See also: Goitein, Society, III, p. 127; Friedman, Polygyny, I, 296-297.

[98] The Hamon family was a wealthy, prestigious Istanbuli family, whose scions held various positions in the Sultan's court and in Jewish society. The Abraham Hamon mentioned here, however, belonged to the Safed branch of the family: He was the friend, and possibly also the brother-in-law, of R. Israel Najara (Benayahu, "Najara," pp. 205-206). A man of this name is mentioned in a letter apparently sent from Safed to Egypt (see MS Cambridge, TS NS 32, p. 53b).

[99] Mabit, III, 184. See also his responsum, I, 119.

[100] Ibid, 28.

> [...] The rule is that the Spanish Jews in the Galilee always follow the
> custom they observed in Spain [...] The widow is paid her dowry ac-
> cording to its value *on the date of payment*, and gets whatever sums were
> specified in the *ketubah*, even if at the time of the marriage the value was
> doubled [according to local custom]. She takes it all![101]

The Radbaz in principle adopted the Musta'rab approach, whereby
the woman was paid her dowry at its original value, even if it had
greatly depreciated meanwhile. However, in cases where the hus-
bands abused the custom in order to shortchange their wives, he did
not hesitate to make exceptions:

> Even though this is the custom, there are exceptions. I myself have
> come across several scoundrels who are planning divorce. When they
> see that a certain garment is about to become unwearable and therefore
> cease to fulfill its original function, they hide it away, and buy her a new
> one. Then, when they divorce her, they give her the rags they hid away.
> In such cases, I assess the objects at their current value, or at some
> compromise value, since obviously this custom was not designed for
> such people. No doubt, if this possibility had been explained to the
> woman before she married, she would never have agreed. It is right and
> proper that every *dayyan* act in this way, in order to foil the schemes of
> the wily. In no way is this to be construed as tampering with a custom.
> On the contrary, it is simply a way of bringing about truth and jus-
> tice![102]

Thus we see that the Radbaz was willing to 'adapt' the custom in
order to prevent its abuse by rapacious husbands.

The custom of the Spanish Jews regarding assessment of the
dowry was far more generous toward women than was the Musta'rab
custom. This may have been because the objects, clothes and fabrics
showered on Spanish brides were usually more valuable than those
bestowed on the average Musta'rab girl. The paterfamilias in the
Spanish Jewish family, who was often a merchant or businessman,
had his daughters' interests at heart. For him, the artificial inflation
of the dowry's value was not so much a matter of 'honor' (as it was
for the Musta'rabs), as a financial commitment that the husband had
to honor when the time came. As we saw from R. Joseph Caro, the
Spanish Jews specified the overall value of the dowry in the *ketubah*,
and not the value of each item. The Musta'rabs, on the other hand,

[101] Caro, Responsa *Beit Yosef*, 18 (= Laws of *Ketubot*, 2). Ibid, R. Joseph Caro's
responsum, p. 31a.
[102] Radbaz, I, 383.

were careful to return the items of the dowry in a usable state (even if worn) and to assess them at the highest possible rate, so that they could deduct their value from the amount of the *ketubah*.

2. *Monetary assessments*

Payment of the sums specified in the *ketubah*, like payment of debts in general, became especially problematic toward the end of the 16th century, due to the galloping inflation that overtook the Ottoman Empire, sparing neither merchant, businessman, nor worker.[103]

A collection of Responsa on payment of a *ketubah* sheds light on the problem.[104] The *ketubah* in question, written in Damascus in 1564, specified a sum of 981 "gold florins (*perahim*) sultanis," and an increment of 206 florins. It also stated that "each florin is equal to 40 silver pieces of the currency used today in Damascus."[105] Thirty-five years later, in 1599, when the widow claimed her *ketubah*, the rates had drastically changed: Each gold florin was now worth 110 silver pieces! Although the woman claimed her *ketubah* in gold florins, the heirs naturally sought to pay her in the smaller coins, at the rate specified in the *ketubah*.

From the responsa, it is obvious that the rabbis of Safed were aware of the problem. In an attempted compromise whereby both parties would share the brunt of the devaluation (although not equally), they ruled that a florin would be valued at 63 silver pieces for the purposes of paying commercial bills *and ketubot*.[106] As R.

[103] Barkan; Bashan, "Crisis," pp. 107-115; Kahane, "Revaluation"; Shohetmann, "Regulation"; Gerber, "Enterprise," especially pp. 59-64; Shmuelevitz, pp. 168-175; Gibb & Bowen, Vol. I, Part II, pp. 49 ff.; Hall (ed.), *The Cambridge History of Islam*, pp. 344-345; Inalcik, pp. 50 ff. Already in 1525, Ottoman currency was devalued as we learn from a wedding that took place in Tsobah (Aleppo) (Ralbah, 134).

[104] Maharit, I, 74; Maharitatz, 109; Shohetmann, "Regulation" (responsum from manuscript of R. Moses Galante, R. Shem-Tov Attia, R. Jacob Altaras, R. Hiyya Rofeh, R. Abraham Shalom and R. Samuel de Uçeda).

[105] "*Perah*" in Hebrew corresponds to the European gold florin. The '*sultanis*' (altons) were Ottoman gold coins that served mainly for tax calculations. "*Hatikhot*" (pieces) or "*qatash*" were small silver coins, also known as *paras* or *muayydi*. 1 *para* = 2 *akçe*. The *akçe* was a silver coin that was standard currency in the Ottoman Empire. In the early 16th century, a gold coin was worth about 40 *akçe*, in the middle of the century about 60 *akçe*, and by the end of the century about 90 *akçe*. In the 17th century, one gold coin was worth about 120 *akçe*. See: Shmuelevitz, pp. 168-175.

[106] Galante's responsa in Shohetmann, "Regulation," p. 115; Ibid, on similar regulations from other places.

Joseph Trani pointed out: "This regulation has been the custom in Palestine since the times of the luminaries of the previous generation until now. This regulation was surely introduced by way of conciliation, to counteract the effect of inflation on orphans and on the population at large. For several businessmen have become impoverished as a result of currency devaluation."[107]

The aforementioned heirs in Damascus invoked the Safed regulation when it came to paying the widow's *ketubah*, hoping to get away with paying only 63 silver pieces, and not 110, for each florin. However, the Safed sages involved in the case, in a unanimous ruling, ordered the widow to be paid in gold florins, as specified in her *ketubah*. The Safed regulation, they stated, was a local regulation, that had no legal validity elsewhere, especially since it had met with disapproval in Safed itself. Even R. Moses Galante, himself one of the legislators of this regulation, commented: "Our ruling is not in accordance with the strict letter of the law, and was introduced only for "fairness' sake" [*tikkun 'olam*] [...] In any case, it only applies if the term "florins" is used, without further specification. If, however, *gold* florins or *gold sultanis* are specified, our ruling does not apply!"[108] In other words: the compromise regulation was invoked only when the type of coin was not specified. If the word "gold" was actually specified, bills – including *ketubot* – were to be paid in gold coins (or at their current value).

Egypt had no regulation akin to the Safed one and at least until the mid-17th century, inflationary losses were not spread over borrower and lender, as was the custom in Palestine. Just as merchants, creditors, and businessmen suffered the effects of monetary fluctuations, so did widows or divorcees who wished to redeem their *ketubah*.[109]

From the above, we see that the custom of the Iberian Jews favored the woman in all cases. The Spanish Jews assessed objects and garments at their real value, unlike the Musta'rab Jews who

[107] Maharit, II, *Even ha-'Ezer*, 2.

[108] Shohetmann, "Regulation," pp. 114-116. In another responsum, Galante relates that it was the Safed custom to record the *ketubah* amounts in *groshos* [European silver coins also known as "thalers" or "*arayot*" (=lions)], or in gold coins "which last forever," but not in smaller denominations (Galante, Responsa, 82). The same practice was adopted by international merchants, who wished to safeguard their business interests (Gerber, "Enterprise," p. 62).

[109] Gavizon, I, 9 (ibid, note 4, and references); Radbaz, I, 560.

assessed them at their original value, even if they were now worth less. Most Spanish rabbis also approved regulations that compensated for monetary fluctuations, while the Egyptian (mainly Musta'rab or Maghrebi) sages did not.

These different approaches were a reflection of cultural differences between the Spanish and indigenous Jews. Not only were the Spanish Jews more affluent, their social mores encouraged them to flaunt their wealth and status through the dowry they gave their daughters. It followed that one of their major concerns was to preserve the family property within the family, ensure that it did not pass into alien hands, and safeguard its value. As we saw above, this concern found concrete expression in the inheritance regulations which favored the woman's heirs on her father's side. Altogether, the regulations and customs of the Spanish Jews were an expression of the good business sense of merchants interested in protecting their investments.

The other congregations of Palestine and Egypt, in particular the Musta'rab and Maghrebi communities, were less affluent and lived in a different social climate. Therefore, they tended to give their daughters the minimum necessary to marry them off. The fact that each object of the dowry was specified in the *ketubah*, rather than an overall sum, made it possible for the Musta'rab husbands to avoid paying the full value of the objects when it came to paying the *ketubah*.

16th-century Safed, with its rabbinical luminaries and patchwork of communities and congregations, arrived slowly at some integration between the various traditions regarding the assessment of dowries and *ketubot*. We saw above how an attempt by the Mabit, a Spanish decisor, to follow the Palestine custom was strongly opposed by his colleagues, who refused to detract from the value of the woman's dowry, even if the heirs or other creditors lost out as a result. As far as monetary assessments were concerned, a compromise between the Musta'rab and Spanish customs was worked out, whereby the parties shared the loss arising from a currency devaluation. This compromise solution, however, never really gained ground in Palestine, and Safed soon reverted to the Spanish custom of assessing amounts at their real value.

Egypt was slower to respond to inflation and the economic vicissitudes that befell the Ottoman Empire. The local sages continued assessing money at its original value for a long time, without taking inflation into account. Only in the second half of the 17th century, at

the time of R. Abraham Halevi, did things change, when the Egyptian sages too introduced a regulation stipulating a compromise between lender and borrower.[110] Naturally, women also benefited thereby.

Ketubah of male sons (Ketubat banin dikhrin)

An ancient mishnaic regulation stipulated that sons inherited their mother's *ketubah*, even if their father had sons from another woman or women. Originally, this regulation, like others concerning the husband's right to inherit his wife's estate, was designed to encourage fathers to give a more generous dowry to their daughters, in the knowledge that the property would remain within the family, and would not be handed down by the husband to children from other wives. It was customary to introduce a condition in the *ketubah* which read: "Any sons of ours shall inherit your *ketubah* money, on top of receiving their share along with their brothers."[111] Over the generations, this regulation fell into disuse, but in the 16th century, some claimants still relied on it, although they were not always given legal redress.

In adjudicating a dispute in relation to *ketubat banin dikhrin*, the Mabit gives us an insight into the complex issues involved in this regulation: "While some Gaonim are of the opinion that it no longer applies, others, such as Rabenu Hai Gaon and the Rambam, may they rest in peace, believe it does. There is also some uncertainty as to whether it applies also to chattels, or only to landed property. In addition, Rabenu Hananel ruled that the regulation applies only in cases where two [wives of the deceased] have died, even if one died after the deceased, but other Gaonim disagree."[112] After careful consideration of the various arguments, he, as well as R. Caro and the Maharitatz, summarily dismissed the claim. R. Jacob Castro also claimed that the sages of Egypt had declared the regulation obsolete

[110] *Ginnat Veradim*, *Hoshen Mishpat*, Rule 4, 1 (p. 124b); ibid, *Even ha-'Ezer*, Rule 4, 24 (p. 80a).

[111] *Ketubot*, 52b (and in the Jerusalem Talmud, *Ketubot*, 84, *halakha* 12); Caro, *Shulhan 'Arukh*, *Even ha-'Ezer*, *Ketubot*, 111, 1. See also: Assaf, "Abolition"; Dikstein, "Contracts"; Elon, *Jewish Law*, pp. 472-474, 538-539; Schipansky, *Takkanot*, II, pp. 244-250.

[112] Mabit, II, 209.

already in the previous generation.[113] R. Moses Galante, on the other hand, based a ruling on this regulation.[114]

Despite the ambivalence concerning this regulation, one thing is clear: It too was an economic regulation designed to keep the property within the nuclear family. Therefore, it was particularly popular among Iberian Jews who, as merchants and businessmen, were anxious to safeguard the generous dowries they gave their daughters. Even though the regulation fell into disuse toward the end of the 16th century, the Spanish Jews continued to invoke it, pending legislation safeguarding the inheritance of women. The Jews of Italy, particularly the affluent Portuguese merchants of Livorno, continued to uphold the *ketubat banin dikhrin* even in the 17th century, as reflected in petitions by local Jews married to women of Egyptian origin.[115]

The inheritance rights of daughters

According to biblical law, if there are sons in the family, the daughters do not inherit. In order, therefore, to ensure their livelihood after their father's death, the sages passed the "daughters' maintenance regulation" whereby daughters were entitled to live off their father's property after his death until they came of age or married. In addition, the "*issur nekhasim* regulation" entitled unmarried daughters to receive a tenth of their father's real estate, as a dowry.[116]

The daughters' entitlement to maintenance usually took precedence over the sons' rights to inherit or the '*ketubat banin dikhrin*': "If the property is great, the sons inherit and the daughters receive maintenance; but if the property is small, the daughters receive main-

[113] Castro, *Ohalei Ya'aqov*, 68 (see also his annotations to *Shulhan 'Arukh*, in *'Erekh ha-Lehem, Even ha-'Ezer*, 111, 14); Mabit, I, 277; Maharitatz, 92; Maharitatz, New Responsa, II, 134, 203; Caro, Responsa *Beit Yosef*, 28 (= Laws of *Ketubot*, 5). In the *Shulhan 'Arukh* he wrote: "Many of the Gaonim have written that the *ketubat banin dikhrin* no longer applies" (*Even ha-'Ezer, Ketubot*, 111). On the attitudes of the Gaonim on this issue, see Tykocinski, pp. 74-77.

[114] Galante, Responsa, 1.

[115] *Ginnat Veradim, Even ha-'Ezer*, Rule 4, 23, 30; Faraji, 17-18.

[116] *Ketubot*, 52b; 53b; 68a; Caro, *Shulhan 'Arukh, Even ha-'Ezer, Ketubot*, 113. On the regulations and their ramifications, see Kerlin, pp. 201-207; Elon, *Jewish Law*, pp. 471-476, 682-686; Neeman; Mescheloff, pp. 295-299; Falk, "Inheritance"; Schipansky, *Takkanot*, II, pp. 242-244, 260-266.

tenance, and the sons go a-begging."[117] However, payment of a *ketubah* to the widow, or payment of debts, took priority over both.

In the absence of a will or other instruction, the 16th-century sages throughout the Ottoman Empire applied these regulations literally. Daughters were given a tenth of the father's estate but had no share in their mother's estate, even if there were no sons. Even though according to the laws of succession daughters are allowed to inherit when there are no sons, the right to inherit the mother's *ketubah* remained an exclusively male privilege.[118]

The fact that many wealthy fathers wished to make generous provisions for their daughters over and above the strict requirements of Jewish law generated social pressure for extending the inheritance rights of daughters. In various places, regulations and customs were passed which, under certain circumstances, redressed the balance between daughter and son.[119] At the same time, many women preferred to take their claims to Islamic courts, since Islamic inheritance laws were generally more favorable towards women, as the sages themselves acknowledged: "According to gentile [Islamic] law, everyone inherits: the son, the daughter, the son's son, the sister's son, and the mother of the deceased, all receive a share [...] In Jewish law, on the other hand, the sons inherit everything, and everyone else goes a-begging."[120] As the Mabit states: "[In Islamic courts] the daughter's right takes precedence over the son's, in contrast to biblical law."[121] It

[117] Mishnah, *Ketubot*, XIII, 3; Mishnah, *Bava Batra*, IX, 1; Caro, *Shulhan 'Arukh, Even ha-'Ezer, Ketubot*, 112; Kerlin, *Even ha-'Ezer*, 112-113, and ibid, p. 204, note 18. See also Radbaz, IV, 1326, 2299.

[118] Radbaz, I, 419; III, 897; Maharitatz, New Responsa, I, 13, 71, 94; II, 136; Dikstein, "Contracts", pp. 45-46. The law of succession (Numbers 27: 8) explicitly states: "If a man die, and have no son, then ye shall cause his inheritance to pass unto his daughter." For a discussion of this subject, see Radbaz, *Metzudat David*, Commandment 530.

[119] Examples of such regulations are: the Valladolid regulations of the 14th century, the regulations of the exiles in Fez in the early 16th century, and inheritance deeds known as "*Shetar hatzi zakhar*" that were customary in Poland, the Rhineland, and later also in Italy from the early 14th century, which allotted the daughter one half of a son's share in the estate. For further information, see: Assaf, "Daughter"; Elon, *Jewish Law*, pp. 682-686; Gulack, *Origins*, III, pp. 100-101. On the inheritance of daughters whose brothers were Marranos, see Assaf, "Marranos," pp. 49-50.

[120] Rofeh, 12. In Muslim law, a daughter inherits half the share of a son. See Goitein, *Introduction*, pp. 142-145, 148-149; Shmuelevitz, pp. 65-68; On the division of the deceased's estate in Jerusalem according to Muslim law, see Chapter 4 above, "Married Life."

[121] Mabit, I, 130.

is interesting to note the Radbaz's reply to a query by Islamic sages concerning the fact that by Jewish law, daughters are not entitled to inherit: "The gentile sages ask how it is possible that the Torah does not allow a daughter to inherit? My answer is that the Torah knows that the Jews are compassionate, and that her brothers will provide for her and will find a suitable match for her."[122]

In practice, however, it was impossible to rely on the compassion of brothers or other heirs. In Egypt, therefore, despite a certain amount of rabbinical opposition,[123] it was customary to grant the daughter one tenth of her deceased father's estate, not only of landed property, but also of chattels. The Radbaz, who on several occasions advocated total adherence to the biblical laws of succession,[124] nevertheless justified this custom on the following grounds: "If the daughter is dissatisfied, she will simply bring her case to an Islamic court, where the daughter inherits about half the son's share. Therefore, we have had to arrive at some sort of compromise arrangement."[125]

A similar regulation existed in respect of a daughter's right to her deceased mother's estate. "Where there is an established custom to grant the daughter a tenth of her mother's chattels or estate – a custom takes precedence over *halakha* in financial matters."[126] R. Joseph Trani even recommended that: "The father himself should make provisions for his daughter in accordance with local custom."[127]

Many fathers tried to circumvent *halakha* by granting daughters an equal share in their property to their sons, through a gift, or a will. There was no halakhic objection to granting gifts to a daughter (or to a wife), even if this interfered with the biblical laws of succession.[128]

Another way of circumventing *halakha* was through the Muslim

[122] Radbaz, *Metzudat David*, Commandment 530.
[123] Maharitatz, New Responsa, II, 136.
[124] Radbaz, I, 430; III, 897; Idem, *Metzudat David*, Commandment 530.
[125] Radbaz, IV, 1190.
[126] Ibid, III, 897.
[127] Maharit, *Hoshen Mishpat*, 5.
[128] See for example: Pinto, 106; Mabit, I, 162, 197; Maharit, *Hoshen Mishpat*, 21, 41, 54; Radbaz, I, 419; Castro, *Ohalei Ya'aqov*, 1. This custom was extremely prevalent in Istanbul: "In this city, all fathers make financial settlements in favor of their daughters. If they fail to do so, the daughters obtain their share through litigation." (Maharitatz, New Responsa, I, 33). On a father who moved to Jerusalem and left a legacy for his daughters in Istanbul, see: MS Jerusalem, *Iggerot Shadarim*, Letter 180, p. 211.

legal institution of the '*Waqf Awlad*' (Children's Endowment),
whereby the father's property was endowed to a Muslim institution,
but the children (both sons and daughters and their offspring) were
allowed to use it in perpetuity. R. Yom Tov Zahalon explains this
custom as follows: "The reason why the Jews have adopted this
Ishmaelite custom is twofold: Firstly, rent in that city [Istanbul,
where the responsum was sent] is exorbitant, and should his offspring
become poor, such an endowment will at least spare them the cost of
rent [...] Secondly, such an endowment ensures that both sons and
daughters are provided for equally, as far as accommodation is con-
cerned. There should be one house for them all [...] and for their
children and grandchildren."[129]

This practice, naturally, was not condoned by the sons. Many
challenged the legality of such endowments, on the grounds that they
contradicted *halakha*, or claimed that the term '*awlad*' (children) re-
ferred to boys only. Both arguments were rejected by R. Yom Tov
Zahalon, who ruled that such endowments were akin to gifts "and
that girls had the same right as boys to inherit in the form of a
gift."[130] R. Hiyya Rofeh added that the term '*awlad*' referred to boys
and girls alike.[131]

Conclusion

The laws of succession reflect the status of the parties who form a
wedding-bond. Jewish succession, by differentiating between male
and female, perpetuates the latter's dependence on father, brother
and husband. Women had no primary claim to their husband's or
father's estate, but were dependent on the latter's good will. The
desire to provide generously for wife or daughter clashed with the
wish to keep the property within the family. This conflict was most
conspicuous among the Iberian Jews. Great efforts were made to
ensure that family property remained within the woman's family
(direct heirs, or her heirs on her father's side, if she died without
issue).

[129] Maharitatz, New Responsa, I, 32(2). For a detailed explanation of the signifi-
cance of the Shari'a settlement, see Rofeh, 13; See also Maharit, *Hoshen Mishpat*, 5, 6;
MS Jerusalem, Tzayyah, 487, pp. 192b-201b; Gerber, "Wakf"; Ashtor, II, p. 228.
[130] Maharitatz, New Responsa, I, 32(2).
[131] Rofeh, 13.

The sages were able to redress the balance to a large extent through appropriate regulations. Despite this, women increasingly preferred to bring inheritance disputes to the Muslim courts. This was such a common practice that a special regulation was passed prohibiting it. As R. Samuel De Medina of Salonika stated: "A strong and binding regulation has been passed prohibiting any Jew from taking an inheritance or *ketubah* case to a gentile court. The said regulation has been drawn up and signed by all the holy sages, past and present, in all parts of Israel: By the *rabbis of Safed* [may it be speedily rebuilt], the rabbis of Istanbul [may the Almighty preserve it, Amen], and the rabbis of Salonika [may the Almighty preserve it, Amen]."[132]

A study of the decisions reached by the 16th-century sages shows that they were often lenient towards women in matters of inheritance, in deference to social reality, and in accordance with the wishes of the deceased father or husband. Usually, however, the importance of the family as an economic unit took precedence over the woman's interests.

[132] Rashdam, *Even ha-'Ezer*, 131. See also Danon, "Communauté," pp. 112-113.

CONCLUSION

The century which followed the Expulsion from Spain was character-
ized by political upheaval and demographic changes, culminating in
the encounter of the Iberian refugees with the traditions of Ashkenaz,
North Africa, Italy and the Orient. In this book, I have tried to follow
one aspect of the expellees' integration, namely: the status of women
in the two to three generations following the expulsion.

Unfortunately, this historical event and its implications did not
bring about significant changes in the status of women. True, the
wish to bring the *conversos* back into the fold and facilitate their ab-
sorption into Jewish communities led to a certain relaxation of the
laws on divorce, *igun*, and the like – matters affecting the personal
status of women. However, this was less a deliberate policy to ease
the lot of women than a desire to ensure the survival of the nation,
after the terrible catastrophe that had befallen in. Moreover, the
idealization of women as mothers and housewives rendered them
powerless in all other areas, and served to perpetuate their inferior
status. From a legal point of view, men continued to enjoy an abso-
lute advantage over women (although there were a few exceptional
women who managed to achieve a certain measure of autonomy in
their own lives, or who were influential within their own families).
However, in public and social life, and naturally in the eyes of the
law, their ability to participate in decisions and express themselves
was extremely limited. The attitude towards women was evident also
in the way people responded to the birth of a girl, in matchmaking
procedures which were totally governed by financial considerations,
and in child marriages, where girls were perceived as a burden to be
dispensed with as soon as possible.

Women were hardly ever totally independent at any stage in their
lives. Prior to their marriage they were under their father's or broth-
ers' jurisdiction, and any education they received was merely to pre-
pare them for their future domestic tasks. Child marriage was ex-
tremely wide-spread: In most cases a woman's childhood ceased
around the age of twelve, when she was married off without having
any say in the matter. Once she married, she was under her hus-
band's tutelage, and any money or property she owned were man-
aged by him, signifying in effect her absolute economic subjugation

to him. Since childless couples had no place in Jewish society, women were expected to prove their fertility by bearing a child, preferably a male child, as soon as possible. Woe the woman who was unable to conceive, or bore only girls: Sefardic, oriental, and even Ashkenazi Jews had no compunctions about implementing their right to take a second wife in order to fulfill the commandment of procreation. A woman who wanted to divorce soon discovered that she was laying herself open to extortion on the part of her husband – a practice which the rabbis and *dayyanim* tended to overlook.

One of the few options available to independent women when all else failed was to 'rebel' – namely, to refuse to fulfill their marital obligations in general, and their sexual obligations in particular. This 'solution,' however, frequently left them destitute. Another popular solution was to appeal to gentile courts, which were often more favorable toward women than were the rabbinical courts. More radical options were promiscuity or apostasy as ways of severing all ties with normative society. However, the available sources indicate that this option was used only as a last resort. Sometimes, though not always, the threat of gentile litigation or apostasy was sufficient to render the sages' attitudes more tractable.

The above notwithstanding, a woman who had no man – be it father, brother or husband – to depend on, frequently felt so vulnerable that she preferred any husband to none. This explains why widows and divorcees remarried almost always immediately, and why almost all women went through several marriage cycles. The difference was that the second or third time round, women who had managed to amass some capital could lay down their own conditions: They could retain their property, or set aside sums of money for their own use. Ironically, therefore, the 'optimum' situation for a woman of those times was to be an affluent widow! It was the only situation in which a woman was both respected and allowed to dispose of her property as she wished.

Although the way Jewish women were perceived by the 16th - century sages was not particularly flattering, it was no different from the way women were perceived in other religions. If they were praised at all, it was for fulfilling their destiny, or the expectations men had of them: looking after the home and family, and encouraging the menfolk to study Torah. Any departure from this feminine ideal was condemned.

Women who came from aristocratic or wealthy homes enjoyed

greater privileges than their less wealthy sisters. They were treated with more respect and consideration, both within the family and by the rabbinical establishment, which tended to show more leniency toward them on this account.

Another conclusion of this research is that the halakhic rulings of the 16th century sages – at least as far as women were concerned – were far from uniform. Although the Iberian sages usually abided by their own traditions, stormy halakhic debates frequently erupted even between sages of similar extraction. No doubt, personal preferences and feelings also played a part in their decisions.

The various sages also 'borrowed' from each other's tradition on several halakhic issues, such as the regulations concerning inheritance of a wife's estate (on which the Iberian Jews inclined toward the Damascus Musta'rab custom) and polygamy (a custom which appealed to a number of Ashkenazi Jews). It is interesting that on these and similar issues, which favored men, the rabbis were willing to show flexibility, accept external influences, and amend obsolete customs and regulations. Not so on issues relating to women. Cross-cultural influences or even marriage did nothing to enhance the status of women. The above seems to indicate that despite the halakhic difficulties inherent in amending family law or the law of inheritance, the rabbis were not averse to doing so when the wellbeing of men was at stake.

As stated, the decisors of the generation usually adhered to the letter of the law and were afraid to innovate. Mostly, they failed to take into account the specific geohistorical circumstances which might have alleviated the plight of women through a broader interpretation of *halakha*. This conservative approach was particularly manifest in financial cases involving women, such as inheritance suits. Requests for divorce by women were summarily dismissed, unless they forfeited their property and *ketubah*. Extortion in connection with levirate marriages was a frequent occurrence.

Thus, although the community leaders and sages enjoyed the prerogative of legislating new laws (*takkanot*) in accordance with changing circumstances or with specific social requirements – this option was hardly ever used to benefit women, and certainly not to grant them equal rights. On the contrary, regulations relating to matrimony, inheritance and morality, although mirroring a degree of social conflict, effectively perpetuated women's inferior personal, public and economic status. Even the few exceptional rabbis who acknowledged

the right of rabbis and congregations to legislate far-reaching regulations on matrimonial matters too, were not anxious to stick their necks out, for fear of being in the minority.

Typical of this approach is R. Moses Alashqar's responsum concerning the annulment of a betrothal. He begins by expressing his own opinion: "In every generation, the townsfolk and its rabbinical court may introduce enactments and safeguards, and may even depart from the strict letter of the Torah law [...] Therefore, the townsfolk may annul a betrothal that was contracted in defiance of its enactments." Further on, however, he admits that it is not his intention to take on "the entire country and its rabbis" single-handed, and he is prepared to approve only if the other rabbis go along with the decision. Thus, he concludes: "If they [all the town's communities] decide [...] to annul a betrothal which contravened their enactments, forever or until such time as they see fit – I shall have no hesitation in casting my vote with them [according to *Horayot*, 3b]. But if only *one* congregation rules accordingly, far be it from me to go along with them!"[1]

If this antipathy towards innovation was somewhat indicative of a dismissive attitude towards women, it was far more indicative of a concern that governed the sages throughout the 16th century – the fear of setting a precedent that might overturn the normative way of life and compromise their authority. The sages were not so much insensitive to the plight of women, as concerned to uphold the social order. They felt it their duty to stand 'in the breach' and stem the tide of social upheaval that threatened to engulf them. Therefore, rather than judge each case on its own merits, they preferred to adhere to the letter of the law.

Virtually the only field in which the 16th-century sages showed special consideration of women was in the area of *igun* (desertion). This was not only because *halakha* itself advocated flexibility in such cases, but also out of concern that some *agunot* for whom no solution was found might go astray or apostatize. Therefore, almost 76% of *agunot* whose case were heard were permitted to remarry. A certain degree of flexibility was also shown in respect of 'borderline' (dubious) marriages.

[1] Alashqar, 48.

Such a work would be incomplete without reference to the sorry fact that over the past five centuries, little has been done to improve the status of women in the rabbinical courts. In the 20th century, as in the 16th century, there are hundreds of "chained" women in the State of Israel whose husbands refuse to grant them a *get*, and who are at the courts' mercy if they wish to start a new life. Today, too, the rabbinical courts (which rule on matters of Jewish personal law) are powerless to compel recalcitrant husbands to grant a divorce, and are unable to provide a solution for their wives. Although many rabbis, Knesset members, and intellectuals have proposed a variety of solutions to this problem, they have been overruled by more conventional opinions which stress the importance of women's traditional role as defined by *halakha*.[2]

As stated, there is room for leniency even within the purview of *halakha*. However, so far no Torah scholar has been sensitive or brave enough to exploit the latitude granted by *halakha* to pass regulations on this painful issue. This failure has alienated large sections of the community from the rabbinical courts.

In many other aspects, too, the latitude allowed the halakhic arbiters is immeasurably greater than they are prepared to admit. This contention is not only borne out by my research, but is also reflected – although to a lesser degree – in contemporary halakhic decisions.[3] Evidently, over and above halakhic and social considerations, the rabbis, now as then, are reluctant to take responsibility for fear of 'things getting out of hand'. The rabbinical decisors fear they will lose control of their well-ordered masculine world and of the lives and property of their wives and daughters. For this reason, they often prefer stringency even when there is room for leniency. It is impossible to escape the conclusion that in practice the rabbis are not concerned with the wishes, feelings, or motives of women. If they were really concerned to ease their plight, the way is open for them, today as in the past. As D. Mescheloff says:

[2] Some of these works are referred to by Mescheloff (see his Note 1). Mescheloff reviews the main problems and proposes solutions on pp. 299-309. See also: Freimann, *Betrothal*, appendix; Silberg, pp. 116-117; Zemer.

[3] On the latitude of *halakha* see: Weinroth, p. 458. On the willingness of the Moroccan sages to confront the problem of time-prescribed commandments, see: Amar, "Status". On the many possibilities of incorporating Israeli civil law into Jewish law,and on existing and desirable precedents, see: Rozen-Zvi, esp. pp. 124-127; Elon, *Jewish Law*, pp. 667-676, 711-712. See also: Bleich; Freimann, *Betrothal*, pp. 385 ff.

> Loyalty to *halakha* does not imply blind deference to every ruling and every rabbi, irrespective of time, place or social context [...] Each issue must be examined on its own merits, and a distinction must be drawn between cases in which the critics [of the *halakha*] failed to understand a ruling properly, were mistaken, or lifted it out of context; cases where there are nuances in the stringency of a prohibition, and where there is a possibility of rectifying injustice; and cases where one may have to actually side with the critics in order to redress a wrong [...] Changes in *halakha* do not necessarily challenge the eternal nature of *halakha* [...] We must consider the question of the dividing line between the immutable and the mutable in *halakha* [...] Not every question is a halakhic question requiring submission to the will of God alone; there are issues that require the exercise of personal discretion in accordance with the circumstances.[4]

A historical chain of traditions and laws that have favored men, granting them control over the economic, legal, and social establishment, has perpetuated their privileged status. As in other patriarchal societies, in Jewish society too the powers that be have frozen the status quo in an attempt to preserve their religious and social privileges unchallenged. In practice, the religious and social establishments have joined forces in order to perpetuate a system that grants such clear advantages to men.

[4] Mescheloff, pp. 270-271, and ibid, excerpt of the edifying comments made by Rabbi Eliyahu Hazan. See also Berman.

GLOSSARY

agunah	a deserted woman, or a woman whose husband's whereabouts are unknown, and is therefore forbidden to remarry
arus, arusah	a person bound by a betrothal vow (sacrament) prior to the wedding (*nissuin*, *'huppah'*) ceremony
Ashkenaz, Ashkenazim	The Rhineland, Germany; Jews of central-European origin
dayyan	Jewish judge
dhimmis	tolerated non-Muslim population (mainly Christians and Jews) in Muslim lands
erusin	see: kiddushin
gaonim, gaonic period	Post-Talmudic scholars of late 6th to 11th centuries
get	bill of divorce
halakha	Jewish law; codex of Jewish legal decisions and practices
halitzah	a procedure releasing a childless widow from the necessity of undergoing *yibbum* (levirate marriage)
haskamah	a communal regulation; communal agreement to accept a *takkanah*
huppah	wedding (*nissuin*) ceremony (literally: canopy)
igun	desertion (see: *agunah*)
kabbalah	Jewish mistical tradition
kabbalist	a scholar who practices or advocates *kabbalah*
ketubah	(1) marriage contract (2) the sum due to a woman when she is widowed or divorced (as specified in her marriage contract)
kiddushin	betrothal, a halakhic procedure performed prior to the wedding ceremony (*nissuin*) which binds the couple in marriage
kinyan	halkhic form of acquisition
maghreb, maghrebis	North Africa; Jews of North African origin
miqveh	ritual bath
mitzvah	Biblical commandment
moredet	'rebellious wife' – a woman who refuses to have conjugal relations with her husband
Musta'arabs	Jews of Oriental origin; Arabic speaking Jews
nikhsei melog	usufruct property; wife's estate of which husband has usufruct without responsibility for loss or deterioration
nikhsei tzon barzel	inalienable property; wife's estate held by husband, which he must restore (in case of divorce or widowhood), being liable for loss or destruction with all his binded property

nissuin	wedding ceremony, which complements *kiddushin*
posek, posekim	rabbinical scholar and decisor
qadi	Muslim judge
Sefarad, Sefardim	Spain; Jews of Iberian origin
shari'ah	Muslim law
shiddukhin	engagement
Shulhan 'Arukh	Joseph Caro's halakhic code based on his 'Beit Yosef', published in his lifetime
takkanah	communal regulation
waqf	Islamic endowment for charitable or religious purpose
yibbum	a procedure whereby the brother of the deceased marries the deceased's widow in order to bear offspring

APPENDIX

BRIEF BIOGRAPHICAL SURVEYS OF SAGES

Bezalel Ashkenazi
Expositor and commentator, many of his writings are still in manuscript. Born probably in Palestine c. 1520, R. Bezalel Ashkenazi studied under the Radbaz in Cairo. After the latter's emigration to Palestine, he replaced him as the leading rabbi in Egypt, and headed a *yeshiva* there. R. Bezalel Ashkenazi is the author of the famous "*Shitah Mequbbetzet*" on the Talmud. Around 1575, he settled in Safed where he headed a *yeshiva*. From 1587, he served as religious leader and emissary of the Jerusalem community. There is evidence to suggest that he returned to Egypt toward the end of his life. Died before 1595.

David ibn (ben Abi) Zimra (Radbaz)
Born in Spain in 1479, the Radbaz came to Palestine following the expulsion from Spain via North Africa. After several years, he moved to Cairo, where he served as head of the Egyptian community for forty years. His disciples included R. Bezalel Ashkenazi, R. Isaac Luria Ashkenazi (the Ari), and R. Jacob Castro. He returned to Palestine in the mid-16th century, settling in Jerusalem (c. 1558-1564) and Safed (from 1568). The Radbaz was considered one of the greatest decisors of his and later generations. He left behind thousands of responsa, kabbalistic commentaries and other works. Died in Safed in 1573.

Eleazar Azkari (Azikri)
Kabbalist and expositor. Born in 1533 in Palestine. R. Eleazar Azkari was leader of kabbalist circles in Safed. Died after 1599.

Eliezer ibn Arha
In his youth, R. Eliezer, the son of R. Isaac Arha – Safed sage in the latter half of the 16th century and a disciple of the Ari – resided and studied in Safed. He subsequently served as *Dayyan* and rabbi in Gaza and Hebron. Died in Hebron in 1652.

Elijah de Vidas
Sage and kabbalist. Born in Safed in 1550, Elijah de Vidas was a
disciple of R. Moses Cordovero and of the Ari. He is best known for
his ethical-kabbalistic work *"Reshit Hokhmah."* Toward the end of his
life he settled in Hebron where he became the leading halakhic au-
thority. Died in 1586.

Hayyim Vital
Born in Safed in 1543, R. Hayyim Vital was the disciple of R. Moses
Alshekh and R. Moses Cordovero. Beside his extant halakhic works,
he was considered one of the greatest kabbalists of Safed, and the
spiritual heir of the Ari. Lived for short periods in Egypt and Jerusa-
lem. After 1593, became leader of the Sicilian congregation in Da-
mascus. Died in 1620.

Isaac Luria Ashkenazi (the Ari)
Sage and outstanding kabbalist, founder of a major school of kabba-
listic thought. Evidence suggests he was born in Jerusalem in 1534.
Came to Cairo at a young age, where he studied under the Radbaz.
His main kabbalistic doctrines were developed in Egypt but reached
their apex during the three years he lived in Safed, from late 1569 to
his death in 1572. During these years, Luria gathered around him a
select group of disciples, the most famous of whom were R. Hayyim
Vital and R. Joseph Ibn Tabul, who disseminated his teachings
throughout the Jewish world in manuscript and printed form.

Jacob Berab
Expositor and decisor. Born in Spain circa 1474. After the expulsion,
he served as a rabbi in Morocco, Algeria and Egypt. Emigrated to
Palestine shortly before the Ottoman conquest, and headed a *yeshiva*
in Jerusalem until late 1519. He moved to Egypt for a short period,
and subsequently set up a *yeshiva* in Safed, where he was undisputed
head of the city's sages. In 1538, he caused an uproar in the Jewish
world by ordaining himself and four of his top disciples with the
intention of reinstating the *Sanhedrin* (ancient Supreme Court). For
reasons that are unknown, he left Safed in the early 40s. Died appar-
ently in 1541.

Jacob Castro
Decisor and expositor. Born in Egypt, R. Jacob Castro studied in

Jerusalem under the Radbaz. In the second half of the 16th century, served as head of Cairo's Musta'rab community. Was acclaimed throughout Egypt and Palestine. Died after 1606.

Joseph Caro

Decisor, expositor and kabbalist. Born in Spain shortly before the expulsion (1488), R. Joseph Caro migrated with his family to Portugal, Salonika, Nikopol and Adrianople, finally settling in Safed in 1536. He was the spiritual heir of R. Jacob Berab, by whom he was ordained. From the early 1540s until his demise in 1575, Caro commanded a position of eminence in Safed and played a major role in the city's intellectual and communal scene. His seminal works, *Beit Yosef* and *Shulhan 'Arukh*, were widely distributed throughout the Jewish world. Even in his lifetime, his halakhic authority was accepted throughout the diaspora. Died in 1575.

Joseph ibn Tzayyah

Decisor and kabbalist. Evidence indicates he was born in Jerusalem. Active mostly in Damascus, where he headed the Musta'rab community, and in Jerusalem, where he lived intermittently. Was in close contact with the scholars and kabbalists of Safed. Died after 1569.

Joseph Trani (Maharit)

Born in Safed in early 1568. Son of R. Moses Trani (the Mabit). Served as rabbi and decisor in Safed and as emissary of the Jewish community there. Lived for short periods of time in Egypt, Istanbul, Sidon, Aleppo, and other places. Wrote copious responsa and other works. From 1605, headed a *yeshiva* in Istanbul, where he died in 1639.

Josiah Pinto

Expositor and decisor. Born in Damascus in 1565, R Josiah Pinto served as rabbi in Damascus and later in Palestinian communities. Died in 1648.

Levi ben (ibn) Habib (Ralbah)

Son of R. Jacob ibn Habib. Born in Spain around 1483. After the expulsion, his family fled to Portugal, where they were forcibly converted to Christianity. In 1499, the family moved to Salonika and reverted to Judaism, and the Ralbah studied and taught at his fa-

ther's *yeshiva*. In 1513, moved to Jerusalem, but later returned to Salonika. In 1525 took up permanent residence in Palestine, first in Safed, and then in Jerusalem, where he was the leading scholar and head of the community until his death. Was R. Jacob Berab's main antagonist in the polemic over ordination (1538). Died in the 1540s.

Meir Gavizon

Born between 1545 and 1555. Apparently spent his youth in Safed. Moved to Egypt and was head of the rabbinical court in Cairo. Kept close contact with the sages of Palestine. Died after 1622.

Moses Alashqar

Decisor and expositor. Born in Spain in 1466. After the expulsion lived in North Africa and Greece. Served for many years as *dayyan* in Cairo. Toward the end of his life moved to Jerusalem, where he died in 1542.

Moses Alshekh

Decisor, commentator and expositor. Evidence suggests he was born in Adrianople around 1520. Studied in Salonika under R. Joseph Taitatzak, and in Safed under R. Joseph Caro. An admired figure and head of two *yeshivot* in Safed. In the early 90s, was sent by the Safed community as an emissary to Turkey. En route, he wrote a letter entitled "*Hazut Kashah*" describing the dire economic situation of Safed's Jews. Apparently died on this mission, in late 1593.

Moses Cordovero (Ramak)

Sage and kabblist. Born around 1522, probably in Salonika. Lived in Safed from his youth, where he served as *dayyan* and head of *yeshiva*. Trained many scholars. Developed a kabbalistic method that was widely acclaimed in the Jewish world before the dissemination of the Ari's kabbalist doctrine. Died in 1570.

Moses Galante

Head of *yeshiva*, decisor and expositor. Born in Italy in 1540. Moved to Safed in his youth where he studied under R. Joseph Caro and R. Moses Cordovero. Died after 1614.

Moses Trani (the Mabit)

Head of yeshiva, rabbi, and decisor who left hundreds of responsa.

Born in Salonika in 1500. Educated in Adrianople, he moved to Safed in his youth. Studied under R. Jacob Berab, by whom he was ordained. Was heavily involved in community life. Colleague and sparring partner of R. Joseph Caro. After the latter's death, was acclaimed spiritual leader of the Safed community. Died in 1580.

Samuel ibn Sid
Head of the rabbinical court, rabbi and expositor in the communities of Cairo and Alexandria. Moved to Jerusalem after 1619 where he died in 1635.

Samuel Vital
Born in Damascus in 1598. Son of the kabbalist R. Hayyim Vital. Served as *dayyan* in Damascus for many years. In the 1660s, moved to Egypt, where he died in 1677.

Yom Tov Zahalon (Maharitatz)
Born in 1558, he served for many years as a rabbi and decisor in Safed, and also acted as the community's emissary to Egypt and Turkey. Left hundreds of responsa. Died after 1638.

BIBLIOGRAPHY

Manuscripts

(IMHM = The Institute of Microfilmed Hebrew Manuscripts, Jewish National and University Library, Jerusalem)

Israel

Jerusalem:

MS *Iggerot Shadarim*	National and University Library, 8°61, *Iggerot Shadarim* (Letters for Emissaries) from Jerusalem. On pages 281-394: Letters of R. Yoseph Mataron.
MS Misc.	National and University Library, 8°6549, Miscellanea.
MS Samuel Ibn Sid	National and University Library, 4°1444, The Sermons of R. Samuel Ibn Sid.
MS *Sefer Tikkun Soferim*	National and University Library, 8°958, Itzhak Tzabah, *Sefer Tikkun Soferim* (Scribes' Guide Book).
MS Tzayyah	National and University Library, 4°1446, Yoseph Ibn Tzayyah, Responsa.
MS Zera' Anashim	National and University Library, 8°2001, Zera' Anashim, Responsa.

England

Cambridge:

MS Misc.35.23	Cambridge University Library,Misc.35.23.
MS TS 13 J 24	Cambridge University Library, Taylor-Schechter Collection, TS 13 J 24.
MS TS Glass 16	Cambridge University Library, Taylor-Schechter Collection, Glass 16 (Microfilm in IMHM no. 19683).
MS TS Or. 1080.11	Cambridge University Library, Taylor-Schechter Collection, Or. 1080.11.
MS TS Or. 1080.15	Cambridge University Library, Taylor-Schechter Collection, Or. 1080.15.
MS TS NS 32	Cambridge University Library, Taylor-Schechter Collection, NS 32.

London:

MS BM, Or. 10112	British Museum Library, Gaster Collection, Or. 10112 (Microfilm in IMHM no. 7474).
MS BM, Or. 10118	British Museum Library, Gaster Collection, Or. 10118 (Microfilm in IMHM no. 7480).
MS BM, Or. 10162	British Museum Library, Gaster Collection, Or. 10162 (Microfilm in IMHM no. 7524).
MS Garçon	British Museum Library, Gaster Collection, Or. 10726 (Microfilm in IMHM no. 8041).

| MS Montefiore | Jews College, Montefiore Collection, 116 (Microfilm in IMHM no. 4629). |

MS *Shoshan Yesod ha'Olam* Sassoon Collection, 290 (Microfilm in IMHM no. 9273).

Manchester
| MS Manchester | John Rylands University Library, No.B 4349. |

Oxford:
| MS Hayyim Hevraya | Bodleian Library, 2553, The Sermons of R. Hayyim Hevraya (Microfilm in IMHM no. 22257). |

Holland

Amsterdam:
| MS Rosenthaliana | Biblioteca Rosenthaliana, Manuscript 1807 C 29 (Microfilm in IMHM no. 3668) |

U.S.A.

New York:
MS ENA 2747	Jewish Theological Seminary, Adler Collection, 2747.
MS ENA 3616	Jewish Theological Seminary, Adler Collection, 3616
MS Hayyim Capusi	Jewish Theological Seminary, Rab. 1454, R. Hayyim Capusi, Responsa (Microfilm in IMHM no. 43450).

Printed Responsa, Halakhic and Jewish Primary Sources (all in Hebrew)

(*Editted collections* of sources appear in the general list, under the entry of the editor's name)

Alashqar	Alashqar Moses, *Responsa* (Sadilkow, 1834).
Al-Dahri	Al-Dahri Zacharia, *Sefer Hammusar*, Y. Ratzaby's edition (Jerusalem, 1965).
Alfassi	Alfassi Itzhak ben Ya'aqov (Rif), *Sefer Halakhot ha-Rif* (Vilna,1877).
Aligieri	Aligieri Abraham, *Lev Same'ah*, Responsa (Salonica, 1743).
Alshekh	Alshekh Moses, *Responsa* (Jerusalem, 1975).
Amram	Amram Natan, *Or Torah* (Noa Amon [Alexandria],1850).
Ankawa	Ankawa Abraham, *Kerem Hemer*, Vol. II (Livorno, 1871) (Photocopy and Intruduction by S. Bar-Asher, Jerusalem, 1977).
Arha	Arha (ben Archa) Eliezer, *Responsa* (Jerusalem, 1978).
Ashkenazi	Ashkenazi Bezalel, *Responsa* (Lemberg, 1904).
Azulai, *Birkei Yoseph*	Azulai Hayyim Yoseph David (Hida), *Birkei Yoseph*, New Interpretations on the *Shulhan Arukh* (Vienna, 1860).
Azulai, *Hayyim Shaal*	Azulai Hayyim Yoseph David (Hida), *Hayyim Shaal* (Lemberg, 1886).
Azulai, *Lev David*	Azulai Hayyim Yoseph David (Hida), *Lev David* (Livorno, 1789). Reprinted in *Sefer Otzrot ha-Rav Hida* (Jerusalem, 1976).

Azulai, *Yoseph Ometz* Azulai Hayyim Yoseph David (Hida), *Yoseph Ometz*, Responsa (Livorno, 1798) (reprinted Jerusalem, 1961).

Bacharach Bacharach Naftali, *Sefer Emek ha-Melekh (Amsterdam, 1648).*

Beer Beer Shabtai, *Beer Eshek*, Responsa (Venice, 1674).

Ben Haviv Moses Moses ben Haviv, *Sefer Get Pashut* (Ortakoy, 1719; Zholkva, 1835) (reprint: Jerusalem, 1980).

Ben Lev Yoseph ben Lev (Rival), *Responsa* (Jerusalem, 1959/60).

Benveniste Benveniste Hayyim, *Knesset ha-Gedolah*, *Even ha-Ezer* (Izmir, 1721).

Berab Berab Ya'aqov, *Responsa* (Venice, 1663).

Berukhim Abraham Berukhim Abraham Halevi, *Other Moral Percepts which are Observed in Safed* [in S. Schechter, *Studies in Judaism*, Second Series (Philadelphia, 1908), pp. 297-299].

Binyamin Zeev Binyamin ben Matatia, *Binyamin Zeev*, Responsa (Jerusalem, 1959) (Reprint of Venice 1639 edition).

Caro, *Avkat Rokhel* Caro Yoseph, *Avkat Rokhel*, Responsa (Jerusalem, 1960) (Reprint of Leiptzig 1859 edition).

Caro, *Beit Yoseph* Caro Yoseph, *Beit Yoseph*, Commentary on *Arba'ah Turim* [the Four Colums] of Rabbi Ya'aqov ben Asher (traditional reprints).

Caro, *Maggid Meisharim* Caro Yoseph, *Sefer Maggid Meisharim* (Vilna, 1875).

Caro, Responsa *Beit Yoseph* Caro Yoseph, *Beit Yoseph*, Responsa on *Even ha-Ezer* (Salonica, 1598).

Caro, *Shulhan Arukh* Caro Yoseph, *Shulhan Arukh* (Lemberg, 1893).

Castro, *Erekh ha-Lehem* Castro Ya'aqov, *Erekh ha-Lehem*, Annotations on *Shulhan Arukh* (Constantinople, 1718).

Castro, *Ohaley Ya'aqov* Castro Ya'aqov, *Ohaley Ya'aqov*, Responsa (Livorno, 1783).

Conforte Conforte David, *Koreh ha-Dorot* (Venice, 1746) (reprinted: Berlin, 1846).

Cordovero Cordovero Moses, *Tomer Dvorah* (New York, 1960).

Darkhei No'am Halevi Mordecai, *Sefer Darkhei No'am*, Responsa (Venice) (Reprint: Jerusalem, 1970).

De Buton De Buton Abraham, *Lehem Rav*, Responsa (Krakow, 1885) (Reprint: Jerusalem, 1968).

De Vidas, *Reshit Hokhmah* De Vidas Elijah, *Reshit Hokhmah* (Zitamir, 1804) (first published Venice, 1579).

De Vidas, *Tozeot Hayyim* De Vidas Elijah, *Tozeot Hayyim* (Warsaw, 1878) (first published before 1650).

Dei Rossi Azaria Dei Rossi [*Min ha-Adumim*] Azaria, *Sefer Me'or Einayim* (Warsaw, 1899) (first printed Mantova, 1573).

Diwan Yehudah Diwan Yehuda, *Sefer Hut ha-Meshulash*, Responsa (Constantinople, 1739).

Duran Duran Shimon bar Zemah, *Responsa* [*Tashbetz*] (Lemberg, 1891).

Faraji Faraji Ya'aqov, *Responsa* (Alexandria, 1901).

Galante Abraham Galante Abraham, *Righteous Moral Precepts which are Observed in Eretz Israel* [in S. Schechter, *Studies in Judaism*, Second Series (Philadelphia, 1908), pp. 294-297].

Galante, *Kohelet* Galante Moses, *Kohelet Ya'aqov* (first printed in Safed, 1578).

Galante, Responsa Galante Moses, *Responsa* (Jerusalem, 1960) (first printed in Vencie, 1608).

Garmizan Garmizan Shmuel, *Mishpetei Zedek*, Responsa ((Jerusalem, 1983).

Gavizon	Gavizon Meir, *Responsa* (Jerusalem, 1985) (edited by E. Shochetman).
Gershom	Gershom ben Yehuda (Rabbenu Gershom Me'or ha-Gola), *Responsa* (New York, 1957).
Ginat Veradim	Halevi Abraham, *Ginat Veradim*, Responsa (Constantinople, 1716).
Ha-Cohen David	Ha-Cohen David (Radakh), *Responsa* (Constantinople, 1834) (reprint Jerusalem, 1968).
Ha-Cohen Solomon	Ha-Cohen Solomon (Maharshakh), *Responsa* (Jerusalem, 1950).
Hagiz Jacob	Hagiz Jacob, *Halakhot Qetanot*, Responsa (Venice, 1704).
Hagiz Moses	Hagiz Moses, *Sefer Sefat Emet* (Vilna, 1876).
Hemdah Genuzah	Z. Wolfinsohn and S. Shneorsohn (eds.), *Hemdah Genuzah*, A Collection of Gaonic Responsa (Jerusalem, 1863) (reprint: 1963).
Hotzin	Hotzin Zedaka, *Zedaka u-Mishpat*, Responsa (Tel-Aviv, 1975).
Katzin	Katzin Yehudah, *Sefer Mahaneh Yehudah* (Livorno, 1803) (reprinted: Jerusalem, 1989).
Laniado	Laniado Abraham, *Sefer Magen Avraham* (Venice, 1703).
Lieria Moses	Lieria Moses, *More Moral Precepts and Usages Observed by the Sages of Safed* [in S. Schechter, *Studies in Judaism*, Second Series (Philadelphia, 1908), pp. 299-301].
Lieria, Responsa	Lieria Yehoseph, *Responsa* (Jerusalem, 1988).
Mabit	Trani Moses ben Yoseph (Mabit), *Responsa* (Lvov, 1861).
Mabit, *Iggeret*	Trani Moses ben Yoseph (Mabit), *Iggeret Derekh Ha-Shem* (attached to *Sefer Ha-Yashar*, Venice, 1553) (Jerusalem, 1967).
Maharam, Lvov	Meir ben Barukh of Rothenburg (Maharam), *Responsa*, R.N.N. Rabbinowicz Edition (Lvov,1860) (reprint: Jerusalem, 1968).
Maharam, Prague	Meir ben Barukh of Rothenburg (Maharam), *Responsa*, (Prague, 1608), M.A. Bloch Edition (Berlin, 1891) (reprint: Jerusalem, 1968).
Maharit	Trani Yoseph ben Moses (Maharit), *Responsa* (Lemberg, 1861).
Maharit, New Responsa	Trani Yoseph ben Moses (Maharit), *Maharit's New Responsa* (edited by Z. Leitner) (Jerusalem, 1978).
Maharitaz	Zahalon Yom Tov (Maharitaz), *Responsa*, (Jerusalem, 1968).
Maharitaz, New Responsa	Zahalon Yom Tov (Maharitaz), *New Responsa* (Jerusalem, 1980-1981).
Mizrahi Elijah	Mizrahi Elijah, *Responsa* (Constantinople, 1560) (reprint: 1938).
Mizrahi Moses	Mizrahi Moses, *Admat Kodesh*, Responsa (Constantinople, 1742).
Moses Ibn Makhir	Moses Ibn Makhir, *Sefer Seder Hayom* (Lublin,1876).
Najara, *Meimei Yisrael*	Najara Yisrael, *Meimei Yisrael* (appended to the 3rd edition of Zemirot Yisrael, Venice, 1600).
Najara, *Zemirot*	Najara Yisrael, *Zemirot Yisrael*, I. Pris-Horev edition (Tel-Aviv, 1946) (first printed in Safed, 1587).
Pinto	Pinto Yoshiyahu, *Nivhar mi-Kesef*, Responsa (Aleppo, 1869).
Radbaz	David ben Zimra (Radbaz), *Responsa* (Warsaw, 1882).
Radbaz, *Maggen David*	David ben Zimra (Radbaz), *Maggen David* (Amsterdam, 1713).

Radbaz, *Mezudat David* David ben Zimra (Radbaz), *Mezudat David* (Zolkiev, 1862).
Radbaz, New Responsa David ben Zimra (Radbaz), *New Responsa from a Manuscript* (Bnei Beraq, 1975).
Ralbah Levi ben Haviv (Ralbah), *Responsa* (Jerusalem, 1975) (reprint of the Lemberg edition).
Rambam Moses ben Maimon (Rambam), *Mishne Torah* (various editions).
Rambam, Responsa Moses ben Maimon (Rambam), *Responsa*, Blau edition (Jerusalem, 1958-1961).
Rashba Solomon ben Abraham Adret (Rashba), *Responsa*, I-III (Bnei- Beraq,1958-1965), IV-VII (Jerusalem, 1960).
Rashba-Ramban Solomon ben Abraham Adret (Rashba), *Rashba's Responsa attributed to Ramban* (Tel-Aviv, 1959).
Rashdam Samuel de Medina, *Responsa* (Salonica, 1862) (reprint: New York, 1959).
Refuah ve-Hayyim Izhak ben Rabbi Eliezer, *Refuah ve-Hayyim mi-Yerushalayim* (Jerusalem, 1892).
Ribash Itzhak ben Sheshet Perfet (Ribash), *Responsa* (Jerusalem, 1968).
Rofeh Hiyya Rofeh, *Sefer Ma'aseh Hiyya* (Venice, 1652).
Rosh Asher ben Yehiel (Rosh), *Responsa* (New York, 1954) (First published in Constantinople, 1517).
Sambari Sambari Yoseph, *Sefer Divrei Yoseph*, photocopied from MS Paris AIU H130A, with an introduction by S. Shtober (Jerusalem, 1981).
Sefer Zera' Anashim Frankel, D. (Ed.), *Sefer Zera' Anashim*, Responsa (Husyatin, 1902).
Shabtai Shabtai Hayyim, *Responsa* (Salonica, 1651).
Shivhei ha-Ari Dayan Sha'ul, *Shivhei ha-Ari* (Aleppo, 1872).
Sithon Sithon Hayyim, *Sefer Eretz Hayyim* (Jerusalem, 1908).
Vital, *Etz Hayyim* Vital Hayyim, *Sefer Etz Hayyim* (Warsaw, 1891).
Vital, *Sefer ha-Hezyonot* Vital Hayyim, *Sefer ha-Hezyonot*, A.Z. Aescoly's edition (Jerusalem, 1954).
Vital, *She'arim* Vital Hayyim, *Shmonah She'arim* (Revised edition: Tel-Aviv, 1961- 1964).
Vital Samuel Vital Samuel, *Beer Mayim Hayyim*, Responsa (Tel-Aviv, 1966).

Primary Sources in Other Languages

Belon Pierre Belon du Mans, *Les Observations de Plusieurs Singularitèz, & choses memorables trouvées en Grece, Asie Judée, Egypte, Arabie & autres pays estranges*, I-III (paris,1555).
Busbecq Busbecq, O.G., *The Turkish Letters of Ogier Ghiselin de Busbecq, Imperial Ambassador at Constantinople 1554-1562*, Translated from the Latin of the Elzevir edition of 1633 by E.S. Forster (Oxford, 1968).
Harff Arnold von Harff, *The Pilgrimage of Arnold v. Harff*, Translated and edited by M. Letts (London, 1946).

Books and Articles

Abarbanell	Abarbanell, *Eve and Lilith* (in Hebrew) (Israel, 1994).
Aber	F. Aber, "The Grande Dame in Jewish History", in L. Jung (ed.), *The Jewish Library*, Third Series (New York, 1934), pp. 155-298.
Abrahams	Abrahams, I., *Jewish Life in the Middle Ages* (London, 1932).
Adelman, Custom	Adelman, H.,"Custom, Law and Gender: Levirate Union among Ashkenazim and Sephardim in Italy after the Expulsion from Spain", in R.B. Waddington and A.H. Williamson (eds.), *The Expulsion of the Jews, 1492 and After* (New York-London, 1994), pp. 107-125.
Adelman, Education	Adelman, H.E., "The Educational and Literary Activities of Jewish Women in Italy during the Renaissance and the Catholic Restoration", in A. Oppenheimer ed al. (eds)., *Shlomo Simonsohn Jubilee Volume*, English Section (Tel-Aviv, 1993), pp. 9-23.
Adelman, Wife-Beating	Adelman, H., "Wife-Beating among Early Modern Italian Jews (1400-1700)", *Proceedings of the 11th World Congress of Jewish Studies*, Division B, Vol. I (Jerusalem, 1994), pp. 135-142 (English Section).
Amar, Status	Amar, M., "The Woman's Status in Rabbinical Courts of Morocco in the 20th Century" (in Hebrew), *Miqqedem Umiyyam, Tradition and Modernity in the North African and Oriental Jewry*, 3 (1990), pp. 187-202.
Amar, Wife	Amar, M., "The Wife's Waiver in the *Takkanot* of Fez" (in Hebrew), *Sefunot, New Series*, 4(19) (1989), pp. 23-49.
Aptowitzer	Aptowitzer, A., *Introduction to Sefer Rabiah by Rabbi Eliezer ben Yoel Halevi* (in Hebrew) (Jerusalem, 1938).
Aries	Aries, Ph., *Centuries of Childhood – A Social History of Family Life* (New York, 1962).
Arussi	Arussi, R., "The Ethnic Factor in Rabbinical Decision-Making" (in Hebrew), *Dinè Israel*, 10-11 (1981-1983), pp. 125-175.
Ashtor	Ashtor (Strauss), E., *History of the Jews in Egypt and Syria under the Rule of the Mamluks* (in Hebrew), vol. II (1951), vol. III (1970).
Assaf, Abolition	Assaf, S., "Abolition of Marriage Contracts on behalf of Male Sons" (in Hebrew), *Hazofeh le-Hokhmat Israel* (Qwartalis Hebraica), 10 (Budapest, 1926) (reprinted Jerusalem, 1972), pp. 18-30.
Assaf, Appointment	Assaf, S., "Appointment of Women as Guardians" (in Hebrew), *Ha-Mishpat ha-Ivri*, 2 (1927), pp. 75-81.
Assaf, Contribution	Assaf, S., "Contribution to the Lives of R. Jonathan Nagid and R. Isaac Nagid" (in Hebrew), *Zion*, 2 (1937), pp. 121-124.
Assaf, Court Provision	Assaf, S., "A Court Provision from Jerusalem in the Time of the Ralbah" (in Hebrew), *Lu'ah Yerushalaim le-Shnat 5604 [1944]*, Fourth Year, pp. 99-108.
Assaf, Daughter	Assaf, S., "On the Daughter's Right to Inherit" (in He-

	brew), in *Festschrift zum siebzigsten Geburtstage von Jakob Freimann*, Hebrew Section (Berlin, 1937), pp. 8-13.
Assaf, Documents	Assaf, S., "New Documents Regarding the Last *Negidim* in Egypt" (in Hebrew), *Zion*, 6 (1941), pp. 113-118.
Assaf, Family	Assaf, S., "On the Family Life of the Jews in Byzantium" (in Hebrew), in *S. Krauss Jubilee Volume* (Jerusalem, 1936), pp. 169-173.
Assaf, Letter	Assaf, S., "Another Letter by Rabbi Shlomo Shlumil of Dreznitz" (in Hebrew), *Qovetz Al Yad*, New Series, 3(13) (1939), pp. 117-133.
Assaf, Manuscripts	Assaf, S., "On Various Manuscrips" (in Hebrew), *Qirjath Sepher*, 11 (1935), pp. 396-400; 492-498.
Assaf, Maran	Assaf, S., "A Letter from Maran Rabbi Yoseph Caro" (in Hebrew), *Sinai*, 6 (1940), pp. 517-518.
Assaf, Marranos	Assaf, S., "The Marranos of Spain and Portugal in the Responsa Literature" (in Hebrew), *Zion (Me'asef)*, 5 (1933), pp. 19-60.
Assaf, Regulations	Assaf, S.," The Various Regulations and Norms Regarding the Husband's Inheritance of His Wife's [Fortune]" (in Hebrew), *Mada'ei ha-Yahadut* (Jerusalem, 1926), pp. 79-94.
Assaf, Responsum	Assaf, S., "From a Responsum of Rabbi Yehiel Ashkenazi" (in Hebrew), in *Minha le-David, In Honour of David Yelin* (Jerusalem, 1932), pp. 233-235.
Assaf, Sources	Assaf, S., *Sources on the History of Education in Israel (in Hebrew)*, (Tel-Aviv, 1936).
Assis, Crime	Assis, Y., "Crime and Violence among the Jews of Spain (13th-14th Centuries)" (in Hebrew), *Zion*, 50 (1985), pp. 221-240.
Assis, Jews	Assis, Y., "The Jews of Spain in Gentile Courts (13th-14th Centuries)" (in Hebrew), in R. Bonfil et al. (eds.), *Culture and Society in Medieval Jewry, Articles in Memory of H. Ben Sasson* (Jerusalem, 1989), pp. 399-430.
Assis, Ordinance	Assis, Y., "The 'Ordinance of Rabbenu Gershom' and Polygamous Marriages in Spain" (in Hebrew), *Zion*, 46 (1981), pp. 251-277.
Attias, Canconero	Attias, M., *Canconero Judeo-Espanol* (in Hebrew and Judeo-Spanish) (Jerusalem, 1972).
Attias, Romancero	Attias, M., *Romancero Sefaradi, Romanzas y cantes popolares en Judeo-Espanol* (in Hebrew and Judeo-Spanish) (Jerusalem, 1956).
Avenary	Avenary H.,"Gentile Song as a Source of Inspiration for Israel Najarah", *Papers from the Fourth World Congress of Jewish Studies*, vol. II (Jerusalem, 1968), pp. 383-384 (in Hebrew), p. 208 (summary in English).
Avitsur	Avitsur, S., "Safed – Center of the Manufacture of Woven Woolens in the 16th Century" (in Hebrew), *Sefunot*, 6 (1962), pp. 41-69.
Badhab	Badhab, I. (ed.), *Kunteres Hidushei Dinim me-Rabbanei Yerushalim (1509)*, in Kovetz ha-Yerushalmi (Jerusalem, 1930).
Badinter	Badinter, E., *L'Amour en Plus*, Histoire de l'amour maternel (Paris, 1980) (in Hebrew: Tel-Aviv, 1985).

Baer
Baer, Y., *History of the Jews in Christian Spain* (in Hebrew) (Tel-Aviv,1965).

Baneth
Baneth, D.Z.,"Geniza Documents on Jewish Commercial Affairs in Egypt" (in Hebrew), in *Alexander Marx Jubilee Volume*, Hebrew Section (New York, 1950), pp. 75-93.

Baqshi-Doron
Baqshi-Doron, A., "Divorce as one of the TARIAG (613) Commandments" (in Hebrew), *Torah she-Be'al Peh*, 27 (1986), pp. 75-83.

Bardea
Bardea, Y., "The Rebellious Wife in Halakha" (in Hebrew), *Dinè Israel*, 5 (1974), pp. 49-84.

Barkai, Science
Barkai, R., *Science, Magic and Mythology in the Middle Ages* (in Hebrew), (Jerusalem, 1987).

Barkai, Traditions
Barkai, R., "Greek Medical Traditions and Their Impact on Conceptions of Women in the Gynecological Writings in the Middle Ages", in Azmon Y. (ed.), *A View into the Lives of Women in Jewish Societies* (Jerusalem, 1995), pp. 115-142.

Barkan
Barkan, O.L., "The Price Revolution of the 16th Century – A Turning Point in the Economic History of the Near East", *International Journal of Middle East Studies*, 6 (1975), pp. 3-28.

Barnai
Barnai, Y., "The Regulations of Jerusalem in the 18th Century as a Source on the Society, Economy and Daily Activities of the Jewish Community" (in Hebrew), in A. Cohen (ed.), *Jerusalem in the Early Ottoman Period* (Jerusalem, 1979), pp. 271-316.

Baron
Baron, S.W., *A Social and Religious History of the Jews: High Middle Ages 500-1200*, Vol. 7 (New-York, 1957) (Hebrew translation Tel-Aviv, 1965).

Bashan, Changes
Bashan, E., "Changes in the Social and Intellectual Status of Jewish Women in the Middle East" (in Hebrew), in *Mishpahot Beit Israel – Papers from the Conference on Jewish Thought*, 18 (1976), pp. 177-187.

Bashan, Crisis
Bashan, E., "The Political and Economic Crisis in the Ottoman Empire from the End of the 16th Century as Reflected in the Responsa Literature" (in Hebrew), in *Proceedings of the Sixth World Congress of Jewish Studies*, vol. II (Jerusalem, 1975), pp. 107-115.

Bashan, Regulations
Bashan, E., "Regulations for the Limitation of Luxury: Social and Halakhic Background" (in Hebrew), *Haggut*, 4 (1980), pp. 41-68.

Bashan, Testimonies
Bashan, E., "Testimonies of European Tourists as a Source for the Economic Life of the Jews in the Middle East in the Ottoman Period" (in Hebrew), in I. Ben-Ami (ed.), *The Sephardi and Oriental Jewish Heritage* (Jerusalem, 1982), pp. 35-80.

Basri
Basri, W., "A Divorce Given under Coercion" (in Hebrew), *Shenaton ha-Mishpat ha-Ivri*, 16-17 (1991), pp. 535-553.

Benayahu, Ari
Benayahu, M., *The Life of the Ari* (in Hebrew) (Jerusalem, 1967).

Benayahu, Beauty
Benayahu, M.(ed.), *Beauty and Bands, Rabbi Eliyahu Capsali's Responsum to Rabbi David Vital* (in Hebrew), (Tel-Aviv, 1990).

Benayahu, Collections
Benayahu, M., "Collections of Regulations and Customs of

Jerusalem" (in Hebrew), *Kirjath Sepher*, 22 (1946), pp. 262-265.

Benayahu, Community Benayahu, M., "The Ashkenazi Community of Jerusalem 1687-1747" (in Hebrew), *Sefunot*, 2 (1958), pp. 128-189.

Benayahu, Controversy Benayahu, M., "The Controversy between the Schools of the Mabit and Rabbi Yoseph Caro" (in Hebrew), *Asufot*, 3 (1989), pp. 9-98.

Benayahu, Devotion Benayahu, M., "Devotion Practices of the Kabbalists of Safed in Meron" (in Hebrew), *Sefunot*, 6 (1962), pp. 11-40.

Benayahu, Geniza Benayahu, M., "Geniza Documents on the Commercial Activities of the Ari and his Family in Egypt" (in Hebrew), in M. Benayahu (ed.), *Studies in Memory of Rabbi Yitzhak Nissim* (Jerusalem, 1985), vol. IV, pp. 225-253.

Benayahu, Letter Benayahu, M., "A Letter Sent by Daniel Finzi from Jerusalem to Carpi in 1625" (in Hebrew), *Asufot*, 1 (1987), pp. 215-242.

Benayahu, Mabit Benayahu, M., "Rabbi Moses son of Rabbi Yoseph of Trani" (in Hebrew), *Introduction to a photocopied edition of the Responsa of the Mabit* (Jerusalem, 1990).

Benayahu, Najara Benayahu, M., "Rabbi Israel Najara" (in Hebrew), *Asufot*, 4 (1990), pp. 203-284.

Benayahu, Portaleone Benayahu, M., "The Writings of Rabbi Samuel Portaleone" (in Hebrew), *Asufot*, 11 (1998), pp. 127-150.

Benayahu, Reasoning Benayahu, M., "The Reasoning behind Rabbi Elisha Gallico's Commentary on the Five Scrolls" (in Hebrew), *Asufot*, 4 (1990), pp. 73-98.

Benayahu, Revival Benayahu, M., "The Revival of Ordination in Safed" (in Hebrew), in S.W. Baron et al. (eds), *Yitzhak F. Baer Jubilee Volume* (Jerusalem, 1960), pp. 270-286.

Benayahu, Sermons Benayahu, M., "The Sermons of R. Yosef ben Meir Garson as a Source for the History of the Expulsion from Spain and Sephardi Diaspora" (in Hebrew), *Michael*, 7 (1981), pp. 42-205.

Benayahu, *Shoshan* Benayahu, M., "'*Shoshan Yesod ha-Olam*' by Rabbi Yoseph Tirshom" (in Hebrew), *Temirin*, 1 (1972), pp. 187-269.

Benayahu, Sources Benayahu, M., "Important Sources on the History of Jerusalem in the Time of Ibn Farukh" (in Hebrew), *Asufot*, 7 (1993), pp. 303-379.

Benayahu, Views Benayahu, M., "Controvertial Views of Rabbi Samuel Portaleone on the *Beit Yossef*" (in Hebrew), Asufot, 3 (1989), pp. 141-244.

Benayahu, Yonah Benayahu, M., "Rabbi Moses Yonah, a Disciple of the Ari and the First to Write Down his Teachings" (in Hebrew), in M. Benayahu (ed.), *Studies in Memory of Rabbi Yitzhak Nissim*, vol. IV (Jerusalem, 1985), pp. 7-74.

Ben Shalom Ben Shalom, R., "The Jewish Community in Arles and its Institutions: Ben Sheshet's Responsum 266 as an Historical Source" (in Hebrew), *Michael*, 12 (1991), pp. 9-41.

Ben Shimon, *Bat* Ben Shimon, R.A., *Bat Na'avat ha-Mardut* [The Rebellious Woman] (in Hebrew) (Jerusalem, 1917).

Ben Shimon, *Nahar* Ben Shimon, R.A., *Nahar Mitzrayim* [The River of Cairo] (in Hebrew), vol. II (Noa-Amon [Alexandria], 1908).

Bentov Bentov, H., "Autobiographic and Historical Register of

Rabbi Yosef Trani" (in Hebrew), *Shalem*, 1 (1974), pp. 195-228.

Ben Zeeb, Archive
Ben Zeeb I., "The Archive of the Cairo Jewish Community" (in Hebrew), *Papers of the World Congress of Jewish Studies – Summer 1947*, vol. I (Jerusalem, 1952), pp. 434-438.

Ben Zeeb, Cemetery
Ben Zeeb, I., "Documents Pertaining to the Ancient Jewish Cemetery in Cairo" (in Hebrew), *Sefunot*, 1 (1956), pp. 7-24.

Ben Zeeb, Hebrew Documents
Ben Zeeb, I., "The Hebrew Documents from the Cairo Community Archives" (in Hebrew), *Sefunot*, 9 (1964), pp. 265-293.

Ben Zvi, *Eretz Israel*
Ben Zvi, I., *Eretz Israel Under Ottoman Rule* (in Hebrew) (Jerusalem, 1975).

Ben Zvi, *Musta'rabs*
Ben Zvi, I., "Musta'rabs, The Ancient Natives of Palestine" (in Hebrew), *Research and Sources* (Jerusalem, 1966), pp. 15-20.

Berkovitz
Berkovitz, E., *Conditions in Marriage and Divorce Contracts* (in Hebrerw) (Jerusalem, 1966).

Berman
Berman, S., "The Status of Women in Halakhic Judaism", in E. Kolton (ed.), *The Jewish Woman – New Perspectives* (New York, 1976), pp. 114-128.

Biale
Biale, D., *Eros and the Jews* (in Hebrew) (Tel-Aviv, 1994).

Bleich
Bleich, D.I., "A Proposed Solution for the Problem of a Recalcitrant Husband" (in Hebrew), *Torah she-Be'al Peh*, 31(1950), pp. 124-139.

Bornstein-Makovetzky, Arta
Bornstein-Makovetzky, L., "Life and Society in the Community of Arta in the 16th Century" (in Hebrew), *Pe'amim*, 45 (1990), pp. 126-155.

Bornstein-Makovetzky, Community
Bornstein-Makovetzky, L., "The Community and its Institutions" (in Hebrew), in J.M. Landau (ed.), *The Jews in Ottoman Egypt* (Jerusalem, 1988), pp. 129-216

Bornstein-Makovetzky, Conversion
Bornstein-Makovetzky, L., "Jewish Conversion to Islam and Christianity in the Ottoman Empire in the 16th – 18th Centuries" (in Hebrew), in M. Abitbul et al. (eds.), *Hispano-Jewish Civilization after 1492* (Jerusalem, 1997), pp. 3-29.

Bornstein-makovetzky, Stratification
Bornstein, L., "Social Stratification in the Jewish Communities of the Ottoman Empire" (in Hebrew), in I. Ben-Ami (ed.), *The Sephardi and Oriental Jewish Heritage* (Jerusalem, 1982), pp. 81-95.

Braude
Braude, B., "The Textile Industry of Salonica in the Context of Eastern Mediterranean Economy" (in Hebrew), *Pe'amim*, 15 (1983), pp. 82-94.

Briffault
Briffault, *The Mothers*, vol. 2 (New York, 1969).

Buber-Agassi
Buber-Agassi, J, "The Status of Women in Israel", in: D. Izraeli et al. (eds.), *The Double Blind, Women in Israel* (in Hebrew) (Tel-Aviv, 1982), pp. 210-230.

Castro
Castro, A., *The Structure of Spanish History* (Princeton, N.J., 1954).

Cohen, Changes
Cohen, A., "Demographic Changes in the Jewish Community of Jerusalem in the 16th Century on the Basis of Turkish and Arabic Sources" (in Hebrew), in A. Cohen (ed.), *Jerusalem in the Early Ottoman Period* (Jerusalem, 1979), pp. 93-111.

Cohen, Damascus Cohen, D., "Damascus and Jerusalem" (in Hebrew), *Sefunot, New Series*, 2 (17) (1983), pp. 97-104.

Cohen, History Cohen, A. (ed.), *The History of Eretz Israel under the Mamluk and Ottoman Rule (1260-1804)* (in Hebrew), Volume VII of The History of Eretz Israel (ed. Y. Shavit) (Jerusalem, 1981).

Cohen, Jerusalem Cohen, A., *The Jewish Community of Jerusalem in the 16th Century* (Jerusalem, 1982).

Cohen-Lewis Cohen, A. and Lewis B., *Population and Revenue in the Towns of Palestine in the 16th Century* (Princeton, N.J., 1978).

Cohen-Pikali Cohen A. and Simon-Pikali S., *Jews in the Moslem Religious Court, Documents from Ottoman Jerusalem* (Jerusalem, 1993).

Cohen R. Cohen, R., "Problems relating to the Religious and Social Absorption of ex-Marranos by Greek Jewry Under Ottoman Rule after 1536", in Z. Ankori (ed.), *From Lisbon to Salonica and Constantinople, Annual Conference on Jews in Greece 1986* (Tel-Aviv, 1988), pp. 11-26 (in Hebrew).

Cohen-Tawil Cohen-Tawil, A. , "Sephardic Jews in *Aram Tsobah* (Aleppo) in the 16th Century" (in Hebrew), in I. Ben-Ami (ed.), *The Sephardi and Oriental Jewish Heritage* (Jerusalem, 1982), pp. 97-107.

Cohen Y. Cohen, Y., "The Inheritance of a Wife of her Husband in the Communal Enactments" (in Hebrew), *Shenaton ha-Mishpat ha-Ivri*, 6-7 (1979/80), pp. 134-175.

Danon, Communauté Danon, A., "La Communauté Juive de Salonique au 16e Siècle", *Revue des Etudes Juives*, 41 (1900), pp. 98-117, 250-265.

Danon, Letters Danon, A., "Seven Letters from the Holy City of Safed" (in Hebrew), Lunz's *Jerusalem*, 8 (1909), pp. 110-124.

David, Ashkenazi Community David. A., "The Ashkenazic Community in Jerusalem in the 16th Century" (in Hebrew), in *Proceedings of the Sixth World Congress of Jewish Studies*, vol. II (Jerusalem, 1975), pp. 331-341.

David, Castellazzo David, A., "The Castellazzo Family" (in Hebrew), *Sinai*, 64 (1969), pp. 282-287.

David, Community David, A., "On the Ashkenazic Community in Jerusalem in the 16th Century" (in Hebrew), in H.Z. Hirschberg (ed.), *Vatiqin, Studies on the History of the Yishuv* (Ramat Gan, 1975), pp. 25-33.

David, Data David, A., "Additional Biographical Data Concerning R. Moses Castro from a Geniza Fragment" (in Hebrew), *Te'uda*, 7 (1991), pp. 347-351.

David, Geniza David, A., "New Geniza Documents: Ties of Egyptian Jewry with Eretz Israel in the 16th Century" (in Hebrew), *Cathedra*, 59 (1991) pp. 19-55.

David, Immigration David, A., *Immigration and Settlement in the Land of Israel in the 16th Century* (in Hebrew) (Jerusalem, 1993).

David, Letter David, A., "The Letter of R. Israel Ashkenazi of Jerusalem to R. Abraham of Perugia" (in Hebrew), *'Alei Sefer*, 16 (1989/90), pp. 95-122.

David, Molina David, A., "R. Isaac di Molina" (in Hebrew), *Kirjath Sepher*, 44 (1968/69), pp. 553-559.

David, Personalities David, A., "New Information on some Personalities in Jeru-

	salem in the 16th Century" (in Hebrew), *Shalem*, 5 (1987), pp. 229-249.
David, Relations	David, A., "Relations between North African Jewry and Eretz Israel in the 15th and 16th Centuries" (in Hebrew), *Pe'amim*, 24 (1985), pp. 74-86.
David, Responsum	David, A., "Additional Responsum of R. Isaac di Molina" (in Hebrew), *Kirjath Sepher*, 46 (1970/71), pp. 580-582.
David, Safed	David, A., "Safed as a Center for the Resettlement of *Anusim*" (in Hebrew), in A. Haim (ed.), *Proceedings of the Second International Congress for Research of the Sephardic and Oriental Jewish Heritage 1984* (Jerusalem, 1991), pp. 183-204.
David, Settlements	David, A., "Jewish Settlements from the 16th Century to the 18th Century" (in Hebrew), in J.M. Landau (ed.), *The Jews in Ottoman Egypt* (Jerusalem, 1988), pp. 13-26.
David, Sholal Family	David, A., "On the History of the Sholal Family in Egypt and Eretz-Israel at the End of the Mameluke Period and the Beginning of the Ottoman Period in the Light of New Documents from the Geniza" (in Hebrew), in *Exile and Diaspora, Studies Presented to Prof. H. Beinart on the Occasion of his 70th Birthday* (Jerusalem, 1988), pp. 374-414.
David, Termination	David, A., "The Termination of the Office of *Nagid* in Egypt and Biographical Data Concerning the Life of Abraham Castro" (in Hebrew), *Tarbiz*, 41 (1972), pp. 325-337.
David, To Come to the Land	David, A., *To Come to the Land* (Tuscaloosa and London, 1999).
De Beauvoir	Beauvoir, S. de, *The Second Sex*, trans. H.M. Parshley (London, 1983).
Dengler	Dengler, I.C., "Turkish Women in the Ottoman Empire", in N. Keddie and L. Beck (eds.), *Women in the Muslim World* (Cambridge, MA – London, 1978), pp. 229-244.
Dikstein, Contracts	Dikstein, P., "Marriage Contracts on behalf of Male Sons" (in Hebrew), *Ha-Mishpat Ha-Ivri*, III (Tel-Aviv, 1928), pp. 25-82.
Dikstein, Mysteries	Dikstein (Dykan), P., "The Mysteries of Marital Law: Studies on Marital Law in Israel" (in Hebrew), in M.D. Cassuto et al. (eds.), *Sefer Assaf* (Jerusalem, 1953), pp. 201-216.
Dimitrovsky	Dimitrovsky, H.Z., "A Dispute between Rabbi J. Caro and Rabbi M. Trani" (in Hebrew), *Sefunot* 6, (*Safed Volume*, I), (1962), pp. 71-123.
Dinary, Impurity	Dinary, Y., "The Impurity Customs of the Menstruate Woman – Sources and Development" (in Hebrew), *Tarbiz*, 49 (1979/80), pp. 302-324.
Dinary, Profanation	Dinary, Y., "The Profanation of the Holy by the Menstruant Woman and *Takanat Ezra*" (in Hebrew), *Te'uda*, 3 (1983), pp. 17-37.
Dinur	Dinur, H., *Women and Personal Law in 'Bereshit Rabah'*, M.A. Dissertation, Tel-Aviv University (Tel-Aviv, 1992).
Elon, Jewish Law	Elon, M., *Jewish Law: History, Sources, Principles* (in Hebrew) (Jerusalem, 1978).
Elon, Nature	Elon, M., "On the Nature of Communal Legislation in Jew-

ish Law" (in Hebrew), in G. Tedeschi (ed.), *Studies in Law in Memory of Abraham Rosenthal* (Jerusalem, 1964), pp. 1-54.

Epstein, Marriage Contract — Epstein, L.M., *The Jewish Marriage Contrat* (New York, 1927) (Hebrew Edition: *Toldot ha-ketuba be-Yisrael*, New York 1954).

Epstein, Studies — Epstein, I., *Studies in the Communal Life of the Jews of Spain* (New York, 1968).

Euerbach — Euerbach, D., *The Ways of her Household* (in Hebrew) (Jerusalem, 1983).

Falk, Inheritance — Falk, Z., "The Inheritance of Daughters and Widows" (in Hebrew), *Tarbitz*, 23 (1952), pp. 9-15.

Falk, Marriage — Falk, Z., *Marriage and Divorce* (in Hebrew) (Jerusalem, 1961).

Falk, Status — Falk, Z., "The Status of Women in the Jewish Communities of Ashkenaz [Germany] and France in the Middle Ages" (in Hebrew), *Sinai*, 48 (1961), pp. 361-367.

Finkelstein — Finkelstein, L., *Jewish Self Government in the Middle Ages* (New York, 1964).

Fishman — Fishman, T., "A Kabbalistic Perspective on Gender-Specific Commandments: On the Interplay of Symbols and Society", *AJS Review*, 17 (1992), pp. 199-245.

Freimann, Betrothal — Freimann, A.H., *Betrothal and Marriage from the Redaction of the Talmud to the Modern Era* (in Hebrew) (Jerusalem, 1964).

Freimann, Critique — Freimann, A., "A Critique of L.M. Epstein's 'Marriage Laws in the Bible and the Talmud' (Mass. 1942)" (in Hebrew), *Kirjath Sepher*, 23 (1946), pp. 108-113.

Freimann, Regulations — Freiman, A., "Regulations of Jerusalem" (in Hebrew), in I. Baer et al. (eds.), *Sepher Dinburg* (Jerusalem, 1949), pp. 206-215.

Friedhaber, Customs — Friedhaber, Z., "Dance Customs at Jewish Weddings in Turkey from the 16th-19th Centuries" (in Hebrew), in M. Abitbol et al. (eds.), *Hispano-Jewish Civilization after 1492* (Jerusalem 1997), pp. 233-240.

Friedhaber, Dancing — Friedhaber, Z., "Dancing in Spanish Jewish Communities in the light of Communal Regulations and Halakhic Sources " (in Hebrew), in I. Ben Ami (ed.), *The Sephardi and Oriental Jewish Heritage* (Jerusalem, 1982), pp. 347-353.

Friedman, Division — Friedman, M.A., "Division of the Marriage Gift into Immediate and Postponed Portions in the Cairo Geniza Documents" (in Hebrew), in *Proceedings of the Sixth World Congress of Jewish Studies*, vol. III (Jerusalem, 1977), pp. 377-387.

Friedman, Divorce — Friedman, M.A., "Divorce upon the Wife's Demand as Reflected in Manuscripts from the Cairo Geniza", *Jewish Law Annual*, IV (1981), pp. 103-126.

Friedman, *Halakha* — Friedman, M.A., "*Halakha* as Evidence of Sexual Life among Jews in Muslim Countries in the Middle Ages" (in Hebrew), *Pe'amim*, 45 (1990), pp. 89-107.

Friedman, Intervention — Friedman, M.A., "Intervention des autorités de Kairouan au sujet d'un divorce d'une fiancée, un nouveau fragment d'un grand recueil de Responsa des *Gueonim*" (in Hebrew), *Michael*, 5 (1978), pp. 215-242.

Friedman, Jewish Marriage — Friedman, M.A., *Jewish Marriage in Palestine* (Tel-Aviv – New York, 1980).

Friedman, Marriage Friedman, M.A., "Marriage Laws Based on *Ma'asim Livne*
Laws *Yisra'el*" (in Hebrew) , Tarbiz, 50 (1980/81), pp. 209-242.
Friedman, Friedman, M.A., "Matchmaking and Betrothal Agreements
Matchmaking in the Cairo Geniza" (in Hebrew), in *Proceedings of the Seventh
 World Congress of Jewish Studies*, vol. III (Jerusalem, 1981), pp.
 157-173.
Friedman, Polygamy Friedman, M.A., "Polygamy in the Documents of the
 Geniza" (in Hebrew), *Tarbiz*, 40 (1970/71), pp. 320-359.
Friedman, Polygyny Friedman, M.A., *Jewish Polygyny in the Middle Ages* (in He-
 brew) (Jerusalem, 1986).
Friedman, Proceedings Friedman, M.A., "Divorce Proceedings Initiated by the
 Wife in Eretz-Yisrael, Egypt and North Africa, according to
 the Cairo Genizah Documents" (in Hebrew), *East and
 Maghreb*, 2 (1980), pp. 19-25.
Friedman, Ransom Friedman, M.A., " The Ransom-Divorce – Divorce Pro-
 ceedings Initiated by the Wife in Mediaeval Jewish Prac-
 tice", *Israel Oriental Studies*, 6 (1976), pp. 288-307.
Friedman, Tamar Friedman, M.A., "Tamar, A Symbol of Life: The 'Killer
 Wife' Superstition in the Bible and Jewish Tradition", *AJS
 Review*, 15 (1990), pp.23-61.
Friedman, Termination Friedman, M.A., "Termination of Marriage upon the
 Wife's Request", *Proceedings of the American Academy for Jewish
 Research*, 27 (1969), pp. 25-55.
Galanti, Histoire Galanti, A., *Histoire des Juifs de Rhodes, Chio Cos, etc.* (Istanbul,
 1935).
Gelbard Gelbard, S., *Coercing a Husband to Grant a Divorce in Tannaitic
 and Amoraic Literature* (in Hebrew), M.A. Dissertation, Tel-
 Aviv University (1970).
Gelis, Customs Gelis, J., *Customs of Eretz Israel* (in Hebrew) (Jerusalem, 1968).
Gelis, Encyclopedia Gelis, J., *Encyclopedia of the Sages of Eretz Israel* (in Hebrew)
 (Jerusalem, 1974).
Gerber, Bursa Gerber, H., "The Jews in the Economic Life of the
 Anatolian City of Bursa in the 17th Century: Notes and
 Documents" (in Hebrew), *Sefunot, New Series*, 1(16) (1980),
 pp. 235-272.
Gerber, Enterprise Gerber, H., "Enterprise and International Commerce in
 the Economic Activity of the Jews of the Ottoman Empire
 in the 16th-17th Centuries" (in Hebrew), *Zion*, 43 (1978),
 pp. 38-67.
Gerber, History Gerber, H., "On the History of the Jews in Istanbul in the
 17th and 18th Centuries" (in Hebrew), *Pe'amim*, 12 (1982),
 pp. 27-46.
Gerber, Ottoman Gerber, H., *Economic and Social Life of the Jews in the Ottoman
Empire Empire in the 16th and 17th Centuries* (in Hebrew) (Jerusalem,
 1982).
Gerber, *Wakf* Gerber, H., "The Jews and the *Wakf* in the Ottoman Em-
 pire" (in Hebrew), *Sefunot, New Series*, 2(17) (1983), pp. 105-
 131.
Gibb and Bowen Gibb, H.A.R., and Bowen H., *Islamic Society and the West*
 (Oxford, 1969).
Gil Gil, M., *Palestine During the First Muslim Period (634-1099)* (in
 Hebrew) (Jerusalem, 1983).

Goitein, Education | Goitein, S.D., *Jewish Education in Muslim Countries* (in Hebrew) (Jerusalem, 1962).

Goitein, Introduction | Goitein S.D., *Introduction to Muslim Law* (in Hebrew) (Jerusalem, 1958).

Goitein, Position | Goitein, S.D., "The Position of Women according to the Cairo Geniza Documents" (in Hebrew), *Proceedings of the Fourth World Congress of Jewish Studies*, vol. II (1968), pp. 177-179.

Goitein, Society | Goitein, S.D., *A Mediterranean Society* ,Berkeley-Los Angeles-London, 1 (1967), 2 (1971), 3 (1978),4 (1983), 5 (1988).

Goodblatt | Goodblatt, M.S., *Jewish Life in Turkey in the 16th Century as Reflected in the Legal Writings of Samuel di Medina* (New York, 1952).

Goren | Goren, S., "Women's Obligations with regard to Positive Commands", *Mahanayim*, 98 (1965), pp. 10-16.

Gottheil-Worrell | Gottheil, R., and Worrell, W.H., *Fragments from the Cairo Genizah in the Freer Collection* (New York, 1927).

Graetz | Graetz, N., "Some Halachic Aspects of Wife-Beating in the Jewish Tradition: The Case of Rejection", *Proceedings of the 11th World Congress of Jewish Studies*, Division B, Vol. I (Jerusalem, 1994), pp. 143-150 [English Section].

Green | Green, Y., "A Polemic between Moses ben Shoshan, Rabbi Moses Provencal and the Printers of Sabionetta" (in Hebrew), *Zion*, 51 (1986), pp. 223-240.

Grossman, Child Marriage | Grossman, A., "Child Marriage in Jewish Society in the Middle Ages" (in Hebrew), *Pe'amim*, 45 (1990), pp. 108-125.

Grossman, Family | Grossman, A., "Family Lineage and its Place in Early Ashkenazic Jewish Society" (in Hebrew), in E. Etkes and Y. Salmon (eds.), *Studies in the History of Jewish Society in the Middle Ages and in the Modern Period Presented to Prof. Yaakov Katz* (Jerusalem, 1980), pp. 9-27.

Grossman, Sages | Grossman, A., *The First Sages of Ashkenaz* (in Hebrew) (Jerusalem, 1981).

Grossman, Violence | Grossman, A., "Violence Against Women in Medieval Mediterranean Jewish Society" (in Hebrew), in Azmon Y. (ed.), *A View into the Lives of Women in Jewish Societies* (Jerusalem, 1995), pp. 183-207.

Grunwald | Grunwald, M., "The Child in Sephardic Folklore" (in Hebrew), *Folklore Research Center Studies*, 6 (1982), pp. 225-228.

Gudemann | Gudemann, M., *Torah and Life* (in Hebrew), III (Warsaw, 1899).

Gulack, Origins | Gulack, A., *The Origins of Jewish Law* (in Hebrew) (Tel-Aviv, 1967 – reprint).

Gulack, Treasury | Gulack, A., *A Treasury of Customary Legal Documents in Israel* (in Hebrew) (Jerusalem, 1926).

Guthold | Guthold, Z., "The Status of Women in the *Halakha*" (in Hebrew), *Mahanayim*, 98 (1965), pp. 18-27.

Gutwirth, Family | Gutwirth, E., "The Family in Judeo-Spanish Genizah Letters of Cairo", *Vierteljahrschrift für Sozial und Wirtschaftsgeschichte*, 73/2 (1986), pp. 210-215.

Gutwirth, Letter | Gutwirth, E., "A Judeo-Spanish Letter from the Genizah", in I. Banabu and J. Sermonita (eds.), *Judeo-Romance Languages* (Jerusalem, 1985), pp. 127-138.

Hacker, H. M. — Hacker, Helen M., "Women as a Minority Group", *Social Forces*, 30 (1951/52), pp. 60-69.

Hacker, Autonomy — Hacker, J., "Jewish Autonomy in the Ottoman Empire: Its Scope and Limits" (in Hebrew), in S. Almog et al (eds.), *Transition and Change in Modern Jewish History, Essays Presented in Honor of Shmuel Ettinger* (Jerusalem, 1987), pp. 349-388.

Hacker, Patterns — Hacker, J., "Patterns of the Intellectual Activity of Ottoman Jewry in the 16th and 17th Centuries" (in Hebrew), *Tarbiz*, 53 (1984), pp. 569-603.

Hacker, Pride — Hacker, J., "Pride and Depression – Polarity of the Spiritual and Social Experience of the Iberian Exiles in the Ottoman Empire" (in Hebrew), in R. Bonfil et al. (eds.), *Culture and Society in Medieval Jewry, Articles in Memory of H. Ben Sasson* (Jerusalem, 1989), pp. 541-586.

Hacker, Spanish Jewry — Hacker, J., "The Intellectual Character and Self-Perception of Spanish Jewry in Late 15th Century" (in Hebrew), *Sefunot, New Series*, 2 (17) (1983), pp. 21-95.

Hallamish, Literature — Hallamish, M., "Kabbalistic Ethical Literature before and after the Expulsion from Spain", in M. Abitbol et al. (eds.), *Hispano-Jewish Civilization after 1492* (Jerusalem 1997), pp. 165-185.

Hallamish, Text — Hallamish, M., "On the Text of Behavioral Mannerisms of the Sages of Safed" (in Hebrew), *Alei Sefer*, 14 (1987), pp. 89-97.

Havlin, Creativity — Havlin, S.Z., "Intellectual Creativity" (in Hebrew), in J.M. Landau (ed.), *The Jews in Ottoman Egypt* (Jerusalem, 1988), pp. 245-310.

Havlin, New Light — Havlin, S.Z., "New Light on the Enactments of Rabbenu Gershom Meor ha-Golah, Their Authorship, Scope and Spread" (in Hebrew), *Shenaton Ha-Mishpat Ha-Ivri*, 11-12 (1984-1986), pp. 317-335.

Havlin, *Takkanot* — Havlin, S.Z., 'The *Takkanot* of Rabbenu Gershon Ma'or Hagola in Family Law in Spain and Provence' (in Hebrew), *Shenaton ha-Mishpat ha-Ivri*, 2 (1975), pp. 200-257.

Heyd, Ottoman Documents — Heyd, U., *Ottoman Documents on Palestine 1552-1615* (Oxford, 1960).

Heyd, Safed — Heyd, U., "Ottoman Documents on the Jews of Safed in the 16th Century" (in Hebrew), *Jerusalem – Eretz Israel Studies*, II-V (1955), pp. 128-135.

Heyd, Turkish Documents — Heyd, U., "Turkish Documents on the Rebuilding of Tiberias in the 16th Century" (in Hebrew), *Sefunot*, 10 (1962), pp. 195-210.

Horowitz, C. — Horowitz, C., "Notes on the Attitude of Moses De Trani toward Pietist Circles in Safed" (in Hebrew), *Shalem*, 5 (1987), pp. 273-284.

Horowitz, E. — Horowitz, E., "Between Masters and Maidservants in the Jewish Society of Europe in Late Medieval and Early Modern Times" (in Hebrew), in I. Bartal and I. Gafni (eds.), *Sexuality and the Family in History* ['*Eros, Erussin ve-Issurim*'] (Jerusalem, 1998), pp. 193-211.

Hufton — Hufton, O., "Women in History: Survey Article", *Past and Present*, 101 (1983), pp. 125-141.

Idel	Idel, M., "Rabbi Yehudah Hallewa and his *Zafenat Pa'aneah*" (in Hebrew), *Shalem*, 4 (1984), pp. 119-148.
Inalcik	Inalcik, H., *The Ottoman Empire: The Classical Age 1300-1600* (London, 1973).
Ish Shalom	Ish Shalom, M., *Christian Travels in the Holy Land* (in Hebrew) (Tel-Aviv, 1965).
Israeli	Israeli, S., "On Coercion and Volition in Divorce" (in Hebrew), *Torah she-be'al Peh*, 12 (1970), pp. 32-38.
Jellinek	Jellinek, A., *Bet ha-Midrasch*, Kleiner Midraschim und vermischter Abhandlungen aus der ältern Jüdischen Literatur, Vols. III, IV (Leipzig, 1853) [Jerusalem, 1938].
Jennings, Kayseri	Jennings, C.R., "Women in Early 17th Century Ottoman Judicial Records – The *Sharia* Court of Anatolian Kayseri", *Journal of the Economic and Social History of the Orient*, 18 (1975), pp. 53-114.
Jennings, *Zimmis*	Jennings, R.C., "*Zimmis* (Non-Muslims) in Early 17th Century Ottoman Judicial Records", *Journal of the Economic and Social History of the Orient*, 21 (1978), pp. 115-193.
Kahane, *Agunot*	Kahane, I.Z., *Sefer ha-Agunot* [The Book of Agunot] (Jerusalem, 1954).
Kahane, Studies	Kahane, I.Z., *Studies in the Responsa Literature* (Jerusalem, 1973).
Katz, *Halakhah*	Katz, J. *Halakhah and Kabbalah, Studies in the History of Jewish Religion* (Jerusalem, 1984).
Katz, Levirate Marriage	Katz, J., "Levirate Marriage (*Yibbum*) and *Halizah* in Post-Talmudic Times" (in Hebrew), *Tarbiz*, 51 (1981), pp. 59-106.
Katz, Marriage	Katz, J., "Marriage and Sexual Life among the Jews at the Close of the Middle Ages" (in Hebrew), *Zion*, 10 (1945), pp. 21-54.
Katz, Relations	Katz, J., "Post-Zoharic Relations between *Halakha* and *Kabbalah*" (in Hebrew), *Da'at*, 4 (1980), pp. 57-74.
Katz, Though He Sinned	Katz, J., "'Though He Sinned – He Remains an Israelite'" (in Hebrew), *Tarbiz*, 27 (1957), pp. 203-217.
Katz, Tradition	Kats, J., *Tradition and Crisis* (in Hebrew) (Jerusalem, 1963).
Keddie & Beck	Keddie, N. and Beck, L., Introduction, *Women in the Muslim World* (Cambridge, MA – London, 1978), pp. 1-34.
Kerlin	Kerlin, A., *Torat Even ha-Ezer* (in Hebrew) (Jerusalem, 1950).
Kraemer, Letters	Kraemer, J.L., "Women's Letters from the Cairo Geniza: A Preliminary Study" (in Hebrew), in Azmon Y. (ed.), *A View into the Lives of Women in Jewish Societies* (Jerusalem, 1995), pp. 161-181.
Kraemer, Spanish Ladies	Kraemer, J. L., "Spanish Ladies from the Cairo Geniza", *Mediterranean Historical Review*, 6 (1991), pp. 237-267.
Kupfer	Kupfer, E., "The Jewish Community of Safed and the Activity of R. Menahem Azariah of Fano on Behalf of the *Yishuv* in Eretz-Israel" (in Hebrew), *Shalem*, 2 (1976), pp. 361-364.
Lamdan, Child Marriage	Lamdan, R., "Child Marriage in Jewish Society in the Eastern Mediterranean during the 16th Century", *Mediterranean Historical Review*, Vol. 11, 1(1996), pp. 37-59.
Lamdan, Female Slaves	Lamdan, R., "Female Slaves in the Jewish Society of Palestine, Syria and Egypt in the 16th Century" (in Hebrew), in M.

Rozen (ed.), *The Days of the Crescent, Chapters in the History of the Jews in the Ottoman Empire* (Tel-Aviv, 1996), pp. 355-371.

Lamdan, Separate — Lamdan, R., *A Separate People – Jewish Women in Palestine, Syria and Egypt in the 16th Century* (in Hebrew) (Tel-Aviv, 1996).

Lamdan, Status — Lamdan, R., *The Status of Jewish Women in the Communities of Egypt, Syria and Palestine in the Sixteenth Century* (in Hebrew), Ph.D. Dissertation, Tel-Aviv University (Tel-Aviv, 1992).

Lavsky — Lavsky, A., *Jerusalem Regulations from the Early 16th Century to the Mid 19th Century*, MA Dissertation, Bar Ilan University (Ramat-Gan, 1974).

Lee Osborne — Lee Osborn, M., *Women in Western Thought* (New York, 1979).

Levin — Levin, B.M., *Otzar ha-Geonim*, Vol. VIII, *Ketubot* (Jerusalem, 1939).

Lewis, History — Lewis, B., *On History – Collected Studies* (Revised Hebrew translation of articles first published in English) (Jerusalem, 1988).

Lewis, Jews — Lewis, B., *The Jews of Islam* (New York, 1984).

Littman, Capusi — Littman, M., "A Responsum of R. Hayyim Capusi" (in Hebrew), *East and Maghreb*, 2 (1980), pp. 53-57.

Littman, Family — Littman, M., "The Jewish Family in Egypt" (in Hebrew), in J.M. Landau (ed.), *The Jews in Ottoman Egypt* (Jerusalem, 1988), pp. 217-244.

Littman, Relations — Littman, M., "Relations between Different Jewish Communities in Egypt in the 16th and 17th Centuries" (in Hebrew), *Pe'amim*, 16 (1983), pp. 29-55.

Lusitanus — Lusitanus, I., "El viajero Pierre Belon y los Judios Sefardies" (in Hebrew), in *Tesoro de los Judios Sefardies*, 1(1959), pp. 62-73.

Mann, Jews — Mann, J., *The Jews in Egypt and in Palestine Under the Fatimid Caliphs* (Oxford, 1969).

Mann, Texts — Mann, J., *Texts and Studies in Jewish History and Literature*, vol. I (Cincinnati, 1931).

Maoz — Maoz, B., "Nineteen Annotated Epic Songs" (in Hebrew), *Folklore Research Center Studies*, 6 (1982), pp. 117-181.

Marcus — Marcus, A., "Privacy in 18th Century Aleppo: The Limits of Cultural Ideals", *International Journal of Middle East Studies*, 18 (1986), pp. 165-183.

Markon — Markon, I.D., "A Book of Songs, Hymns and Praises" (in Hebrew), *Dvir*, 1 (1923), pp. 228-284.

Marmorstin — Marmorstin, E., "The Veil in Judaism and Islam", *The Journal of Jewish Studies*, 5 (1954), pp. 1-11.

Marsot — Marsot Lutfi al-Sayyid, A., "The Revolutionary Gentlewomen in Egypt", in Keddie, N. and Beck, L. (eds.), *Women in the Muslim World* (Cambridge, MA – London, 1978), pp. 261-276.

Meir — Meir, L.A., "Jewish Dress in the Mamluk Period" (in Hebrew), in *Studies in Memory of Asher Gulak and Samuel Klein* (Jerusalem 1942), pp. 115-118.

Meroz — Meroz, R., "The Circles of R. Moses ben Makhir and its Regulations" (in Hebrew), *Pe'amim*, 31 (1987), pp. 40-61.

Mescheloff	Mescheloff, D., "The Woman in the Halakha" (in Hebrew), *Dinei Israel*, 13-14 (1986-1988), pp. 263-312.
Neeman	Neeman, P., "The Daughter's Inheritance in the *Torah* and *Halakha*" (in Hebrew), *Beit Mikra*, 16, 4 (47) (1971), pp. 476-489.
Newman	Newman, A.A., *The Jews in Spain*, vol. I (Philadelphia, 1942).
Pachter, Azikri	Pachter, M., "The Life and Personality of Rabbi Eleazar Azikri According to His Mystical Dairy" (in Hebrew), *Shalem*, 3 (1981), pp. 127-147.
Pachter, *Hazut Kasha*	Pachter, M., "*Hazut Kasha* of Rabbi Moses Alsheikh" (in Hebrew), *Shalem*, 1 (1974), pp. 157-193.
Pachter, Karo	Pachter, M., "Joseph Karo's *Maggid Mesharim* as a Book of Ethics" (in Hebrew), *Da'at*, 21 (1988), pp. 57-83.
Pachter, Literature	Pachter, M., *Homiletic and Ethical Literature of Safed in the 16th Century*, Ph.D. Dissertation, The Hebrew University (Jerusalem, 1976).
Pachter, Safed	Pachter, M., *From Safed's Hidden Tresures* (in Hebrew) (Jerusalem, 1994).
Pearl	Pearl, D., *A Textbook on Muslim Personal Law* (Kent, 1987).
Pollock	Pollock, L.A., *Forgotten Children – Parent-Child Relations from 1500 to 1900* (Cambridge, 1983).
Posner	Posner, A., "Literature for Jewish Women in Medieval and Later Times", in L. Jung (ed.), *The Jewish Library*, 3rd Series (New York, 1934), pp. 213-243.
Radai	Radai, F., "Women in Israeli Law", in: D. Izraeli et al (eds.), *The Double Blind, Women in Israel* (in Hebrew) (Tel-Aviv, 1982), pp. 172-209.
Ratzhaby	Ratzhaby, Y., "Troubles in Jerusalem in 1542" (in Hebrew), *Shalem*, 5 (1987), pp. 265-272.
Regev	Regev, S., "A Fragment from a Commentary on the Book of Ruth by R. Elisha Galiko" (in Hebrew), *Asufot*, 4 (1990), pp. 99-126.
Rivlin B., Family	Rivlin, B., "The History of the Jewish Family in Greece in the 16th and the 17th Centuries" (in Hebrew), in M. Abitbol et al. (eds.), *Hispano-Jewish Civilization after 1492* (Jerusalem 1997), pp. 79-104.
Rivlin E., Chapter	Rivlin, E.,"A Chapter in the History of Eretz Israel" (in Hebrew), *Mada'ei ha-Yahadut*, vol I (1926), pp. 95-111.
Rivlin E., History	Rivlin, E. and Rivlin, J.J., "On the History of the Jews in Damascus" (in Hebrew), *Rashumot*, 4 (1926), pp. 77-119.
Rivlin J., Gift	Rivlin, J., "A 'Separate Gift' Deed" (in Hebrew), *Asufot*, 11 (1998), pp. 167-181.
Rivlin J., Wills	Rivlin, J., "Inheritance, Wills and Legacies" (in Hebrew), *Diné Israel*, 13-14 (1986-1988), pp. 167-192.
Rohrich	Rohrich R. and E.B. Hoffman (eds.), *Women in Search of Utopia* (New York, 1984).
Rosanes	Rosanes, S.A., *History of the Jews in Turkey and the Lands of the East*, vol. II-III (Sofia, 1933-1938).
Rosen-Zvi	Rosen-Zvi, A., *The Law of Matrimonial Property* (in Hebrew) (Tel-Aviv, 1982).
Rozen, Community	Rozen, M., *The Jewish Community of Jerusalem in the 17th Century* (in Hebrew) (Tel-Aviv, 1984).
Rozen, Influential Jews	Rozen, M., "Influential Jews in the Sultan's Court in Istan-

	bul in Support of Jerusalem Jewry in the 17th Century" (in Hebrew), *Michael*, 7 (1981), pp. 396-490.
Rozen, *Musta'rabs*	Rozen, M., "The Position of the Musta'rabs in the Inter-Community Relationships in Eretz Israel from the End of the 15th Century to the End of the 17th Century" (in Hebrew), *Cathedra*, 17 (1980), pp. 73-101.
Rozen, Routes	Rozen, M., *In the Mediterranean Routes, The Jewish-Spanish Diaspora from the 16th to 18th Centuries* (in Hebrew) (Tel-Aviv, 1993).
Rozen, Ruins	Rozen, M. (ed.), *The Ruins of Jerusalem, A History of Jerusalem Under the Rule of Muhammad Ibn Farrukh* (in Hebrew) (Tel-Aviv, 1981).
Rubens	Rubens, A., *A History of Jewish Costume* (New York, 1967).
Schapiro	Schapiro, M., "Divorce on Grounds of Revulsion" (in Hebrew), *Dinè Israel*, 2 (1970), pp. 117-153.
Schechter	Schechter, S., *Studies in Judaism, Second Series* (Philadelphia, 1908).
Scheiber	Scheiber, A., *Geniza Studies* (Hildesheim – New York, 1981).
Scheiber-Benayahu	Scheiber, A. and Benayahu, M., "Communication of Rabbis of Egypt to Radbaz" (in Hebrew), *Sefunot*, 6 (1962), pp. 127-134.
Schereschewsky	Schereschewsky, B.Z., *Family Law in Israel* (in Hebrew) (Jerusalem, 1984).
Schipansky, Luxury	Schipansky, I., "Luxury as Viewed by the Sages and as practised by the Communities" (in Hebrew), *Or Hamizrach*, 18 (New York, 1969), pp. 274-281.
Schipansky, Ordinances	Schipansky, I., "Ordinances of the Early Rabbis" (in Hebrew), *Hadarom*, 28 (New York, 1969), pp. 145-159.
Schipansky, *Takkanot*	Schipansky, I., *The Takkanot of Israel*, I-IV (in Hebrew), Tel-Aviv, 1993/4).
Scholem, Insights	Scholem (Shalom), G., "New Insights into *Ashmedai* and *Lilith*" (in Hebrew), *Tarbitz*, 19 (1948), pp. 160-175.
Scholem, Trends	Scholem (Shalom), G., Major Trends in Jewish Mysticism (Jerusalem, 1941).
Schur, Community	Schur, N., "The Jewish Community of Jerusalem in the 16th – 18th Centuries According to Christian Chronicles and Travel Descriptions" (in Hebrew), in A. Cohen (ed.), *Jerusalem in the Early Ottoman Period* (Jerusalem, 1979), pp. 242-434.
Schur, Jerusalem	Schur, N. "Jerusalem in Czech Itineraries during and after the Hussite Period" (in Hebrew), in *Proceedings of the Tenth World Congress of Jewish Studies*, div. B, vol. I (Jerusalem, 1990), pp. 171-175.
Schur, Jews	Schur (Shur), N., "The Jews of Lebanon" (in Hebrew), *Pe'amim*, 24 (1985), pp. 117-144.
Schur, Relationship	Schur, N. "The Numerical Relationship between the Number of Households and the Total Polpulation in the Cities of Eretz Israel during the Ottoman Period" (in Hebrew), *Cathedra*, 17 (1980), pp. 102-106.
Schwarzbaum	Schwarzbaum, H., "Female Fickleness in Jewish Folklore", in I. Ben Ami (ed.), *The Sephardi and Oriental Jewish Heritage* (Jerusalem, 1982), pp. 589-613.
Shahar, Childhood	Shahar, S., *Medieval Childhood* (in Hebrew) (Tel-Aviv, 1990).

Shahar, The Fourth Estate — Shahar, S., *The Fourth Estate: A History of Women in the Middle Ages* (London, 1983) (in Hebrew: Tel-Aviv, 1983).

Shapiro & Ben-Eliezer — Shapiro Y. and Ben-Eliezer, U., *Elements of Sociology* (in Hebrew) (Tel-Aviv, 1986).

Shatzmiller — Shatzmiller, Y., "The Appearance of the Jews in Gentile Courts" (in Hebrew), *Proceedings of the Fifth World Congress of Jewish Studies*, vol. II (Jerusalem, 1972), pp. 275-381.

Sherman — Sherman, A., "The Validity in Israel of the Enactments of Rabbenu Gershom on Polygamy" (in Hebrew), *Torah she-be'Al Peh*, 27 (1986), pp. 104-117.

Shmuelevitz — Shmuelevitz, A., *The Jews of the Ottoman Empire in the Late 15th and 16th Centuries* (Leiden, 1984).

Shohat — Shohat, A., "The Jews in Jerusalem in the 18th Century" (in Hebrew), *Zion*, 1 (1936), pp. 377-410.

Shohetmann, Marriage — Shohetmann, A., "Marriage under Duress" (in Hebrew), *Sinai*, 105 (1990), pp. 109-124.

Shohetmann, Regulation — Shohetmann, A., "The Regulation of Safed and the Sages' Responsa concerning Monetary Revaluation" (in Hebrew), *Sinai*, 82 (1978), pp. 109-122.

Silberg — Silberg, M., *Personal Status in Israel* (in Hebrew) (Jerusalem, 1957).

Sinclair — Sinclair, D.B., "The Legal Basis for the Prohibition of Abortion in Jewish Law" (in Hebrew), *Shenaton ha-Mishpat ha-Ivri*, 5 (1978), pp. 177-207.

Soloveitchik — Soloveitchik, A., "Forcible Emigration to Israel", *Torah she-be-'al Peh*, 2 (1970), pp. 39-45.

Stahl, Family — Stahl, A., *Family and Child-rearing among Oriental Jewry* (in Hebrew), (Jerusalem, 1993).

Stahl, Love — Stahl, A., "Love as a Factor in the Choice of a Spouse (Historical, Literary and Folkloristic Sources)" (in Hebrew), *Folklore Research Center Studies*, 4 (1974), pp. 125-136.

Stillman N.A. — Stillman, N.A., *The Jews of Arab Lands* (Philadelphia, 1979).

Stillman, Attitudes — Stillman, Y.K., "Attitudes toward Women in Traditional Near Eastern Societies", in S. Morag et al. (eds.), *Studies in Judaism and Islam Presented to S.D. Goitein on the Occasion of his 80th Birthday* (Jerusalem, 1981), pp. 345-360.

Stillman, Geniza — Stillman, Y., "The Geniza *Ketubbot* as a Source for Medieval Female Attire" (in Hebrew), *Te'uda*, 1 (1980), pp. 149-160.

Stillman, Wardrobe — Stillman, Y.K., "The Wardrobe of Jewish Brides in Medieval Egypt", *Folklore Research Center Studies*, 4 (1974), pp. 297-304.

Stone — Stone, L., *The Family – Sex and Marriage in England 1500-1800* (London, 1977).

Tamar — Tamar, D., *Studies in the History of the Jewish People in Eretz Israel and in Italy* (Jerusalem, 1986).

Tishby — Tishby, I., *The Wisdom of the Zohar* (in Hebrew), Vol. II (Jerusalem, 1991).

Toledano — Toledano, J.M., *Treasured Archives* (in Hebrew) (Jerusalem, 1960).

Trachtenberg — Trachtenberg, I., *Jewish Magic and Superstition* (New York, 1977).

Turniansky — Turniansky, Ch., "A Correspondence in Yiddish from Jeru-

	salem, Dating from the 1560s" (in Hebrew), *Shalem*, 4 (1984), pp. 149-209.
Tykocinski	Tykocinski, H., *The Gaonic Ordinances* (in Hebrew) (Jerusalem, 1959).
Valler	Valler, S., *Women and Womanhood in the Stories of the Babylonian Talmud* (in Hebrew) (Tel-Aviv, 1993).
Vilnay, Ariel	Vilnay, Z., *Ariel, Encyclopedia for the Geography of Eretz Israel*, Vol. 7 (in Hebrew) (Tel-Aviv, 1979).
Vilnay, Holy Tombs	Vilnay, Z., *Holy Tombs in Eretz Israel* (in Hebrew) (Jerusalem, 1985).
Warhaftig, Coercion	Warhaftig, Z., "Coercion of a Divorce in Theory and Practice" (in Hebrew), *Shenaton Hamishpat Ha'ivri*, 16-17 (1991), pp. 153-216.
Warhaftig, Compensation	Warhaftig, Z., "The Custom of Divorce Compensation" (in Hebrew), *Sinai*, 98 (1986), pp. 67-77.
Weinroth	Weinroth, J., *The Law of the Rebellious Wife* (in Hebrew), Ph.D. Dissertation, Tel-Aviv University (Tel-Aviv, 1981).
Weiss	Weiss, S., *Holy Sites in Eretz Israel* (in Hebrew) (Jerusalem, 1986).
Westreich, Grounds	Westreich, E., *Grounds for Permitting a Man to Marry Bigamously in Jewish Law*, Ph.D. Dissertation, The Hebrew University (Jerusalem, 1990).
Westreich, Right	Westreich, E., "A Woman's Right to a Child in Jewish Law" (in Hebrew), in D. Gutwein and M. Mautner (eds.), *Law and History* (Jerusalem, 1999), pp. 103-126.
Winter, Jews	Winter, M., "The Jews of Egypt in the Ottoman Period according to Turkish and Arabic Sources" (in Hebrew), *Pe'amim*, 16 (1983), pp. 5-21.
Winter, Society	Winter, M., *Society and Religion in Early Ottoman Egypt* (New Brunswick – London, 1982).
Yaari, Letters	Yaari, A. (ed.), *Letters from the Land of Israel* (in Hebrew) (Ramat-Gan, 1971).
Yaari, Travels	Yaari, A. (ed.), *Travels to the Land of Israel* (in Hebrew) (Ramat-Gan, 1976).
Yaari, Women	Yaari, A., "A Letter from Ashkenazi Women in Jerusalem" (in Hebrew and Yiddish), *Kirjath Sepher*, 23 (1946), pp. 140-155.
Yahalom	Yahalom, J., "Rabbi Israel Najara and the Revival of Hebrew Poetry in the East after the Expulsion from Spain" (in Hebrew), *Pe'amim*, 13 (1960), pp. 96-124.
Yohas	Yohas, E. (ed.), *Spanish Jews in the Ottoman Empire* (A catalogue of the Israel Museum, in Hebrew) (Jerusalem, 1989).
Yuval	Yuval, I., "An Appeal against the Proliferation of Divorce in 15th Century Germany" (in Hebrew), *Zion*, 48 (1983), pp. 177-215.
Zack	Zack, S., "R. Moses Cordovero's Moral Philosophy" (in Hebrew), in M. Idel et al. (eds.), *Tribute to Sara [Wilensky], Studies in Jewish Philosophy and Kabbalah* (Jerusalem, 1994), pp. 163-183.
Zeevi	Zeevi, D., *The Ottoman Century*, Ph.D.Dissertation, Tel-Aviv University (Tel-Aviv, 1991).
Zemer	Zemer, M., *The Sane Halakhah* (Tel-Aviv, 1993).
Zohar	Zohar, Z., "The Halakhic Teaching of Egyptian Rabbis in Modern Times" (in Hebrew), *Pe'amim*, 16 (1983), pp. 65-88.

INDEX OF SUBJECTS

INDEX OF NAMES AND PLACES

BRILL'S SERIES
IN JEWISH STUDIES

1. Cohen, R. *Jews in Another Environment*. Surinam in the Second Half of the Eighteenth Century. 1991. ISBN 90 04 09373 7
2. Prawer, S.S. *Israel at Vanity Fair*. Jews and Judaism in the Writings of W.M. Thackeray. 1992. ISBN 90 04 09403 2
3. Price, J.J. *Jerusalem under Siege*. The Collapse of the Jewish State 66-70 C.E. 1992. ISBN 90 04 09471 7
4. Zinguer, I. *L'hébreu au temps de la Renaissance*. 1992. ISBN 90 04 09557 8
5. Gutwein, D. *The Divided Elite*. Economics, Politics and Anglo-Jewry, 1882-1917. 1992. ISBN 90 04 09447 4
6. Eraqi Klorman, B.-Z. *The Jews of Yemen in the Nineteenth Century*. A Portrait of a Messianic Community. 1993. ISBN 90 04 09684 1
7. Ben-Dov, N. *Agnon's Art of Indirection*. Uncovering Latent Content in the Fiction of S.Y. Agnon. 1993. ISBN 90 04 09863 1
8. Gera, D. *Judaea and Mediterranean Politics*, 219-161 B.C.E. 1998. ISBN 90 04 09441 5
9. Coudert, A.P. *The Impact of the Kabbalah in the Seventeenth Century*. The Life and Thought of Francis Mercury van Helmont (1614-1698). 1999. ISBN 90 04 09844 5
10. Gross, A. *Iberian Jewry from Twilight to Dawn*. The World of Rabbi Abraham Saba. 1995. ISBN 90 04 10053 9
12. Ahroni, R. *The Jews of the British Crown Colony of Aden*. History, Culture, and Ethnic Relations. 1994. ISBN 90 04 10110 1
13. Deutsch, N. *The Gnostic Imagination*. Gnosticism, Mandaeism and Merkabah Mysticism. 1995. ISBN 90 04 10264 7
14. Arbel, B. *Trading Nations*. Jews and Venetians in the Early Modern Eastern Mediterranean. 1995. ISBN 90 04 10057 1
15. Levenson, D. *Julian and Jerusalem*. The Sources and Tradition. 1996. ISBN 90 04 105441
16. Menache, S. (ed.). *Communication in the Jewish Diaspora*. The Pre-Modern World. 1996. ISBN 90 04 10189 6
17. Parfitt, T. *The Road to Redemption*. The Jews of the Yemen 1900-1950. 1996. ISBN 90 04 10544 1
18. Assis, Y.T. *Jewish Economy in the Medieval Crown of Aragon, 1213-1327*. Money and Power. 1997. ISBN 90 04 10615 4
19. Stillman, Y.K. & Stillman, N.A. (eds.). *From Iberia to Diaspora*. Studies in Sephardic History and Culture. 1999. ISBN 90 04 10720 7
20. Barkai, R. *A History of Jewish Gynaecological Texts in the Middle Ages*. 1998. ISBN 90 04 10995 1
21. Heller, M.J. *Printing the Talmud*. A History of the Individual Treatises Printed from 1700 to 1750. 1999. ISBN 90 04 11293 6
22. Deutsch, N. *Guardians of the Gate*. Angelic Vice Regency in Late Antiquity. 1999. ISBN 90 04 10909 9
23. Ratzabi, S. *Between Zionism and Judaism*. The Radical Circle in Brith Shalom 1925–1933. 2000. ISBN 90 04 11507 2

24. Brasz, C. & Kaplan, Y. (eds.). *Dutch Jews as Perceived by Themselves and by Others.* Proceedings of the Eighth International Symposium on the History of the Jews in the Netherlands, 22–25 November 1998. 2000. ISBN 90 04 11705 9

25. Drory, R. *Models and Contacts.* Arabic Literature and its Impact on Medieval Jewish Culture. 2000. ISBN 90 04 11738 5

26. Lamdan, R. *A Separate People.* Jewish Women in Palestine, Syria and Egypt in the Sixteenth Century. 2000. ISBN 90 04 11747 4